Advance praise for
Anteaesthetics

"In this brilliantly conceived and exquisitely rendered study, Bradley offers a path-breaking analysis that will revolutionize how we approach, contest, and undo the Western visual field. *Anteaesthetics* offers an indispensable and undisciplined new frame for black feminist theorizing."
— HUEY COPELAND, University of Pennsylvania

"*Anteaesthetics* is the study of black aesthetics I didn't know I sorely needed. Bradley offers a razor-sharp and sumptuous meditation on black aesthetics in, through, and vestibular to an anti-black world."
— ALEXANDER GHEDI WEHELIYE, Brown University

"Bradley's searching theory of black aesthesis traces black art's recursions through the violent origins of the aesthetic. *Anteaesthetics* opens a mode of reading for black art's non-instrumental exploration of abyssal descent. An incisive and energizing book through and through."
— REI TERADA, University of California, Irvine

"*Anteaesthetics* limns the depths of aesthetic and semiotic violence, refocusing our theoretical vision. This is an indispensable text—a tour de force."
— CALVIN WARREN, Emory University

"Incisive and compelling, Bradley's *Anteaesthetics* restores to thought and feeling a capacious sense of the aesthetic, revealing its tremendous and violent power as nothing less than foundational to a racially typified modern world."
— SHANE DENSON, Stanford University

Anteaesthetics

Inventions Black Philosophy, Politics, Aesthetics

Edited by David Marriott

Anteaesthetics

Black Aesthesis and the Critique of Form

Rizvana Bradley

Stanford University Press
Stanford, California

Stanford University Press
Stanford, California

Printed in the United States of America on acid-free, archival-quality paper

ISBN 9781503633025 (cloth)
ISBN 9781503637139 (paperback)
ISBN 9781503637146 (electronic)

Library of Congress Control Number: 2022060438

 Library of Congress Cataloging-in-Publication Data available upon request.

Series and cover design: Aufuldish & Warinner
Cover art: Théodore Géricault, *African Signaling*, study for *Raft of the Medusa*, 1819, oil on canvas, Musée Ingres. © RMN-Grand Palais / Art Resource, NY. Reprinted with permission.
Typeset by Elliott Beard in Freight Text Pro 10/14.75

For Zarina and D.K.L.

Contents

Acknowledgments

I want to begin by expressing my gratitude to Erica Wetter, Kate Wahl, and Caroline McKusick at Stanford University Press, whose enthusiasm for and diligent attention to my manuscript were instrumental in bringing this book to life. Two anonymous readers provided pointed insights that served to strengthen and clarify the arguments that follow. Barbara Armentrout's scrupulous copyedits were invaluable. The research for and writing of this book were substantially supported by the Creative Capital | Andy Warhol Foundation Arts Writers Grant Program. Additionally, the Terra Foundation for American Art provided opportunities to present on the project. I am especially grateful to Arthur Jafa, Glenn Ligon, Sondra Perry, and Mickalene Thomas for granting me permission to reproduce images of their artworks in these pages. Earlier versions of portions of the introduction and chapter 1 previously appeared as "On Black Aesthesis," *Diacritics* 49, no. 4 (2021), published with permission by Johns Hopkins University Press; and "The Vicissitudes of Touch: Annotations on the Haptic," *b2o: an online journal*, 21 November 2020, previously commissioned by 47 Canal, New York.

My most immediate thanks go to my students, colleagues, and staff members, past and present, in the Department of Film and Media at UC Berkeley; at the John F. Kennedy Institute for American Studies; at Yale University in the History of Art Department, the Department of African-American Studies, and the Department of Film and Media Studies; and at the University College of London in the History of Art Department and the Institute for Advanced Study. I am perpetually indebted to fellow members of the Practicing Refusal Collective and The Sojourner Project: Dionne Brand, Tina Campt, Hazel Carby, Denise Ferreira da Silva, Kaiama L. Glover, Saidiya Hartman,

Arthur Jafa, Simone Leigh, Tavia Nyong'o, Darieck Scott, Christina Sharpe, Maboula Soumahoro, Deborah A. Thomas, Françoise Vergès, Alexander G. Weheliye, and Mabel O. Wilson.

My thinking has been indelibly marked by years of generative conversations with thinkers and friends too numerous to name, among them: Larne Abse-Gogarty, John Akomfrah, Carol Anderson, Dudley Andrew, Tim Barringer, Ian Baucom, Lauren Berlant, Rich Blint, Troizel Carr, Clarence Bradley, Osei Bonsu, Melissa Blanco Borelli, Paul A. Bové, Sonia Boyce, Simone Browne, Donna Faye Burchfield, Shikeith Cathey, Sarah Cervenak, Ron Clark, Stuart Comer, Huey Copeland, Iggy Cortez, Margo Crawford, Ashon Crawley, Anne Cvetcovitch, Thadious Davis, Aria Dean, TJ Demos, Shane Denson, Mary Ann Doane, John Drabinski, Amalle Dublon, Kodwo Eshun, Jennifer Fay, Briony Fer, James Ford III, Rosalind Galt, Tamar Garb, Rosemarie Garland-Thomson, Michael Boyce Gillespie, Aracelis Girmay, Macarena Gómez-Barris, Elena Gorfinkel, Che Gossett, Jack Halberstam, Michael Hardt, Laura Harris, Leon Hilton, Erica Hunt, Bruce Jenkins, Charlotte Ickes, Axelle Karera, Kara Keeling, Tiffany Lethabo King, Marci Kwon, Fredric Jameson, Steffani Jemison, Jessica Marie Johnson, Donna Jones, R. A. Judy, Isaac Julien, Jennifer Krasinski, Jort van der Laan, Thomas Lax, Pamela M. Lee, Taylor Le Melle, Ligia Lewis, Sarah Lewis, Candice Lin, John Lucas, John MacKay, Nathaniel Mackey, Molly Magavern, Erin Manning, Brian Massumi, Deborah McDowell, Uri McMillan, Kobena Mercer, Saretta Morgan, Laura Mulvey, John Murillo III, Amber Musser, Julie Beth Napolin, Mignon Nixon, Ikechukwu Onyewuenyi, Meghan O'Rourke, Jennifer Packer, Tyrone Palmer, Linette Park, Donald Pease, Emily Pethick, Levi Prombaum, Chris Pye, Claudia Rankine, Will Rawls, Sangeeta Ray, Karen Redrobe, Mark Reinhardt, Anthony Reed, Jordy Rosenberg, Cameron Rowland, Anjalika Sagar, Isabelle Saldana, Mark Sandberg, Fred Schwartz, Greg Seigworth, Jorinde Seijdel, Jared Sexton, Rebecca Schneider, Staci Bu Shea, Aliza Shvarts, C. Riley Snorton, Dianne Stewart, Jacqueline Najuma Stewart, Martine Syms, Rei Terada, Amy Tobin, Kyla Tompkins, Wu Tsang, Maurice Wallace, Dorothy Wang, Calvin Warren, Leila Weefur, Simone White, Geoffrey Wildanger, Dagmawi Woubshet, Lynette Yiadom-Boakye, Soyoung Yoon, Damon Young, Constantina Zavitsanos, and Mila Zuo.

Fred Moten taught me to turn my ear with and toward "the hard row of beautiful things." Trinh T. Minh-ha renews my faith in experimentation. To

Hortense Spillers, whose work is the condition of possibility for so much of this project, I want to say thank you, not only for lighting the halls of this dismal institution with your searing intellect but also for your commitment to speech that no extant language can hold, to a poetics of thought that refuses closure. Frank Wilderson's generosity of spirit found me when I most needed it. David Marriott deserves far greater appreciation than my unfinished words can extend. I first had the pleasure of meeting Marriott during our session of the Rethinking the Black Intellectual Tradition: Pessimism as an Interpretive Frame conference at Amherst College. In retrospect, his critical reflections on my talk, particularly with respect to the problem of blackness and metaphoricity, could be marked as something of a trough between waves, an elliptical gathering that would in time issue a sea change in my thinking. Without his trenchant insight and his uncompromising commitment to black philosophy, in the face of conditions that would render every word a reinscription, this would not be the book it is today. Marriott reminds me that poetry's greatest gift lies in what remains unspoken.

Anteaesthetics

Introduction

Cruelty is formal.
—Steve McQueen[1]

Anteaesthetics: Black Aesthesis and the Critique of Form is a book that began from a question: how can we think with the vexed existence and gendered reproductions of blackness, which cannot be represented within modernity's aesthetic regime, yet are everywhere "bound to appear"?[2] I sensed that somewhere in the recesses of this question stirred "a truer word"[3] on the black work of art than those discourses that would extol the artwork's authentic testimony, resistive politics, or reparative potential. Too often, the celebration of black art is tethered to the presumptive affordances of *the aesthetic*, figured as a domain of the social fortuitously sheltered from or uncorrupted by the antiblack terror that lies just beyond its sanctuary. Or, where the putative autonomy of the aesthetic is regarded with skepticism, black art is overdetermined by the requisitions of a politics invariably predicated on suppressing the riotous emergence, the unmitigated fall that black art ineluctably verges on. *Anteaesthetics* radically diverges from the axiomatic presumption of black art's ontological inhabitancy, aesthetic coherence, and political instrumentality. This book is an effort to think philosophically with black art, with the philosophical invention black art necessarily undertakes. More precisely, this book follows (from) black art's thinking *before philosophy*—a thinking which precedes, exceeds, and yet is everywhere subject to the violence of philosophy. *Anteaesthetics* is less concerned with (re)drawing the categorical boundaries of black art than with accompanying black art in its insistent theorization of its own conditions of (im)possibility. Black art cries out, from beyond the brink, for a thought of negativity without recu-

1

peration or redress, a negativity whose movement establishes neither dialectic nor voidance, but illimitable descent. Black art turns the world inside out, tracing its absent center and anterior remains. Black art shudders and seethes with contaminative touch, with fleshly impurity, with the ruinous exorbitance it has been made to bear. Black art enunciates in an unspeakable tongue and finds ringing in the ears of those who would listen.

––––––––

The theoretical project that *Anteaesthetics* opens begins from the aesthesis of a black existence that is *before* the metaphysics of the antiblack world and the representational regime which endeavors to secure and sustain this metaphysics. My conception of *before*—signaled in the title of this book by the prefix *ante-*—assumes a dual spatiotemporal valence. Black aesthesis is at once vestibular to the antiblack world—its metaphysical threshold and abyssal limit—and always already subject to the violence of that world, even if not reducible to or completely subsumed by it.[4] *Before* names an interminable recursivity. *Anteaesthetics* asks after a constellation of experimentations and inhabitations that emerge before the antiblack world, as that world's condition of possibility and inexpungible mar. And though these anteaesthetic practices often evince a singular straining against or even retreat from the ramparts of the world, the fraught existence from which they emerge and which they bear can neither claim a home within the world nor escape it. Such a contention does not suggest that black artistry is either a contradiction in terms or an exercise in futility. On the contrary, *Anteaesthetics* is an attunement to and defense of what is indefensible in black art—of a tradition of artistry that serially and diffusively constitutes a problem of and for metaphysics.

Black aesthesis, which emerges in the vertiginous cut between black existence and black nonbeing, demands thinking with or toward the unthought.[5] Interrogating the difficult entanglements of race, gender, fleshly reproduction, and the (aesthetic) worlding of forms, *Anteaesthetics* attends to blackness as the bearing of the unbearable.[6] Only by lingering with the racially gendered bearings of and in the cut between black existence and black nonbeing, without recourse to the idioms of resolution or redress, might we renew our attunement to the minor dispositions of anteaesthetic invention.

July 21, 2020, Portland, Oregon

A photographer for *The New York Times* captures an image of a demonstrator waving a Black Lives Matter flag at the base of the front steps of the Multnomah County Justice Center.[7] The building became one of the notable flashpoints for the protests against racial injustice and police brutality, as it houses courtrooms, the Portland Police Bureau's Central Precinct, and a nearly 400-cell maximum-security jail. The background of the photograph reveals the building's facade illuminated by two projections, one stacked above the other (figure 1). The uppermost projection, though partially obscured by cropping and the flag flying defiantly in front of it, reads "POWER TO THE PEOPLE" and is cast in a thick, bright yellow typeface across the center's boarded-up front windows. Below it, behind the demonstrator's waving flag, is a video projection of Nina Simone's performance of "Tomorrow Is My Turn," from her 1965 concert in Holland.[8] In this photograph, the video of Simone appears in saturated dusky blue tones over the building's front entrance, now sealed off with a concrete barrier installed by the Department of Homeland Security.

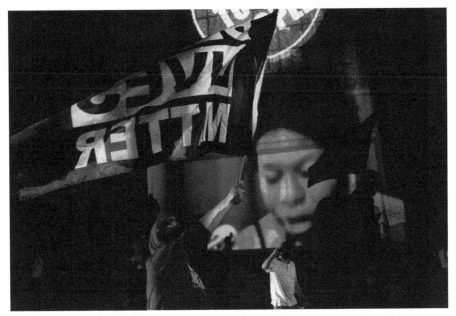

Figure 1. Projection of Nina Simone at Portland demonstration. Credit: Mason Trinca for *The New York Times*, 21 July 2020. Reprinted with permission.

What are we to make of this restaging of Simone's performance as the image and anthem of freedom's limit and horizon? How are we to regard this audiovisual projection as a form of political homage, when fashioning its visual and sonic power as diagnostic and panacea for the catastrophes of the present depends upon the preclusion of any attunement to the dissonant refusals which made such black artistry possible? What are we to make of this public projection and projection of a public, in which the audiovisual interface for mobilizing and coordinating political subjectivity and civic space[9] moves through the figure of a performer whose persona developed and cultivated strategies of "black feminist distanciation" precisely in order to "signify upon the ideological opacity of white spectators"?[10] Is this spectacularized projection not itself a form of containment that disavows Simone's performances as "crucial epistemic critiques" of "oppressive forms of 'knowing,'" critiques that "awaken[ed] her audiences to their own abjection"?[11]

This dramatic *New York Times* photograph, which would generally be taken to index the spirit of the summer protests in Portland and its dissident political inflections, returns me to another performance by Nina Simone, at the Montreux Jazz Festival in 1976. This performance was a return for Simone as well, her first time back at Montreux since she premiered there in June 1968, a moment which could be taken to symbolize the manner in which the High Priestess of Soul came to emblematize and mediate the conjoinment of art and politics not only for black diasporic radicalisms but for the world-historic revivification of that utopian figure of coalitionalism called "the Left."[12] In the eight years that had elapsed, much and little had changed. As Simone put it in her memoir, "The protest years were over not just for me but for a whole generation and in music, just like in politics, many of the greatest talents were dead or in exile and their place was filled by third-rate imitators."[13] Simone herself was now in "voluntary" exile in Barbados and Liberia,[14] one expression of a broader set of tribulations that have generally been narrated as the tragic consequences of personal pathology. Indeed, footage from Simone's 1976 performance at Montreux, which has been widely circulated in numerous formats,[15] opens Liz Garbus's acclaimed Netflix documentary *What Happened, Miss Simone?* (2015), as if her mercurial return to this stage could be readily taken as an allegory of her fall from grace.[16] At the outset, Simone declared that this would be her last time performing at a jazz festival, even though it would not, in fact, be her last.

Notwithstanding this broader tendency to read the strange or disorienting quality of Simone's 1976 performance at Montreux as merely symptomatic of some woeful spiraling toward personal and professional ruin, Simone's performance in fact presents a far more complicated scene for interpretation. Throughout the concert, Simone's ensemble of gestures appears to anticipate and frustrate the audiovisual coordinations of the racial gaze through the cathectic utility of her embodied figure, intransigently signifying upon the orchestrations of sound, silence, and word, of audience and performer, of performer and performed.[17] Take, for instance, the fifth song and first encore Simone performed during this concert, her medley rendition of Janis Ian's "Stars" and Morris Albert's "Feelings," which has been discussed by several scholars[18] and which appears toward the end of Garbus's film to cement the documentary's tragic arc, just prior to its predictably redemptive resolution.[19]

After being presented with flowers by her hosts, Simone promptly takes her seat at the piano, in accordance with the choreographic expectations of her hosts, audience, and documentarians. Yet no sooner than this dance commences, it is broken. "I'm quite aware that I have left you hanging [laughter from audience] . . . but I'm *tired*. You don't know what I mean, so I think I will sing." Interrupting herself multiple times and drifting through a series of apparently disconnected digressions, Simone holds her audience in an abeyance which signifies upon her own suspension in a set of "orchestrated amusements,"[20] the aesthetic dimensions of which her own reinventions of soul[21] have been made to catalyze and mediate. Simone made no secret of her contempt for this orchestration. Indeed, earlier in the concert, she allegorized the life and death of Janis Joplin, telling her audience, "I started to write a song about it, but I decided you weren't worthy . . . Anyway, the point is, it pained me, how hard she worked . . . and she played to *corpses*." Ironically, Simone's indictment of her audience could itself be considered an iteration of what David Marriott, invoking a theatrical idiom, refers to as "corpsing," or "the violation of rules of prescribed performance under the command of social laws."[22] Simone's itinerancy insists upon an awkwardness and recalcitrance before her necropolitical spectators,[23] as if baiting the foreseeable confrontation.

After Simone's periphrastic caesura within "Stars/Feelings" has gone on for some time, an audience member attempts to rein in her dereliction while

capitalizing upon an opportunity for humiliation: "Sing a song already!" Once seated again at her piano, as a cameraman homes in for his shot on her left side, Simone responds to the heckler: "What you're talking about ain't got nothing to do about nothing but show business, and I'm not about show business." Returning to her encore, Simone declares, "Now, okay, we leave you with this . . . It's sad, but that's what you expected anyway." Throughout her performance, Simone appears unbalanced and off-kilter and yet poised, exhibiting either a willful refusal to focus her gaze on the piano or the audience, repudiating her onlookers' gaze with indomitable intensity (figure 2). Her unpredictable movements and bewildering looks as she dizzyingly scans her enclosive surroundings seem almost to veer from the negentropic fixations of the spectatorial gaze, before gradually collapsing back into the deranged space and time of a performance that reaches its crescendo halfway through, when Simone pauses to offer her own acerbic formulation about the very song she feels compelled to sing: "Goddamn. I mean, you know, what a shame to have to write a song like that. . . . I do not believe the conditions that produced a situation that demanded a song like that!"

What are we to make of Simone's performance? Daphne Brooks might

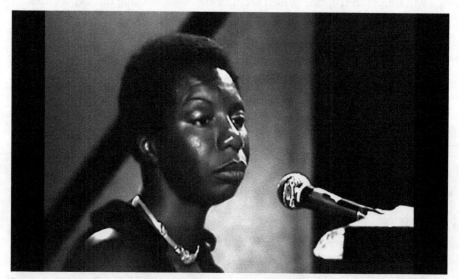

Figure 2. Nina Simone, "Stars/Feelings" medley, *Live at Montreux*, 1976. Permission granted by the Nina Simone Charitable Trust and Rich & Famous Records Ltd., Courtesy of Mercury Studios and Steven Ames Brown.

suggest that Simone's rendition of "Stars/Feelings" proffers a "poetics of sonic alienation as coruscating socio-political commentary."[24] For Charity Scribner, Simone's performance evinces a "calculated set of aesthetic techniques" that deconstruct the concert *form* itself.[25] How are we to interpret the fact that the very aesthetic forms which have been recomposed through Simone's inventiveness—not least the "freedom song"[26]—ultimately become instruments of her subjection? And how are we to think through Simone's strategies of "distanciation" amidst the immediacy and pervasiveness of violence to which she is subject? For the purposes of this book, Simone's performance foregrounds a set of hermeneutic conundrums which not only pertain to the dynamics of its specific scene of emergence but which, I argue, differentially subtend *every* nominal appearance of blackness, *every* instantiation of blackness *before* the world.

The aesthetic uses to which Simone's appearances are put in 1968 and 2020—in fashioning 1968 and 2020 as world-historic metonyms for an articulable politics, a politics which is inevitably an "extension . . . of the master's prerogative"[27]—are both paradoxically haunted by this 1976 performance, notwithstanding the absolutist pretensions of linear temporality. What are the implications of Simone's foreknowledge of the mediatic afterlives of her performance,[28] of knowing that her Montreux performance is not only being watched by her live audience but recorded and filmed? Of her knowledge that the "sovereign spectatorship"[29] of her audience will be endlessly redoubled in the subsequent audiovisual reproductions and circulations of her performance? Whether with foresight or in hindsight, when Simone peered through "the spectator-screen nexus"[30]—a nexus to which she is ubiquitously subject, even as she is never granted the capacity to be among its subjects— would she recognize herself in the image? Would the image of herself she is made to bear at the moment of her performance—her double consciousness of her audience's racially gendered gaze—be any more or less violent than the image which appears through successive audiovisual reproductions, if both images cohere through the organization of visual technologies and a visual field that are tethered to what Simone Browne would call the "surveillant gazes" of antiblack spectators?[31] And if Simone's performance could be said to emerge within or as a "theater of invisibility,"[32] then how are we to understand its implications for a more general understanding of the relationship between blackness and the aesthetic?

This book takes up the irreducibly corporeal dimensions of appearance and non-appearance as a racially gendered aesthetic problematic. I argue that, for the black, every appearance before the racial regime of aesthetics is an instance of violence, at once a conscription and a concealment. In *Anteaesthetics*, the force of black art is, in part, derived through its return to this scene of violence and the dehiscence it at once sustains and encloses, however incompletely. To be clear, black art exhibits an attunement to and extension of the black aesthesis that is neither apart from nor reducible to this violence. In the theoretical idiom I develop throughout this book, the image Nina Simone confronts and must negotiate is not an appearance of the flesh, but rather a dissimulation of the 'black body.' Throughout *Anteaesthetics*, I place *'black body'* in single quotation marks in order to emphasize the specious character of the phenomenological operation both the phrase and the figuration perform. This deconstruction of the axiomatic discourse on black corporeality is elaborated at length in the following chapter.

Nina Simone is faced with a vexed and inescapable dilemma, wherein her inhabitation of and labors within a fleshly existence which cannot appear are perversely tethered to a phantasmatic 'black body' which is made to appear, by the sweat of her own brow. If the example of Simone would seem to be extraordinary, it is only to the extent to which, paradoxically, it evinces the cruel mundanity of the aesthetic subjection blackness is singularly made to bear. Simone is forced to body forth the very audiovisual economy to which her serial reproductions are endlessly subject and from which her fleshly existence is endlessly barred. In a timeless echo of Frantz Fanon's theorization of the black's (non-)encounter with cinema, Simone is forced to wait for herself to appear, without avail.[33]

The Ontology of the World

In an era in which the aesthetic is generally regarded either as separate from and ancillary to the political or as a curative political space of unfettered imagination and even emancipatory potential, *Anteaesthetics* is an inquiry that proceeds from a radically divergent premise. Neither autonomous nor innocent, neither peripheral nor unfettered, the aesthetic is in fact constitutive of and indispensable to the modern world, in all its brutality and depredation. As David Lloyd suggests, after Sylvia Wynter and many others,

within modernity the aesthetic is above all a "racial regime of representa-tion."[34] This regime of aesthetics is foundational to the antiblack world, to carving its essential antagonisms and to suturing its metaphysical fissures.

Anteaesthetics inaugurates a theoretical project which is not, in the first instance, concerned with elaborating a critique of the racial regime of aesthetics. Rather, this project aims to think with the aesthesis of a black existence that is before the metaphysics of the antiblack world and the repre-sentational regime which endeavors to secure and sustain this metaphysics. Inspired by Hortense Spillers's incomparable declaration that "before the 'body' there is the 'flesh,'" my conception of *before* assumes a dual spatio-temporal valence: black aesthesis serves as the vestibule for the antiblack world; it is the threshold for and abyssal limit of its racial metaphysics. Yet black aesthesis is also always already subject to the world's violence, even if it ultimately remains irreducible to worldly depredation. Hence my modifica-tion of the word *aesthetic* with the prefix *ante-* (meaning "before, in front of; previous, existing beforehand; introductory to")[35] to signal a black aesthesis which is at once vestibular and subject to the impositions and circumscrip-tions of the racial regime of aesthetics.

Each of this book's chapters endeavors to think with the enfleshed exis-tence and racially gendered reproductivity of blackness. Blackness, I argue, has no place within the ontology of the antiblack world and cannot be repre-sented within modernity's aesthetic regime; yet, paradoxically, this regime insatiably demands its labors and appearance. Simone's example prompts us to ask, How do we think black art against the grain of an aesthetic grammar within which blackness may only ever appear as an aberration, mistrans-lation, or, more precisely, dereliction?[36] How do we begin to approach the splayed, (in)communicable corpus of blackness without recourse to a con-ceptual grammar for and from which blackness is the ultimate declension? How to attend to an existence that is perennially given, again as before, to an aesthesis which is always already the condition of our affection and affliction? (*Affection* here bears a dual valence, signaling a question that is woven throughout this book: what modalities of feeling, what sensoriums, affiliations, or affinities are fashioned by those whose affliction is at once an absolute expulsion from and absolute exposure to the world?) This book is one effort to inquire into the racially gendered (re)productions of both blackness and the racial regime of aesthetics for which that existence is

both threshold and abyssal limit. And, if the question of black existence is inevitably a question of bearing—of emergence and sustenance, enduring and duration—then it is also a question of the black feminine and the black maternal, irreducibly tethered to the terrors and beauties of reproduction. Within this inquiry, blackness poses a distinctive aesthetic problematic—a problem for and prerequisite of the aesthetic which sustains the semblance of an ordered world, a world formalized in and through its putative remove from chaos and entanglement, from catastrophe.

Simone's example can help us to understand that the racially gendered bearings of the cut between black existence and black nonbeing can be glimpsed only through an ulterior inquiry into the philosophy of ontology. *Anteaesthetics* proceeds by troubling, as many recent theorists in black studies have, the ontological foundations of various humanist (and nominally posthumanist) discourses from phenomenology to psychoanalysis. Such excavations and desedimentations of the ontological are crucial for our project, not least because so much of the contemporary criticism on black art commences from the twinned axiomatic presumption of the artwork's ontological inhabitancy and aesthetic coherence. Yet the implications of a radical critique of ontology's constitutional antiblackness are not isolated to the black artwork but rather pertain to the entirety of modernity's order of forms. The black critique of ontology is vital to this book's methodological deviation from the assumptive logics and categorical inscriptions that undergird the variegated fields *Anteaesthetics* traverses, fields which include film and media studies, contemporary art and art historical discourses, visual studies, literary studies, and gender studies, among others. In general, blackness is completely occluded from questions of ontology, whether ontology is in fact consciously posed as a question or simply reiterated in the structure of civil society's political unconscious. Notwithstanding the overwhelming consensus of this malign neglect, I share the contrary assessment of a range of theorists across black studies, generously construed, who have declared that antiblackness is not epiphenomenal to modern ontology but rather its singular condition of possibility.

Critical interrogation of the philosophy of ontology vis-à-vis blackness may be traced at least as far back as W. E. B. Du Bois, whose sociological study, Hortense Spillers tells us, aimed at "trying to discover—indeed to posit—an ontological meaning in the dilemma of blackness."[37] Here I briefly

sketch the critique of ontology that has emerged in black studies in recent decades, as a means of thinking further about anteaesthetic practices which cannot be fully understood only with recourse to the conceptual tools or hermeneutics afforded by ontology and the aesthetic regime to which it is bound. As many have gone to great lengths to argue, this is so because the philosophy of ontology cannot think black existence. David Marriott minces no words on this account, declaring "ontology irrelevant for understanding black existence."[38] Differing from this position, Nahum Chandler and Fred Moten emphasize a "paraontological approach to the facticity of blackness."[39] R. A. Judy, in both concert and contradistinction with Chandler's and Moten's paraontological emphasis, stresses what he terms "poiēsis in black"—a "thinking-in-disorder" whose method "is indicial of a perennial crisis of ontology," that is indeed "emergent in that crisis" but is not, nevertheless, "circumscribed by ontology."[40] Axelle Karera, in her careful parsing of Chandler's, Moten's, and Judy's respective orientations, their inheritances, and what she reads as their divergent lines of flight, cautions that "to be ontologically or phenomenologically unreadable is not synonymous with flight or fugitivity."[41]

Anteaesthetics contends that, if we can indeed speak of black existence or the existence of blackness, it is clear that neither ontology nor phenomenology can provide the conceptual tools for tending to the inhabitations of this existence which emerges before, but not within, the aesthetic. Making sense of the artistic practices discussed in this book requires a provisional understanding of the theoretical efforts to grapple with the logics that subtend the foundational interdiction of blackness from ontology and the indispensable role of the aesthetic in securing this interdiction. Furthermore, we will need a more precise understanding not only of the gendered distinctions in the aesthetic dispensations and recuperations of modernity's antiblack ontology but of the racially gendered reproduction of this ontology and its dehiscent anterior. This coerced reproductivity, which sustains the cut between black existence and nonbeing, is central to my theoretical elaboration of the racially gendered aesthesis that subtends the practices I examine in this book.

For some within contemporary black studies, the deduction that blacks have an existence in an antiblack world is accompanied by a critique of ontology's bearing on such existence. The pursuit of another means of thinking black existence finds myriad expressions. Christina Sharpe speaks of *"wake

work" as an analytic and "mode of inhabiting *and* rupturing" the epistemic valences of slavery's enduring cataclysm "with our known lived and un/ imaginable lives . . . [such that] we might imagine otherwise from what we know *now* in the wake of slavery."[42] Saidiya Hartman, in her ongoing encounter with the limits, gaps, and distortions of the archive, turns to what she terms "critical fabulation," a method of creative re-presentation that seeks to "jeopardize the status of the event, to displace the received or authorized account," and to thereby "reckon with the precarious lives which are visible only in the moment of their disappearance."[43] Hortense Spillers has stressed the importance of a hermeneutic attuned to "intramural dynamics of alterity . . . that would account for the 'secret' text . . . [of black life] in a world of keen ears, of decisively configured discursive interests."[44] Each one of these critical motifs is differentially taken up in this book in an effort to think the racially gendered vestibularity that is anterior to ontology and bears its various deconstructions.

In attending to the racially gendered reproductions of and in the cut between black existence and black nonbeing, I mean to take seriously Calvin Warren's suggestion that "the task of black thinking is to limn the distinction between existence, inhabitation, and being."[45] Warren's *Ontological Terror: Blackness, Nihilism, and Emancipation* is among the most pointed and compelling of contemporary efforts to "return to the question of Being and the relation between this question and the antiblack violence sustaining the world."[46] Because, for Warren, the ontology of the antiblack world requires the black's eternal consignment to "the function of embodying metaphysical nothing(ness) for modernity" and thereby necessitates "the systematic concealment, descent, and withholding of blackness through technologies of terror, violence, and abjection," Warren calls for a black thought that would endeavor "to imagine black existence without Being, humanism, or the human."[47] For the purposes of this book and from the resolute refractions of a black radical critique of the metaphysics of antiblackness that is not only enduring but necessarily perennial, I wish to emphasize the precedence of a black aesthesis that calls for a rigorous understanding of modernity's aesthetic regime as the violence of antiblack worlding.

The artistic examples I discuss all differentially engage the singularity of this aesthesis, precisely by deconstructing the site of aesthetic imposition and enclosure which conditions their forced (and fictive) appearance within

the racial regime of aesthetics. It is important to stress, however, that these anteaesthetic experiments do not supersede the antiblack world nor fashion another but rather move recursively back through the antiblack world in order to deconstruct the racial regime of aesthetics by which they are nevertheless still circumscribed. An analysis of these anteaesthetic experiments could be said to open a different path to thinking the racially gendered, minor registers of refusal insofar as the black anteriority from which these refusals emerge is never completely subsumed by the violent regime it is made to come before. But even more directly, this book reveals a potent black critique of the antiblack metaphysics that continuously ground the world and its reproduction as a thoroughly aesthetic project.

The world—whether in Kant's sense of "the absolute totality of the aggregate of existing things" or in Heidegger's sense of the constitutive relation between Being and world ("There is world only insofar as Dasein exists")[48]—requires the endless repetition or diffusive reproduction of antiblackness, even as blackness cannot be located within the world. Frank Wilderson succinctly encapsulates this metaphysical parasitism and foundational displacement: "No slave, no world. And, in addition . . . no slave is in the world."[49] The black cannot be in the world, because being-in-the-world would require the ontological being from which the black is interdicted, precisely so that the ontology of the world can cohere. But what I wish to underscore here is that the world is not simply given but always already predicated upon the ongoing "worlding of a world" (to borrow Gayatri Spivak's "vulgarization" of Heidegger).[50] The metaphysics of the world must be reproduced by its "worlding refrains."[51] Throughout this book, I consider the implications of the ways the black feminine is forced to function as "the belly of the world," to use Saidiya Hartman's language,[52] for a theory of anteaesthetics. Although these conceptual problematics run throughout *Anteaesthetics*, the matter of black feminine vestibularity to the myriad refashionings of the modern world is taken up most directly in chapter 3, "Before the Nude, or Exorbitant Figuration," while my critique of the very project of worlding is most pointedly articulated in chapter 5, "Unworlding, or the Involution of Value." For now, it is crucial to stress that the metaphysical violence through which the (antiblack) world is secured must be understood as a thoroughly, though not exclusively aesthetic set of operations.

Before the Racial Regime of Aesthetics

An analysis of the constitutive imbrication of the antiblack world and the aesthetic requires that we briefly attend to the theoretical partitioning of the political and the aesthetic which too often persists even in radical critiques of political ontology. Indeed, the presumed separation of the political and the aesthetic is one of the founding conceits of the modern world. As Sianne Ngai writes in her study of aesthetic categories under late capitalism, "Art in modernity came to refer exclusively to a class of objects made explicitly for contemplation. In the subsequent rise of aesthetics as a theoretical discourse . . . aesthetic experience became synonymous with contemplative distance,"[53] safely sheltered from the vicissitudes of politics. Yet the degree to which the very same Western philosophical traditions that have furnished the theoretical underpinnings of the modern subject, the nation-state, (settler) colonialism, and (racial) capitalism have been eminently preoccupied with questions of aesthetics should at the very least give us pause and prompt a thorough re-evaluation of what has been taken for common sense. As Simon Gikandi contends, "The aesthetic derives much of its authority [precisely] from its ability to claim autonomy from the historical, social, or cultural event and thus from the consciousness of a sovereign subject."[54] David Lloyd tightens the screw: "Aesthetics is a historical discourse that occludes the historicity of its own emergence."[55]

There are, of course, various intellectual traditions that have sought to develop radical critiques of bourgeois aesthetic discourse. To cite a prominent example, the Marxist scholar Terry Eagleton argues that "the modern notion of the aesthetic," far from being some tertiary phenomenon reserved for philosophers, connoisseurs, and dilettantes, "is no more than a name for the political unconscious: it is simply the way social harmony registers itself on our senses, imprints itself on our sensibilities."[56] Partly because of its conceptual elusiveness and definitional indeterminacy, the aesthetic is able "to figure in a varied span of preoccupations: freedom, and legality, spontaneity and necessity, self-determination, autonomy, particularity, universality," largely without scrutiny.[57] Unfortunately, when it comes to the most influential discourses of critical aesthetic theory, raciality has been largely occluded from substantive inquiry, presumed as epiphenomenal and marginal to the most pressing intellectual questions. A central contention

of this book is that black existence has from the beginning been an (ante) aesthetic problematic, one which has necessitated the work of "rethinking 'aesthetics,'" as Sylvia Wynter puts it.[58] Those of us who have always lived within the dark corners of the visual, within the "lower frequencies" of the sonic,[59] must constantly remind ourselves that the concealments, interdictions, expulsions, and contortions of the aesthetic are neither incidental nor secondary to the exigencies perpetually figured as present. *Anteaesthetics* emerges from my conviction that now, as always, aesthetics are a matter of life and death.[60]

In an important study of the constitutive relation between modernity's aesthetic regime and the racial-colonial world order, David Lloyd argues that the modern aesthetic produces a "racial regime of representation" in which representation functions "not merely [as] the mimetic depiction of the world or [as] a means of securing political advocacy within democratic or republican institutions" but rather as "an activity that articulates the various spheres of human practice and theory, from the most fundamental acts of perception and reflection to the relation of the subject to the political and the economic, or to the social as a whole."[61] From this vantage, Immanuel Kant's sensus communis, or the shared (a priori) capacity for aesthetic judgment,[62] is revealed as a decisively exclusive universality, the borders of which are erected and policed by and through the racial regime of representation. In Lloyd's summation, "representation regulates the distribution of racial identifications along a developmental trajectory: The Savage or Primitive and the Negro or Black remain on the threshold of an unrealized humanity, still subject to affect and to the force of nature, not yet capable of representation, not yet apt for freedom and civility."[63]

The indispensable role of the aesthetic in constructing and sustaining what Alexander Weheliye, in his adaptation of Wynter's formulation, refers to as "the mirage of western Man as the mirror image of human life as such"[64] remains severely understudied. While the full scope of the actual operations of the racial regime of aesthetics cannot be simply deduced from the axiomatic disavowals and interdictions of its canonical philosophical texts (the aesthetic uses to which blackness is put are in fact far more complicated, predatory, and perverse), it is worth repeating a salient example of these foundational dispossessions and debasements. As G. W. F. Hegel infamously remarked in *The Philosophy of History*, the "Negro . . . exhibits the natural

man in his completely wild and untamed state. . . . There is nothing harmonious with humanity to be found in this type of character."[65] As for Africa, "it is no historical part of the World; it has no movement or development to exhibit."[66] The interminable consignment of the black, following Denise Ferreira da Silva, to the "scene of nature"—as a radically affectable thing "whose existence is ruled by violence"[67]—serves to furnish the fantasy of the disinterested subject of aesthetic judgment, just as the founding "disqualification of sub-Saharan Africa and its populations" (diasporic or otherwise), as the late Lindon Barrett wrote, "organizes the linear progression of historical temporality."[68] The black is both the very "index of the pathological," as Lloyd declares, and the constitutive negation of historicity which enables the conceit of developmentalist teleology.[69] In other words, blackness marks the spatial and temporal conditions of (im)possibility for Kant's sensus communis and, in turn, the subject this sensus communis presumes and conjures. This is the figure Da Silva and I have elsewhere (after Sylvia Wynter) theorized as *homo aestheticus*, the aesthetic dispensation of the subject who is coterminous with the "totalizing onto-epistemology of the human."[70] The ongoing onto-epistemic refurbishment of the subject of modernity is always already the aesthetic revivification of *homo aestheticus*.

The hermeneutic orientation pursued in *Anteaesthetics* requires an understanding of the aesthetic as foundational to the antiblack world. I argue that the black is at once vestibular to and the terminus of the racial regime of aesthetics. This regime is not ancillary within but rather constitutive of the modern world and the antiblack metaphysics through which this world coheres. However, an anteaesthetic orientation also crucially requires theoretically attending to the racially gendered character, not simply of the myriad representational forms antiblackness assumes but of the material-discursive (re)production of aesthetic form itself. *Anteaesthetics* argues that the operations which reproduce blackness as threshold for the antiblack world are both irreducibly corporeal and racially gendered, borne singularly by the black feminine. This black feminine fleshly bearing, in turn, involves not only the reproduction of blackness as the constitutive and delimiting threshold of the racial regime of aesthetics but also the reproduction of blackness as a dehiscence that this regime must constantly work to suture. Dehiscence, as Jared Sexton notes, is definitionally polyvalent, "indicating, in surgical medicine, the opening up of a wound along the lines of incision

... or, in botany, the opening up of plants along a seam at the age of maturity as a means of dissemination, or, in otology, the perforation in the inner ear labyrinth causing chronic disequilibrium or vertigo."[71]

Black art compels us to think through the irreducibly corporeal, reproductive cut of this dehiscence. Grappling with the dehiscent anteriority to which black art turns us makes it possible to approach a radically ulterior vantage. The anteaesthetic experiments that comprise this book proceed through a series of racially gendered recursive deconstructions. These practices do not fashion another world nor supersede the world they would refuse; rather, they inhabit the world's negative underside. One might be tempted to call this underside a netherworld, but only if the etymological emphasis falls on *nether*—for this inhabitancy is neither worldly nor worlding but an illimitable descent made to come before the world.

From the Anti-Aesthetic to Anteaesthetics

In the introduction to his 1983 anthology of collected essays, *The Anti-Aesthetic: Essays on Postmodern Culture*, Hal Foster raises the aesthetic as a concept worthy of critical interrogation. While Foster places emphasis on the historicity of forms and the periodization of the aesthetic with respect to both modernism and postmodernism, he alludes to the postmodern as having thrown the very notion of the aesthetic into philosophical and conceptual disarray. Foster stresses that the rhetorical choice to organize the volume's diverse intellectual concerns under the rubric of the "anti-aesthetic" is emphatically not in order to make "one more assertion of the negation of art or of representation as such."[72] In fact, Foster states, these essays "take for granted that we are never outside representation—or rather, never outside its politics."[73] What Foster terms the "anti-aesthetic" aims at "a critique which destructures the order of representations in order to rein-scribe them."[74] In this respect, Foster continues:

> "Anti-aesthetic" ... signals that the very notion of the aesthetic, its network of ideas, is in question here: the idea that aesthetic experience exists apart, without "purpose," all but beyond history, or that art can now effect a world at once (inter)subjective, concrete and universal—a symbolic totality. Like "postmodernism," then, "anti-aesthetic" marks a cultural position on the present: are categories afforded by the aesthetic still valid? ... More locally, "anti-aesthetic"

also signals a practice, cross-disciplinary in nature, that is sensitive to cultural forms engaged in a politic (e.g., feminist art) or rooted in a vernacular—that is, to forms that deny the idea of a privileged aesthetic realm.[75]

Foster's remarks have the virtue of foregrounding a critique of art that would purport or aspire to an unmitigated, universal purview, as well as a critique of the presumption that aesthetic experience could ever be post-historical. He is also attuned to the ways in which putatively subversive aesthetics are not immune to instrumentalization and thus even a strategy of Adornoian "negative commitment" might have exhausted its utility for defying the encroachments and recuperations of late capitalism. Foster's term *anti-aesthetic* is a declaration of the need for and a reaching toward a new "practice of resistance," with implications for both the means and methods of artistic production as well as critical reception.[76] *Anteaesthetics*, however, proposes and contends with a problematic which is anterior to the critical art historical procedure advocated by Foster, an *ante*representational dilemma from which no amount of revision or rectification of the order of representation can release us.

The homonymic slippage between *anteaesthetics* and the *anti-aesthetic* is intentional and accentuates crucial distinctions between my argument and Foster's proposition, even as they share a sense that the very notion of the aesthetic deserves to be rethought, as well as a concern for the ways that even practices which are draped in the regalia of resistance can reinscribe the prison house they would purportedly endeavor to dismantle or transcend. The black experimentations and inhabitations engaged throughout this book do not emerge in the wake of a conjunctural disordering or troubling of the aesthetic or as a resistance to the enclosure of the aesthetic within an increasingly "administered world."[77] The predicament they confront is perennially before the modern world.

I refer to these experimentations and inhabitations as *anteaesthetic practices* because of the profound reflexivity evinced by their mode of engagement with this predicament of forced anteriority, particularly in their recursive deconstructions of the relationship between blackness, the aesthetic, and form. Crucially, the relationship of blackness and the aesthetic is not one of "ethnographic locality" but of (ante)metaphysical generality.[78] The anteriority of blackness constitutes the condition of (im)possibility for

the aesthetic as such. The anteaesthetic practices under consideration in this book ought to be regarded not merely as critiques of but as vestibular to the very racial regime of aesthetics that they would refuse.

The anteaesthetic practices I engage cannot simply "take for granted that we are never outside representation"[79] or fashion localized practices that deprivilege the reigning aesthetic regime. For even the most radical forms of black artistic experimentation are always already made to come before the representational violence of the racial regime of aesthetics, even as they emerge from the difficult inhabitations and fleshly labors of an existence without ontology and hence cannot be properly genealogized by the regime to which they are nonetheless subject. In this respect, we might say that these forms emerge from an existence that is neither inside nor outside the racial regime through which representation coheres, but rather an existence which is made to "cut the border," as Spillers might say.[80] It is in this cut—between existence and nonbeing—that black aesthesis emerges. The anteaesthetic practices considered throughout this book may all be said to differentially trace and reproduce this cut, this emergence. In turn, these practices throw into question whether the very notion of resistance might be an impediment to grappling with the immanent (dis)ordering of an aesthesis which is an inescapable fact of black existence.

It must be stressed that while this book takes up contemporary black artworks as sites of anteaesthetic practice, it by no means suggests that anteaesthetic practices are exclusive to the contemporary. My wager is that anteaesthetics as a heuristic device pertains to every relationship between blackness and the aesthetic across the variegated times and spaces of modernity. In some respects, the book's choice of artists and artworks reflects the idiosyncrasies of my scholarly research, which has largely, though not exclusively, focused on contemporary black artists, variously situated in North Atlantic diasporic milieus, whose practices span experimental film and media, art installation, painting, sculpture, dance and performance, and literature. Although my work across this line of inquiry has always sought to attend to the historical and geographical particularity of a given artist's practice, it has also consistently aspired to elucidate the ways in which particular black artistic practices disclose general philosophical problematics, all of which differentially cleave to the fraught relationship between blackness and the aesthetic under modernity's racial metaphysics.

Moreover, although *Anteaesthetics* takes contemporary black artworks as its points of departure, the book's argument also moves through nineteenth-century painting and sentimentalist literature, the emergence of cinema at the turn of the twentieth century, and early twentieth-century black literary modernisms. These inquiries across history and geography are not undertaken, however, in an effort to construct definitive accounts of aesthetic lineage, influence, appropriation, or citationality but rather in order to advance philosophical reconsiderations of the compositions, recompositions, and decompositions of form in and through specific anteaesthetic practices. That is, what could at first glance appear as historical or geographical divagations are in fact undisciplined modes of elucidating a theory of black aesthesis as a general critique of form.

It is worth further underscoring this book's orientation to the historiographical in particular: *Anteaesthetics* is concerned with that which unfolds before rather than within history. It is concerned, in other words, with the distended temporalities of blackness, which marks history's anterior. While this book draws from art history and film history, it makes no pretense to being a work of either art history or film history. This book aims not to construct a historical account but rather to deconstruct the racially gendered mechanisms of history's reproduction and thereby approach a glimpse, no matter how opaque, of that cut of indeterminacy which David Marriott, after Fanon, calls the "tabula rasa"—that which is "radically *unwritten*, and whose structure is enigmatic, and outside of teleology or eschatology."[81]

Negative Inhabitation and the Recursivity of Black Art

Let us return to Nina Simone's 1976 Montreux performance and its exemplification of being made to come before the racial regime of aesthetics in order to understand the recursive deconstructionism of her anteaesthetic practice and the complexities it presents for this book's commitment to negative inhabitation. Nina Simone's rendition of Morris Albert's song "Feelings" radically transforms its affective syntax: "Feelings, nothing more than feelings, trying to forget my feelings of love." The ten and a half minutes over which the second part of her medley painfully and painstakingly unfolds offer a studied consideration of what Sianne Ngai terms the "aesthetics of negative emotion."[82] But as Simone moves elliptically before the racially

gendered grammar of the aesthetic and the difficult if not impossible terrain of emotionality that grammar dictates for the black (femme),[83] we begin to sense that she is not exactly singing about having and feeling *feelings*; rather, her rendition veers toward something more abstract, something which is perhaps even antithetical to the axiomatics of emotion.[84] The song becomes a meditation on a history of interdicted feeling, and Simone's dysphoric performance sketches out a singular impasse: the racially gendered predicament of being held before a world which demands an unbearable bearing and castigates the negative emotionality which is inevitably borne in and through that bearing. If, as Ngai would have it, "forms of negative affect are more likely to be stripped of their critical implications when the impassioned subject is female,"[85] then they are stripped of all intelligibility when the "subject" is a black woman. The impossible structural relation that Simone inhabits, which has everything to do with the racially gendered imposition and displacement of affect(ability), is the performance's spur and foremost problematic.

Simone's performance is bound to a necessarily improvisational reiteration of two interwoven questions: How does one live within an impasse? And how can we attune to that which somehow, against all reason, survives? For Lauren Berlant, the term *impasse* designates not simply "a time of dithering from which someone or some situation cannot move forward" but "a stretch of time in which one moves around with a sense that the world is at once intensely present and enigmatic," wading through "processes that have not yet found their genre of event."[86] But the impasse Simone confronts is not that of a "shared historical present."[87] Perhaps the most significant difference between the experience of impasse theorized by Berlant and that which Simone is forced to inhabit is that the latter is marked not by "a mounting sense of contingency"[88] but rather by *overdetermination* (in the Fanonian rather than the Althusserian sense of the word).[89] This form of overdetermination, as David Marriott suggests, is "marked by a kind of intimacy that remains radically alien to the subject, a sort of self-interrupting *that within* in which the subject cannot reflect itself as a subject."[90]

Simone's "Feelings" is terribly attuned to the impasse which compels and structures her performance, even if incompletely. This attunement is articulated in the singularity of the performance itself, evinced by a lyricism which is marked by the incurable grief of the one who must bear it out. Simone

rehearses this aesthetic predicament, subjecting it to a deconstructive operation. Her raveling of the aesthetic structure of her predicament is an act of defiance—a refusal of "the conditions that produced a situation that demanded a song like that," the conditions which continuously conscript her performance, the conditions under which she is made to appear. When her audience hesitates, seemingly bewildered before her unexpected gesture of defiance, Simone issues an equally unexpected demand: "Well, come on, clap, dammit!" In an operation thinly veiled by comicality, she effectively flips the script, coercing a performance from her audience. She exposes their sovereign spectatorship as a ruse, one which is sustained only through the ubiquity of racially gendered violence.

The doubleness of Simone's gestures opens onto a seemingly intractable question, one which lies at the heart of the inquiry undertaken in *Anteaesthetics*: How can we attune to the unspeakable edge or recessive declension of practices and inhabitations that emerge from ontology's anterior? For, on the one hand, "Feelings" offers a critique of the racial regime of aesthetics that Simone's performance is made to come before, the regime which, indeed, her performance is made to reproduce. On the other hand, the performance itself is a subversion of that regime which in fact exceeds it, but only by way of returning to it. These entangled moments constitute a recursive operation, but in a highly specific sense. For Yuk Hui, "recursivity is not mere mechanical repetition; it is characterized by the looping movement of returning to itself in order to determine itself, while every movement is open to contingency, which in turn determines its singularity."[91] The returns of Simone's performance, in contradistinction, paradoxically reproduce both the conditions of metaphysical overdetermination to which they are subject and the radical indeterminacy of a black existence which has no place in modernity's metaphysics.[92]

Yet to claim that there exists an irreducibly ulterior valence to Simone's performance and to argue for both the urgency and perplexity of fashioning a means of attuning to this ulteriority are not tantamount to a utopian proposition. For even as Simone's gestures strain against and recede from the aesthetic, they are also violently marshalled to reproduce it. Every black performance before the aesthetic is ultimately conscripted into the labor of its own submission before the latter's racially gendered orders of intelligibility and permissibility. The eccentric digressions of Simone's performance, in this

instance, might be idiomatically expressed as tragedy, virtuosity, resistance, or madness, but, in every instance, they will be put to work in the service of the aesthetic. For if blackness is itself the ante- and anti-foundation of the political, does not even the idiom of resistance risk eclipsing such negative inhabitations, which have little purchase within the ethico-representational economies of the present, perhaps especially as these inhabitations are imbricated with or given through the coerced reproductivity of the black feminine? Even the figure of black resistance, it would seem, is summoned to aestheticize the founding antagonism of the social, precisely so that it might be displaced, its cacophonies serially mined, curtailed, and routed through the stratagems of political discourse. Neither *Anteaesthetics* as a philosophical performance nor the racially gendered labors which subtend this performance are exceptions to this rule.

Unsurprisingly, Simone's recursive deviations from and through the aesthetic, which we might too readily valorize as resistance, were not without cost. As Simone bitterly observed earlier in her 1976 Montreux performance, "Oh, everybody took a chunk of me." Late in her career, in the midst of acute financial, physical, and emotional duress, Simone pointedly said to her audience at Royal Albert Hall, "Talent is a burden not a joy. . . . I am not of this planet. . . . I do not come from you. I am not like you."[93] Everywhere subject to an aesthetic order to which she did not and could not ever belong, Simone's "Feelings" marks at once an indictment, a subversion, and a movement back through that aesthetic order, precisely in an effort to flee it. Her performance intimates a different kind of return—to an existence which cannot be truly named or known by worldly means.

Anteaesthetics wagers that it is only by tracing and descending with the racially gendered reproductions of and in the cut between black existence and black nonbeing, without hope of remedy or injunction to rectification, that we might renew our attunement to the minor refrains of black aesthesis. The anteaesthetic examples engaged in this book span experimental film and media, art installation, painting, and literature. My theorization of these works emerges as a thinking-with-and-alongside a number of intellectual traditions and interlocutors across multiple fields, and it endeavors to contribute to key conversations and debates by which these fields are presently animated. The canonical and ongoing work of a richly differentiated tradition of black feminist thought in particular and black radical thought

more generally is indispensable to the core theoretical premises of *Anteaesthetics*. A heterogenous tradition within these lineages that has endeavored to theorize blackness and raciality not as matters restricted to ethnographic locality but rather as problematics that disclose the making and unmaking of the very foundations of the modern world has been especially important in laying the intellectual groundwork upon which *Anteaesthetics* builds. Postcolonial theories of the racial-colonial genealogies of modernity's aesthetic regime are also essential to this study's engagement with, critique of, and departure from continental aesthetics.

While I take up a wide range of fields and intellectual formations, film and media studies and art history are this book's foremost interlocutory disciplines, in conjunction with black studies. This interdisciplinary emphasis reflects the inherent intermediality of the artistic forms this book engages. With respect to film and media studies, I am guided by the innovative theoretical and historical work of scholars working at the intersection of film theory and black studies, as well as the few scholars thinking at the nexus of blackness and the philosophy of media. I elaborate my theory of anteaesthetics by moving through an analysis of experimental film and new media, drawing out the implications for aesthetic questions regarding theories of audiovisuality, spectatorship, and narrative temporality. Of crucial importance is the book's theorization of the immanent relations between blackness, mediality, and mediation—an intervention which is brought to bear upon the materiality of the image in particular and the relays of aesthetic experience more generally. With respect to art history, the book draws upon Afro-diasporic art history and criticism and its sometimes dialogic, sometimes fractious relationship to various methodologies within art history (including psychoanalytic, Marxist, feminist, structuralist, poststructuralist, and formalist approaches) and their respective theorizations of form and formlessness and genealogies of form, figuration and abstraction, figure and ground, surface and depth. In addition, the book takes up contemporary debates concerning the relationship between blackness, corporeality, subjecthood, and objecthood as they pertain to the work of art.

Since Frantz Fanon's notorious proposition of blackness and the body as a problem for thought and Hortense Spillers's brilliant conceptualization of the distinction between body and flesh, a wide range of studies both within and beyond black studies have taken up corporeality as a racial and/or ra-

cially gendered question, many of which I discuss in this book. The theory of racially gendered corporeality advanced in *Anteaesthetics* is staged in appositional relation[94] to a much broader, variegated, transdisciplinary pivot toward the corporeal in the latter decades of the twentieth century (from biopolitics to new materialisms). I discuss these multiplicitous trajectories under the rubric of "the bodily turn," a movement within which, I argue, blackness may be regarded as the principal lacuna and aporia. The difficult and enigmatic corporeality to which the black is forcibly given is tethered, we shall see, to the inherent intermediality of black artistic forms (between, for example, painting, literature, media, architecture, and performance). Both out of respect for the artworks engaged and in order to avoid treating them as passive mediums for theoretical projection—a stratagem which would redouble the brutality to which they are necessarily subject by inscribing upon them what Saidiya Hartman would call a "second order of violence"[95]—my readings prioritize a nuanced attunement and attending to form. However, even as I draw transversally from formalisms across distinct disciplinary formations and traditions of aesthetic criticism—across which the artistic examples considered are fragmented, splayed, or effectively barred—I also emphasize the ways in which these works reveal the racially gendered genealogies of both formalism and form, just as they emerge from and gesture toward a black aesthesis that cannot be represented. As we shall see, attuning to practices that emerge at the threshold of the racial regime of aesthetics—at once this regime's spatiotemporal vestibule and limit—practices that move back through this regime precisely to recede from it, requires an unconventional methodological approach. Many of the hermeneutic protocols that obtain within and across specific disciplines—whether phenomenology or linear historicization—cannot in and of themselves account for these anteaesthetic practices without reproducing the violence of the racial regime of aesthetics, for these protocols have themselves been established in concert with that regime.

———

Let us briefly return to the projection of Simone on the Multnomah County Justice Center in the midst of the 2020 Portland protests. The image bears the affective trace of the lyrics inflected by Simone's arresting contralto in "Tomorrow Is My Turn": "Though some may reach for the stars / others will

end behind bars . . . My only concern for tomorrow is my turn." Simone's lyrics seem to almost anticipate the racial haunting that inevitably accompanies this scene in which her performance is resurrected in the name of justice belated and prophesied. It is a cruel irony that the manner in which she is made to appear in this context has less to do with reparation and more to do with suturing the irreparable antagonisms of an inflamed present. What Wendy Haslem would call a "spectral projection," in which the layered impressions and residue of older technologies, histories, and forms meet "the tactile surface of the screen,"[96] becomes inseparable from projection as racial phantasmagoria. That spectral projection is an aesthetic operation that should not be regarded as distinct from what Calvin Warren describes as the interlinking of antiblack terror and projection but ought rather to be considered as entangled with that interlinking, which serves as the image's condition of possibility. As Warren writes: "Black being becomes the site of projection and absorption of the problem of metaphysics."[97] Simone's projection in the name of democratic freedom becomes tied to a metaphysics that "neglect[s] the ontological horrors of antiblackness by assuming freedom can be attained through political, social, or legal action."[98] Freedom, as the site of the human's unfolding, Warren explains, "propels its project (projectionality) into the world."[99] In this instance, projectionality is effected through an audiovisual register in which Simone's artistic labors are instrumentalized to suture an antiblack metaphysics, to recuperate humanization as freedom's horizon. Her lyrical surplus is summoned so that it might be contained, reabsorbed by the social field from which she is interdicted.[100]

For many a reader, indictments of the depth and extent of antiblackness are taken as a solicitation for empathy. Empathy, in these receptions, is generally taken as a kind of bridge between two divided subjectivities or positionalities. Within this orientation, empathy is figured as a means of transcending violent differentiation or the hierarchization of difference. But empathy is not innocent. As Hartman writes in her indispensable study *Scenes of Subjection: Terror, Slavery, and Self-Making in Nineteenth-Century America*, "Properly speaking empathy is a projection of oneself into another in order to better understand the other or 'the projection of one's own personality into an object with the attribution to the object of one's own emotions.'"[101] In other words, although empathy is frequently elaborated in the name of solidarity with black liberation, more often than not, such instances

of empathetic identification serve as the mechanisms for the (non-black) liberal subject's renewal of their subjectivity in and through the projective objectifications of empathy.

The literal (technical) projection of Nina Simone during the Portland protests, however, unconsciously marks an attempt to mobilize empathic identification for conclusive political ends. The aesthetics of political dissent illustrate how a racialized history of empathic projection extends into the present, becoming the ground for the renewal of what Lisa Lowe describes as the "liberal promise of freedom."[102] This promise, which Lowe argues has been a crucial mechanism for the reiteration of "a colonial division of humanity" over the longue durée of "liberal modernity"[103] is in this instance revitalized precisely through taking Simone's 'black body' as a medium for racially gendered projection. And yet, Simone's nonperformative withholding not only refuses the subsumption of antiblackness under the generalized problematic of empathy but insists upon the antiblack structuring of the very political world order that coerces and compels her performance. To contemplate one's vestibularity to and expulsion from that world order is to foreground an irrecuperable challenge to every legible grammar of ethics, aesthetics, and politics. It marks an inchoate commitment to understanding the ethical, aesthetical, and political means by which the racially gendered labors of blackness come to be continually instrumentalized in the reproduction of the very world order that would serially inscribe the metaphysical expropriation and annihilation of blackness.

In both the 1965 performance and the 2020 spectral projection, the strangely dissonant virtuosity of black artistry and its avant-garde comportments are conditioned by and absorbed within though not subsumed by a regime of racial aesthetics. Simone's practice exceeds that regime but cannot escape it. She compels us to think about an inhabitation that is not predicated upon positive appearance. If one would speak of this inhabitation as "fugitive," we must underscore that it does not signal a flight from an aesthetic regime in an attempt to supersede or transcend its constraints. Rather, Simone's performance marks a recursive movement back through an interdiction in an effort to inhabit something like the negative underside of that interdiction. I prefer to speak of Simone's enactment as a negative inhabitation. This inhabitation is predicated upon an interminable (with) holding and the reproductive labor to which this (with)holding is bound.[104]

We might say that what remains withheld in Simone's performances, even in their spectral resurrections, is performance itself in and through *nonperformance*, following Sora Han's and Fred Moten's elaborations of the term.[105] Drawing on the precise idiom of contract law, Han suggests that blackness is nonperformance insofar as it is necessarily "a performative in and against the law."[106] This nonperformance is improvisational in the "precise legal sense of a form of pure performativity. . . . It is that which cannot be contracted, nor performed against a contract but is nonetheless a legal form of being that contract law might refer to as nonperformance."[107] At the scene of Simone's nonperformance of "Feelings," her radical improvisation unmakes the very law her performance is called to renew, precisely through her return to that law in and through a recursive deconstruction of it. To borrow Moten's words regarding another scene of nonperformance, "In returning, she refuses to perform the terms of the contract she had been forced to enter."[108] Simone effectively (con)scripts her audience—those who, in their spectatorship, might be figured as the notary public which certifies the violent contractual obligations to which Simone is subject—into the nonperformance ("Well, clap dammit!"). Each becomes implicated in "performing willed refusal, fraud, bad faith or protest."[109] Yet Simone's inversion of the agential terms of the contract of performance discloses the "exhaust(ion)"[110] of agency itself, insofar as agency is conceptually reduced to an individuated dialectic of subjection and resistance.

In the nonperformative fold of the refusal of what is refused, as the very anterior of being refused or refused being, Simone's ineluctable rendition of "Feelings" traverses and anticipates the question posed by Moten: "What's the relationship between the scene of (subjection) and [Simone's] obscene act of nonperformance?"[111] This entanglement of fugitivity and subjection is an irreducible dimension of the black experimentations this book engages, even as the scope of my inquiry is not exhausted by either idiom. This entanglement, *Anteaesthetics* stresses, is at once reproduced and ruptured by a singularly black feminine bearing of both the metaphysics of antiblackness and all that serially exceeds that metaphysics, even if only to be reabsorbed into its enclosures. Simone's nonperformance helps us to attune to a crucial dimension of the anteaesthetic practices considered in this book: namely, that these racially gendered practices do not, in the first instance, proceed through an experimental departure from the violence of racial enclosure

either through the positive elaboration of an outside or a movement toward that outside that is always unfinished—what Nathaniel Mackey might call an aesthetics of unremitting centrifugalism.[112] Rather, these anteaesthetic experiments proceed through a set of returns, through a deconstructive recursivity that occasions something like a negative inhabitation, bound to an interminable (with)holding.

The problematic of nonperformance opens onto another conceptual problem and returns us to a methodological insight regarding the ontology of the world, held in Simone's utterance: "I do not believe the conditions that produced a situation that demanded a song like that!" That utterance, which unfolds from within an instance of black feminine nonperformance, alludes to the conditions of possibility for the world as such. Nina Simone's nonperformance compels a reconsideration of the scope and breadth of antiblackness as an analytic. Tracking antiblackness across the scene of political life and culture requires us to recognize that its structural violence—too often reduced to the idioms of inequality or exclusion—is constitutive of aesthetic forms and representations. As this book argues, attuning to what I am theorizing as black aesthesis requires moving our analysis to "a higher level of abstraction."[113] The myriad brutalities visited upon black people— that so many would seek to measure (or consume) in their expositions of judicial and extrajudicial murder, mass incarceration, interlocking economies of hyper-expropriation and "organized abandonment"[114]—are symptomatic rather than indexical of antiblackness. Indexing antiblackness is an impossibility, because there is no grammar of black suffering that can be rendered coherent, cohesive, and meaningful within the semiotics to which black people are subject.[115] Black aesthesis compels us to trace the dehiscent anterior of the world, which is neither apart from nor reducible to the violence of antiblackness and offers no promise of utopian or reparative presencing. It is to this noneventual emergence and its hermeneutic implications for a reading of anteaesthetic practices to which we now turn.

Black Aesthesis

What I have termed *black aesthesis* is precisely what emerges in the cut between black existence and black nonbeing, between the violent dissimulation of the 'black body' and a black enfleshment that has always been both

more and less than the phenomenological body. As the term *aesthesis* has had some currency within critical theory in recent years, it is worth elaborating my specific deployment of the term with precision. Black aesthesis is an ante-formal heuristic which endeavors to attune to that which is at once the prerequisite of and radically incommensurate with (aesthetic) form. The manner in which black aesthesis is irreducible to every instance of emergence or codification within the racial regime of aesthetics can be clarified by way of contradistinction. In *Aisthesis: Scenes from the Aesthetic Regime of Art,* Jacques Rancière revises the ancient Greek philosophical concept of *aisthēsis* in order to theorize the dynamic relationship between the "singular event" and the "aesthetic regime of art."[116] These singular events are not necessarily canonized in art history but embrace an expansive range of activities and activations which are implicated in aesthetic experience more generally. Rancière's concern is not only the manner in which such events come to constitute art's historicity but, moreover, the ways in which they exhibit and effectuate transformations in modalities and repertoires of thought and feeling, of affect and perception, "constituting the sensible community that these links create, and the intellectual community that makes such weaving thinkable."[117] For Rancière, aisthesis introduces a new thinking into the aesthetic regime—"a thinking that modifies what is thinkable by welcoming what was unthinkable."[118] Thus, such instances of emergence and transformation are also moments of incorporation, of the assimilation of that which had hitherto been unassimilable. It is precisely the possibility of assimilation, of the presencing of thought, feeling, and perception, that allows a sensus communis to cohere.

My concept of black aesthesis resonates with and radically departs from Rancière's proposition in *Aisthesis.* It may be described as a "disfigurement" of the concept of aisthesis (to invoke David Marriott's idiom). Here I briefly outline four valences of the concept's fleshly corruption. First, while instantiations of black aesthesis are indeed conditioned by, or rather subject to, the racial regime of aesthetics—and they do indeed compel modulations in the operations of this regime—they can neither be assimilated by nor effectuate foundational metamorphoses of this regime. Black aesthesis emerges in the abyssal cut between black existence and black nonbeing, between the dissimulated 'black body' and enfleshment. It cannot be integrated because it is forced to bear the unassimilable, the obdurate, the irreducible, because it is

conscripted into the reproduction of the very distinction between being and nonbeing. Second, insofar as this aesthesis is irreducibly material, it cannot be simply elucidated through either dialectical or new materialist hermeneutics. If anything, it gestures to an exorbitant materiality that calls for something akin to what Marriott terms a "black materialism"—a materiality that requires a poetic thinking with the "dark luminosity of an ultimate and absolute experience . . . that is equally incapable of being exposed to the light of philosophy or of being duped by its aesthetic formalism."[119] My use of the term *exorbitance* here and throughout *Anteaesthetics* stresses that which is the condition of (im)possibility for modernity's codifications of form, not least the formal distinction between the material and the immaterial. A central claim of this book is that such exorbitance is necessary for, yet irreducible within and irreconcilable with the myriad encodings of aesthetic formalism. Third, because the spatiotemporal determinacy and legibility of the event is conditioned by the racial regime of aesthetics, which structures the sensorium of the world, black aesthesis can exist only as a dehiscence, a deformation, an irruption that can never claim the status of the event. Fourth, the (un)thought and (un)feeling it extends cannot generate a new sensus communis, as blackness is the constitutive interdiction of the social field as of the sensorium which binds it.

My deployment of the concept of black aesthesis should therefore not be conflated with the Aristotelian "apophantic discourse," which, as R. A. Judy astutely observes, "aims at superimposing order on the chaos of perception (αἴσθησις, aesthesis) by filtering conceptualizations through the discipline of formulaic statement."[120] As I elaborate in chapter 2 by extending my critical engagement with Rancière, black aesthesis constitutes the anterior condition of (im)possibility for every aesthetic ordering. As the unassimilable anterior of the aesthetic, black aesthesis is at once the condition of possibility for and radically incommensurate with aesthetic form—an emergence as yet unaccounted for in the scholarly canons of art history and continental philosophy. The irreducible corporeality of black aesthesis is a function of the modern body's displacements and compels us to assiduously descend into the impossible, yet necessary distinction between bodily dissimulation and enfleshed existence, to take seriously the question of what happens in the absence of a body.[121]

Aesthesis, in the sense I have been deploying the term, is also neither,

pace Zakiyyah Iman Jackson, "a political matter"[122] nor a transparent aesthetic emergence. Rather, black aesthesis is that which bears an exorbitant materiality that the political, the aesthetic, and their ruse of contradistinction can neither abide nor do without. Black aesthesis is not a political challenge to the racial regime of representation, but rather representation's dehiscent anterior—its expropriatively displaced condition of (im)possibility. The anterior remains of black aesthesis, which *Anteaesthetics* endeavors to recursively disclose, constitute the condition of (im)possibility for the world and its order of forms, just as surely as this anteriority (su)stains the extemporaneousness of black existence and its dissimulative appearances, but it offers no compensatory or reparative recuperation of blackness. Black aesthesis is an emergence without home or horizon, an abyssal plane without terminus, a luminous tear or effluent fissure anterior to the sensus communis, a black (w)hole that perpetually incompletes itself. Black aesthesis is neither ontological nor phenomenological but rather the vertiginous rupture of modernity's aesthetic relays between being, body-subject, and world. It is an aesthesis which can only appear as ontology and "phenomenology's exhaust and exhaustion."[123]

This book opens with a reading against the grain of the racial regime of aesthetics that makes it possible to conceive of the spectral projection of Nina Simone's 'black body,' in service of civic restoration in and through the resuscitation of freedom's promise, as manifestly benign, tracing what remains most intractable about her performativity. Her recessive inhabitation before an antiblack world she would prefer to circumvent but which circumscribes her is at the crux of the formal antagonism she exhibits or is made to stand in for. My intervention commences here, precisely where Simone's undisciplined example unfolds a central motif of this book. Her exemplary nonperformance underscores the (de)formative dimensions of black artistic practices that deconstruct the ontology of the world by moving recursively back through its lineaments. These practices are at once bound to and absorbed by the ontology of the world but are still not reducible to or completely subsumed by that ontology. They constitute an immanent scoring with and against the world. Indeed, they mark and are marked by a (dis) ordering of the very idea of world.

This book does take up the grueling work of unveiling the aesthetic operations that make the catastrophic metaphysics of an antiblack world possi-

ble, but not as an end in itself, for no amount of representational critique will overturn the morbid logic and protocols of the racial regime of aesthetics. Rather, *Anteaesthetics* moves through such a critique in order to elucidate the violent context before which black artistic practices necessarily unfold and with which they are forced to contend. My primary object of inquiry remains the black aesthesis that is made to come before—at once vestibular and subject to—the antiblack world and those experimentations and inhabitations which are ceaselessly drawn and redrawn by the racial declensions that have long facilitated modernity's displacements. The racially gendered burden of the black (feminine) is to bear the displacements of an entire metaphysics—to be cast, in the words of Zora Neale Hurston, as "the mule of the world"[124]—as an object of denigration and disposal, of boundless labor and unforgivable debt.[125] This book contends that the means of effectuating this displacement, of conscripting this bearing, are quintessentially aesthetic. Nevertheless, the racially gendered bearings of blackness are also reproductions of a radical dehiscence—an immanent failure of the racial regime of aesthetics to suture the ruptures borne of the antagonisms and impossibilities of its own metaphysics and the diffusive irruption of a black existence that is interdicted from presence in the world.

To reiterate: *Anteaesthetics* theorizes black experiments and inhabitations that are before the racial regime of aesthetics in a dual sense. On the one hand, these practices are vestibular to the racial regime of aesthetics, at once its constitutive threshold and abyssal limit. On the other hand, these practices are always already subject to the racial regime of aesthetics, placed before its violence, even if not completely reducible to or subsumed by it. This book's attunement to these anteaesthetic practices unfolds through a series of analytic propositions, none of which can be understood in isolation from the others. First, the aesthetic is an indispensable means of establishing and sustaining the world and suturing the antiblack metaphysics upon which the world is predicated. Second, the (re)productions of both black aesthesis and the antiblack world that conditions but cannot completely contain its emergence are thoroughly bound up with the complex racially gendered valences, expropriations, and displacements of corporeality. Third, the fraught corporeality of blackness serves as the nexus for a set of metaphysical problems that are both exhibited by and concealed in the phantasmatic appearance of the 'black body' within the racial regime

of aesthetics. Because black aesthesis is bound to the violent dissimulation of the 'black body,' without, however, being reducible to it, the 'black body' becomes a site for recursive deconstructions of the impositions of form. Inspired by the poet Jay Wright's turn of phrase, I refer to these instances of anteaesthetic practice as the "arts of dissimulation."[126] Fourth, the bearings of black femininity constitute the (re)productive singularity that undergirds both the racial regime of aesthetics and black social and artistic refusals of this regime. In the next chapter, I theorize this as the double bind of reproduction. Even those anteaesthetic practices which evince an interminable (with)holding or a quality of infinite recession cannot be disentangled from the fact that the affordances of positive appearance (of an outside, of another world or otherworlding, or even of a counter-aesthetic) proceed only by reconscripting the black feminine (re)productivity that subtends them.

Fifth, the racially gendered, anteaesthetic unfolding that emerges in the cut between black enfleshed existence and the dissimulation of the 'black body,' between black existence and black nonbeing, which I term *black aesthesis*, is a paradoxical emergence. On the one hand, this aesthesis is bound to an antiblack world of interdiction and instrumentalization and is required by and partially reabsorbed by this world. On the other hand, this aesthesis constitutes the world's singular dehiscence. Although both Jacques Lacan and Maurice Merleau-Ponty have theorized dehiscence across psychoanalytic and phenomenological registers, respectively, my point of departure for thinking dehiscence is Dionne Brand's conceptualization of the anoriginary and unfinished displacements of the Middle Passage as "a tear in the world."[127] Anteaesthetics—as heuristic, hermeneutic, and an unruly constellation of practices—emerge from this irreparable wounding, from the vertigo of black experience, disclosing the immanent rupture of every suture. This emergence is also bound to the disseminative valence of dehiscence in botany, insofar as anteaesthetics disclose a racially gendered problematic at the heart of reproduction.

Sixth, precisely because anteaesthetic practices are always already before the antiblack world in the dual sense outlined above, these practices proceed by way of recursive, deconstructive operations. Reading for the racially gendered dimensions of this recursivity, I suggest, opens up a minor register within discourses on fugitivity, allowing a consideration of experimentations that inhabit a negative underside, rather than a positive outside

or even outward movement. I argue that the recessive movement of these minor experiments is not so much an elective practice as it is an unavoidable consequence of their sustained encounter with the intractable problematic of black femininity. Together, these six indiscrete moments comprise the difficult manifold of anteaesthetics.

Errancy as Method

If black art emerges from an existence that is the condition of (im)possibility for the racial regime of aesthetics, from an aesthesis that cannot appear within the racial regime of aesthetics yet is everywhere subject to its violent impositions and circumscriptions, then how can art criticism attend to this antethetical emergence? The failure of conventional art criticism to attend to black art without immediate recourse to the representational protocols of the racial regime of aesthetics is by now well-established. Within the "art-historical representational script,"[128] to borrow Krista Thompson's phrasing, the black artwork is figured as a vehicle for the transmission of presumptively transparent ethnographic content. To the extent that the formal experimentations of an artwork are taken seriously, the artist is lauded for transcending their otherwise limiting identitarian attachments. In Kobena Mercer's words, "The biographical and sociological reductionisms that pervade the literature on black visual arts . . . ultimately leave intact opposing tendencies that write out race and ethnicity in the name of an outmoded formalist universalism."[129]

We must be wary of imagining that the terrible representational predicament with which black artistry is inevitably confronted can be rectified by means of what Denise Ferreira da Silva would call "racial critique"[130]— whereby racial violence is regarded as epiphenomenal to the metaphysical conceits of modernity, whether this violence is figured as an aberration from or incomplete realization of the liberal tenet of universalism or as an ideology which is merely instrumental and ancillary to a primary material relation, such as class struggle. We must also beware the temptation to submit black art to a teleology of liberation, to the demand that the aesthetic can or should simply become a diagnostic or emancipatory instrument—whether as a means to the end of transforming this world (or for the fashioning of another or others) or even as a resistant "means without end"[131]—especially

given that, as Copeland observes, in recent years "various curators and critics have come to view American and European museums as machines for the production of alterity."[132] Mercer's attention to a quintessentially "diasporic sensorium,"[133] Huey Copeland and Krista Thompson's theorization of "afro-tropes,"[134] and Copeland and Sampada Aranke's recent effort to open the question of "Afro-Pessimist aesthetics,"[135] are exemplary of art history and criticism which fashion an ulterior method, one which is not predicated upon recuperating the universalist pretenses of the racial regime of aesthetics.

How might we "loosen up"[136] our hold on the black art object, even knowing that such a loosening will not prevent the artwork's ensnarement by the racial regime of aesthetics? That is to say, how do we expect the black artwork to behave, and how does this expectation condition and constrain the potentialities of our formal attunement? In da Silva's words, how might we "release the artwork from the grips of understanding (which is the mental faculty to which criticality is attributed) and allow it to follow the imagination"?[137] To truly follow the imagination, in da Silva's sense, would mean releasing it even from the injunction to otherworlding—to allow it to tread a path that is absolutely indeterminate, which is, to reprise Marriott's words, "radically *unwritten*."

Da Silva has experimented with "black feminist poethical reading of an artwork" as an approach that might avoid the injunctions to "finality or efficacy" and their reinscriptions of the "onto-epistemological pillars of modern thought, namely separability, determinacy, and sequentiality."[138] Such a poethical reading thereby finds resonance with "the task of unthinking the world, of releasing it from the grips of the abstract forms of modern representation and the violent juridical and economic architectures they support,"[139] but retains an appositional relation to the political project of thinking the world anew. The artwork is attended to as "a poethical piece, as a composition which is always already a recomposition and a decomposition of prior and posterior compositions."[140] *Anteaesthetics* joins company with such efforts to swerve from "the colonial and racial presuppositions inherent to concepts and formulations presupposed in existing strategies for critical commentary on art,"[141] lingering with the questions posed by art which necessarily emerge at the nexus of aesthetics and violence. While I do not believe that the work of art can or should offer any political, ethical, or epistemic resolution of this interminable violence, *Anteaesthetics* neverthe-

less remains committed to the renewal and reanimation of the conditions for black invention.

My method of attunement to black experimentations that traverse film and media, painting and literature, architecture and installation takes seriously Christina Sharpe's call for black scholars to become undisciplined. Sharpe argues, "We are often disciplined into thinking through and along lines that reinscribe our own annihilation, reinforcing and reproducing what Sylvia Wynter . . . has called our 'narratively condemned status.' We must become undisciplined."[142] Sharpe's call is a critical interruption of and departure from established academic procedures that would otherwise radically circumscribe our capacity to think with and alongside the artworks considered in this book. However, my enthusiastic embrace of Sharpe's call to undisciplinarity is neither intended to suggest that the reproduction of the violence of the racial regime of aesthetics can be altogether escaped if only we apply the proper method, nor that we can easily dispense with entrenched hermeneutics in fashioning an ulterior mode of reading. For no amount of methodological tinkering will yield a transparent hermeneutic relation to black art, even if that were a defensible ambition.

My commitment to undisciplined study moves between, on the one hand, what Sylvia Wynter termed "decipherment"—or the excavation not so much of meaning as of practice, as well as the "'illocutionary force' and procedures with which . . . [these practices] do what they do"—and, on the other, what da Silva calls "poethical reading," or an attunement to various formal "de/re/compositions" without immediate recourse to "separability, determinacy, and sequentiality" as onto-epistemological anchors.[143] Because the practices I engage might be considered moments of differentiation within a black ensemble of recursive deconstructionisms, I pay particular attention to the ways these nominally individuated practices move back through the racial regime of aesthetics, from which they are barred and to which they are subject, in order to (re)fashion an existence in and through the inevitable failure of that regime's sutures and displacements.

My method is ultimately appositional and transversal, moving beneath and cutting across disciplines, mediums, hermeneutics, and spatiotemporal configurations of anteaesthetic movements and forms. This errant method of reading reflects both an attunement to and exhibition of an anteaesthetic itinerancy that is constitutive of black diasporic life. Errantry, as Édouard

Glissant has theorized it with respect to the "forced diaspora" of black-ness,[144] is inseparable from the vertiginous descent, the illimitable (dis)pos-sessions, precipitated by the "abyss" of the Middle Passage.[145] For Glissant, "errantry is rooted movement but still a 'desire to go against *the* root,' where '*the* root' refers to the imposition of a univocal (or monolingual) meaning on the self and the world."[146] My deployment of an errant method has affinities with R. A. Judy's theoretical movement through "multiplicitous interpola-tion," a thinking at the "crossroads of confluence without any resolution or synthesis."[147]

Errantry also pertains to questions of medium-specificity in readings of black artistry. In his inventive study of "the many pathways and passages between two putatively discrete media (sound and writing)," *Epistrophies: Jazz and the Literary Imagination*, Brent Hayes Edwards makes the compel-ling assertion that "pseudomorphosis—working one medium in the shape of or in the shadow of another—is the paradigm of innovation in black art."[148] Edwards notes that, in thinking through this interface, he refrains from the language of intermediality in spite of the term's growing prominence in media theory over recent decades, because "the scholarship on *intermediality* tends to employ the term in a normative fashion ... [that] could be accused of technological determinism (taking for granted the 'independent properties of the medium' rather than understanding any medium to be ... unavoidably ... a 'form of social organization')."[149] Edwards's intervention is a welcome critique of strands of technological determinism within media scholarship that would approach the medium as if it could be simply abstracted from concrete configurations of the social. Following Edwards, I would add that the fetishization of medium as technology becomes particularly apparent when it is brought to bear upon anteaesthetic interventions.

Although the anteaesthetic practices engaged in this book may be tracked within or across discrete mediums (such as painting, installation art, experimental film and video), they often erode or exceed the parameters of medium-specificity. This is because these practices emerge from a black aesthesis that confounds efforts to firmly anchor a given practice within an isolated medium. One of the central questions with which *Anteaesthetics* is concerned is, What does it mean to speak of the medium in which a par-ticular black artist works, when the 'black body' is itself taken by the nor-mative subject (the human) for boundlessly fungible medium? Among the

reasons for choosing the particular artworks considered here is that they differentially disclose that blackness itself constitutes one of the principal medialities through which the exteriorizations of the human are effectuated. Rather than relinquish the conceptual language of mediality, however, this book stresses the (de/re)constitutive relations of blackness to the medial. The forms associated with anteaesthetic practices are immanently (inter) medial. Furthermore, these practices recursively deconstruct the mediums through which they are thought to cohere. An anteaesthetic orientation could thus be interpreted as a radical enrichment of or challenge to media archaeology, which approaches "media cultures as sedimented and layered, a fold of time and materiality where the past might be suddenly discovered anew."[150] Beginning from the racially gendered elisions of media archaeology, *Anteaesthetics* posits the material-discursive extractions from and displacements of blackness as constitutive of the onto-phenomenological coherence of modern forms of media. If one were to nominate this approach as black media archaeology, then it could be said to share Thomas Elsaesser's refusal of "the retroactive recovery of the past for the immediate (practical) uses of the present," while emphatically parting ways with his contradistinctive avowal of humanist (re)invention.[151] At stake for *Anteaesthetics* is the possibility of attunement to the minor refrains of black existence, the displaced anterior of every humanist conceit.

To invoke errantry as method is also to suggest that the conceptual movement of *Anteaesthetics* is always already a movement of non-arrival. In this regard, the very "thought of errantry is a poetics,"[152] where poetics comes to signal not a craft specific to literary genre but rather the forced itinerancy from which black experimentation continuously unfolds. This itinerancy is a movement paradoxically marked by radical overdetermination and radical indeterminacy. In tracing this movement, my methodological orientation heeds Erica Hunt's avowal of writing and art that evince "a restlessness to know beyond the knowing (the *as if*, art's impulse) that keeps Black people in their place."[153] For *Anteaesthetics*, this "as if" does not extend a utopian fantasy of a reconstructed world, or another world altogether, wherein black life would be belatedly welcomed into the great halls of being or wherein black art would find its rightful home within the aesthetic. Rather, *Anteaesthetics* approaches this "as if" as a poetics of attunement to the abyssal cut between black existence and black nonbeing into which we are forced to descend.

The Critique of Form

The unwieldy, internally variegated, and contested traditions that one might nevertheless nominate as black critical theory and black artistic practice, respectively, have had difficult relationships with various traditions of scholarly and aesthetic formalism (though these are, of course, hardly discrete designations). To begin with, the intellectual and artistic forms associated with blackness have typically been regarded by established traditions of formalism with, at best, skepticism. Where the myriad forms associated with blackness have been valorized by preponderant formalisms, it has generally been with extractive intent and far too often at the expense of sustained or nuanced attention to the manner in which these forms prove to be either vestibular to or irreconcilable with the presuppositions of the formalism that imposes itself as hermeneutic authority. For example, Huey Copeland draws our attention to the manner in which Clement Greenberg's claim that "in Africa today we find that the culture of slave-owning tribes is generally much superior to that of the tribes that possess no slaves" rhetorically advances his defense of the true work of art and the social hierarchies upon which he believes it to have been historically predicated, over and against a romance of "folk art."[154] For Copeland, Greenberg's rhetorical maneuver discloses the constitutive relation between the aesthetic formalism that subtends art historical modernism and the raciality this formalism both mobilizes and erases. In Copeland's words, Greenberg's passing lines reveal that "racialized barbarity and aesthetic discrimination go together, underlining how dark figures have been mobilized as linchpins of a modern metaphysics that not only demarcate the limits of culture and humanity within Western discourse, but that also trouble the visual, epistemological, and historical categories that structure so-called white civilization."[155] Although Greenberg's statement may now, more than eight decades later, appear a particularly egregious example of the racial fabrication of aesthetic formalisms—or what *Anteaesthetics* would theorize as the anteriority of blackness to the aesthetic and formalization as such—it is, substantively, hardly unique. Little wonder, then, that not a few black artists and critical theorists have regarded various aesthetic formalisms as orders of enclosure.

Where black artists and critics have endeavored to pay deference to reigning traditions of intellectual and aesthetic formalism, even going so

far as to offer themselves as the most enthusiastic champions of the very formalisms that hold them at a remove, it has often been at the expense of the development or interpretation of their own intellectual and artistic practices. This pitfall may be regarded as a predictable consequence of a more general tendency on the part of art critics to "confer upon the [black art] work a form that it forcefully disavows . . . [thereby] attract[ing] considerable attention to the rhetorical work they oblige" black art to do, as Darby English observes.[156] Be that as it may, this is not to suggest that all formalisms can or should be simply dispensed with. As Spillers avers, formalism can be "preeminently useful"[157] even, or perhaps especially, when it is deployed as an instrument of its own self-destruction. Indeed, Spillers's careful attention to the filigree, concealments, and excrescences of form—not least with respect to her conceptualization of the "hieroglyphics of the flesh"[158] to which this book repeatedly returns—offers an exemplary model for the kind of ante-formal heuristic *Anteaesthetics* endeavors to develop and extend.

Various hallmarks of modernity—among them, commodity fetishism, the vicissitudinous coupling of deterritorialization and reterritorialization (wherein "all that is solid melts into air"),[159] and the will to epistemic mastery that is one face of the self-possessive subject—have all but ensured the incessant fixation on the problem of form within modern thought. Indeed, Fredric Jameson suggests the conjoined problematic "of content and form . . . in the long run come[s] to haunt all the corners and closets of the social itself."[160] But what exactly is *form*, and what distinguishes the modes of making and interpretation that lay claim to the title of *formalism*? In *Forms: Whole, Rhythm, Hierarchy, Network*, Caroline Levine gives a capacious definition of form, one which aims to refuse the partitioning of the aesthetic from the social: "'Form' always indicates *an arrangement of elements—an ordering, patterning, or shaping* . . . Form, for our purposes, will mean all shapes and configurations, all ordering principles, all patterns of repetition and difference."[161] Levine's study is written, at least in part, against the antiformalist tendency that has ostensibly swept literary and cultural studies in recent decades, wherein scholars have become "so concerned with breaking forms apart that we have neglected to analyze the major work that forms do in our world."[162] Levine's concern is echoed across a wide array of fields and, indeed, across political milieus that would appear, at first glance, to operate at a remove from the specialized interests of the academy or the art world.

Anna Kornbluh, who affirmatively cites Levine's definition of form in *The Order of Forms: Realism, Formalism, and Social Space*, argues that the "pervasive political lament of form's order," which is equally in evidence in philosophy and art criticism, has become manifest as a naive and reprehensible "anarcho-vitalism," which equates constitution with violence and reflexively "favors fragmentation, unmaking, decomposition."[163] In fact, in Peter Osborne's view, the reaction against formalism is constitutive of contemporary art as an historical designation:

> Contemporary art is a field of generically artistic practices that developed via its Euro–North American heartlands in reaction against both (i) the formal critical norms of medium-specific modernisms and their transformative reproduction and extension of the old, Renaissance "system of the arts," and (ii) the residual cultural authority of all other received aesthetic forms and universals—residual, that is, from the standpoint of the thesis of the tendentially increasing nominalism or individuality of works of art in liberal (now neoliberal) capitalist societies.[164]

Needless to say, both the variegated resistances to form and formalism and the countervailing condemnations of antiformalism across art, scholarship, and politics must be situated in relation to the transgeographic anticolonial, feminist, queer, and many other rebellions in the latter half of the twentieth century, as well as the various iterations of revanchism that have become ascendant in their wake. A historical genealogy or political diagnosis of these contrapuntal tendencies is beyond the scope of this study. What concerns me is the matter of form—more specifically, the relationships between the gendered reproductions of blackness, the racial regime of aesthetics, and the (im)material extractions, transfers, consumptions, and displacements of form, including that genre of form through which form itself is thought to emerge—the form that is *medium*. *Pace* Kornbluh, I am not so much concerned with aesthetic forms as "privileged vehicle[s] of mediation" as I am with the manner in which all forms are constituted by the aesthetic, as that which endeavors to suture the metaphysical lacunas and aporias of "iterative discourse and conceptual logic."[165]

I contend that the relationship of blackness to form poses singular problems for formalism, most immediately because the phenomenological appearance of blackness within the antiblack world is necessarily dissimula-

tive, while the enfleshed existence of blackness is without ontology, relegated by the world to the status of nonbeing. The figure of blackness is therefore not only far from self-evident but, apropos Marriott, always already disfigured and disfiguring. Every form blackness is assigned is thus intrinsically aporetic. However, we will see that the converse is also true: blackness is, or bears, the aporia within and before every form.

My attention to the aporias of form and the forms of aporia within the racial regime of aesthetics finds at least some resonance with Theodor Adorno's interest in "the unresolved antagonisms of reality [that] return in artworks as immanent problems of form."[166] While my method is not dialectical materialist per se, I share the Marxian interest in the material relations that are expressed (and obscured) in (the fetishism of) aesthetic forms. However, my method finds a deeper philosophical intimacy with black critiques of form and formalism, which have witnessed a flowering in the academy in recent years but which are also part and parcel of a diverse intellectual tradition that is coterminous with the history of the diaspora and that is as much in evidence in vernacular traditions as it is in scholarship. Within the contemporary scholarly iterations of the black critique of form, theorists such as Calvin Warren stress that the modern world must be understood as formalization, and that antiblack violence both subtends and is effectuated through the order of forms.[167] "Pure form is the consequence of perfect death, black death."[168]

At the same time, blackness poses irresolvable problems for form, which no amount of formalist interpretation can fully reconcile. Denise Ferreira da Silva elucidates the problem blackness poses for form by suggesting that, within the modern world, blackness bears the mantle of an ostensibly antiquated, Aristotelian definition of matter as "substance without form," which ultimately disrupts modernity's braiding of formalization and "the Equation of Value."[169] Making recourse to a series of deconstructive (anti) mathematical operations (which I will not reproduce in detail here), da Silva suggests that blackness is functional to both "the ordered universe of determinacy and the violence and violations it authorizes" and the "*materia prima*—that which has no value because it exists (as ∞) without form"— which decomposes form and poses the thought of an "unbounded sociality . . . without time and out of space, in the plenum."[170] Warren, however, advocates a "mathematical nihilism," or an embrace of a catastrophe that

would dispense even with the critical recuperation of raw materiality, as "both matter and form are caught in antiblack imaginations."[171] For Warren, "the obsolescence of both matter and form," which he calls the catastrophe, "opens a horizon of the unthinkable, where life, death, value, and nonvalue are displaced."[172]

My own approach to a black critique of form could be said to move appositionally with da Silva's and Warren's. I share their interest in the inescapable blackness of what Georges Bataille called *"l'informe"* (the formless),[173] or what Yve-Alain Bois and Rosalind E. Krauss articulate as an operation of "declassification, in the double sense of lowering and of taxonomic disorder."[174] However, my principal interest is in the anteriority of blackness to (aesthetic) forms—wherein blackness is vestibular to the emergence, maintenance, modulation, and transformation of the very (antiblack) forms to which it is violently subject—as well as in the racially gendered reproduction of this anteriority. As I elaborate over the course of this book, the bearings of black femininity are doubly bound to the (re)production of the order of forms, as well as to black social and artistic refusals of this order. My thesis of black feminine anteriority has considerable implications for theories of the genesis and development of the modern order of forms, as well as the "quest(ion)" of this order's dissolution.[175]

This book's traversal of ante-formalism promises neither redemption nor emancipation. As Moten reminds us, violence cannot be excised from the materiality of the terrible gift of the hold, which is none other than black art: "Black art neither sutures nor is sutured to trauma. There's no remembering, no healing. There is, rather, a perpetual cutting, a constancy of expansive and enfolding rupture and wound, a rewind that tends to exhaust the metaphysics upon which the idea of redress is grounded."[176] Thinking with and against the force of that rewind, *Anteaesthetics* lingers with the inarticulable yet enduring questions that emerge from the formal entanglements of aesthetics and violence—questions that are unavoidable for those given to blackness.

While the making and unmaking of artistic form is thematized most explicitly in chapter 3, all the anteaesthetic practices analyzed throughout the book variously deconstruct the modern order of forms, whether the latter's impetus to formalization is expressed as the body (chapter 2), the medium (chapter 4), or the world itself (chapter 5). That is, the world itself is an aes-

thetic form, a paradigm defined by the chiasmatic worldmaking of form and form-making of world. I would also accent this book's interrogation of formal technics, not least with respect to time-based media, that "position . . . certain bodies and things within, outside, or across the threshold of form in order to maximize the functionality and reach of the system it constitutes."[177] In thinking with the anteaesthetic practices explored over the course of these chapters, a central concern will be the ways in which the gendered reproduction of black anteriority to the order of forms, within which blackness is an existence without ontology, instills an aporia or exorbitance within every form. Not even the onto-phenomenologically truncated form assumed by matter can escape this exorbitance, which can never be fully subsumed, displaced, elided, or eradicated by the order of forms. As we shall see, in every instance, blackness is the condition of (im)possibility for form.

Chapter Summaries

Each of the chapters in *Anteaesthetics* elaborates distinctive, if entangled conceptual moments of a general theory of black aesthesis as the critique of form. Each chapter differentially traces the making and unmaking of (aesthetic) forms through the racially gendered bearings of blackness. Chapter 1, "Toward a Theory of Anteaesthetics," elaborates the theoretical architecture which structures my approach throughout *Anteaesthetics*, contextualizing my central interventions in relation to the various discourses and methodologies they are situated within, beside, or against. Taking the manifold problematics opened up by Arthur Jafa's 2013 experimental film *Dreams are Colder than Death* as my point of departure, my reading foregrounds a critique of (film) phenomenology so often posed as an alternative to the reifications and foreclosures of ontology. I argue that blackness is no more available to phenomenology than to ontology. Every appearance of blackness is necessarily a dissimulation—a violent phenomenological feint with which every instantiation of black art must contend. Out of sheer necessity, these dissimulations nevertheless become sites of experimentation, occasioning what I term *the arts of dissimulation*. I turn to black feminist theories of reproduction in order to argue that the bearings of black femininity not only subtend modernity and its aesthetic regime but also social and artistic traditions of black radicalism and the immanent dehiscence from which they

may be said to emerge. I then argue for the anteriority of this racially gendered reproductivity to the centrality of the body within modernity, demonstrating how the bodily turn of the latter twentieth century has failed to grapple with the lacuna and aporia posed by blackness. Black aesthesis, I argue, is an inescapably corporeal phenomenon. Moving with several black feminist thinkers, and Hortense Spillers especially, I stress the medial uses of the violent immediacy with which every black inhabitation is confronted. The chapter closes with a proposal for a theory of black mediality, which dissents from the discourses on mediation that have generally informed various theoretical approaches to new media studies.

Chapter 2, "The Corporeal Division of the World, or Aesthetic Ruination," and chapter 3, "Before the Nude, or Exorbitant Figuration," undertake an extended investigation into the constitutive imbrications of the racial regime of aesthetics and what I term "the corporeal division of the world" in their racially gendered dispensations across artistic forms. Across these chapters, I argue that the historical cartography of the modern world and the aesthetic form that is "the body" turn upon a racial division of corporeality, for which blackness is the absent center. This corporeal order at once conscripts and expels the black, who becomes the negative vestibule for the spacetime of the (proper) body and its others. Both of these earlier chapters analyze a number of signal instantiations of black anteriority to the corporeal division of the world, variously tethered to the formal innovations and structural recalibrations of aesthetics, knowledge, and biopolitics during the nineteenth century. These chapters trace the racially gendered dimensions of black anteriority contrapuntally, through the descendent figure of masculine heroism and the ascendance of the female nude, respectively.

Chapter 2 centers on an iterative reading of Théodore Géricault's *The Raft of the Medusa* (1819) and the oil study referred to as the Montauban study, the *Study for the Signaling Black,* or *African Signaling* (1819). Taking up art historian Thomas Crow's pointed interpretation of Géricault's work and, in particular, Crow's analogical turn to the *Belvedere Torso* (mid-first century BCE), I introduce a theory of the black bodily fragment as a metonymic rend(er)ing of flesh. I suggest that Géricault's painting and oil study, as well as Crow's interpretation of them, provide exemplary instances of the black mediality which undergirds the corporeal division of the world and its historical recalibrations in and through the aesthetic. The *Torso* also occa-

sions a further exposition of the ways in which black aesthesis is not only irreducible to but the condition of (im)possibility for Rancière's *aisthesis*. Furthermore, black mediality and the myriad uses to which it is put are revealed as indissoluble from the violent (im)mediations of touch. I theorize touch as one of the principal registers for discerning the boundary between those who may claim belonging within the corporeal division of the world and those who remain that division's constitutive exclusion. A comparative reading of *Raft of the Medusa* and Louis François Charon's c. 1814–1815 *Les Curieux en extase, ou les cordons de souliers* (The curious in ecstasy or shoelaces) serves to accentuate the disjunctive economies of touch as essential demarcations of the boundaries of the corporeal division of the world. *Les Curieux en extase*, a hand-colored engraving which caricatures one of the key figures in the chapter that follows—Saartjie Baartman, the so-called Hottentot Venus—reveals by contradistinction the commonalities and differentiations within the (im)mediations of the flesh across canonical figurations of black masculinity and femininity. We will see that these (im)mediations gesture toward the racially gendered unevenness in the forced reproduction of blackness before the antiblack world.

Chapter 3, "Before the Nude, or Exorbitant Figuration," is bookended by a reading of Mickalene Thomas's 2016 multimedia installation, *Me As Muse*. Whereas Thomas's work, in this instance and more generally, has typically been interpreted and celebrated as representationalist, I read *Me As Muse* as an exemplar of anteaesthetics—as an inhabitation which is anterior to the racial regime of representation. Specifically, I theorize *Me As Muse* as the recursive deconstruction of the corporeal division of the world and the historical development of its myriad aesthetic permutations. What Thomas's work ultimately opens onto is not so much the presence of a new or refashioned form as the racially gendered genealogy and agonistics of form as such. Taking a specific set of figural, formal, and historical examples invoked within or provoked by Thomas's work as my point of departure—in particular, the figure of Saartjie Baartman (c. mid-1770s–1789 to 1815), Jean-Auguste-Dominique Ingres's *La Grande Odalisque* (1814), and the complicated nineteenth-century histories with which blackness and the aesthetic form of the nude are entwined—I move through critical moments within two strands of transformation within the corporeal division of the world, conventionally partitioned as the aesthetic and the scientific. I emphasize

the interdicted history of the brutalized flesh and dissimulated 'body' of Baartman, who was made the medium for an interwoven series of aesthetic, epistemic, and biopolitical transformations during the nineteenth century. Because Ingres's work is not only emblematic of a crucial moment of formal innovation and structural revision within the corporeal division of the world and the racial regime of aesthetics but, moreover, has been widely scrutinized with respect to its gendered and Orientalist architecture, it provides an exemplary instance of the racially gendered anteriority of blackness, which is made the medium of the world's remakings but can never be properly located within them. Furthermore, the racially gendered anteriority of blackness, or the vestibularity of black (feminine) enfleshment, proves to be both the condition of possibility for these recalibrations of the corporeal division of the world, the racial regime of aesthetics, and their braided work to sustain modernity's antiblack metaphysics in and through the making of new aesthetic forms. Baartman's anteriority to the entwined scientific and aesthetic metamorphoses of the nineteenth century raises a question, which is history's silent refrain: What happens to a metaphysics that depends upon a contaminant for the purification of its system of knowledge, being, meaning, and value? Returning to Thomas's installation and Baartman's fleeting appearance in the midst of various morphological transformations of the art historical nude, I argue that Thomas's morphological technics, in exhibiting a radical non-separation from its nineteenth-century invocations, are not so much an exercise in appropriation or the remediation of nineteenth-century forms and mediums within a new media practice as a technesis of the flesh: a deconstructive exhibition of black mediality. *Me as Muse* thereby discloses the anteriority of black femininity as a contaminative touch which every conscription of this black mediality cannot help but contract and extend, a contamination that threatens a ruination without restoration. Once again, we see how the anteriority of blackness to the world just as surely bears an immanent contamination which threatens to leave this order in ruins.

Chapter 4, "The Black Residuum, or That Which Remains," turns to the artist Glenn Ligon in order to excavate the concealments and failures of the racial metaphysics undergirding modern aesthetic formalisms, particularly as they pertain to medium-specificity and genealogy. Tracing the conceptual affinities between Ligon's painterly and videographic practices, I argue that his visual, textual, and sonic dramatizations of the color line divulge an

opacity that precedes the racial hyper(in)visibility which subtends the ocularcentric field of representation. While Ligon's work is often read through the conceptual grammar of hyper(in)visibility, my theorization of opacity signals an irreducible materiality that is the condition of possibility for signification within the visual field, yet cannot itself signify. Ligon's paintings work with and from this "obdurate materiality"[178]—the black residuum—that marks and is marked by the failures of an ocularcentric logic, which tends toward the excision of materiality from the visual field. The first half of the chapter takes up Ligon's various text-based engagements with Ralph Ellison and Zora Neale Hurston, in particular, arguing that the critical intimacies he sustains with both modernist painting and black literary modernism compel a reconsideration of what is at stake in his intervention into language-based conceptualism. The prominence of questions of blackness and embodiment within these works is central to their engagements with the racially gendered mattering upon which the very distinctions between word and image, figure and ground, abstraction and figuration intrinsically depend. The second half of the chapter turns to Ligon's 2008 video installation *The Death of Tom* and draws out the implications of his citation of Edwin S. Porter's 1903 silent film version of Harriet Beecher Stowe's nineteenth-century sentimentalist novel *Uncle Tom's Cabin*. I argue that Ligon's *The Death of Tom*, far from simply exposing or indicting the racist origins of American cinema, recursively deconstructs the cinematic itself, disclosing black mediality as the condition of possibility for the medium's emergence. Finally, through a critical engagement with Eugene Thacker's concept of "dark media," I suggest that the hauntological dimensions of Ligon's dark media must be thought not only in relation to the figure of Tom but also in relation to the figure of Topsy, who manifests as the artwork's haptic suffusion with a hauntology of the flesh.

The book's final chapter, "Unworlding, or the Involution of Value," reads the recent work of Sondra Perry to develop an anteaesthetic critique of the metaphysical architecture of worlding, the phenomenological body-subject of worldly inhabitation, and their aesthetic reproduction in and through the logic of value. The chapter argues for the importance of attending to the ulterior force of unworlding as a racially gendered emergence or submergence that is anterior and antithetical to worlding. The first part of the chapter undertakes a reading of Perry's immersive video installation *Typhoon coming*

on (2018), which deconstructs the metrics and imperatives of value through a recursive descent into the enfleshed existence which is value's anoriginary condition of (im)possibility.[179] The second part of the chapter turns to Perry's *Flesh Wall* (2016–20), which utilized ninety-two massive digital displays in Times Square to produce a media architecture from a finely modulated image of her own skin, cut, splayed, and magnified. In Perry's work, the dissimulated 'black body' begins to blur into the enfleshed existence it conceals. Drawing upon deconstructionist critiques of architecture and expositions of the racial genealogy of architectural forms, among other interventions, I argue that architecture constitutes a modality for designing the world, a technology of worlding. Furthermore, I suggest that Perry's *Flesh Wall* traces the antephenomenal existence of blackness, signaling a radical critique of Maurice Merleau-Ponty's concept of "the flesh of the world" and the phenomenological body-subject who would inhabit this chiasmus. Perry's work stages the unworlding that is vestibular to "the flesh of the world."

Codetta

"I do not believe the conditions that produced a situation that demanded a song like that!" Nina Simone's rhetorical declension is an oblique exposition and impossible refusal of being made the world's anterior. Held in the tortuous folds of her nonperformance is an anticipatory echo of the project *Anteaesthetics* endeavors to trace through the recursive deconstruction of the modern order of forms. Her gesture is neither reparative nor utopian but marks a refusal to displace the terrible imposition of the black feeling she is made to bear. If *Anteaesthetics* could be said to have emerged from a feeling, it is a feeling to which Simone returns us, a feeling to which she was always already given. Simone's nonperformative refusal to perform the spectacularity and interdiction of black feeling ought to be understood as an anteaesthetic critique of the world, of the very project of worlding. Her nonperformance recursively veers back into the violence of the worlding refrain for which she is bound to appear, precisely for the sake of the black feeling this refrain would both covet and obliterate. The brutality and failure of this refrain is implicit in Simone's extended prelude to "Feelings," titled "Stars": "But they'll never know the pain of living with a name you never owned. Or the many years forgetting what you know too well." There is a doubled

signification of memory and forgetting that gathers in the transit between these two songs, which hinges upon a critique of the racially gendered violence of denomination. As Hortense Spillers famously opens her classic essay "Mama's Baby, Papa's Maybe: An American Grammar Book":

> Let's face it, I am a marked woman, but not everybody knows my name. "Peaches" and "Brown Sugar," "Sapphire" and "Earth Mother," "Aunty," "Granny," God's "Holy Fool," a "Miss Ebony First," or "Black Woman at the Podium": I describe a locus of confounded identities, a meeting ground of investments and privations in the national treasury of rhetorical wealth. My country needs me, and if I were not here, I would have to be invented.[180]

Here Spillers gestures to the ways in which the serial denominations of black femininity mark and are marked by a racially gendered (re)productivity that is indispensable to a social formation that would assume the garb of the national but is hardly reducible to it. I want to suggest that this formation is in fact the world—the form of the world and the world of forms. The conscripted (re)productivity of the black feminine and its dissimulative guises mark and are marked by the "investments and privations" of the modern order of forms and this order's apotheosis—the form of the world. Before the world, black femininity has no name but must be relentlessly named, cannot appear but is constantly made to appear, cannot be but must exist.

Simone's nonperformance of "Feelings" emerges from precisely such a terrible awareness and obdurate refusal of being called to respond to the litany of violent denominations *as if* her name had been spoken, of being instructed to inhabit the violent dissimulation of a 'black body' *as if* it indexed her enfleshed existence. In other words, a forgetting precedes and encloses the event of appearance through coerced performance. And yet, in a kind of prefatory nonperformance, Simone's "Stars" signifies upon what it means to bear the injunction of this disjunctive denomination, this violent (mis/dis)appearance. What does it mean to find a way to live with and through "name[s] you never owned"—and worse: names which themselves trace a history of being owned, of being made the fleshly transit that renders the forced performance of forgetting an existence "you know too well"? And yet, even at the moment of violent (mis)naming, what does it mean to bear the material-semiotic exorbitance that Spillers terms "signifying property *plus*"?[181] Such questions move us toward the racially gendered problemat-

ics that are necessarily woven through a theory of anteaesthetics, which the following chapter ventures to expound upon. But the true potency of such questions lies in their irresolution, in the wounding of the semiotic order their query precedes and exceeds. *Anteaesthetics* is an effort to return us to the difficult artistry of that anterior irresolution.

One

Toward a Theory of Anteaesthetics

> And how to formulate questions that did not only *not* have an "answer" per se, but that problematized the conditions of interrogation in the first place?
>
> —Hortense Spillers[1]

Arthur Jafa's film *Dreams are Colder than Death* (2014) is a reflexive engagement with the singular weave of possibility and constraint to which both black existence and black anteaesthetic experimentation are given. I turn to *Dreams* in order to open a series of inquiries into the shrouded relations between modernity's antiblack metaphysics, the racial regime of aesthetics, the modern order of forms, and the racially gendered reproductivity that lies at the heart of their perpetuation and concealment. Poised at what would appear to be the conjunction of aesthetics and politics, and steeped in both overt and tacit philosophical reflection, *Dreams* insistently signifies upon the conditions of black existence by bringing into painful and often unbearable relief the (meta)physical and psychic violence of antiblackness to which the 'black body,' enfleshment, and anteaesthetic experimentation are ineluctably bound.

Dreams proceeds through a series of "black operations,"[2] which, in Alessandra Raengo's view, are activated by a manifold of "'passages' between seemingly disparate and incongruous concepts and situations. . . . It performs . . . what [Jared] Sexton describes as a series of conceptual moves 'from the empirical to the structural or, more precisely, from the experiential to the political ontological.'"[3] The film's approach to blackness has resonances with Gilles Deleuze's notion of the transversal; it alights upon or descends into transitory convergences or divergences among the histo-

riographies and intertextualities that serially refigure black existence and its dissimulative appearances. Jafa's film does not advance through narrative linearity or conceptual teleology. Rather, it is a film whose peripatetic movement properly attunes to the rhythms of black existence.

What is important for our purposes is how Jafa's filmic improvisations thread quotidian black experience through the ontological and its interdictions, emphasizing both their twining and fraying as eminently aesthetic fabrications. Jafa thereby opens paths to thinking with black existence that are wholly foreclosed by the ethnographic (de)valuations of blackness that generally predominate in representationalist discourse. If black film is an art practice which, as Michael Gillespie contends, "emanates from the conceptual field of black visual and expressive culture,"[4] then *Dreams are Colder than Death* is an exemplar of the genre. The low roil, halting percussion, and eerie distortions of Melvin Gibbs's ambient soundscapes, the desultory emergence and then submergence of fragments from Martin Luther King Jr.'s "I Have a Dream" speech within the audible field, and the "formal discontinuity of sound and vision or spoken word and the sight of a speech act"[5] all signify upon the dislocation of blackness from normative spatiotemporal cartographies.

Dreams moves against and apposite the reigning presumption that the cinematic medium is essentially a vehicle for phenomenological experience. The (ante)aesthetic fashioned by *Dreams* emerges precisely through the exposure and inhabitation of the racial disjunction in the phenomenological relay between subject, body, and world. One of the film's central interlocutors, Hortense Spillers, first makes her appearance within a passage in which she recounts the story of her sister's recent partial amputation. This sequence evinces the conceptual tension between the representational procedures and protocols of cinema vis-à-vis what Gillespie would call "film blackness"[6] in ways that complicate the phenomenological grammar undergirding, in the words of Vivian Sobchack, "cinematic communication and its dialogical 'address of the eye.'"[7]

I focus on the sequence in which Spillers appears because it foregrounds the racially gendered reproductivity that film and (film) phenomenology both require and displace. Moreover, by attending to a (mis)reading of the conditions under which blackness is "bound to appear," specifically with respect to the hermeneutic conflation of flesh and 'body,' I draw out the impli-

cations of this sequence for the more general critique of phenomenology that an anteaesthetic method demands. According to the phenomenological understanding of cinematic experience, "the embodied spectator and embodied film are dually and simultaneously engaged in both the intrasubjective, introceptive, and invisible activity of visual perception and the intersubjective, projective, and visible activity of visual expression."[8] This sequence in *Dreams*, however, deconstructs the tacit universalism of film phenomenology's conception of cinematic communication as an unbroken dialogical relay. My reading of this sequence pays special attention to its anteaesthetic inhabitation of the metaphysical rifts produced in the phenomenological dissimulation of forms of embodied intra- and intersubjectivity—modalities of being-in-the-world which the black only encounters as interdiction or farce.

Dreams sustains its accentuations of the spatiotemporal discordance that blackness invariably produces and confronts in the circuit of cinematic presence and embodiment throughout the film. But the passage in which Spillers appears is notable for the ways it places this aesthetic deconstruction into immediate proximity with her critical meditation on the singular relation, at once immanent and disjunctive, between racial slavery's "captive body" and its "high crimes against the flesh."[9] In this passage, a portion of Spillers's narration is voiced over slowed-down footage of an anonymous black woman crossing a city street. Spillers declares:

> We were available in the flesh to slave masters. In the flesh. Immediate; hands on . . . I can pluck your little nappy head from wherever it is. Bang! . . . That's flesh.

The visceral force and sheer concision of Spillers's speech is a "philosophical performance"[10] that returns us to an anoriginal violation which obtains in and as the present; it rhetorically exhibits the hyperproximity, the terrible nonseparation, between black flesh and the violence of the master's touch. Spillers condenses a colossal history of incalculable brutality into the space of an instant—a rhetorical doubling of the absolute immediacy of violation to which black flesh, cut and splayed before the body, remains subject. What Spillers's philosophical performance makes clear is that this unthinkable violence appears phenomenologically in the dissimulation of the captive body, but it is borne in and by the flesh (it is flesh that "registered the wounding").

Black audiovisual aesthetics are bound to the historio(geo)graphic co-

Figure 3. Arthur Jafa, *Dreams are Colder than Death*, 2013, video still. © Arthur Jafa. Courtesy of the artist and Gladstone Gallery.

Figure 4. Arthur Jafa, *Dreams are Colder than Death*, 2013, video still. © Arthur Jafa. Courtesy of the artist and Gladstone Gallery.

nundrum conveyed in and through the substance of Spillers's speech, a fact which is further illustrated in this sequence by the ways the film recalibrates the visual to press further into the problematic she foregrounds. That is to say, Spillers's philosophical performance is redoubled by the formal strategies of a black filmic intervention into perceived spatiotemporal continuity, upon which the projected world of film rests. The dissociation between Spillers's story and the camera's visual recording of the anonymous woman is heightened by the visual semblance of a lag or delay, an effect strategically deployed to track the trajectory of the anonymous woman's look (see figures 3 and 4). This effect, or what Arthur Jafa refers to as a "declension," is part of a distinct film grammar that exploits and experiments with manipulating the frame rate as a means of conceptualizing, in Jafa's words, "the indeterminacy of who black people were."[11] The filmic declension, in other words, becomes a means of translating the affective dimensions of blackness as spatiotemporal indeterminacy, so as to convey a "transitory" sense of presence, contingent upon "loss, longing, memory."[12]

The unbearable duration of this particular declension is organized around the camera's attention to the anonymous woman's own awareness of being seen. The drama of vision is heightened in the final instance of her engagement with the camera, wherein her look shifts into a glare that intensifies at exactly the moment she catches hold of our gaze, as if in defiance of being "seen" at all. The declension thereby transfigures the dialogics and dialectics of seeing and being seen, as it strains against what Merleau-Ponty, writing explicitly on cinematography within the medium of film, describes as a "definition of cinematographic rhythm" dependent upon "a cinematographic system of measurements with very precise and very imperious requirements."[13] The camera, which exploits the difference between its own speed and the woman in motion, produces something akin to a motion blur. And yet the final image of the anonymous woman in this sequence generates and sustains a strange sort of spatiotemporal warp or disjunction. The reverberation of sound and image opens up to "a different sensory experience," indicating that black film cannot be truly sensed or seen without attuning to the "frequency" and vibrational excess internal to black filmic images.[14]

This filmic declension emerges within and testifies to a sensorium that warps normative spatiotemporality, drawing the viewer toward the drift of black consciousness immersed in the interminability of quotidian an-

tiblackness. Spillers's voice is cast into irreducible entanglement with the variegated tempos of black movement, thereby amplifying the philosophical singularity she bears. By unmooring the viewer from normative spatiotemporality, the sequence subverts the conventional logic of shot progression, or the presumption that "the meaning of a shot therefore depends on what precedes it."[15] In his insightful work on changes in affective materialities and embodiments across cinematic and post-cinematic regimes, *Discorrelated Images*, Shane Denson theorizes shots like this one as "subtly dismantling rational orderings of time and space that served, conventionally, to correlate spectatorial subjectivity with cinematic images."[16] We might say that *Dreams* gestures toward the ways in which every image within black film is necessarily discorrelated, having emerged from practices bound to an existence that is interdicted from both normative spatiotemporality and spectatorial subjectivity.

Cinematographically, *Dreams* anarranges phenomenological film grammar, exhibiting what Christina Sharpe would call "anagrammatical blackness" through its ulterior spatiotemporal rendering of black images whose anterior relation to history can hardly be visualized.[17] In this instance, the blur of the tracking shot is essential to the film's ulterior visuality, as it cuts the singular iconicity of a 'black body' that all too often serves as the spectacular cipher for cinematic spatiotemporal continuity. The breakdown in spatiotemporal continuity is particularly apparent at the end of this passage, wherein Spillers's emphatic "Bang!" and the anonymous woman's look appear to temporally coincide. Alessandra Raengo writes that "the sound of . . . [Spillers's] 'Bang!' is cued to the image of the same woman, who now turns in slow motion toward the camera with a puzzled and inquisitive look, as if reacting to Spillers's mimicked slap."[18] In this reading, the anonymous black woman's gesture is interpreted as merely figurative, as emblematic of Spillers's assertion. However, this hermeneutic synchronization betrays a conflation that rests upon an inherently phenomenological conceit.

The visual relay between Spillers's declaration and the anonymous woman's affective comportment is constructed in order to make it appear as though the anonymous woman's reaction is itself the embodied performance of Spillers's theoretical formulation. Raengo's account effectively reduces the anonymous woman's nonperformance to a performance of bodily mimesis. But the illusion of coincidence between Spillers's declaration and the

anonymous woman's look proves to be a phenomenological feint—an ideological ruse exposed in the theoretical interventions of this very sequence. Contra the positivist reflexes that enable the body as racial apparatus, the 'black body' as a given proposition, as an a priori sign of ineluctable presence is in fact a dissimulation. The 'black body' is a phantasmatic presencing of an absence, of the corporeality which is phenomenology's constitutive negation and whose dissimulation is affixed yet irreducible to what Spillers theorizes as the relegation to and the uses of flesh.

In short, *Dreams* foregrounds black corporeality as a singular problematic—one which is vestibular to and aporetic within the phenomenological register that undergirds the presumption of the embodied spectator as a spatiotemporally situated, perceiving subject. Moreover, *Dreams* fashions an anteaesthetic experiment in and as the return to that problematic, making an art out of the recursive deconstruction of the very dissimulations to which its filmic declensions are necessarily subject. In these regards, *Dreams* is exemplary rather than exceptional. That is, it must be situated within an expansive ensemble of black cultural histories and artistic devotions that Gillespie terms *film blackness*. Film blackness, as Gillespie conceives it, begins from the restless "belief that that the idea of black film is always a question, never an answer."[19] I would add that it must remain a question because the black aesthesis that film blackness emerges from and serially returns to, far from being a mere "effect of a historically specific cinematic apparatus,"[20] is in fact the anterior condition of (im)possibility of that apparatus.

Internally differentiated and differentiating, film blackness is ulterior to a series of hermeneutic foreclosures, from the narrative imperatives of cinema to the presumptions regarding what Raymond Bellour calls *the cinema-situation,* or "'the condition' that permits 'a unique experience of perception and memory'" (une experience unique de perception et mémoire).[21] What do the phenomenological conceits embedded in the reproduction of Bellour's cinema-situation assume about cinema's constitutional relations with the spectator, about the relations that make it possible to generalize about perception, cognition, memory, and affect? More pointedly, what do they indicate about the availability and receptivity of the body for the cinematic medium? If historically, as Gillespie contends, cinema's encounter with blackness has repeatedly troped "the somatic spectacle" of a "body

denied,"[22] then how do we contend with blackness as both vestibular to and the material disruption of a transhistorical cinema-situation that is structurally predicated upon a universalized "experience that defines the cinema spectator as a specific embodiment"?[23] If the critique of the spectatorial subject and the cinematic apparatus does not considerably diminish the force of phenomenological example, should it not at least compel a differential analysis of the somatic dynamics of cinema's communicative structure?

For Frantz Fanon, as for Kara Keeling who reads him, the 'black body' is given in advance of any encounter with the cinematic apparatus, even as this apparatus plays a crucial part in the ongoing dissimulation of the epidermalized body. The discursive, historical, and aesthetic protocols afforded the community of generically embodied spectators—that is, civil society—in their dialogic relation to the cinematic apparatus are simply not afforded the black, as the black has always been the foundational exclusion that allows this community and dialogics to cohere. Jafa's filmic disruption of the spatiotemporal relays through which the traumatic repetition of violation is scored and rescored on the 'black body' and the film's specular rehearsal of the minor refrains of enfleshed existence cannot help but to return us, as if for the first time, to Fanon's aphoristic testimony: "I am the one who waits."[24]

Fanon teaches us that the belated witnessing which affixes (to) this enfleshed existence abounds and redoubles in the cinematic encounter. If the power of film lies in its capacity to sustain a self-conscious philosophical relation to the world,[25] Fanon brings us into unbearable proximity with the fact that there is no space for the black in the cinematic picture. His attestation suggests not just that black cinematic spectators are unable to perceive themselves but points to the black's deeper incapacity to arrive at a self-conscious relation to their existence in the world through an encounter with film. Spectating becomes foundational to and constitutive of aesthetic modernity, precisely by way of and not despite the exclusion of blackness from the cinema's phenomenology of experience. By extension, viewing and watching, as activities pertinent to the history and discourse of cinema, become essential to modern subjectivation.[26] The belated temporality from which the statement "I wait for me" unfolds leads to the deconstruction of self-reflexive spectatorship, so as to betray the "metonymic slippage between vision, the image, the eye, and the 'I' of subjectivity."[27] Waiting, its "double

signification,"[28] radically cuts into what film studies has conceived of as the "imaginary relation between spectator and screen."[29] The black spectator who lies in wait, who "watch[es] with hostile intent"[30] inevitably "unsticks" or is unstuck from the screen—which is to say, the screened world.[31]

Denied any place within the normative dialogics of the cinematic apparatus and spectatorial subjectivity, the images which confront Fanon are necessarily discorrelative—marked by a temporality at once anticipatory and endlessly deferred. If the black spectator caught in such "suspended anticipation" waits within an interminable belatedness "that delays, perhaps permanently, the timely expression of anything that might be called one's own,"[32] then this temporal anomaly also gives lie to the phenomenological conceit of the spectator as an iteration of the putatively self-determined, "transparent I."[33] The persistence of an ineradicable difference in the black's comportment to spectating, a difference which ultimately exposes the racial fabrication of spectatorial subjectivity as such, is not restricted to the taxonomies of experience that emerge from the axiom of medium specificity. As David Marriott deftly demonstrates in his study of the haunted forms of visuality that gather beneath the decentralized rubrics of surveillance and media technologies, the disjunctive spectatorship confronted by the black is not peculiar to the cinematic situation but general to the black's encounter with the visual. As Marriott perceives it: "A certain fallen aura and out-of-timeness is what defines our spectatorship . . . more generally and our exposure to the depressing emptiness of a nullity without horizon."[34] In this respect, one might say that the inherent discorrelativeness of black spectatorship anticipates the post-cinematic media regime, redoubling the historical and semiotic indeterminacy of the "post" and extending this indeterminacy to the historicization of mediums and forms in general.[35] Needless to say, every regime of visuality's arrival, however contingent, will have been first predicated on the black's non-arrival.

Conversely, the tacitly universalized spectatorial embodiment that anchors the history of cinema and film philosophy alike is merely a particular instantiation of a more general imbrication of the modern subject with a violent modality of seeing. This "imperial vision," as Ariella Azoulay calls it,[36] is as much a strategy of containment as predation. The reproduction of this violent visuality, upon which modernity's phenomenological subject depends, requires the endless projection and absorption of the dissimulated 'black

body.' As with the apparent coincidence I analyzed in Jafa's filmic sequence—the phenomenological feint that would synchronize Spillers's final declaration ("Bang!") and the anonymous woman's look—modern visuality in general must render the irreducible distinctions between the 'black body,' enfleshment, and aesthesis as absolutely indistinct, subsumed under the phenomenologically overdetermined 'black body.' Modern visuality therefore also requires the pretense of spatiotemporal contemporaneity, which, in the context of cinema, requires that the suspended anticipation, the indefinite belatedness, which marks the experience of black spectatorship, masquerade as synchroneity. In this respect, we may take Merleau-Ponty at his most literal meaning when he asserts as phenomenological decree: "Let us say right off that a film is not a sum total of images but a temporal gestalt."[37] Within but interdicted by, without yet subject to this temporal gestalt, blackness remains the remainder, at once temporality's precedent and exorbitance.

Blackness discloses an ontological rift not only at the heart of a cinematic grammar predicated upon an audiovisual articulation of shots, frames, and scenes but within the spatiotemporal structure of modernity as such. As we will see in chapters 3, 4, and 5, black aesthesis is no less a dehiscent force in the comparatively heterogeneous spatiotemporalities of post-cinematic media forms than in the traditional structure of the cinematic.[38] It is a dehiscence which is, I will argue, in fact endemic to the general economy of mediums and forms that is operative within the modern world. To declare this endemicity is not to vitiate the hermeneutic importance of attending to the specificities of mediums and forms. Indeed, this book traces the recursive movements of anteaesthetic experimentations through careful attention to the specificities of medium and form precisely in order to disclose black aesthesis as the ineluctable anterior of every instantiation of medium and form.

This book theorizes the brutally immanent laying on of hands that Spillers characterizes as being made "available in the flesh," being passed "from hand to hand,"[39] as the racially gendered (re)production of blackness as mediality—of black flesh as the corporeal bearing of a series of violent (im)mediations. My use of the term *(im)mediation* is an appositional revision of Pooja Rangan's deployment of the term in her important critique of "the presentist politics of compassion cultivated by [humanitarian documentary] images of immediacy . . . [in order] to emphasize the *mediated* quality of . . . immediacy."[40] In contradistinction, I use the term *(im)mediation* to elucidate the

paradoxically inverted violence to which the black is subject: (im)mediation names a violence which the black substantively confronts as immediate, as a condition of absolute exposure before the world. Nevertheless, for the subject and the world the subject inhabits, the brutal immediacy to which the black is subjected provides a constitutive mediation that enables, for example, the distinction between interior and exterior. We can see an attunement to this inversion formally at play in *Dreams are Colder than Death*, where the dissimulation of the mediated experience of cinematic spectatorship becomes an experimental site for the recursive disclosure of the violent (im)mediations that mark black existence (incidentally signaling the radical incommensurability of Jafa's filmic practice with the calculated humanizations that characterize conventional documentary).[41] I argue that this appositional theorization of (im)mediation has massive implications for theories of embodied intra- and intersubjectivity and for theories of media and mediation.

Taken in discordant concert, Jafa's anteaesthetic practice, Spillers's philosophical dehiscence, and Raengo's (mis)reading of both serve as a heuristic anticipation of the key conceptual moments in the expositional movement toward a theory of anteaesthetics undertaken over the course of this chapter. We begin with the double bind of reproduction that ensnares black femininity—an excursus that will clarify why and how the harrowing (re)productive violence of being made "available in the flesh" is always already a racially gendered imposition. We will see that the conscripted bearings of black femininity are bound to the reproduction not only of the modern world, but of the modern corpus. Tracing the modern body through its reiterations and subterfugic displacements within the contemporary bodily turn, we will discern that this body is in fact a racial apparatus, which depends upon both the endless fabrication of the 'black body' as phenomenological feint and the enfleshed black labor conscripted for the reproduction of these bodily dissimulations. At stake in the critique of Raengo's hermeneutic synchronization of Spillers's emphatic declaration ("Bang!") and the anonymous woman's look is precisely the subsumption both of flesh that cannot be phemenonalized and a 'black body' that can only be phemenonalized as dissimulation under the latter's reified appearance. This subsumption, in turn, forecloses the possibility of attuning to the black aesthesis that emerges in the cut between enfleshed existence and bodily dissimulation, between blackness as an existence without ontology and blackness as nonbeing. Raengo's (mis)

reading follows from a failure to interrogate the reciprocal stratagems of (film) phenomenology and the modern body. The racially gendered (re)production of this reciprocality, I argue, proceeds through the disjunctive entanglements of enfleshed labor and bodily dissimulation. Only by grappling with this coerced reproductivity and its relationship to ontology, phenomenology, and (aesthetic) form can we begin to understand the depth of the violence and scope of the implications of being made "available in the flesh," or what I theorize as the (im)mediations of the flesh. We turn finally to a theory of the (im)mediations of the flesh that has massive implications for the grammar of technics that predominates in the philosophy of media, as well as the impoverished conception of mediality this grammar inscribes, in order to show how the technological exteriorizations of the modern human subject are bound to the scene of racially gendered violation. *Anteaesthetics* contends that, far from a matter of local ethnographic concern, the bearings of the black feminine in fact generally subtend the modern order of forms.

The Bearings of Black Femininity

The slave ship is a womb/abyss. The plantation is the belly of the world. *Partus sequitur ventrem*—the child follows the belly. The master dreams of future increase. The modern world follows the belly.[42]
—Saidiya Hartman

If the ontology of the antiblack world emerges through the constitutive negation of the black, whose incarnation of metaphysical nothingness under the signs of absolute affectability, primitivity, and dereliction furnishes the coherence of modernity's spatiotemporal coordinations, then black femininity bears this terrible emergence in and through the flesh. In this book, *bearing* assumes a tripled valence: simultaneously evoking the reproductive, the orientative, and that which must be endured. My approach to the bearings of black femininity is boundlessly indebted to black feminist scholarship. In what follows, I briefly review some of the contributions this scholarship has made to thinking through the entanglements of subjection and subversion that are given in the racially gendered (re)productions of slavery and its afterlives[43] in order to draw out their implications for a theory of anteaesthetics. These (re)productive entanglements, I shall argue, are constitutive dimensions of the anteaesthetic practices and predicaments this book tracks

across film and media, art installation, painting, and literature. It is critical to understand these entanglements not simply because of the ethical or political implications of black femininity's conscription into the (re)making and sustainment of the antiblack world but because it is at the point of reproduction that the dehiscence of black aesthesis emerges.

We begin by parsing the concept of reproduction, moving through its classic articulation in Marxist feminism to its expanded theorization within black feminism. At stake is the racially gendered anteriority which is constitutive of black femininity and which can only be fully apprehended through an exposition of what I term the *double bind of reproduction*. In short, black femininity is conscripted not only in the (re)production of the world but also its fugitive ulteriors. This critique of the racially gendered valences of reproduction serves to elucidate an anteaesthetic critique of form—for it suggests that the womb of the black feminine is not one form (of abjection) among many but rather the vestibule through which all forms must pass, and not least where form appears shorn of the traces of passage. Black femininity bears the modern world of forms and the form of the modern world.

Reproduction is a term with a diverse and complicated modern history, generally invoked with pronounced biological inflections.[44] Although some would insist upon tracing a theoretical genealogy back to Karl Marx's *Grundrisse* (1857–58) and *Capital*, vol. 1 (1867),[45] the application of the concept of reproduction to a critical theory of labor is generally attributed to the Marxist or socialist feminist interventions beginning in the 1970s.[46] These Marxist feminist theories of social reproduction critiqued what they viewed as an analytical lacuna within Marxist theories of value and capitalist development, pointing to a gendered division of labor under patriarchal capitalism that found expression in the distinction between production and reproduction. Beginning largely from the experience of "housewives" in Europe and the United States, this Marxist feminist critique emphasized the gendered concealment and devaluation of labor outside the formal workplace. Against the traditionally narrow Marxist view of the factory floor as the point of production or the site for the extraction of surplus value from (male) workers, Marxist feminists argued that by establishing power over and exploitation of women's reproductive labors (whether physical, biological, sexual, or affective), the patriarchal household became integral to capitalist accumulation and ideology.[47]

Although this Marxist feminist tendency had the virtue of developing an analytical and political vocabulary for critiquing a (particular) gendered division of (re)productive labor, the conceptual pillars of this analysis come apart as it approaches the problematic of black femininity.[48] As black feminist thinkers such as Angela Davis were quick to point out, the experience of the gendered division of (re)productive labor within predominantly white working-class households can hardly be analogized with the racially gendered (re)productive regime that obtained under plantation slavery (a regime in which white women were deeply implicated, including as slave owners).[49] Nor could the gendering of labor on the plantation be analogized with that gendered division of labor that obtained between the white household and workplace, for enslaved women were "also there in the fields, alongside the man, toiling under the lash from sun-up to sun-down," while also performing reproductive labor within their quarters. Furthermore, for enslaved women, all the "protections" or "privileges" conventionally associated with femininity or maternity were entirely denuded.[50] Under the racially gendered regime of (re)production on the plantation, "the black woman had to be annulled as woman," establishing her instead "as a female animal," whose biological abstraction and racial subjection would be consolidated through the violent "act of copulation," figured as the sign of bestialization.[51] Moreover, after the nominal abolition of slavery, black women did in fact often work for wages, frequently performing various forms of reproductive labor within white households. Crucially, Marxist feminism's failure to meaningfully diagnose the problematic of (re)production that confronts black femininity is not merely due to an insufficiently capacious historical and geographical analysis; rather, the failure is a function of presuming the universality of gendering and the unitary character of the category "woman."

What is most important for our purposes here is not the racial elisions of Marxist feminism, but rather how we might draw out the implications of a particular constellation of black feminist insights on race, gender, and reproduction for a theory of anteaesthetics. For the bearings of black femininity have significant implications for the critique of form—across the registers of both reproduction and invention. Attending to the bearings of black femininity, whose subtensions stretch from modern personhood to civil society as a whole, furthermore reveals these dispensations as aesthetic forms. Jennifer L. Morgan, one of the first historians to write a sustained

and systematic monograph on the entanglement of gender and reproduction under modern racial slavery,[52] observes that "Atlantic slavery rested upon a notion of heritability. It thus relied on a reproductive logic that was inseparable from the explanatory power of race."[53] Juridically codified in the State of Virginia's Act XII of 1662, the racial heritability of enslavement followed the logic of *partus sequitur ventrem*—"children to follow the condition of the mother,"[54] "or, literally, 'offspring follows belly.'"[55] The absolute pervasiveness and quotidian nature of sexual violation on the plantation—which was not only ruthlessly instrumental to a political economy predicated on the expanded reproduction of laboring property but also an expression of the diabolical libidinal economy of antiblackness—was implicit and foundational to the legislation of partus sequitur ventrem. For "if a child fathered by a free white man with an enslaved African woman became a slave, that child was transformed from kin to property."[56] The dictate of partus sequitur ventrem became a crucial means of fixing the demographic indeterminacy of racial blackness, thereby consolidating the order and imperatives of slavery.

Hardly just one dynamic among others, "all manner of relationships and affiliations in the early years of the colony were reshaped by the tortured logic of the race/reproduction bind."[57] Following Alys Eve Weinbaum's use of the term, I understand race and reproduction to be inextricably bound within and to the modern episteme in ways that are neither apart from nor formally reducible to the biopolitical imperatives of the plantation.[58] That is, the singularity of this "race/reproduction bind" is not historically confined to the era of formal slavery. As Dorothy Roberts declares in her classic study of the history of the racial regulation of black maternal reproduction in the United States, "*reproductive politics . . .* [are] *inevitably . . . racial politics.*"[59] Neither are the imbrications and implications of this racially gendered problematic of reproduction peculiar to the Americas. As Françoise Vergès argues, modernity itself, in its globalized dimensionality, has been built upon the "plundered wombs of black women."[60]

In *Anteaesthetics*, I am concerned with how this coerced reproductivity may be theorized not only as a historical predicament but as a metaphysical problematic which finds myriad surreptitious expressions within the racial regime of aesthetics and across its aesthetic forms. That is, I am concerned with how the conscription of black feminine reproductivity subtends and sustains the ontology of the world, the modern aesthetic order, and the life

of form, as well as their dehiscent anterior. To fully attune to the permutations and significance of black feminine reproductivity, we must first unsettle the assumptive logic that would index this reproductivity through the figure of "the black woman" that the modern representational order would mendaciously present to us. Black feminism offers a salient critique of the presumption of gendering as a unified or self-evident process. For Hartman, theorizing the gendered violence of racial slavery and its afterlife requires grappling with "the divergent production of the category woman."[61] Hartman asks, "What happens if we assume that the female subject serves as a general case for explicating social death, property relations, and the pained and punitive construction of blackness? . . . How would woman be cast in this process?"[62]

In anticipatory dialogue with Hartman, Hortense Spillers begins her extraordinary essay "Mama's Baby, Papa's Maybe" from the "materialized scene . . . of female flesh 'ungendered' . . . [in order to extend] a praxis and a theory, a text for living and dying, and a method for reading both through their diverse mediations."[63] Descending into the "interminable catastrophe" of the Middle Passage and its aftermath,[64] Spillers marks a crucial distinction between the normative "gendering" that "takes place within the confines of the domestic" and the "ungendering" borne by the black diaspora during and in the wake of transatlantic slavery, which "contravenes notions of the domestic"[65]

> in the historic outline of dominance, the respective subject positions of "female" and "male" adhere to no symbolic integrity. . . . Those African persons in "Middle Passage" were literally suspended in the oceanic . . . removed from the indigenous land and culture. . . . These captives, without names their captors would recognize, were in movement across the Atlantic, but they were also *nowhere* at all. . . . They were the culturally "unmade," thrown in the midst of figurative darkness that exposed their destinies to an unknown course. . . . Under these conditions, one is neither female, nor male, as both subjects are taken into account as *quantities*. . . . [In short,] the sociopolitical order of the New World . . . [is such that] we lose at least *gender* difference *in the outcome*, and the female body and the male body become a territory of cultural and political maneuver.[66]

Although it is a common practice to read Spillers's concept of "ungendering" as theorizing black interdiction from the semiotics of gender difference that

adhere to the ontology of the modern world (which it most certainly is), I would suggest that reducing ungendering to this interdiction alone is insufficient to explain her turn to black "female flesh ungendered" as "a praxis and a theory, a text for living and dying, and a method for reading both through their diverse mediations." That is, ungendering is also a gendering—an (un)gendering.[67]

Taking up the paradoxes that necessarily obtain to (un)gendering, Zakiyyah Iman Jackson argues that "raciality arbitrarily remaps black(ened) gender and sexuality, nonteleologically and nonbinaristically, with fleeting adherence to normativized heteropatriarchal codes."[68] I would certainly agree with Jackson that (un)gendering does not adhere to heteropatriarchal codes of gender and sexuality and, moreover, that these codes are fundamentally insufficient for reading the singular semiosis of (un)gendering. Jackson emphasizes gendering as a modality of humanization[69] (with the latter process understood as a violent "inclusion into a racially hierarchized universal humanity"[70]). However, *Anteaesthetics* stresses a crucial distinction between two recursive moments within the reproductive life of (un)gendering. These two recursive moments—the (un)gendered reproductive labors undergirding the enfleshed existence of blackness and the dissimulative appearance of the black (feminine) 'body'—together comprise a disjunctive entanglement. The concept of (un)gendering, as deployed in this book, certainly traces the dissimulation of gendered figurations that function as stratagems for alternately negating or effecting the semblance of "black humanity." However, (un)gendering also cannot be divorced from the quality and distribution of the (re)productive labors of blackness in its (dis)placement before the world, and, crucially, from the ways these enfleshed labors are violently conscripted by the aesthetic.

It must be emphasized that, notwithstanding the dissimulation of the black feminine 'body' as phenomenological feint, neither the flesh nor the 'body' of black femininity, to differentially reprise Spillers's formulation, "adhere to . . . symbolic integrity." This makes the work of parsing the fleshly and dissimulative registers of coerced black feminine reproductivity exceedingly difficult but no less necessary. I should also make clear that when I speak of the bearings of black femininity, I am speaking of a material-discursive reproductivity that black women bear but which precedes and exceeds the myriad figurations of black womanhood. That is, my phrase "the bearings of

black femininity" extends "an altered reading of gender"[71] that theorizes a reproductivity whose distributions are at once diffusive and radically uneven and that cannot be neatly mapped onto any discrete representational form or putatively individuated "identity." Furthermore, it is a reproductivity that can be deconstructively traced but not indexed. This premise will guide us over the course of *Anteaesthetics* as we trace the bearings of black femininity through the works of artists such as Mickalene Thomas and Sondra Perry, as well as Glenn Ligon, but also those of Théodore Géricault and Jean-Auguste-Dominique Ingres, which would appear to be far removed from the black feminine.

The (re)productive imperative of (un)gendering, illuminated by Spillers's inimitable reading of the (unfinished) cataclysm of the Middle Passage, can be most clearly discerned through the constitutive entanglement of plantation slavery and the womb of black femininity. There is no doubt that modernity is marked by the onset of new biopolitical and heteropatriarchal regulations of the biological reproductive capacities of groups variously gendered as women.[72] However, the conscription of black feminine (re)productivity under slavery is completely without analogy, for as Morgan contends, not only was it impossible for the enslaved to lay claim to the private domesticity of the household, but the material and symbolic (re)productive labors of the enslaved were foundational to the making of the modern household[73]—even more pointedly, that of the *oikeios*, the ontological terrain in which the modern subject would stake a dwelling. It is in this sense that *bearings* assumes an orientative valence—that which is borne, that which is endured by the black feminine is also that which allows the modern subject to find his or her bearings in the world.

The singular conscription of black feminine (re)productivity was and remains part and parcel of the architecture of the world, a matter we turn to explicitly in chapter 5. Partus sequitur ventrem was a blueprint for a world in which those who were made to give life to its designs had no place in its plans. Here the gendered significance of Édouard Glissant's figuration of the hold of the slave ship as "the belly of the boat," the boat as "a womb abyss"—a belly which "dissolves you, precipitates you into a nonworld from which you cry out," a womb abyss which "expels you"—comes into full view.[74] Hartman and other black feminist theorists help us to read the displacement of gender back into Glissant's agonistic formulation: the (re)productive imperative

singularly borne by black femininity in its ceaseless conscription before the world is a womb abyss. For as "enslaved women's reproductive capacities are rendered as violent conduits of human commodification," so too was "a kinlessness born in a woman's womb."[75] The black maternal womb became a singular site of violent passage, of (dis)possession and (un)making, leaving every black child irrevocably "touched . . . by the mother."[76] In chapters 2 and 3, I argue for the centrality of touch in demarcating the boundaries, expulsions, and reproduction of the corporeal division of the world. Throughout the book, touch becomes a critical concept in the elaboration of a theory of the racially gendered dynamics of black mediality—of being taken for (another's) medium.

Womb Aesthetics and the Double Bind of Reproduction

The political philosopher Joy James makes a powerful case for the importance of art in the world's conscription of black feminine (re)productivity. For James, the world continues to depend upon the (re)productivity of the "Captive Maternal" not merely in a pecuniary or biopolitical sense but in the ongoing maintenance of an episteme.[77] In James's conception, "Western Theory" is "Womb Theory," that which requires the "Captive Maternal" to marry "democracy with slavery."[78] Within this regime, "art presents a bridge between irreconcilable interests. Yet it, too, is influenced by Womb Theory."[79] James's intervention is indispensable for the project *Anteaesthetics* undertakes, which endeavors to explicate the aesthetic transits between womb and world. These transits constitute not only the condition of possibility of but an implacable problem in and for (aesthetic) form. In the context of the argument made in *Anteaesthetics*, I insist that the racial regime of aesthetics is a *womb aesthetic*—indissolubly bound to and endlessly reinscribing the forced (re)productivity of the black "Captive Maternal" but also thereby (re)generating that maternal's potential "to fracture the Western womb."[80]

James's allusion to the fracturing potential of the captive maternal pertains to what I theorize as the double bind of reproduction that distinguishes the bearings of black femininity. Here we might recall, revise, and extend Angela Davis's assertion that enslaved women were not only "thrust by the force of circumstances into the center of the slave community . . . [as] essen-

tial to the survival of the community" but also rendered "uniquely capable of weaving into the warp and woof of domestic life a profound consciousness of resistance."[81] For Davis, the reproductive impositions on the enslaved woman were paradoxically or, rather, dialectically entwined with her role as "the custodian of a house of resistance."[82] In an appositional vein, I want to suggest that the bearings of black femininity are bound not only to the (re) production of the world but also to the (re)production of the fugitive impulse that animates black socialities and artistic practices that move in flight from the world. The dehiscent force of black feminine (re)productivity traces the sharp edge of black invention, while the compulsory suturing of metaphysics, to which this force is tethered, is what ultimately ensnares this invention in and as form. The inescapable bearing of both the world and that which moves in flight from the world is the double bind of reproduction. One of the questions *Anteaesthetics* seeks not to answer but to descend with is, What might be withheld even from the project of escape?

The question of withholding is bound up with the doubled violence of a racially gendered interiorization, for which the black maternal womb is the nexus. In Morgan's view, *terra nullius*, an essential teleology within (settler) colonial slavery, "came into cartographic focus precisely because of [the enslaved woman's] interiority, the contained and private transformation happening inside . . . [the black maternal] body that produced a New World space of racial inheritance and geographical dispossession."[83] Moreover, these racial-colonial processes were essential to "the production of the aesthetic experience of interiority."[84] As Denise Ferreira da Silva shows, the modern (white/settler) subject is predicated precisely upon the codification of this interiority, in and as self-determination, as its exclusive and defining property.[85] The violently deindividuated, fleshly interiorization which is imposed upon the black maternal is anterior to and the very condition of possibility for the jealously guarded, individuated interiority of the self-possessive subject. The dynamics of this anteriority are crucial to all the subsequent anteaesthetic readings of art that this book undertakes: the violent interiorization of the black maternal, her conscripted womb is here forcibly rendered the fleshly medium for the making and conquest of a new world predicated on both genocidal (dis)possession and the obversely related bestowal and interdiction of subjective interiority. Indeed, the womb of the black maternal is made the medium for the (re)production of the very distinction between

interior and exterior and, as I argue later in this chapter, for the exterioriza-
tions of the human so central to the conception of technics in media theory.
In M. NourbeSe Philip's poetic formulation,

> *"Dis Place"*: the result of the linking of the inner space between the legs with
> the outer space leading to "dis placement." *"Dis Place"*—the space between.
> The legs. For the Black woman "dis placed" to and in the New World, the inner
> space between the legs would also mutate into *"dis place"*—the fulcrum of the
> New World.[86]

The implications of Philip's poetics for "black feminist geographies" have
been rigorously thought through in Katherine McKittrick's work.[87] McK-
ittrick reads Philip alongside Harriet Jacobs, whose slave narrative famously
described her pursuit of a "loophole of retreat" from the sexual and filial vio-
lations of slavery by hiding in "the last place they thought of."[88] McKittrick's
analysis prompts a consideration that perhaps it is precisely the geographic
irresolution and indeterminacy of such "not-quite places" where the diffi-
cult inhabitations of the "captive women's community" are to be found.[89]
Anteaesthetics is an extended rumination on the violent interiorizations of
black maternal reproduction, these "not-quite places" of retreat, and ante-
aesthetic practices that inhabit the negative underside of both worldly enclo-
sure and otherworldly flight.

For the argument I make in *Anteaesthetics*, there are six signal proposi-
tions I would reiterate from the foregoing excursus into the bearings of black
femininity. First, the bearings of black femininity assume a tripled valance:
simultaneously evoking the reproductive, the orientative, and that which
must be endured. Second, black feminine/maternal (re)productive labor is
coercively extracted not merely for economic, affective, or biological ends
but for the making and remaking of worldly ontology. Black femininity/ma-
ternity is "the belly of the world" and of the world as an aesthetic project; it
is the world's vestibularity and abyssal limit, everywhere subject to captiv-
ity. However, though I make recourse to the idiom of labor, I do so with the
knowledge that, as Hartman avers, "the category of labor insufficiently ac-
counts for slavery as a mode of power, domination and production," even as
"reproduction is tethered to the making of human commodities and in ser-
vice of the marketplace."[90] Nor is value a sufficient idiom for what the world
extracts from black feminine (re)productive labors, even as these labors, as

I argue in chapter 5, are value's condition of (im)possibility. Indeed, Jessica Marie Johnson theorizes the "null value" which is given in the inevitable failure of the obsessive quantifying logic of racial administration, as in the "empirical silence" of the "imperial archive."[91] The exhaustion of language, however, is not the same as theoretical impasse. *Anteaesthetics* is precisely an endeavor to attend to practices that inhabit the "not-quite places" where language and, crucially, the language of form ultimately fail us.

Third, the bearings of black femininity signal a (re)productivity whose distributions cannot be conflated with the dissimulative appearance of the 'black feminine body' even as they undergird that appearance. It is a reproductivity that can be deconstructively traced but not indexed within the order of representation. Fourth, black feminine (re)productivity subtends not only the racial regime of aesthetics and the antiblack metaphysics it works to suture but also the fugitive valences of black experimentation—the very social and artistic practices that would fashion an exodus from the antiblack world. This is the double bind of reproduction. Fifth, the (re)productivity to which black femininity has been violently subjected is also bound to a deindividuated, fleshly interiorization that is anterior to the conceits of self-possessive interiority and its concomitant exteriorizations. Because this black feminine interiorization is radically disjunctive with the idiom of the self-determined subject and any extant articulation of interiority, what is withheld in and from this interior approaches the register of the speculative. What is withheld is an interminable recession that is barely legible as flight or subversion. Sixth, as the singular (re)productivity of black femininity unfolds from and enfolds within an irreducibly fleshly existence, we must take care to distinguish this vertiginous corporeality from the concomitantly reviled and exalted stratagem—the body—that would aspire to subordinate or transcend its fleshly anterior. For the body emerges only through the putative disciplining of flesh.[92]

The following sections of the chapter iteratively interrogate the modern corpus and its persistence even in contemporary strands of thought that would nominally disavow or deconstruct it. I argue that the modern body is principally a racial apparatus. Moreover, I suggest that the racially gendered reproductivity of blackness is anterior to the racial apparatus of the body. The enfleshed labors and dissimulative appearances of blackness are

the body's conditions of (im)possibility. It is in the cut of this coerced repro-
ductivity, which is before the (modern) body, that black aesthesis emerges.

The Modern Body and The Bodily Turn

The history of modernity is the history of the body. The philosopher Jean-
Luc Nancy goes so far as to declare the body the exclusive invention of West-
ern civilization, "our old culture's latest, most worked over, sifted, refined,
dismantled, and reconstructed product."[93] *Hoc est enim corpus meum* (this
is my body), Nancy tells us, "displays the body *proper* . . . or Property itself,
Being-to-itself, *embodied*."[94] In *Corpus*, he writes: "The anxiety, the desire to
see, touch, and eat the body of God, to *be* that body and *be nothing but that
body*, forms the principle of Western (un)reason. That's why the body, bodily,
never happens least of all when it's named and convoked. For us, the body is
always sacrificed: eucharist."[95] In Nancy's text, which elliptically traverses
the ontological paradoxes that obtain to the modern body, the Eucharist
marks an uncertain materiality and ideality which distinguishes the body
Nancy claims as Europe's unique inheritance—for him, an enigmatic coil
of anxiety and assurance, penitence and exaltation, openness and closure.

Even as the enduring, if iterative and variegated centrality of the body
to the libidinal, discursive, and political economies of the modern world can
hardly be disputed, it has become increasingly difficult to pin down exactly
what the body is or is meant to signify and for whom. The body which has
formally predominated in the philosophical treatises, juridical codes, and
economic models of the West since the seventeenth century is that which
Nancy terms the body proper, largely shorn of the ambivalence and declen-
sion Nancy finds so alluring. As Ed Cohen has argued, this proper body is a
quintessentially modern invention, the gravitational center and scalar de-
limitation which grounds regimes of property and personhood:

> The modern body aspires to localize human beings within an epidermal fron-
> tier that distinguishes the person from the world for the duration which we
> call a life. . . . The modern body proffers a proper body, a proprietary body, a
> body whose well-bounded property grounds the legal and political rights of
> what C. B. Macpherson famously named "possessive individualism."[96]

Although this proper body has been placed under far more pronounced scrutiny since the tail end of the twentieth century, there are of course many distinctive and long-standing theoretical traditions, too rich and numerous to review here in more than the most cursory manner, that have emphasized different historical dimensions of and different modalities for approaching this body's constitutive role in the making of modernity. Marxism has tended to foreground capitalism's reduction of the body to "accumulation strategy," whether as the vessel for "the capacity to labor" or as the vehicle for "productive consumption."[97] Foucault stressed the disciplinary making of "docile bodies" within a new "machinery of power" in which the body becomes the site of subjectification in the interest of both economic utility and political obedience.[98] For Freud, the ego—that dimension of the human psyche encountered as a "self" or "I" and thus a condition of possibility for modernity's regime of individuated personhood, even as the ego cannot be simply conflated with subjectivity—is "first and foremost a bodily ego"[99] founded in the relation between the subject's body and others. As Patricia Ticineto Clough recapitulates, in Freud's conception the subject's inherent "drive to mastery" necessitates the preservation of the bodily ego through various mechanisms of "disavowal or management of the threat to the ego's definition or boundaries."[100]

Across the Marxist, Foucauldian, and Freudian registers for thinking the modern body, it is clear that this is a body which, for better or worse, must be made "well-bounded property," a body which emerges through an ontological localization that pivots upon the pretense of a subject with the capacity for "*Property* in his own *Person*," in John Locke's notorious phrasing.[101] Of course, although the coterminous fabrication of the proper body and the self-possessive individual was ultimately dressed in the liberal rhetoric of universalism, one need only glance at the tears in this discourse to know that its garb conceals another corpus. Indeed, the very discomfiture that some cannot help but feel when passing over Cohen's words "epidermal frontier" signals the unbridgeable chasm between the subject who imagines himself the possessor (of self, of earth, of things, of others) and she who has been taken as the object of—or more precisely, as the medium for—this brutal imagination, who forever bears the trace of being owned upon her skin. In other words, both the proper body and its necessary analogue, the

self-possessive individual, are products of a decidedly racial mode of subjectivation and subjection.

If the proper body has always rattled with the uncertainties and writhed within the vastness of its own denomination, these convulsive movements multiplied in number and intensity as the new millennium approached. Indeed, Nancy is not alone in turning toward the body as a uniquely dynamic site for contemporary philosophical inquiry. The philosopher's oeuvre must be considered alongside what we may call the "bodily turn" of the latter decades of the twentieth century, in which "the body" has become the discursive meeting ground for an unwieldy multitude of concepts and debates, affects and afflictions, conflicts and contestations, the distinctive expressions of which span not only the arts, humanities, social sciences, and natural sciences but perhaps the whole of civil society.[102]

Within the university, the problematization of "the matter of bodies," to borrow Judith Butler's doubly inflected phrase, has been especially pronounced.[103] Hardly restricted to an idiosyncratic area of specialized interest, what I am referring to with the necessarily imprecise language of the "bodily turn" names an increasingly intricate and widespread tending toward the corporeal within the academy, one which is implicated and reflected in a series of other theoretical pivots, from the "affective turn" to the "biopolitical turn," or to the "more general materialist turn" as the proponents of new materialism would have it.[104] In short, in recent decades the hegemony of the proper body appeared to give way, at least within the intellectual formations which lay claim to theory within the humanities, a development which in turn cannot be separated from the complex reorganizations of knowledge and power within and beyond the university, particularly in the wake of the minority insurgencies (to borrow Roderick A. Ferguson's language) of the last third of the twentieth century.[105] Within the humanities, the most notable feature of the bodily turn has been the epistemic unsettling and/or diversification of the presumptive ontic status of the body—what Butler refers to as "the body posited as prior to the sign"[106]—and the complex materiality in which every process of signification is constitutively co-implicated. As Judith Farquhar and Margaret Lock recount in their introduction to their anthology *Beyond the Body Proper: Reading the Anthropology of Material Life*:

In fields ranging from anthropology to literary studies, history to political science, researchers expanded the classical social science concern with either minds or bodies, meanings or behaviors, individual bodies or the body of the social to focus on a new hybrid terrain, that of the lived body. Seen as contingent formations of space, time, and materiality, lived bodies have begun to be comprehended as assemblages of practices, discourses, images, institutional arrangements, and specific places and projects. . . . Recent scholarship in the human sciences, led perhaps by gender, ethnic, and rights activism in postmodern popular culture, has turned away from the commonsense body . . . learning to perceive more dynamic, intersubjective, and plural human experiences of carnality that can no longer be referenced by the singular term *the body*.[107]

Notwithstanding the obvious diversity of this intellectual movement within the university, the sheer volume of critical academic interrogations of the "proper" or "commonsense" body, at least within the humanities, would seem to suggest that the injunction to move "beyond the body proper" has become so ubiquitous that, ironically, it has begun to assume the features of a new common sense, to use the Gramscian idiom.

A substantive review of the bodily turn's diverse theoretical contestations, reconsiderations, or refusals of the marginalization, displacement, subordination, and disarticulation of corporeality within Western philosophy by feminist theory, posthumanism, postcolonialsim, transgender studies, disability studies, women of color feminisms, and native studies is beyond the scope of this book. At present, one of the more prominent tendencies within these critical theorizations of corporeality has been that which Stacy Alaimo and Susan Hekman have dubbed "materialist feminism," a broad category of intellectual affiliation by which they situate the work of scholars such as Donna Haraway, Elizabeth Grosz, and Karen Barad, among others.[108] Materialist feminism, in Alaimo and Heckman's account, is figured as a refusal and supersession of "postmodern feminism," the latter designation encompassing poststructuralist feminist philosophers from Luce Irigaray to Judith Butler. While granting the important contributions of "postmodern feminism" to the deconstruction of the gendered dualisms and de/valuations that undergird Western thought—such as mind and body, nature and culture, subject and object, rational and emotional, and so forth—Alaimo and Heckman nonetheless claim that "postmodern feminism" in its rejection of reductive materialisms has effectively "retreated from the material" by priv-

ileging the textual, linguistic, and discursive over all else. In contradistinc-
tion, a materialist feminism would insist upon the immanent imbrication of
matter and meaning, upon the "material-discursive" or "material-ideal," as
Barad and Grosz have respectively termed it.[109]

Whether this characterization of thinkers such as Irigaray and Butler
is fair or useful—given that each has also explicitly endeavored to theorize
at the nexus of materiality and discursivity, albeit by different means and
repertoires—is beside the point for my purposes here. Each tendency, if they
should indeed be construed as such, is implicated in the broad theoretical
movement toward the corporeal as a singularly dynamic site of epistemic
rupture or innovation, of ethical solicitation, and of political possibility,
a movement which is differentially inflected across a myriad of fields and
formations not only feminist philosophy but queer theory, transgender
studies, affect theory, posthumanism, and performance studies, among
many others. Importantly, what is at stake for *Anteaesthetics* in these debates
is the racially gendered corporeality of blackness, the disjunctive weave
of bodily dissimulation and enfleshed existence, which are made to come
before the (proper) body and the recent bodily turn.

Before the Bodily Turn

For Nancy, the "body proper" is incessantly figured and refigured in West-
ern modernity, but it cannot be said to exist.[110] In fact, every effort to place
the body proper on display is instantly confronted with the "foreign body,"
the body estranged from itself, confronted with the agony or ekstasis of its
own "in-finity," of being in the *open* space" of its own making.[111] Thus, he
suggests, the body does not so much have an ontology as it is ontology—
the "incorporeal touch" of existence, of "being-with," of "being born unto
the world."[112] Hence Nancy declares the body itself as "something *stranger*
than any strange foreign body."[113] It is this former body, this "absolute body,"
given only in touch, which holds out "the true question of an *aesthetics*,"
just as it is that toward which "all our aesthetics tend."[114] Meanwhile, the
"strange foreign bodies" of the non-Westerner appear "unacquainted with
disaster," unfamiliar with the corporeal estrangement that would seem to
be the condition of possibility for genuine touch—the "spacing of bodies"
which, for Nancy, enables an endless series of departures and enfoldings.[115]

Of course, the "strange foreign bodies" invoked in Nancy's idiomatic no-menclature (those "endowed with Yin and Yang, with the Third Eye, the Cinnabar Field and the Ocean of Qi") are tightly circumscribed by their problematically Orientalist register.[116] These bodies, not yet subject to the fall, remain immersed within "a single, empty, unfeeling sense," to which Nancy nevertheless ascribes an Edenic cast: "bodies liberated-alive, pure points of light emitted entirely from within."[117] The black bodies of Africa and its diasporas, meanwhile, are categorically barred from consideration al-together, unable to even approach the appellations of "strange" or "foreign." In effect, Nancy insinuates that the "Eastern" others of Europe remain im-mersed in a simple materiality of corporeal immediacy, impervious to the wonders and torments of interiority and relation, while black corporeality implicitly becomes what Hortense Spillers terms "the zero degree of social conceptualization,"[118] or the improper body par excellence.

I argue that this racial division of corporeality, an axiomatics of which Nancy's work is exemplary rather than exceptional, is, in the first instance, an aesthetic rather than an epistemological operation. I engage with Nancy specifically because, for many, his labyrinthine deconstruction of the proper body could appear to be an epistemic implosion of the corporeal figuration that is the synecdoche of the (white/European) self-determined subject of modernity and even a philosophical intervention that opens pathways for thinking corporeality beyond reifications of "identity." When read through Denise Ferreira da Silva and Calvin Warren's critiques of the modern human subject and its genesis, however, what Nancy's unapologetically Eurocen-tric meditations inadvertently disclose are the ways in which philosophical inquiries and aesthetic practices that begin from the departure from the proper body—whether through expositions or valorizations of being-in-relation, the porosity of borders, corporeal fragmentation, the body as loss or supplementarity, and even the deconstruction of the nostalgic fantasy of a prior wholeness—risk reinscribing that very same figuration by eliding the ontologically negated improper body, which bears the racial and gendered violence of the former's displacements.

In her indispensable excavation of the racial genealogy of the modern subject and the ontoepistemological structures of modernity, *Toward a Global Idea of Race*, Denise Ferreira da Silva argues that modernity's "arsenal of raciality" establishes "distinct kinds of human beings, namely, the self-

determined subject and its outer-determined others."[119] Within the field of modern representation, the former figuration posits the (white) post-Enlightenment European as the exclusive subject of history, while the latter figuration consigns "the others of Europe" to subjection before "the exterior determination of the 'laws of nature' and the superior force of European minds."[120] The figure of the black, inextricable from the ontoepistemological depredations of slavery, constitutes modernity's paradigmatic fabrication of affectability—absolutely open to determination from without, a (no)thing to be used, moved, shaped, and dispensed with by divine or natural law and the will of the self-determined subject.[121] However, the inescapable fact of corporeal existence and the ungainly surfeit of material and psychic entanglements such existence necessarily entails naturally positioned the body as an enduring intellectual problem and site of anxiety for the philosophical elaborations of the putatively self-determined subject.

Thus, the Cartesian dualism of body and mind—or of a thinking substance (*res cogitans*) from an extended substance (*res extensa*)[122]—was a necessary step in the effort to establish "the ontoepistemological primacy of *interiority*" in the restrictive sense of the rational, self-determined mind.[123] This maneuver of interiorization, as we have seen, is subtended by another—namely, the reproductive scene of black feminine violation. Here we see how the claim upon interiority is accomplished through the denigration and exteriorization of the body, lest corporeality's obdurately material/sensible affectability shatter the fragile artifice of the self-determined subject.[124] Nevertheless, "because man neither is nor exists without his body, exteriority would remain a ghost haunting every later refashioning of self-consciousness."[125] Raciality has been the principle means not of resolving but rather of displacing the contradiction produced in the fabrication of a putatively self-determined subject who must serially disavow the very corporeality which is the condition of possibility for existence. The proper body, in other words, requires the racial cipher of what Calvin Warren terms "improper bodies," the latter term acquiring a singular valence when it approaches the threshold of blackness and the demarcations of corporeality in the wake of transatlantic slavery.[126]

The point I wish to emphasize here is that it is precisely the brutally imposed corporeal immediacy of the improper body which enables the very idea of difference as separation[127] upon which both the proper body and the

irresolute flights from it ultimately depend. The improper body of black en-fleshment is not so much missing from or neglected within the bodily turn but is rather before the bodily turn—at once vestibular to its deconstructions and subject to its racial reinscriptions. But what if we refused to begin with the proper body, even to depart from it? How, as Warren urges us to ask, "does one *think* with the improper? With what grammar do we ascertain the universe of sensations, pleasures, eroticism, and enjoyment without a proper body?"[128] This book contends that these are singularly aesthetic questions, or, more precisely, questions which must begin from black aesthesis and its gendered (re)productions rather than from the racial regime of aesthetics, especially as the latter comes to cloak itself within discourses of alterity.

Within the bodily turn, such fabrications of alterity are often advanced in the name of refusing the elisions, disavowals, or subordinations of corporeal entanglement that are replete in Western philosophy. Here the proper body, its ontic subterfuge of property and propriety appears the victim of its own displacements, assailed by a growing number of investigations into and celebrations of corporealities which are porous, affectable, malleable, or experimental, which are sensuous becomings or encounters with uncertain boundaries between self, other, and world. The body tends to emerge instead as a question, which, more often than not, takes the rhetorical form of "What can a body do?"[129]

And yet, almost without fail, when the speaker of such a question gazes toward black corporeality, the theoretical and aesthetic openness of this Spinozian-Deleuzian query—for which "the body is not a thing, even an extended thing . . . [but rather] a process of encounters"[130]—immediately closes up, and we are left with the Fanonian echo chamber (Look! A Negro!).[131] The declension from potentiative question to phenomenological injunction should prompt us to take heed of a rather glaring disjuncture: that while the rhetorical trope *black bodies* has become so utterly ubiquitous in both critical academic and left-progressive political spheres that it is almost impossible to avoid within the English-speaking world,[132] the bodily turn has almost completely refused to engage blackness as a serious theoretical problematic for "moving beyond" the proper body. The bodily turn's failure to escape "the relentless desire to pursue the black body . . . as an object of inquiry" has been astutely critiqued by Tiffany Lethabo King and Katherine McKittrick, among other black feminist theorists.[133] This desire has largely reflected a

"racialized erotics"[134] (King) and the enduring "ideological currency of dis-possessed black bodies" [135] (McKittrick) rather than a genuine interest in the constitutive imbrications of raciality and embodiment within the modern world.

I am not suggesting that the burgeoning interdisciplinary work on bodies, embodiment, and corporeality which comprises the bodily turn lacks richness or depth or that it has failed to advance crucial theoretical contributions to something like "moving beyond the proper body."[136] What I am suggesting is that the irreducible problematic of blackness and the body has been thoroughly provincialized within the bodily turn at the very same time that critical academic and left-progressive political spheres have come to rhetorically conflate black people and 'black bodies.' This conflation is neither coincidental nor paradoxical but rather symptomatic of the conjunc-tural modulation of an enduring discursive regime. This discursive regime is, in turn, embedded in a more general racial-corporeal organization of mo-dernity that precedes the contingencies of historical conjuncture. Reckoning with blackness as an existence that is irreducible to ethnographic locality, as an existence that is more and less than epiphenomenal to the emergence, reproduction, and deconstruction of the proper body effects something far more radical than an indictment of the epistemic and ethical limits of the bodily turn: it exposes the body itself as a racial apparatus; it calls us toward an irreducibly gendered descent into a black aesthesis, given in the absence of a body.[137]

The Body as Racial Apparatus

This book turns to the concept of apparatus in an effort to clarify and sub-vert the epistemic, aesthetic, and material racial violence which subtends not only the proper body but also many of the approaches—whether phe-nomenological, materialist, or psychoanalytic—that would critique and veer from the proper body without beginning from an interrogation of its quint-essentially racial foundations. We cannot begin to attend to the corporeal aesthesis of blackness and the diverse artistic experimentations that emerge from it without fundamentally reevaluating our conceptions of the body as such. This book principally regards the body as a racial apparatus, central to the emergence and reproduction of the modern world. By *apparatus*, I mean

something along the lines of that which has been theorized by Michel Foucault, Giorgio Agamben, and Karen Barad, iteratively and respectively, under the same denomination. While his use of the term is certainly multifarious and even unwieldy, Foucault's conception of the apparatus (*dispositif*) plays a central role in his theorization of biopolitics, as testified to by the discursive prominence it has assumed within the scholarship of the biopolitical turn.[138]

Elaborating on the concept in a 1977 interview, Foucault states that *apparatus* designates "a thoroughly heterogeneous ensemble consisting of discourses, institutions, architectural forms, regulatory decisions, laws, administrative measures, scientific statements, philosophical, moral and philanthropic propositions—in short, the said as much as the unsaid."[139] The apparatus, Foucault continues, may be conceived of as "the system of relations that can be established between these elements" or "the nature of the connection that can exist between these heterogeneous elements," which is also that which allows for the polyvalent figuration and functionality of the elements within the ensemble.[140] Crucially, the apparatus "has a dominant strategic function" in the modulation of life and politics, in the development, delineation, modification, stabilization, utilization, or repression of "relations of forces."[141] Hence, apparatuses are "always inscribed in a play of power," at once material and discursive but also conditioned by their own epistemic production.[142] Both explicating and expanding upon Foucault's conception, Giorgio Agamben throws the role of apparatuses in the making of subjects into greater relief. Agamben proposes "nothing less than a general and massive partitioning of beings into two large groups or classes: on the one hand, living beings (or substances), and on the other, apparatuses in which living beings are incessantly captured."[143] Subjects, Agamben suggests, may be understood as that social class "which results from the relation and, so to speak, from the relentless fight between living beings and apparatuses."[144]

Without adopting the letter of their respective frameworks and idioms, both Foucault's understanding of apparatuses as heterogeneous, productive, and contingent material-discursive formations that assume specific strategic functions within a play of power and Agamben's foregrounding of apparatuses as the fundamental means through which subjection and subjectivation take place are essential to my conception of the body as racial apparatus. It is worth emphasizing that this is not to suggest that the body is

merely discursive (to invoke the new materialist critique of the "radical con-structivisms" which are said to have eclipsed older materialist approaches, such as existential philosophy or structural Marxism, during the last quarter of the twentieth century). Here Karen Barad's conception of apparatuses within her "agential realist" approach to thinking the indissoluble "entan-glement of matter and meaning" affords a helpful clarification.[145] For Barad, "apparatuses are specific material reconfigurings of the world that do not merely emerge in time but iteratively reconfigure spacetimemattter as part of the ongoing dynamism of becoming."[146] They are "intra-active," material-discursive, "boundary-drawing practices . . . which come to matter," in the doubled sense of substantiation and signification. In other words, appara-tuses are at once "productive of (and part of) phenomena."[147]

To designate the body as racial apparatus is to unsettle the implicitly universalist premises of corporeal inhabitation that undergird phenomeno-logical being in (and of) the world. Black flesh exposes embodiment as a far more difficult ontoepistemological (and ethical) problematic. In her land-mark essay "Mama's Baby, Papa's Maybe: An American Grammar Book," Hortense Spillers theorizes one of the central cleavages of the modern world, wrought and sundered in the cataclysmic passages of racial slavery: that of body and flesh, which Spillers takes as the foremost distinction "between captive and liberated subjects-positions":

> Before the "body" there is the "flesh," that zero degree of social conceptual-ization that does not escape concealment under the brush of discourse or the reflexes of iconography. Even though the European hegemonies stole bodies—some of them female—out of West African communities in concert with the African "middleman," we regard this human and social irreparability as high crimes against the *flesh*, as the person of African females and males registered the wounding. If we think of the "flesh" as a primary narrative, then we mean its seared, divided, ripped-apartness, riveted to the ship's hole, fallen, or "es-caped" overboard.[148]

In my reading of Spillers, flesh is before the body in a dual sense: at once prior and subject to the body. As Zakiyyah Iman Jackson observes, the way Spillers situates flesh "has spatial as well as temporal significance."[149] On the one hand, as Alexander Weheliye stresses, flesh is "a temporal and con-ceptual antecedent to the body."[150] The body, which may be taken to stand for "legal personhood qua self-possession," is violently produced through

the "high crimes against the flesh."[151] On the other hand, flesh is before the body in that it is everywhere subject to the body as racial machinery, violently placed at the disposal of those who would claim the body as property. The body is cleaved from flesh, while flesh is serially cleaved by the body. To be clear, my intervention underscores each of these moments as spatiotemporal and recursively entangled. Yet flesh itself can neither be spatialized nor temporalized. Its existence has no cartography or genealogy, even as its labors undergird every map of the world and narration of history. The violent, excisive and projective rend(er)ing of body from flesh is anoriginary and ongoing, serial and diffusive.

Throughout *Anteaesthetics*, I deploy the term *rend(er)ing* as a neologistic means of stressing the violent rending of flesh that subtends every dissimulative rendering of blackness as phenomenological object or cohesive presence. There is an anticipatory echo of the digital artist Ed Atkins here, who observes that the concept of rendering "reeks of . . . the rendering of bones, and meat, and flesh." This semiotic trace, Atkins suggests, inheres in what the vernacular of editing would term the "cut," and signals "a symbolic order of violence that can't help but become manifest in the work itself."[152] Atkins's sustained interest in the banal horror of the expropriative displacements that make possible the myriad construals of existence within the modern order of forms—the body not least among them—has a deep philosophical intimacy with the inquiry undertaken in *Anteaesthetics*, even as this book dispenses with any pretense to existential universalisms. *Expropriative displacement* is also a formulation that warrants unpacking. By rhetorically conjoining expropriation to displacement, I mean to accentuate the functional coincidence and complementarity of two conceptual moments: on the one hand, the dispossessive extraction of enfleshed black labor by and for the world and, on the other, the requisite expulsion of this endlessly conscripted flesh from the metaphysics upon which the world stands. Because black flesh cannot appear within the world, even as it is anterior to every appearance, we can never truly index expropriative displacement but only recursively follow (in the wake of) its traces.

I theorize the body as racial apparatus in order to expose every phenomenological appearance of that corporeal figuration we call "a body" as an irreducibly racial and racializing operation. The serial (re)production of the proper body or the (always already failed) fantasy of self-possessive individ-

uation that comprises the basis of modern personhood can only be sustained through the serial (re)production of an ontologically negated racial double, the paradigmatic instantiation of which is the black. To theorize the body as racial apparatus is thus not only to understand the body "as an effect of arrangements of power"[153] but, further, to stress its strategic generativity within the material-discursive structuration of the world, its indispensability to the ongoing reproduction of subjectivity and subjection, whether the latter are thought through the registers of global capitalism, settler coloniality, or heteropatriarchy. As I elaborate over the course of the book, it is precisely the violent (im)mediations to which flesh is subject and, crucially, the conscripted (re)productive labors of black feminine flesh that enable the machinery of the body as racial apparatus.

To treat every instantiation of "the body" as the work of a racial apparatus, of course, poses a conundrum for a study which takes up the immanent relations between art and black embodiment. This is because black people do not properly have bodies, insofar as such "having" is in fact a linguistic concealment of a terrible claim: both to the presumptive ontic status of normative personhood and to the regimes of property and propriety to which the metaphysics of individuation are inextricably bound. Rather, black people are no-bodies, given to an enfleshed existence which the body as racial apparatus can neither escape nor completely subsume, as flesh constitutes the body's very condition of (im)possibility. To speak of black embodiment is thus to approach the limits of phenomenology for which the 'black body' can only appear as a dissimulation. These dissimulations are the face of the continued expropriative and projective displacements of the body as racial apparatus. And yet, insofar as the traces of the black enfleshed existence these dissimulations cleave (to) can never be completely eliminated, they are aporetic—constantly threatening to leave the metaphysics of presence this apparatus works to secure in ruins. Moreover, these dissimulations also mark, while not being reducible to, sites of black anteaesthetic experimentation, which both precede and exceed the body as racial apparatus, even as they are everywhere subject to the latter's violence. Moving toward the question of how to attend to black anteaesthetic experiments that run counter to established hermeneutic protocols requires lingering further with black critiques of phenomenology so that we might return to black aesthesis and its differential enfolding within an anteaesthetic register.

Theorizing Dissimulation

Blackness presents intractable problems for phenomenology as a philosophical tradition and analytic which takes the body as our "point of view in the world."[154] This book contends that phenomenology—which posits the body as the perceptual locus from which lived experience unfolds, from which things are regarded, from which the world coheres and to which the world is given—is unable to think the enfleshed existence of blackness that is the body's condition of (im)possibility. Hence, phenomenology is unable to think the black aesthesis which emerges in the absence of a body. Maurice Merleau-Ponty's phenomenology of the body has been especially influential in thinking at the nexus of aesthetics and corporeality since the publication of his two most canonized texts *The Phenomenology of Perception* (1945) and *The Visible and the Invisible* (1964).[155] Indeed, the "renaissance" his work has enjoyed since the turn of the twenty-first century[156] has stretched from film and media studies to art history, from queer theory to feminist philosophy and beyond.[157] In Merleau-Ponty's early canonical formulations, human experience is realized through the a priori possession and conjoining of a "body schema"—or the "inter-sensory" or "sensori-motor unity" of the body as it is emplaced within and opens onto the world—with a pre-logical "operative intentionality," a concept he borrows from Edmund Husserl to articulate the "intentional arc" toward the world with which the body schema is originally entwined, activated, and set in motion.[158] Hence, the body is not merely "one object among others" but rather the essential "vehicle of being in the world."[159] It is the body which "gives us a global, practical and implicit notion of the relation between our body and things, and our hold on them," which enables us to "grasp" the "world of objects."[160] The body, he intones, "is our anchorage in the world."[161]

Although Merleau-Ponty endeavors to depart from Cartesian dualism by characterizing the body as both object and subject, his conception of the body schema nevertheless requires the ontological segregation of human beings, with their innate capacity to be "body-subjects," from passive, unreflecting objects, or "the condition of a *thing*, the thing being precisely what does not know, what slumbers in absolute ignorance of itself and the world."[162] The original intentionality Merleau-Ponty reserves for such a body-subject indicates a classificatory operation that concerns far more than motorics or even

volition; it carves the ontological distinction between "existence in itself and existence for itself."[163] In short, a body-subject existing for itself will "never [be] a mere thing."[164]

However, in the Martinican poet, playwright, and politician Aimé Césaire's famous anti-colonial treatise *Discourse on Colonialism*, published just five years after the first edition of *The Phenomenology of Perception*, "thingification" was precisely the term he used to theorize the violent process to which the colonized were subjected.[165] Only two years later, Frantz Fanon would peel back the interminable layers of the black experience of finding oneself "an object in the midst of other objects" in his *Black Skins, White Masks*.[166] This racial interdiction from the posture of the subject, the reduction to object or thing, is a thoroughly corporeal operation. Throughout *Anteaesthetics*, I show how each instantiation of black aesthesis and the forms of anteaesthetic experimentation which emerge from it can never be taken apart from the corporeal ambition of this phenomenological reduction (to 'black body')—even when considering artworks held under the rubric of abstraction.

The fundamentally racial constitution of Merleau-Ponty's principal phenomenological conceits has been theorized by Afro-diasporic thinkers across various registers, both before and in the wake of his commanding philosophical interventions. From these rich traditions of black philosophical criticism, we can discern several signal disruptions of phenomenological regard which merit emphasis in any inquiry into black aesthetic life. To begin with, phenomenology cannot furnish the conceptual tools for apprehending either the "lived experience of the black" or the experiments in form which emerge from that experience, because black people have never had (which is to say, had the capacity to lay claim to) bodies in the sense presumed by phenomenology.

As Spillers imparts, the "diasporic plight" given in the (unfinished) passages of transatlantic slavery "marked a *theft* of the *body*," a horrific "severing of the captive body from its motive will."[167] The entwined corporeal schema and original intentionality that Merleau-Ponty would take as the subject's entrance into the world of things is confronted by the black as a knot of privation, dereliction, and ruination, its proprietary claim arrested, as Fanon asserts, "by a racial epidermal schema."[168] Whereas Merleau-Ponty encounters a corporeal schema as dynamic and relational, as the boundless

"opening upon a world,"[169] Fanon encounters a racial epidermal schema that is overdetermined, anti-relational, and suffocating as a schematization reserved for mere things, for objects among objects. Racial epidermalization becomes the mechanism for the phenomenological subject to avoid being ontologically subsumed within the world of objects and things—to disavow the "terrifying formlessness" such a radical entanglement would seem to imply. Whereas Merleau-Ponty can declare himself "in undivided possession" of his body, for its outline "is a frontier which ordinary spatial relations do not cross,"[170] the poet Lillian Yvonne Bertram reminds us that "for the negro it is a frontier always crossed."[171] Blackness becomes the epidermalized locus of a set of ontological displacements, secured through boundless and brutal violations, so that the phenomenological body-subject can cohere.

This exalted phenomenology of the subject, however, cannot simply remain impervious to the volatility concealed by racial objectification, for, as Fred Moten asserts, "While subjectivity is defined by the subject's possession of itself and its objects, it is troubled by a dispossessive force objects exert such that the subject seems to be possessed—infused, deformed—by the object it possesses."[172] Insofar as the subject of phenomenology retains the pretense of self-possessive embodiment in its coextensivity with individuated personhood, or what Lindon Barrett calls the "self-authorizing presumptions of modern subjectivity,"[173] it requires the epistemic excision of unwieldy materiality from this subject's corporeal schema. This operation of displacement pivots upon the racial epidermalization which paradoxically renders blackness as "a life *merely* of the body, an existence as obdurate materiality."[174] Blackness marks the immanent return of this terrifying materiality, the irruption of phenomenology's constitutive outside from within.

This book presents a black critique of phenomenology, which I argue is essential for any meaningful engagement with anteaesthetics. This critique implies that what appears within phenomenology as 'the black body' or 'the black figure' is in fact a dissimulation, a violently imposed, fictitious "appearance" of that which cannot appear. Yet precisely because blackness marks phenomenology's constitutive negation, because it is that which bears and exposes the racial aporia within modernity's "semiotic calculus,"[175] blackness must be marked and remarked. The 'black body' is, to reiterate Huey Copeland's language, "bound to appear." My deployment of the term *dissimulation* has resonances with, though is ultimately appositional to and

irreconcilable with its differential theoretical valences in the works of Jean-François Lyotard and Jacques Derrida. Lyotard uses the term *dissimulation* in *Libidinal Economy* to insist that "desire is always manifest in relation to structures . . . both giving rise to them and disrupting their stability. Dissimulation refers to the way in which structures always hide desire, and desire is always manifest in a structured form."[176] Derrida's conception of dissimulation is perhaps more difficult to succinctly relay, but my usage of the term comes nearest to his where he speaks of a "secret shared within itself, its partition 'proper,' which divides the essence of a secret that cannot even appear to one alone except in starting to be lost, to divulge itself, hence to dissimulate itself, as secret, in showing itself."[177] However, my concept of dissimulation is specific to the metaphysical feints and aesthetic operations that effect and instrumentalize the appearance or presence of a black existence that is in fact unavailable to ontology as anything other than the negation of being.

Dissimulation is, in this sense, a mechanism of what Calvin Warren terms "a catachrestic fantasy," or the attempt "to provide a referent for that which does not exist"—that is, because "the Negro lacks an ontological place . . . it also lacks a worldly referent."[178] Dissimulation is a specific operation of formation and formalization, one which, as Yve-Alain Bois and Rosalind E. Krauss might say, endeavors to fashion "the formless into a figure" and thereby stabilize it.[179] In short, the 'black body' is ceaselessly made to appear to suture phenomenology. Yet these violent dissimulations cannot erase the traces of the enfleshed existence for which the dissimulated 'body' is an excisive/projective rend(er)ing, not least because the (im)mediations to which flesh is subject are the means of dissimulation. Thus, every dissimulation of blackness also carries an immanent dehiscence, even as this dehiscence is borne in and by the flesh in its racially gendered (re)productivity and woundings.

For the black, every appearance of the dissimulated 'black body' is necessarily a coercive encounter, shadowed by the body Fanon describes as "sprawled out, distorted, recolored, clad in mourning."[180] It is an encounter with a body which "can only . . . recognize itself as a fiction."[181] Hence da Silva's turn to the language of "no-bodies" as the corporeal figurations of those placed "before the horizon of death."[182] *Anteaesthetics* stresses this formal paradox which confronts any endeavor to think with black art: every artwork

has both everything and nothing to do with the body; it is both bound to the serial reduction of blackness to "a life merely of the body," to the dissimulation of the 'black body,' and fashioned from the irreducible enfleshment of black existence that constitutes and discloses the phenomenological body's condition of (im)possibility. What I have termed *black aesthesis* is precisely what emerges in the cut between the violent dissimulation of the 'black body' and a black enfleshment that has always been both more and less than the phenomenological body.

To be clear, to declare the appearance of the 'black body' as a dissimulation, as both product and productive of the body as racial apparatus, is not to suggest that black corporeality is immaterial or dematerialized. Quite the opposite. It is to insist upon the impossible distinction between the dissimulation of the 'body' and the exorbitant materiality of black enfleshed existence. In my reading of Spillers, flesh is anterior to the body, anterior to individuation, anterior even to the separation of the material from the semiotic. Spillers's conception of flesh should not, however, be conflated with the notion of flesh that emerges in Merleau-Ponty's later work, even though the two could at first appear to share moments of conceptual convergence. For Merleau-Ponty, in Elizabeth Grosz's summation, "flesh is that elementary, precommunicative domain out of which both subject and object, in their mutual interactions, develop. . . . Flesh is the shimmering of a *différance*, the (im)proper belongingness of the subject to the world and the world as the condition of the subject."[183] Flesh, in my usage of the term, does indeed gesture to a corporeal entanglement which precedes and exceeds the relay of subject, object, and world. However, I emphasize how the history of flesh within modernity is in fact inseparable from both the racially gendered displacement of flesh through the dissimulation of the 'black body,' and the violent (re)productivity of black feminine flesh that functions as the medium of this displacement. It is the sequestration and concealment of fleshly exorbitance through the dissimulation of the 'black body' which enables the conceit of the subject who belongs to the world and for whom "the world remains isomorphic."[184] If Merleau-Ponty and his followers can invoke a universalist idiom of human flesh as "invaginative,"[185] it is only because the black feminine has already encountered flesh as abyssal.

Black existence is enfleshed existence, an existence without ontology. Enfleshment signals a corporeal inhabitation that is emergent within the

ecological entanglements the body seeks to disavow and that bears the burdens of that disavowal. Every body is violently rend(er)ed from flesh, and phenomenology is one of the principal philosophical means of this operation. However, the 'black body,' violently dissimulated through racial epidermalization, is singularly designated as the phenomenological dumping ground for the colossal displacements that are required to (re)produce the metaphysics of individuation upon which the modern body more generally depends. Yet because human life, in all its material and psychic dimensionality, cannot in fact do without that which it has sought to displace, the 'black body' also becomes the locus of the most abhorrent desires. The incalculable violence of this endlessly repeated consumption and consummation is borne in and by the flesh.[186] To paraphrase Spillers, it is black flesh that registers the wounding, and, I would add, black feminine flesh which singularly bears these violent (im)mediations.

My refusal of positivist representations of the 'black body' and insistence upon the enfleshed corporeality of black existence is neither prescriptive nor neatly taxonomical. When I say that it is crucial to make a distinction between black enfleshment and the dissimulation of the 'black body' and in the very same breath proclaim such a distinction impossible, it is to signal the hermeneutic inextricability of the two: the 'black body' dissimulates the appearance of that which cannot in fact appear while flesh, as the body's condition of (im)possibility, bears the corporeality of the unthought. Whether performance, film, painting, or multimedia installation, each of the artworks I theorize in this book engages in a practice that grapples with this irreducible problematic. What is crucial to recognize is that the dissimulation of the 'body' becomes the necessary site of a deconstructive anteaesthetic practice—one that is not grounded in but ungrounded by the aesthesis which emerges in the cut between black enfleshment and bodily dissimulation. Hence my use of the phrase *the arts of dissimulation*. These black arts of dissimulation cannot escape the projective excision, the rend(er)ing of flesh, upon which modernity's metaphysics depends. But neither are these arts completely subsumed by it. The black aesthesis from which the arts of dissimulation emerge constitutes the vertiginous tearing of modernity's "relay between self, world, and representation."[187] It is an aesthesis which can only appear as "phenomenology's exhaust and exhaustion."[188]

(Im)mediation, Touch, Technics

Returning once again to *Dreams*: the simultaneously unbridgeable distance and forced intimacy between the myriad onto-phenomenologies of the body which characterize the bodily turn—whether they explicitly claim or nominally disavow the body as an iteration of sovereignty—and the enfleshed existence of blackness, which has no place in either ontology or phenomenology, is painfully exhibited in Spillers's declaration:

> We were available in the flesh to slave masters. In the flesh. Immediate; hands on . . . I can pluck your little nappy head from wherever it is. Bang! . . . That's flesh.

For black existence in the flesh, the fantasy of bodily sovereignty has never been within reach. In fact, the corporeal schism signaled by Spillers's rhetorical pivot from *We* to *I*—from the terrible immediacy of enfleshed black existence to the embodied mastery of the subject who can regard the "captive body" as an instrument to do with as she or he pleases—is so severe that attempting to communicatively traverse the breach, to give enfleshed existence a language the world might comprehend produces the feeling of being "struck with (bodily) aphasia."[189] That condition of aphasia is accompanied simultaneously by an attenuation of speech, the suspension of communicability or comprehension on the terms of a given linguistic and semiotic structure. For Wilderson, this radical interruption of the very possibility for speech maps onto a symbolic paralysis experienced by the black, wherein one is "reduced to the most unadorned and empirical patterns of speech when dramatizing assaults on her/his body; as though they are sure of neither the presence of their bodies nor the presence of an auditor were they to articulate their suffering."[190] And yet, when Spillers declares, "We were available in the flesh to slave masters," something more is indicated than a whittling down of speech.

Spillers's rhetorical exorbitance is worth attending to carefully, for this absolute availability alludes to questions of immediacy and mediation that are central to every anteaesthetic example theorized within this book. Spillers signifies upon the black corporeal experience of a racial terror which, absent spatiotemporal finitude, resists analogy even with the destruction of language that is, according to Elaine Scarry's well-known argument, both

effectuated and mimed in "the structure of torture."[191] This loss of language is also, according to Scarry, the loss of "one's self and one's world, . . . [of all] that gives rise to and is in turn made possible by language."[192] However, as Alexander Weheliye has argued,

> Scarry assumes that world and language preexist and are unmade by the act of torture, which imagines political violence as exterior to the normal order rather than as an instrument in the creation of the world and language of Man. . . . This approach . . . cannot imagine that for many of those held captive by Man it is always already "after the end of the world. . . . Don't you know that yet?" long before the actual acts of torture have begun.[193]

In other words, whereas Scarry is theorizing the "world-destroying" event of extreme bodily pain, the disintegration of a world to which the tortured belongs,[194] Spillers, Wilderson, and Weheliye are theorizing the nonevent of a black corporeal existence that is always already an absolute exposure to the very world from which one is ontologically interdicted. The injunction to account for the corporeal violence of black existence in the flesh through a phenomenological grammar in which black flesh cannot appear inevitably produces the aphasic experience elaborated by Wilderson. Hence Spillers's sounded phrasing "immediate; hands on" bears at once an absence and surfeit of significations, a void and overflow of sense and meaning; it is a diacritical formulation that gestures toward the massive implications of being made absolutely available in the flesh. Furthermore, the absolute availability to which black flesh is subject is bound to what Spillers previously theorized as the rendering and reduction of the captive body "to *being* for the captor"[195]—the terror of immediacy, "That's flesh." To be taken as "*being* for the captor" is to be always already "at hand without mediation,"[196] always already subject to the violence of touch, and as each chapter of this book differentially elaborates, not least when "no trace of hands touching" is permitted.[197]

Conceptions of touch have long been important to the philosophical development of phenomenology and have in recent decades become particularly crucial analytical touchstones for film and media studies, as well as art history. Laura Marks has theorized the tactile, kinesthetic, and proprioceptive dimensions of touch, or the irreducibly "haptic" valences of touch that pressure prevailing distinctions between substance and surface, inside and

outside, body and flesh.[198] And yet, I contend that the aesthetic reverberations of the haptic that obtain within the examples of audiovisual media that animate the artworks discussed in this book cannot be understood without comprehending the conceptual force and weight of Spillers's declaration, which reattunes us to the violence touch occasions and to the violations which occasion touch. That declaration has crucial implications for thinking not only about the relationship of hapticality to the corporeal divisions upon which modernity rests but also the distinctive aesthetic sensoriums these divisions produce.

In Spillers's account, touch emerges in the first instance as a singularly violent immediacy to which the black is always already subject. Touch cuts two ways; it might be understood as the gateway to the most intimate experience and exchange of mutuality between subjects, or taken as the fundamental element of the absence of self-ownership. Thus, we are confronted by a paradox: touch simultaneously registers the unbridgeable gap and total imbrication between forms of subjective intimacy and mutuality on the one hand and, on the other, the corporeal "absence of self-ownership" which demarcates the enslaved. What is more, these two forms of touch are constitutively bound, for it is precisely the violent reduction of the captive body "to *being* for the captor" that negatively secures the ontological verity, stability, and immutability of the captor's being, not least through the latter's juridically and philosophically sanctioned pretense to self-possession that Spillers terms "bodiedness."[199]

The point I wish to emphasize here is that the unique convergence of this history of bodily subjection, the immediacy of its irreducible violations, and touch requires that we re-pose the question of bodily mediation in a radically different way. This singular convergence ultimately brings us to a primary contention within new media studies, which concerns the treatment of the body as itself a medium. For example, Bernadette Wegenstein in posing the question of "whether and to what extent the body is a medium" concludes that it "is a medium in a deeper, phenomenological sense, which is to say, the medium for experience itself."[200] "The human body," she avers, "is, or would seem to be, one of the few constants defining human being."[201] Wegenstein's arguments for the centrality of the body in new media criticism do not critique but take as a founding premise a central phenomenological

conceit concerning embodiment: that *being a body* designates a "first-person perspective, that coincides with dynamic embodiment."[202] It would seem that the residual phenomenology of media studies betrays its preservation of an implicit distinction between subjectivity, bodiedness, being, and self-possession on the one hand and captivity, flesh, nonbeing, and dispossession on the other.

Just as the tectonics of touch—their quakes and strains, fractures and fault lines, accretions and exfoliations—can hardly be taken for simply surface phenomena, neither can they be assumed to unfold upon a universal plane of experience or to obtain between essentially analogous subjects within a common field of relation (a fact betrayed by the nominative excess which threatens to spill from the very word *field*). This presumption of a sensual commons, which would seem to take Merleau-Ponty at his word when he declares that "every relation with being is *simultaneously* a taking and being taken,"[203] inevitably reproduces and rubs up against a foundational schism: *being* taken, where the traces of an inflective doubling disclose a morphological distinction at the level of species-being.[204]

My concept of (im)mediation names the doubled valence of a conjunctive violence: on the one hand, that which the black confronts as the terror of immediacy, of absolute exposure before the world, and on the other, that which offers human subjects a constitutive mediation that enables their claim upon interiority, their sensual commons, and their order of forms. (Im)mediation discloses the black lacuna at the heart of the philosophy of media. Missing from the media theories that have attempted to parse the distinctions between key terms such as *medium*, *mediation*, *immediation*, and *mediality* is a critical engagement with the implications of the (im)mediations to which blackness is bound for the grammar of technics and of the human. Those grammars are predicated upon a general acceptance of the idea that "a deep technoanthropological universal . . . has structured the history of humanity from its very origin."[205] The problem I am tracing at this particular juncture has to do with the construction of a heuristic framework at the intersection of the phenomenology of the body, the philosophy of the human, and the philosophy of technology. What I wish to emphasize is that, irrespective of the transhistorical understandings of technics/mediality as that which distinguishes the species-being of the human, within the ontoepistemology of

the modern world (wrought by the unfinished catastrophe of transatlantic slavery, settler coloniality, racial capitalism, and the dispensation of human being which emerges through the ontological interdiction of the black), the 'black body' nevertheless becomes understood as medium, is taken for medium.

At stake in media studies analysis is the reproduction of an epistemological foreclosure that tropes what Denise Ferreira da Silva names "the ontoepistemological moment" in which the Western transcendental human subject constitutes himself as the subject of reason—as a reasoning and reasonable interiority—precisely by exteriorizing the "scene of nature" through the racial.[206] This has direct bearing on the substance of the conclusions drawn about the ongoing constitution of the human through technological exteriorization, just as it also has direct bearing on the assumptions that undergird both the ways many have come to think about the "coevolution of humans and machines"[207] and the ontological and phenomenological justifications that establish and sustain them as distinct. The striking absence of any consideration of the part raciality might play within technics/mediality would seem to confirm da Silva's claim regarding the hauntological emergence of the racial "in projects of knowledge that presume scientific universality, for which universal reason plays an exterior determinant."[208]

Any theoretically advanced account of the role of the body in the ongoing constitution of the human through technological exteriorization that does not also critically attend to raciality as the violent mechanism for producing the interiority of the subject that serves as technological exteriorization's condition of possibility cannot help but reinscribe the metaphysics of being from which blackness is interdicted. For, as we have seen, it is the doubled violence of interiorization—the terrible (re)productive imperative for which the black feminine, the "captive maternal," is the nexus—through which the putatively individuated interiority of the self-possessive subject is birthed. The successive technological exteriorizations of the modern subject of human development are thus always already bound to the scene of racially gendered violation—the violent (im)mediations the black feminine is forced to bear. In distinctive ways, each anteaesthetic practice analyzed in this book gestures to the displaced anterior of theories of technics and mediality that variously predominate in the philosophy of media.

To the extent that any theory of technics/mediality begins from the pre-

sumptively universal registers of the ontological and phenomenological for thinking human experience and embodiment, it is incapable of grappling with the black existence that has no place within this putatively shared technological capacity, and it fails to recognize this black existence as the condition of (im)possibility for the very technological exteriorizations it would seek to elucidate. It will be unable, in other words, to consider the "terror of inhabiting existence outside the precincts of humanity and humanism,"[209] let alone understand how that existence has been made to body (itself) forth (as) media. W. J. T. Mitchell and Mark B. N. Hansen's assertion that "one of the earliest media of human expression is the malleable physical body itself"[210] is dramatically recast with respect to a history of black subjection and the ontological terror that has come to mark and characterize the totality of black existence. The violent (im)mediations of the flesh trouble the ontological and epistemological ground for a philosophy of technics. As Mitchell and Hansen put it in their succinct gloss of Bernard Stiegler's theory of technics: "the break that gave rise to the human as a distinct species, that is, was the invention of technics (or the technics of invention)—the use of objects not simply as tools but as tools to make other tools."[211] What is at stake in a theory of technics for Stiegler is nothing less than "the very possibility of the deconstruction of the history of metaphysics . . . [as] technics in its modern guise brings subjectivity to its completion as objectivity."[212] Yet one is compelled to ask how this conceit accords with those (non)beings cast outside the dominion of the subject as "the master and possessor of nature"[213]—those cast instead on the side of flesh. To be clear: the question is not one of exclusion from a conjoined elaboration of humanization and technics (that is, What of those not granted access to the human as a species distinguished by the invention of technics?). Rather, the question is, What are those who would claim the human and its technics to do with those whose immediate availability in the flesh establishes their anoriginary function as tools for humanity?

Black Mediality

Mediality is an indispensable concept within media theory, with some going so far as to suggest it constitutes a distinctive feature of Western philosophy stretching back to classical antiquity.[214] For W. J .T. Mitchell and Mark

Hansen, mediality is an essential dimension of what distinguishes the human from the nonhuman:

> In a minimal sense, what the emergence of the collective singular *media* betokens is the operation of a deep, technoanthropological universal that has structured the history of humanity from its very origin (the tool-using and inventing primate). In addition to naming individual mediums at concrete points within that history, "media," in our view, also names a technical form or formal technics, indeed a general mediality that is constitutive of the human as a "biotechnical" form of life.[215]

Mediality, in other words, is taken to be a, if not the, distinguishing feature of the species-being of humanity. I am arguing that, paradoxically, the black is conscripted in and as this "general mediality that is constitutive of the human," while being simultaneously expelled from the ontological status of humanity. Throughout this book, I take up anteaesthetic practices that recursively deconstruct the racially gendered lineaments of the "formal technics" and "general mediality" which Mitchell and Hansen proclaim subtend "the human as a 'biotechnical' form of life." The anteaesthetic practices taken up throughout this book interrogate the relationships between these formal technics and the broader order of forms upon and through which the cartography and historicity of humanity unfolds.

In short, the concept of mediality must be massively revised in light of what Spillers has theorized as black (feminine) availability in the flesh—flesh that is ubiquitously exposed to and instrumentalized in service of the legion of violent desires that animate the material-libidinal economy wrought in and for slavery. Saidiya Hartman has theorized the inexhaustible availability of black flesh for the captor's unmitigated use as bound up with the fungibility of the slave as commodity:

> The relation between pleasure and the possession of slave property, in both the figurative and literal senses, can be explained in part by the fungibility of the slave—that is, the joy made possible by virtue of the replaceability and interchangeability endemic to the commodity—and by the extensive capacities of property—that is, the augmentation of the master subject through his embodiment in external objects and persons. Put differently, the fungibility of the commodity makes the captive body an abstract and empty vessel vulnerable to the projection of others' feelings, ideas, desires, and values; and, as property, the dispossessed body of the enslaved is the surrogate for the mas-

ter's body since it guarantees his disembodied universality and acts as the sign of his power and dominion.[216]

Extending and modifying Hartman's conception of black fungibility, Zaki-yyah Iman Jackson has proposed "ontologized plasticity" as a concept for grappling with "a mode of transmogrification whereby the fleshy being of blackness is experimented with as if it were infinitely malleable lexical and biological matter."[217] My intervention thinks through the implications of this infinite material-discursive malleability, this surrogative availability in the flesh, for theories of mediality, particularly as they obtain in film and media studies and studies of visual culture more broadly. The artworks theorized in this book are exemplary deconstructions of the racially gendered subtensions of mediality across various forms and mediums.

The concrete operations of mediality may be clarified through an exposition of the concepts of substrate and form. In *Discorrelated Images*, Shane Denson employs a revised iteration of a distinction between substrate and form, introduced by Ted Nannicelli and Malcolm Turvey's contestation of the very idea of post-cinema, "Against 'Post-Cinema.'"[218] Rejecting a conception of substrate/form that would reproduce an ontological/phenomenological dualism in which the distinction between technological medium and experiential form becomes reified, Denson instead turns to Niklas Luhmann's concept of "'mediality' as a model for conceiving a dynamic *interplay* between substrate and form."[219] According to this model, *mediality* "names not a particular apparatus but the relation between some substrate and the forms that can be constituted out of it." Moreover, adds Denson,

> because, according to Luhmann, substrate and form consist of the same basic elements—the same "stuff," so to speak—this notion of mediality will not support the oppositional view whereby the technological or ontological realm is separated by an unbreachable gulf from a securely encapsulated phenomenological realm of experience. The difference between substrate and form is instead not a difference of kind but of organization: a substrate consists of a "loose coupling" of elements, a relatively chaotic or unordered mass of particles, while forms emerge out of the substrate as the "tight" or strict couplings or combinations of the same elements.[220]

Thinking mediality through blackness, however, complicates this model. On the one hand, blackness—as ontology's constitutive negation, as ontology's

ante- and anti-foundational condition of (im)possibility—does not exist within the register of the ontological. On the other hand, the appearance of blackness within the realm of phenomenological experience is in fact a dissimulation, which can neither refer back to an originary ontological dispensation nor be constituted in a dynamic relation with an ontological existence, as black existence is an existence without ontology. Nevertheless, I would suggest that Denson's nondualistic conception of substrate/form still offers a compelling idiom for what I theorize as black mediality.

We could almost say that black enfleshed existence is the substrate that is bound to the dissimulation of the 'black body' as form. The latter, however, as a violent reduction, concealment, and illusory projection of the former, cannot readily be said to "consist of the same basic elements" (even if their "difference remains an essential and irreducible tension")[221] without moving through a complicated set of material-discursive deconstructions. That said, this dissimulative form does necessarily bear the trace of its fleshly substrate as "obdurate materiality." This obdurate materiality, we shall see, marks the hauntological disclosure of the inevitable failure of the racial displacement of nothingness or/as entanglement. My point here is that it is precisely the violent immediacy to which black flesh is subject—as a boundlessly fungible commodity, as "infinitely malleable lexical and biological matter"—which enables its singular mediality, its indispensable functionality and unremitting dehiscence within modernity's technics and the modern life of form. Black mediality differentially accentuates blackness as always already "available equipment," to invoke Calvin Warren's nihilistic redeployment of Heidegger's philosophical lexicon.[222] These violent (im)mediations mark the black underside and anteriority of what Richard Grusin would call "radical mediation," or "an immediacy that transforms, modulates, or disrupts experienced relations."[223] The 'black body' is everywhere taken for medium, though it is black flesh which bears the immediacy of mediality, black flesh which "registers the wounding" of this serial, diffusive predation. Moreover, the violent rend(er)ing of body from flesh is not merely a procedure which might be mapped onto the distinction between substrate and form but the very means by which this distinction is effectuated. Throughout *Anteaesthetics*, I explore how the racially gendered operations of black mediality cut the very distinction between inside and outside, materiality and immateriality, form and formlessness, and being and nothingness.

Although the implications of black mediality are far-reaching and by no means restricted to the register of the aesthetic, for my purposes in *Anteaesthetics* I emphasize four conceptual moments through which we may approach black mediality. First, black mediality is central to the racial regime of aesthetics, its formal distinctions and modes of aesthetic experience, not least for the part this mediality plays in the "recursive linking among media."[224] Black mediality constitutes the condition of (im)possibility for these aesthetic distinctions and modes of experience insofar as the boundless fungibility of black flesh can be worked with and upon to secure and mitigate the tensions and contradictions of the racial regime of aesthetics. Yet black mediality also bears the irreducible residuum of the displacements that allow this racial regime to cohere. Second, black mediality becomes a key site for "the ongoing modulation of subjectivity and experience" by the body as racial apparatus.[225] These modulations ensure that the fungibility of black flesh can be reproduced and made available and at the same time disavowed through the dissimulation of the 'black body.'

Third, black aesthesis is given in the cut of blackness as mediality, in the cut of fleshly substrate and the dissimulated form of a 'black body,' taken for boundlessly fungible medium. Fourth, black mediality becomes a crucial site for anteaesthetic experiments that move back through the recursive laminations or enfoldings of black mediality within the racial regime of aesthetics. These experiments move back through black mediality in order to deconstruct the operations that mediality bears and, in this recessive movement toward an irreducible residuum, fashion an anteaesthetic inhabitation within that regime's negative underside. *Anteaesthetics* discloses the black medialities at work across a wide range of media, attending to the conditions of (im)possibility that are marked by their residuum.

In the chapters that follow, all the conceptual moments folded through the preceding sections will be woven through this book's theory of anteaesthetics and its specific ante-formal readings across film and media, painting and literature, architecture and installation. But the theoretical intervention advanced by *Anteaesthetics* is emergent rather than comprehensive. My hope is that *Anteaesthetics* will play some part in decalcifying the habits of interpretation that have been foisted upon us and thereby open indeterminate methods of reading and inhabiting the anteriority of blackness. In this respect, the project announced by *Anteaesthetics* is not so much a clarion call

for yet another redemptive horizon as it is an invitation to return to the dehiscence we already bear—to the vertiginousness that comes before every horizon. For these returns constitute nothing less or more than the minor refrains, the extemporaneous scoring of black artistry and the enfleshed existence of blackness.

Two

The Corporeal Division of the World, or Aesthetic Ruination

The historical cartography of the modern world turns upon a racial division of corporeality for which blackness is the absent center. Blackness is made to come before but is not locatable within the divided corpus of the social. The violence of antiblack (im)mediation—wherein the black is always already "at hand without mediation"—is a double-edged recursivity. The black provides the anoriginary vestibule for the spacetime of the (proper) body and its others—as the constitutive negation of historicity and the geographical limit of the social—while being everywhere subject to their corporeal expropriations, enclosures, and displacements. Bodies and the racial taxonomy that conditions their variegated inhabitations of the world are rend(er)ed from flesh through a brutal concatenation of projections and displacements. This chapter interrogates the entanglements of blackness, the racial regime of aesthetics, and the making, structuration, and unmaking of the corporeal division of the world.

Over the next two chapters, I trace the intricate strains and disjunctive remainders that characterize the metabolics of the corporeal division of the world through a number of signal instantiations of black (feminine) anteriority to the divided corpus of the social—all of which are variously tethered to formal innovations and structural recalibrations of aesthetics, knowledge, and biopolitics during the nineteenth century. However, although my argument moves through the elaborations, modulations, and disorders of the corporeal division of the world that distinguish the nineteenth century, my theoretical intervention is not principally historicist in the methodological sense. The problematics which animate my study are ultimately (ante)metaphysical rather than historical. My theoretical aims are threefold:

firstly, to elucidate the constitutive imbrications of the corporeal division of the world, the racial regime of aesthetics, and the antiblack metaphysics they work in concert to secure; secondly, to demonstrate the gendered vestibularity of blackness to the serial (un)makings of these entangled orders of the social; and, thirdly, to emphasize that it is impossible to attune to the ante-aesthetics of black existence—to the aesthesis which is at once the condition of possibility for the aesthetic life of form and an uncontainable fount of aesthetic ruination—without attending to the racially gendered rend(er)ings of flesh that mark the absent center of the corporeal division of the world.

These dynamics are transhistorical insofar as they emerge from the (dis)placement of blackness before the engine of modern history and pertain to all the black artistic practices interpreted throughout *Anteaesthetics*, contemporary or otherwise. As I further elucidate in the next chapter, which directly engages the relationship between contemporary black artistic practice, the recalibrations of the corporeal division of the world, and the racial regime of aesthetics during the nineteenth century, what we could regard straightforwardly as the present is deeply unsettled by the distended temporality of blackness, even as universalist history would dissimulate this distension under the sign of contemporaneity. "This narrow now," as W. E. B. Du Bois described it,[1] is splayed across the centuries. History derives its momentum and fashions its forms from the labors of black flesh, perennially consigned to history's anterior. An antehistoricism of the flesh turns toward history only in a heuristic overturning of its grandeur, for our concern remains attunement to the minor refrains of black existence.

We move first to the black bodily fragment as a metonymic rend(er)ing of flesh. Such an excursus not only begins to gesture toward the racially gendered distinctions in how the black is put to use by modernity's aesthetic regime but, moreover, serves to establish the incommensurability between black aesthesis and theories of aesthetic transformation that fail to account for the disjunctive ontology of the corporeal division of the world.

The Black Bodily Fragment

Let us begin our foray into the nineteenth century with Théodore Géricault's *The Raft of the Medusa* (1819; figure 5) and the oil study referred to as the Montauban study, the *Study for the Signaling Black*, or *African Signaling*

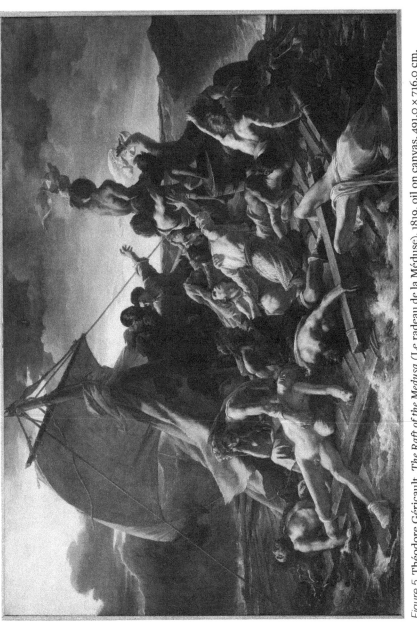

Figure 5. Théodore Géricault, *The Raft of the Medusa* (Le radeau de la Méduse), 1819, oil on canvas, 491.0 × 716.0 cm. Musée du Louvre. Photo: Michel Urtado. © RMN-Grand Palais / Art Resource, NY. Reprinted with permission.

(1819; figure 6). *The Raft of the Medusa* is widely regarded as the most ambitious work of an artist who was not only one of the most influential among the early painters of French Romanticism but whose oeuvre granted the figure of the black a unique importance. David Bindman and Henry Louis Gates Jr.'s *The Image of the Black in Western Art* goes so far as to declare that "in the work of no European artist of equivalent standing do blacks have greater prominence."[2] *The Raft of the Medusa*, completed in 1819, depicts the notoriously catastrophic voyage of *La Méduse*, which set sail for Senegal in 1816 as part of the effort to recover France's colonial ambitions in the wake of the Napoleonic Wars and the fall of the First Empire, during which most of what remained of its colonial territories had been lost. The story of the *Medusa*'s journey, which famously ended in shipwreck, its crew progressively overtaken by the ravages of murder, suicide, illness, starvation, and cannibalism, comes to us first through the narrative of Alexandre Corréard and Jean-Baptiste-Henri Savigny, who were among the survivors.[3]

In *Extremities: Painting Empire in Post-Revolutionary France*, Darcy Grimaldo Grigsby introduces *Raft of the Medusa* thusly:

> Géricault's picture of shipwrecked men on a crudely improvised raft—an island of sorts—has been interpreted as a radically democratic vision of a collective body that rises from its martyrdom to support society's most marginalized constituent, the black man, at its apex. This optimistic reading of the work's Liberal politics is not wrong so much as it is oversimplified. Waving to a rescue ship, the black man at the peak of the *Raft's* pyramidal composition . . . like the steadfast general, he is both the compositional climax and the optimistic narrative resolution of a picture otherwise devoted to the suffering of a ravaged body politic. Buoyantly triumphant at the pyramid's apex, this African . . . potentially draws attention away from the surrounding figures who represent the pain and danger he has overcome . . . the assaulted bodies that serve as the ground from which resolution builds.[4]

As a critical intervention into an art historical discourse in which the "optimistic" yet "oversimplified" celebration of *The Raft of the Medusa's* equalizing, universalist ambit remains predominant, Grigsby's compelling analysis moves toward the "assaulted bodies" from which the black would appear to ascend, reading for a more complex and difficult aesthetics of social wounding and utopian potentiality. My argument proceeds appositionally from and toward what we might call the anterior of the utopian, but I, too, am

interested in the contrapuntal valances of ravaged and triumphant bodies, catastrophe and redemption, fragment and totality, apex and base, and the manner in which they come to hinge upon this strangely doubled figure of the black man.

To fully attune to the aesthetic significance of this figure, we must follow him from his provisional emergence in Géricault's *Study for the Signaling Black* through to his final incorporation in *Raft of the Medusa*. Albert Alhadeff's interpretive description in *Théodore Géricault, Painting Black Bodies* provides a particularly vivid and visceral image of the Montauban study:

> A beautifully wrought study with nuanced rills of flowing light to dark brown paint, the oil is left unfinished, purposively highlighting the figure's full back and flexed right arm. But though the figure's upper frame holds us in thrall with its incisive outline and furtive coloring, the canvas is blank in certain key areas—glimpses of the figure's head and raised left arm and only a few quick dark lines define the figure's lower half, his right hand resting on his hip. The result—an *esquisse* (a finished sketch) in effect—focuses on the figure's torso, its sideward turn and its eruptive mass. With the torso contained in a decisive silhouette, Géricault cuts his figure off at the waist and details with exquisite care its foreshortened bent right arm. The whole, however, comes to an abrupt halt, for the downward line of the lower arm does not extend below the figure's waist. Cut off at the wrist, it ensures the torso's integrity, a fulminating closed and cohesive entity. What lies before us then is only a fragment of a whole, a truncated torso of extraordinary power with a foreshortened lower arm and elbow, the latter forming a compact mass with the torso's rippling muscles. Géricault's intent is clear. The hailer's torso is paramount for its unrivaled presence argues that, in effect, it alone has the concentration and fortitude to focus on the climactic moments ahead, to see the men on the raft through their ordeal.[5]

One of many preparatory sketches and studies for *Raft of the Medusa*, the Montauban oil study's relation to the final painting and the critical responses to each introduce a set of aesthetic problematics germane to an inquiry into the part played by blackness in the making, structuration, and unmaking of the corporeal division of the world. In the course of working through these problematics, we will see how the difficult knot of the dissimulated 'black body' and the enfleshment of black existence at once mediate and desecrate a set of contradictory recuperations of the social and the racial regime of aesthetics through which the socius is secured. Moreover, it is precisely the

Figure 6. Théodore Géricault, *African Signaling*, study for *Raft of the Medusa*, 1819, oil on canvas, Musée Ingres. © RMN-Grand Palais / Art Resource, NY. Reprinted with permission.

singular anteriority of black corporeality that necessitates a theory of black aesthesis: a dehiscent emergence that is irreducible to and calamitous for the representational and the aesthetic operations it is made to come before. At stake is a complex process of aesthetic mediality, incorporation, and expulsion that subtends the transit of a black figure who, for both Géricault and those who read him, assumes a singular importance in the realization of *Raft of the Medusa*. In this figure's passage from his initial, provisional studies to the final work, he is rendered the symbolic pinnacle and aesthetic linchpin, without which, we conjecture, *Raft of the Medusa* could not have attained its canonical status within the history of French Romantic painting.

The importance the "Signaling Black" held for Géricault's vision for *Raft of the Medusa* is evident in the degree of attention this figure commanded. "To this figure he gave particular care. Of no other is he known to have made an oil study as well as pen-and-ink drawings."[6] Of the Montauban study, Thomas Crow remarks: "The universality so often claimed for the classical nude is in this modest canvas won by Géricault from the person of the survivor most marked and thereby relegated to insignificance in European eyes."[7] Crow's observation foregrounds an apparent paradox, insofar as the art historical significance of this figure's aesthetic incorporation into the universalist project of the European nineteenth century depends on the continued insistence of that figure's incomparably degraded status. Of this figure's realization within the completed work, Crow exclaims: "Amid the virtuoso displays of male anatomy with which he invests the classless stalwarts of the raft, he used his acquired command of the ideal figure to bestow heroic status on a singular redeeming figure, the African sailor, the most dispossessed of them all, whose agile grace signals the distant rescue ship from the pinnacle of the pyramidal cluster of bodies."[8]

The raciality of the figure is invoked and interrogated insofar as it can be made functional to or put in the service of the representational ambitions Crow wants to avow as distinctive of that European age and its universalist ambit. The degraded, "dispossessed" African sailor is suddenly relieved of this debasement, it would seem, at the moment of his aesthetic incorporation. The means for dissembling this resolution of the representational incommensurability between the universal body of "the classical nude" and the aestheticized 'black body' become most conspicuous in Crow's critical

assessment of *African Signaling,* wherein the black's figural difference is subsumed under the heroic sign of the classical tradition:

> From that merest membrane of pigment emerges the startling volume of the drastically foreshortened elbow thrusting into virtual space, angular bone and cartilage, as palpable as painting can deliver. Pigment seems transmuted into sculpture, and not necessarily sculpture in the abstract: the isolated torso and arm might be for all the world a damaged, hollow ancient bronze, divested of attributes but as eloquent as the great *Belvedere Torso* in stone.[9]

Here Crow makes quick work of his object, deploying a descriptive touch that, in the first instance, positions the "signaling African" as the figural epitome of the visceral life of painting ("bone and cartilage as palpable as painting can deliver"), and, in the next, transmutes this figure of pigment and sinew into sculpture. And not just any sculpture, but that singular artifact, the *Belvedere Torso* (figure 7), which has so often been made the paradigmatic instantiation of a figure which, though broken, damaged, and fragmentary, nevertheless, through the sheer sublimity of its physical form, attests to the transcendental aesthetic and the universality of human experience. As if unwittingly citing Charmaine A. Nelson's signal interrogation of raciality and neoclassical sculpture, Crow's invocation of the signaling African's "damaged, hollow ancient bronze" constructs a chromatic mechanism for epidermalization, wherein bronze "captures the blackness of black skin"[10] and, further, imbues it with degraded primitivity, voided of interior(ity). No sooner had the signaling African's pigmentation been announced as racial marking than the sweep of Crow's sentence subsumes this figure under the "universal abstraction" of white marble, which, as Nelson shows, was precisely the material seized on in the nineteenth century to displace racialized corporeality and thereby fashion a universal figure of aesthetic humanity.[11] What is crucial here is not only that the raciality of the figure is displaced by the symbolic overdetermination of the *Torso* as heroic anatomic perfection but, moreover, that this displacement is at once effectuated and unsettled by the reduction of blackness to a precisely rendered bodily fragment.

What do we make of the African, reduced to the severed torso that has been cast as the very symbol of insurmountable human virtue and beauty, of immortality, of the heroic anatomic perfection that runs through classical

Figure 7. *Belvedere Torso*, dorsal view, mid-first century BCE, marble, Vatican Museums. Photo © Governorate of the Vatican City State—Directorate of the Vatican Museums. Reprinted with permission.

antiquity? Moreover, what do we make of the fact that Géricault's figuration of the signaling African as the epitome of masculine heroism takes place at precisely the moment when the figure of "the revolutionary hero" is being representationally displaced by "the postrevolutionary sensualized nude"?[12] This alludes to a complex (un)gendering, which I interrogate more fully in the following chapter, tracing the nineteenth-century rise of the sensualized female nude back through the racially gendered anteriority of black flesh and drawing out its implications for both the codification and contamination of the corporeal division of the world. For now, let us note that, for Crow, this dialectical operation, whereby the heroic severed torso is allowed to supersede the abject raciality of Géricault's figure, whose simulated universality is paradoxically facilitated by the obdurate materiality the black is made to

bear, enables a perverse synthesis: the realization of Géricault's oil study as the consummation of a purported aesthetic purity.

Crow's reduction of blackness to bodily essence, that glorious raw material which is nonetheless merely an appendage of subjectivity, reinscribes the black as a corporeal extension to be commanded by the modern subject, whose agential authority is inextricable from his constitutive imbrication with the nation, the state, and the romance of European civilization. But the visual provocations and conceits of Crow's reading run deeper still. The approximation of Géricault's study of the African to sculpture, which in turn facilitates the transposition of the black onto the abstract universality of the human figure, is not merely an operation which depends upon a Eurocentric presumption of the classical nude as universal humanity's exemplary model. More crucially for my argument, it is an operation which requires the black figure to become the (inter)mediality between painting and sculpture, just as he must become the mediator between irredeemable dereliction and exalted universality. In each instance of black mediality, he must be made malleable as clay, yet petrified as stone.

"Petrification" is a crucial concept for Frantz Fanon, introduced in the first two chapters of *The Wretched of the Earth*.[13] As David Marriott reads him, petrification (the etymology of which suggests being turned into stone) theorizes how "the imposition of colonial culture not only produces a certain style of embodiment (petrified, rigidified, inanimate, ankylotic), but to the extent to which all aspects of colonial culture have become racialized, the colonial body mimes or act outs various rigidities as the continuous message of its own subjugation."[14] Under the psychosocial economy of colonialism, "the racialized body . . . [becomes] a series of discontinuous but arrested signs (of affect, movement, motility, musculature, aggression and passivity)."[15] In the theoretical language of *Anteaesthetics*, we could say that Fanon and Marriott direct our attention to the violently dissimulated 'black body,' cut and splayed. Each discontinuous fragment produced through this rend(er)ing becomes of semiotic, libidinal, and material use to the racial regime of aesthetics, even as none can refer back to either the metaphysical conceits of the human and his (social) body or to the enfleshed, antemetaphysics of black existence.

Linda Nochlin has taken Géricault's bodies (in pieces) as exemplary of "the fragment as a metaphor for modernity," wherein the fragment becomes

the figurative expression of a loss of wholeness or totality in the face of the disintegrative force of modern experience, even as "paradoxically, or dialectically," aesthetic modernity is equally marked by what would appear to be "its opposite": "the will to totalization."[16] I want to suggest that Géricault's artistic gesture, which at once places the black bodily fragment in service of yet eclipsed from the unitary corpus of the painting, discloses the technicity of anatomical precision as rend(er)ing. Indeed, as Crow exclaims: "Nowhere in his body of work is technical and anatomical mastery so consummately in evidence as in the oil study for the African figure's torso, in its way a standing reproach to the vanity bound up in pretensions to completion or synthesis. Yet synthesize it does, despite the paint being applied with near-microscopic thinness."[17] From this statement, it becomes clearer that what is at issue is not simply the sketched contours of the African body but more precisely what that body's incompletion holds out for Géricault's oeuvre—the radical contingency of history's epic, transcendental narrative, which is disaggregated by this body's immanence to the interminable upheavals of the slave trade, *la traite*.

The implications of incorporating black dereliction within (while simultaneously displacing it from) the space of one of Western art's most prodigious displays of bodily virtuosity and monumentality are vast. Crow's art historical procedure, which places the black at the threshold of negative humanity and human exemplarity, makes of him an object of both imitation and defamation. Consigned to a medial function, the black is made to sustain at least the appearance of having resolved these antinomic distinctions through an aesthetic rendering of dialectical synthesis. For Crow, this recuperative reading is secured by way of a crucial analogy: between the "Signaling Black" and the *Belvedere Torso*, between the incomparably degraded 'black body' and the universal body of the classical nude.

Black Aesthesis and the Unassimilable

The figure of the *Belvedere Torso* occasions an unsolicited, provisional proximity between Crow's study of European art during and following the fall of the Napoleonic Empire and Jacques Rancière's otherwise disparate philosophical study, *Aisthesis*. I am interested not in comparing their studies in terms of general aims, scope, method, or conclusions but rather in

exploring the braid of divergence and confluence that emerges specifically
in the encounter between their respective readings of this singular figure,
the *Belvedere Torso*. What we find has implications not only for theorizing
blackness as the absent center of the corporeal division of the world but for
distinguishing the recuperations and transformations of the racial regime of
aesthetics from the nonevent of black aesthesis, which bears the absolutely
unassimilable.

In the first chapter of *Aisthesis*, Jacques Rancière turns to the *Belvedere
Torso* (figure 8) as a paradigmatic figure for the "aesthetic revolution" which
is signaled or anticipated in the publication of Johann Joachim Winckel-
mann's seminal 1764 text, *The History of Ancient Art*.[18] Winckelmann's work,
which is widely lauded, in Christopher S. Wood's words, as being the first
"history of art that is not a history of artists,"[19] holds far more sweeping
historical significance for Rancière; it marks the moment "when Art begins
to be named as such, not by closing itself off in some celestial autonomy, but
on the contrary by giving itself a new subject, the people, and a new place,
history."[20] Crucially, the event of Winckelmann's reading of the "abused
and mutilated" statue enables Rancière to approach the *Belvedere Torso* as
an exemplar of the supersession of the representational by the aesthetic.[21]
In Rancière's idiom, it marks a nascent overturning of the "representative
regime of art" by the "aesthetic regime of art"—the former, grounded in
the binary hermeneutic of *poiēsis/mimēsis* and characterized by strict codifi-
cations and hierarchical orderings of genres, forms, and subjects, as well as
modes of creation, reproduction, sense, and judgment; the latter, proceeding
through the "destruction of the hierarchical system of the fine arts"[22] and
characterized by ongoing metamorphoses of modalities and repertoires of
thought, feeling, affect, and perception, as well as of the sensible communi-
ties with which they are constitutively entwined.

Rancière argues that Winckelmann's interpretation recasts the statue's
"accidental lack" as its "essential virtue" and that the radical transforma-
tion announced in this transfiguration remains little understood.[23] Through
Winckelmann's reading, the mutilated statue becomes not a figure of deficit
but of historical surfeit, for it marks the undoing of the two essential axioms
of the representative order: "the harmony of proportions" (the relational
correspondence of parts and whole) and "expressivity" (the tether between
visible form and representational content). The transfiguration of the *Torso*

Figure 8. Belvedere Torso, frontal view, mid-first century BCE, marble, Vatican Museums. Photo © Governorate of the Vatican City State—Directorate of the Vatican Museums. Reprinted with permission.

thus effectuates "the structural breakdown of a paradigm of artistic perfection . . . the classical representative ideal," for it has exposed the gap between "the harmony of forms and their expressive power."[24] For Rancière, this breakdown is tantamount to a derangement of sensorial coordinates, a crumbling of the bridge "between the rules of art and the affects of sensible beings."[25] Yet this destruction is also the introduction of historicity, for it is through this apparent loss that the indeterminacy and incompleteness of the statue become the very conditions for its beauty, the valences of its gathering and dispersal of sensible communities which constitute its historic milieu.

Thus, Rancière proposes the *Torso* as not only an exemplar of but an allegory for an "aesthetic revolution"—the triumph of the aesthetic regime over the representative regime of art: "The history of the aesthetic regime of art could be thought similarly to the history of the metamorphoses of this mutilated and perfect statue, perfect because it is mutilated, forced, by its missing head and limbs, to proliferate into a multiplicity of unknown bodies."[26] In-

terestingly, although both Crow and Rancière ultimately associate the *Torso* with transformative aesthetic scenes, they do so for what would appear to be diametrically opposed reasons. For Crow, the *Torso* remains a figure of anatomic perfection, whose expressivity can be transposed onto the bodily fragment of the African in an operation which at once instrumentalizes and displaces blackness precisely because the *Torso* is presumed to retain what Rancière refers to as the union of "the harmony of forms and their expressive power." That is, even as Crow transposes the eloquence of the *Torso* onto an African figure "divested of attributes," the correspondence of visible form, aesthetic content, and the viewer's judgment nevertheless appears seamless and self-evident: the statue remains the "*beau idéal* of masculine form." Indeed, the presumption of this correspondence, which Rancière takes as "the classical representative ideal," is a condition of possibility for Crow's maneuver. For had Crow approached the *Torso* as "abused and mutilated," as an artifact severed from historical origin, shorn of figural integrity, his analogue would have immediately been placed in dangerous proximity to black flesh rent asunder—to the viciousness of captivity and the vertigo of non-arrival, to the catastrophe haunting every metaphoric conceit.[27]

In contradistinction, for Rancière it is precisely the "inexpressivity, indifference, or immobility" of the *Torso* from which its "sensible potential" is unleashed: "The Torso's inexpressive back reveals new potentials of the body for the art of tomorrow."[28] Although neither race nor blackness are explicitly invoked in this chapter of Rancière's book (for that the reader must be patient and wait, for example, for his celebration of Walt Whitman's stylistic choice to identify "himself with the one who puts up the vilest and the noblest merchandise for auction: this black slave, this 'curious creature', this admirable frame of bone and muscle" in *Leaves of Grass*'s "A Song for Occupations"[29]), one should note that the ease with which Rancière announces the aesthetic dissolution of dualities, such as active/passive, mobility/immobility, expressive/automatonic for the sake of an implicitly universal, new bodily potentiality, elides the racial constitution of these categories within and in service of the modern world and the singularity of the brutalized flesh and dissimulated 'body' of the black within that constitution. For now, however, let us simply observe that Crow and Rancière would appear to arrive at their admiration for the *Torso* by almost inverted analytical routes. But is the endgame of their opposing philosophical procedures really so different?

Crow's reading of the oil study and the *Raft* unfolds within the context of a broader study that would valorize the aesthetic innovations of European art during a period of severe reaction, for "artistic change is never so accelerated or unpredictable as when forces gather to stop it, still more when those in authority make a concerted effort to put things back to some prior, irrevocable state of affairs."[30] In this particular (cursory but nonetheless pivotal) interpretive move, Crow emphasizes the universal humanity bestowed by the *Torso* in its transposition onto the African's bodily fragment as a redemptive event: a reconstitution of the demos, a reclamation of the progressive spirit of the French Revolution, "the Restoration unrestored."[31] Given how large the shadow of the French Revolution looms over Crow's text, we ought to pause and take stock of the fact that Haiti appears nowhere in the book, an omission which becomes all the more ironic when we consider that Crow reproduces the widely accepted (though unsubstantiated) claim that the African model for Géricault's *African Signaling* was "Joseph," who is said to have been from Saint-Domingue.[32] Crow's omission is, in the first instance, telling with respect to the limits of historicization within art history, since the conditions of possibility for "*the* bourgeois revolution"[33] within the modern world were, as C. L. R. James famously argued, not only the accumulated plunders of transatlantic slavery but also that the extension of the ideals of *liberté*, *égalité*, and *fraternité* stop short of the French colonies—not least Saint-Domingue, where close to half a million were enslaved and which was the biggest and most profitable colony in the Caribbean.[34] However, for the purposes of my argument, the significance of Crow's relegation of the Haitian Revolution to historical irrelevance is not, strictly speaking, historiographical. Rather, it serves to illustrate the precarious twine of instrumentalization and displacement that characterizes the incorporative exclusion of blackness within modernity's racial regime of aesthetics, a ubiquitous enterprise of which Crow's hermeneutics are merely emblematic.

Irrespective of the idiosyncratic question of whether Géricault's oil study relied upon the black model known as Joseph, one must not underestimate the enduring influence of the Haitian revolution upon the nineteenth-century European aesthetic imagination, whether or not that influence was explicitly acknowledged or even consciously recognized. For a general insurrection of the enslaved, as Michel-Rolph Trouillot has argued, constituted "an unthinkable history."[35] The revenant "of the great upheaval hovered

over . . . [even] antislavery debates like a bloodstained ghost."[36] Where its memory could not be silenced or repressed, it was sublimated or recast, variously channeled back into a thinkable "world of possibilities."[37] Whether this latent terror of the unthinkable manifested as enmity and dread, as in Géricault's ink drawing and clay terra-cotta statue *A Black Assaulting a Woman*,[38] or donned the trappings of ennoblement, as in *Raft of the Medusa*, its structuring force is no less palpable.

Moreover, as Grigsby points out, the historic voyage depicted in *Raft of the Medusa*, which marked France's effort to reclaim its former colonial territory in Senegal following the Treaties of Paris (1814–1815) and the end of the Napoleonic Wars, must be situated in terms of France's broader post-Revolutionary colonialist ambitions in Africa and their relationship to the Haitian Revolution.[39] As Grigsby writes, "Undergirding post-Revolutionary arguments for the colonization of Africa was always the loss of Saint-Domingue. . . . Many French people still could not believe that the Ancien Régime's most lucrative colony had been irrevocably lost, but some knew that the future of empire would have to lie elsewhere."[40] Grigsby makes clear that Géricault's painting is produced and received amidst the penumbra of the pecuniary, territorial, and psychic losses of empire (not least of which, with respect to the latter, concerns the emasculating character of colonial defeat, further accentuating the significance of the masculine heroism projected onto Géricault's "signaling African"). I would take Grigsby's important observation one step further: perhaps even more portentous than the discrete losses which shadowed the European imagination in the wake of the Haitian Revolution was the persistence of threat—a threat which the Haitian Revolution did not so much inaugurate as amplify, a threat which was (and remains) existential, immanent, and utterly opaque.

If the sentiment conveyed by the white plantation owner M. Le Clerc upon returning to his plantation in Saint-Domingue in the wake of the revolution—"We felt as though we were walking through the ruins of the world"[41]—might have been familiar to his French contemporaries who had never set foot upon the island, it was not simply because they had lost their prized "Pearl of the Antilles" but rather because this loss could not help but raise the specter of the ruination of the world itself. Throughout *Anteaesthetics*, I stress that the singular threat posed by blackness is that of metaphysical ruination, a menace which is perennial rather than contingent, even as the

vicissitudes of history may occasion and distill its convulsive disclosures.[42] It is thus unsurprising that Crow sees the signaling African's muscular angularity "thrusting into virtual space," for this figure is not only made to mediate the actuality of colonial loss and the anticipatory extension toward redemptory conquest, but, insofar as the viewer can feel his thrust into the virtual as a movement of ascendance or penetration into potentiality, the viewer manages to displace the looming menace of a vertiginous descent from the thinkable "world of possibilities." In these respects, his function is not dissimilar from that which the figure of the black man has been made to assume in various guises through the centuries. As David Marriott declares: "From the public spectacle of lynchings to the private dramas of erotic consumption, lynching scenes to 'art' images of black male nudes, what is revealed is a vicious pantomime of unvarying reification and compulsive fascination, of whites taking a look at themselves through images of black desolation, of blacks intimately dispossessed by that selfsame looking."[43] In this instance, I would suggest, the signaling African becomes the mechanism for recovering the "selfsame looking" that the metaphysical specter of slave revolution threatened to leave in ruins. Yet the immanent peril of ruination is never quite shaken. As we shall see, every exercise in displacement is also the (racially gendered) reproduction of the very corruption it had sought to escape. To the extent that the black masculine figure becomes the medium of this reproduction, we may say, by way of Hortense Spillers and Joy James, that he bears the touch of the captive maternal.

These existential anxieties undergird both Géricault's painting and Crow's reading of the painting through the *Belvedere Torso*. At one level, Crow's optimistic reading echoes those of other art historians who have, as Grigsby observes, interpreted *Raft of the Medusa* "as a radically democratic vision of a collective body that rises from its martyrdom to support society's most marginalized constituent, the black man, at its apex."[44] In such readings, the signaling African serves as "both the compositional climax and the optimistic narrative resolution of a picture otherwise devoted to the suffering of a ravaged body politic."[45] What is distinctive about Crow's reading, in other words, is not his instrumentalization of the figure of the signaling African toward the aesthetic reconstitution of the European social body and the universal humanity which it has always taken to be its mirror image but rather the means of his instrumentalization: the transposition of the *Torso*

onto the African's bodily fragment, the fleshly transmutation of paint to stone and of stone to paint, the vivisectory suture of black (inter)mediality.

Rancière, as we have seen, inverts the aesthetic significance of the *Torso* through the event of Winckelmann's reading, claiming that here the statue decomposes the relational correspondence of parts and whole, as well as the tether between visible form and representational content. Yet even as Rancière would nominally decry the phantasmatic scavenging for, in Verity Platt's words, "the *disiecta membra* of the past in order to access an ideal, animated whole in the present," I would argue he remains invested in a "re-membering" of the *Torso* that establishes a general consonance with Crow's reading.[46] For even as Rancière extracts from the *Torso* a seemingly radical contingency, the event of Winckelmann's reading nevertheless produces an ontological map whose topological axes—history and "the people"—are not so different from those by which Géricault's or Crow's gazes navigate. If anything, Rancière figures the eighteenth-century life of the *Torso* as the inauguration of an aesthetic regime that Crow would turn to the *Torso* to redeem. Granted, where Crow finds the reconstitution of the social body, the redemption of the sensus communis, Rancière finds a multiplication of indeterminate social bodies, an ontological pluralization of sensus communis, which ultimately lend themselves to Rancière's metapolitics of "dissensus" and its contests over the "distribution of the sensible."[47] However, the dissensual incorporation of new subjects, new ideas, and new feelings into the sensus communis, which Rancière would regard as transformational, is nevertheless also the confirmation of that sensible community's foundational interdictions. Within the racial regime of aesthetics, the black can only ever enter as the singular dereliction that cuts the border between the thinkable and unthinkable, between sense and non-sense.

A crucial argument of *Anteaesthetics* is that black aesthesis, as that which emerges in the abyssal cut between black existence and black nonbeing, between the dissimulated 'black body' and enfleshment might become conscripted into the production or mediation of a Rancièrean aisthesis—"a thinking that modifies what is thinkable by welcoming what was unthinkable"—but it can never itself be "welcomed" as the thinkable, for it is forced to bear the unassimilable, the obdurate, the irreducible, the exhaust(ion) of the world's antiblack metaphysics. The black bodily fragment as a (dis)figuration of this cut is indeed serially made the medium for the

reconstitution of the social, whether through the redemption of the old or the fabrication of the new, but only through the reproduction of its own negative sign. The black bodily fragment is a dissimulation of the absent center upon which the corporeal division of the world and its organization of (social) bodies are founded. It is a part which can neither refer to a prior or future whole nor bind or liberate the relay between its visible form and representational content, for the enfleshed existence from which it is riven is the black hole which swallows the light of representation. This is the aporia within Crow's operation. For if, as Grigsby suggests, the French Revolution intimated that "it was the assaulted, dismembered body that most acutely vivified the exigencies of the abstract ideal of equality,"[48] then this held only insofar as this dismembered body could be made to signify, elegiacally or triumphantly, an undivided body politic, a sovereign body. But although the black bodily fragment can be made to mediate the agonistics which inhere to bodily sovereignty, individuated and social, it cannot help but tear the metonymy of being and existence, for it remains a semiotic isolate. What happens to an aesthetic that depends upon a contaminant for the purification of its system of signs?

Painting's Ecologies of Consumption

Let us turn once more to Géricault's Montauban study, or the *Study for the Signaling Black*. The distinctiveness of the oil study lies in its paradoxical status as an esquisse, a finished sketch whose oiled portion is intentionally left unfinished. Meaning is made in the tension between what is seen and what is not seen, in the figure's fluctuation between the sketched line, the materiality of paint, and the blankness of the canvas. We may recall here Derrida's provocations on drawing, wherein the trait cannot help but "escape the field of vision," cannot help but signal a play of absence/presence, visibility/invisibility, finitude/infinitude, mimesis/différance which "remains abyssal."[49] The overwrought and radically undone quality of the body in Géricault's oil study never completely settles; the *Signaling Black* invites us to linger in the oscillation between the appearance of the body's form and its deconstruction.

Alhadeff's interpretive description of the study, referred to earlier, serves to illustrate the visceral transit between completion and incompletion, on

the one hand, and the rend(er)ing of the (black) body, on the other. Alhadeff's reading, which stresses the "furtive coloring" of the oil, demonstrates precisely how the "extraordinary power" of the 'black body,' displayed in the "full back" and "flexed right arm," is explicitly accented by posterior perspective. The descent of the body's curved line focuses a dorsal view obsessed with the visceral detail of the "flexed back," whose motif signifies "Géricault's own vigorous black" as "a composite of hard muscles."⁵⁰ More than any other aspect of the body's physicality, the problematic specifically of musculature, which is expressively made manifest in "the sinewy arm . . . bent at the elbow, muscularly piercing space," seemingly overdetermines the figure's provisional appearance. Judging by the muscular diffusion of its reverse motion, one is almost tempted to say that Géricault knows this body as dissimulation, but only insofar as he regards the figure as his to do with as he pleases, for it is not, after all, a "real" body. This is a provisional body rend(er)ed for the world—cut and splayed—but not one which could ever exist within the world.

However, as we learn, Géricault himself would elect not to remain faithful to the extreme musculature of the oil study. When we arrive at the epic scene of the *Raft of the Medusa*, as Alhadeff explains, "it is clear that the overripe musculature Géricault was then favoring would not do. His hailer should not be as Michelangelesque, rather he should merge with the others and not stand apart—he should be a *naufragé* like the others, but a *naufragé* of dark color."⁵¹ Their dispossession must be fashioned as common, just as the black must remain "the most dispossessed of them all," for without his constitutive dereliction there could be no common to hold up or be held within. Between the *Raft* and the studies that precede it, the sinews of the signaling black's musculature are toned down. When we consider that the racial fetish of musculature—a petrification which becomes especially conspicuous in Crow's transposition of the *Belvedere Torso* onto this figure—is one of the principal means by which the African's dissimulated 'body' is rendered a vessel for the redemption of universality and the reconstitution of the social body, we are left to wonder why Géricault ultimately decided to scale back this figure's physicality. Indeed, as Alhadeff observes, "the Montauban torso proclaims with mesmerizing force greater than its counterpart in the finished canvas, that its will, presence and fortitude will save the crew."⁵² What art historical discourse inadvertently shows us, in the aes-

thetic journey from the earlier studies to the epic scale of *Raft of the Medusa*, is the structural advance of a contradiction between the phobic and philic registers of the visual. For if the colonized is at times seduced, as Fanon suggests, "by the mirage of his own muscles' immediacy," then the colonizer nonetheless recognizes in this dissimulation the trace of a "muscular tension" borne in and by black flesh,[53] a tension which portends an immanent/imminent threat of violence that exceeds even the bloodiest imagination—a "decolonial violence [which] amounts to . . . an affirmation of the endless interruption of the political as such."[54]

The transposition of the ideal body of classical antiquity onto the black, an operation of pornotroping and petrification in which Negrophilia reigns ascendant, proceeds—perhaps can only proceed—by way of the phenomenological reduction of black flesh to bodily fragment. ("What lies before us then is only a fragment of a whole."[55]) Yet that gesture cannot escape its imbrication with Negrophobia. Thus, if, as Jaś Elsner provocatively suggests, art history is "nothing other than ekphrasis,"[56] then the black functions within that discourse as the figure who lacks a descriptive term, or rather whose appearance is nothing more and nothing less than the set of descriptive terms assigned to him; the black bears the endless accrual of those terms and their attendant figurations (the "vigorous black" stands as "a grand figure, even Michelangelesque," "a compact mass with . . . rippling muscles," an "unrivaled presence"). And yet, because every dissimulative appearance of the black is necessarily tethered to the exorbitance borne by the conscripted (re)productivity of the flesh, these appearances also carry something infinitely more and less than what art historical discourse delimits and demands.

With respect to the *Raft* and its genesis, we must therefore remember that "Negrophilia and Negrophobia are of the same psychic mix."[57] Indeed, Negrophilia and Negrophobia are the indiscrete libidinal poles of an aesthetic operation which conscripts the black as the medium, not only for the making of form but, moreover, of form which at once exhibits and mediates an expansive array of metaphysical agonistics. What are we to make, for example, of the fact that Géricault's signaling black hinges upon a bodily fragment which, in the broader context of Géricault's oeuvre, could just as easily be associated with the bloody limbs of sundered flesh, with the visceral specter of mortality as with the exalted torso of classical antiquity and its exhi-

bition of the *"beau idéal* of masculine form"? Such slippages were not lost on Géricault's contemporaries. Thus, while Delacroix celebrated Géricault's bodily fragments as "truly sublime . . . the best argument in favor of Beauty as we must understand it,"[58] Jean-Auguste-Dominique Ingres, commenting on Géricault's *Raft of the Medusa* and images of severed limbs in the 1840s, could not have been more opposed: "I don't want any part of the Medusa and the other pictures of the dissecting room which show man as a cadaver, which show only the Ugly, the Hideous. No! I don't want them! Art must be nothing but Beauty and teach us nothing but Beauty."[59] Ingres, whose paintings would play a crucial part in the nineteenth-century ascendancy of the female nude, is taken up at length in the following chapter. As we shall see, his adamant separation of the beautiful from the ugly, of the *beau idéal* of feminine embodiment from the hideousness of the dissecting room and its cadavers, was not so much a refusal of the black bodily fragment as it was symptomatic of a form which requires an even deeper concealment of rend(er)ed black flesh: the female nude.

In any event, Ingres's indictment was not pure hyperbole, for Géricault did indeed frequent the dissection amphitheaters and morgues of hospitals,[60] scenes that no doubt were variously transposed onto the bodily fragments formed by his own hand. For Nina Athanassoglou-Kallmyer, Géricault's fascination with riven flesh "tread[s] the uncertain ground between empathetic social statement and delight in social horror."[61] These affective valences are not in fact irreconcilable; they are complementary means of "achieving a common subversive goal": namely, flouting the aesthetic strictures of elite sensibilities and thereby "setting the stage for a new aesthetic, of the realistic and modern, in rebellion against the conservative establishment of his time."[62] Be that as it may, I would suggest that reading Géricault's aesthetics of sundered flesh and the viscera of mortality, as well as its resonances with a more general European attraction to the gothic, simply as a refusal of conservative mores and the hierarchies of class to which they are bound obscures the manner in which these aesthetics flirt with the edges of a deeper set of metaphysical problems. The slippage of Géricault's bodily fragments between the registers of the vitalist and the deathly, between the beautiful and the grotesque veers up against the metaphysical partition separating the living from the nonliving, the boundary of which, within the modern world, the black has always been made to mediate.

Negrophobia and Negrophilia converge at the site of this indispensable black mediality, which serves to prevent the living and the dead from spilling across the borders of their respective metaphysical enclosures. Their aesthetic interplay is clearly at work in the *Raft*'s ascendant and descendent narrative—descendent and ascendant because Géricault's *Raft* at once depicts the black as the signal medium for ushering in a post-revolutionary hope, while simultaneously rendering the black as the debased "imago of [the] cannibal," thereby accentuating the contradictory and complementary valences of "racial phantasmagoria" that comprise Géricault's epic scene (see figure 9).[63] The nightmarish vision of cannibalism is epitomized in the lower right portion of the painting's depiction of the appropriately contrasted "fallen" or "prostrate" black whose "muscled shoulders cover his [white European] companion's thigh[,] . . . his head hang[ing] over his buttocks," disturbingly positioned in intimate proximity to the European's "sex," intensifying a desperately consumptive desire (see figure 10).[64] Grigsby's detailed account, which takes up the importance of Daniel Dafoe's narrative in *Robinson Crusoe* for Géricault's oeuvre, acknowledges cannibalism and colonialism as "inextricably bound" and demonstrates how the paranoiac fear over cannibalism justified the "European's ambition to exercise power over foreign lands and peoples."[65] Cannibalism becomes an aesthetic motif fueling the unregulated life of Negrophobia in the *Raft*. But what I wish to stress here is that the racial phantasmagoria of the scene, which depends upon the dualistic construction of the dissimulated 'black body' as the Negrophilic/Negrophobic image of the cannibal and his introjected foil, exhibits a precarious recuperation of bodily sovereignty at its very limit. The black, who is made to come before the law of the corporeal division of the world, both negatively founds this juridicality's measure and reinvigorates its proceedings, even while threatening to leave the rule of law in ruins.

The complex projection and displacement of the cannibalistic black imago undergirds the shadowy life of the picture, the intimacy of its corpulent terror, which places that imago in imminent relation to an unbounded sense of devouring and being devoured by the other. The braid of "two models of cannibalism—transitive and intransitive, active and passive, hierarchizing and equalizing"[66] animate Géricault's painting. According to Grigsby,

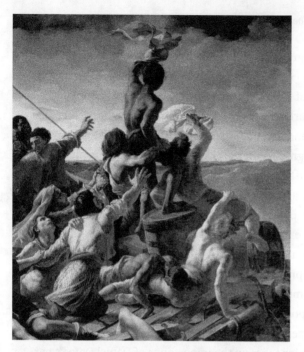

Figure 9. Théodore Géricault, *The Raft of the Medusa*, detail, 1819, oil on canvas, 491.0 × 716.0 cm. Musée du Louvre. Credit: Erich Lessing / Art Resource, NY. Reprinted with permission.

Figure 10. Théodore Géricault, *The Raft of the Medusa*, detail, 1819, oil on canvas, 491.0 × 716.0 cm. Musée du Louvre. © RMN-Grand Palais / Art Resource, NY. Reprinted with permission.

[the] interweaving of cannibalism and colonialism is also circular in its self-justificatory logic: I want to eat you so you must want to eat me; you want to eat me so I must eat you. Like all tautologies, the reasoning is self-fulfilling and without a beginning point. . . . Cannibalism like plague articulates the self (actively) assaulted but also the self (passively) disassembled and unbound. Cannibalism justifies an exercise of violent domination—"I must eat you before you eat me"—but it also conjures a tantalizing, dismantling equality of parts—"a Foot, Toes, Heel." There are anxious, unraveling, and revolutionary pleasures it affords. The king may be undone.[67]

Cannibalism is like plague. The priority accorded both of these metaphors in the nineteenth-century imagination allows us to obliquely glimpse the corporeal antagonisms that animate and suffuse post-revolutionary France and should alert us to the racial phantasmatics deployed to manage and sustain the pretense of bodily sovereignty amidst an incalculable set of material and psychic entanglements. In no small part, bodily and statal sovereignty are always already failed regulative orderings of ecological metabolism, of the unavoidable intimacies of eating and being eaten. If the *Raft* exposes not only the anxieties and unravelings of cannibalism but also the "revolutionary pleasures it affords"—the libidinal surplus of a "sublime somatic materiality" that Eric Santner terms "the flesh"[68]—it is not so that viewers might be touched by sovereignty's obliteration but rather so that they might participate in the jouissance exuded in the passage "from the divine sovereignty of the King to the popular sovereignty of the People."[69]

Yet insofar as this prodigal descent toward the appetites and horrors of the flesh is ultimately channeled back into a reconstituted sovereignty, its excess comes to function, ironically, as a mechanism of aesthetic containment and displacement of the radical nonsovereignty that an absolutely unlegislatable consumption portends. For what is truly terrifying is not the fall into a cannibalistic state of exception but a cannibalism that has neither prior standing to slip from nor glorious redemption or solemn judgment to look forward to. This cannibalism is a metonym for the ecology of difference without separability, in which the boundaries between consuming and being consumed become irrevocably blurred. Thus, in contradistinction, this latter "primordial and unreconstructed" cannibalism[70] becomes projected onto the black as a singularly phobic/philic image of "the scene of nature." As the dissimulation of an unsovereign ecology, the scene of nature legitimates the

sovereign by giving "ontological terror" form. What metaphysical displacements cannot be borne are gathered under the sign of blackness, or rather its (dis)figuration in and as the signaling African and his unreconstructed doubles. In turn, for this dissimulated form to emerge, black flesh, the anterior to the ascensions of history and the ramparts of the socius, must bear the burdens of an absolute exposure before the law, of the nonsovereignty from which sovereignty claims to wrest itself. The black bodily fragment is at once condition, consequence, and contraversion of this operation: the fragment which furnishes the sovereign body, which cannot refer back to the flesh from which it is rent and which, in its reproduction of the cut between blackness as nonbeing and existence without ontology, bears an unsuturable dehiscence.

Opacity, Contamination, Ruination

The inscriptions of erotic terror that attend the ongoing imbrication of the Negrophobic and the Negrophilic are not only germane to Géricault's oeuvre and the repertoires of vision his painting generates and emerges from but also point to the metabolic destabilization of an ecology—a thoroughly racialized ecology of bodies, of flesh and appetites that throws into relief the contingency of violent corporeal entanglement and the breakdown of sovereignty and law. Géricault projects the 'black body' into a scene of aesthetic unraveling, whose visual economy requires that body's dissimulation for the imagined reconstitution of sovereignty and the socius. Between the exaggerated provisionality of the 'black body' in the Montauban study and the physical attenuations that sustain not only that body's rendering but also the subsequent renderings of the final painting's other integral figures, what we confront is the following: the dissimulated 'black body' that subtends the animative tension generated at sovereignty's brink and in the service of sovereignty's revivification. This dissimulation traces the metaphysical displacement of the very flesh that suffuses the painting with ecstasy and horror, delirium and exaltation.

Approaching the racialized displacement of flesh in Géricault's *Raft of the Medusa* requires that we attend to that displacement in and as the problematic of visual saturation. It is not merely the painting's dark cast but the conditions that structure the appearance of what Crow terms its intentionally rendered "dark passages," which heighten just as they strain against its epic

scale and amplify what is perhaps the painting's central conceit: the "unmediated human solidarity" it is thought to lay bare. This passage is worth attending to further:

> The consequent unity of the main group extends to the compelling coherence of the entire composition, which makes its own declaration about the primacy of unmediated human solidarity. In seeking to intensify the dark passages out of which his straining figures emerge—thus rendering the light on the horizon even more salvific—he mixed far too much black bitumen into his medium. The result has been a growing opacity without nuance and the pervasive cracking over much of the work's semiruined surface. A great loss to be sure, but forgoing chapters contain the signal lesson that culminating and consummate work in this period need not announce itself as such; it can and most often does assume the appearance of the provisional or fragmentary.[71]

To approach Crow's reading is to ask after the relationship between darkness and appearance. Darkness, for Crow, is the aesthetic register through which the world is rendered legible and illegible. And it is where darkness veers into opacity that painting runs up against its own formal limitations. Correlating opacity with a lack of visual nuance, Crow ascribes the problematic erosion of the work's surface and the depreciation of its visual representation to a too-black medium. The black bitumen that Géricault is said to have used effectively contaminated his medium, and according to Crow, this subsequently contributed to the work's "cracking," "semiruined surface." But what lingers at the edges of Crow's description is the matter of blackness as the indiscrete source of a *contamination* which is, paradoxically, without origin.

Blackness bears the contamination that is always already held within the pretense of purification, whether that purification assumes the trappings of heritage, destiny, or sovereignty. For although we might be tempted to suggest that Géricault's signaling African necessitated that the "dark passages" of his origin sink into opacity, it is also true that the ruinous opacity this figure may ironically be said to signal is already operative within the form itself, within the metaphysics that allow for its appearance. This is because this figure's dissimulated 'body' is conjured from nothingness, for which origin can only be a catachrestic signifier. As Derrida wrote: "It is like a ruin that does not come *after* the work but remains produced, *already from the origin*, by the advent and structure of the work. In the beginning, at the origin, there was ruin. At the origin comes ruin; ruin comes to the origin, it is

what first comes and happens to the origin, in the beginning. With no promise of restoration."[72] The blackness which contaminates Géricault's painting, the blackness which is exorbitant to an aesthetic register of darkness that would fashion the spatiotemporal origin and terminus of a world threatens far more than a ruined painting; it bears the inordinate force of *metaphysical ruination*. What happens to an aesthetic regime that depends upon an uncontainable contaminant for the purification of its system of signs? What happens to a corporeal order founded upon the expropriative displacement of flesh and the rend(er)ing of 'bodies' which bear an anoriginal corruption and the corruption of origination?

Touch and the Restoration of the World

We have seen that Géricault's *Raft* acquires its aesthetic significance within the nineteenth-century revisions of the social through the redemptive figure of the African whose salvific function is insinuated in the act of signaling the distant rescue ship: "The Europeans below him extend their arms to support his precarious perch on the tipping barrel, but seem at the same time to be reaching out to touch a holy figure."[73] As Crow's phraseology inadvertently suggests, the means of securing this aesthetic function for the signaling African—the figure who supplies a vertex which gathers the broken bodies of "classless stalwarts" and "abandoned souls" into an ascendancy fit for history's epic scale—crucially pivot upon the image of touch, as that which certifies the painting's redemptive aspirations. Touch not only registers the legibility of an a priori historical agency and expressive interiority for the painting's European figures but moreover appears to close and thereby activate the painting's circuit of signification, channeling its unwieldy currents back through a moment of aesthetic recuperation. In the midst of this aesthetic composition, a sleight of hand takes place between a form of touch that would appear to be predicated upon mutual desire and a touch that ought to be read as nothing less than the figural culmination of the violent laying on of hands. This desire to be subjectively made anew through a touch which acts as proxy and extension for black subjugation and its attendant medialities is far from incidental and calls for deeper interrogation. In fact, I contend that it is precisely the (im)mediations of touch, at once evinced and obscured by Géricault's figuration and its readings, that carves the distinc-

tion between those who claim a place within the corporeal division of the world and its aesthetic regime and those who are cast out before the fact, consigned to a constitutive anteriority en perpetua.

The *Raft* invites us to meaningfully reckon with touch, displaying precisely how the textured, haptic materialities that suffuse the visual imagination of a nineteenth-century aesthetic are centrally preoccupied with the corporeal making and unmaking of the world. Needless to say, I am compelled to read against Crow's assessment of the outstretched arms of Géricault's beleaguered Europeans, who would seem "to be reaching out to touch a holy figure," as indicative of a touch essentially benevolent and resolutely salvific. For as Hortense Spillers has rigorously elucidated, the dimensions of touch which would be understood as "curative, healing, erotic, [or] restorative" cannot be held apart from the myriad "violation[s] of the boundaries of the ego in the enslaved, that were not yet accorded egoistic status, or, in brief, subjecthood, subjectivity."[74] Touch, in her view, "defines at once, in the latter instance, the most terrifying personal and ontological feature of slavery's regimes across the long ages."[75] In this instance, the fact that the signaling African forms a metonymic foil for the cannibalistic black to which he is irrevocably sutured brings us straight to the threshold that uncertainly divides the sentimental and predacious valences of touch—the no-man's-land where being looked upon and being consumed become indistinguishable. Marriott specifies this racial scopophilia: "To incorporate, to eat, through the eyes; to want to look, and look again, in the name of appreciating and destroying, loving and hating."[76] The violent (im)mediations of touch to which the black is relentlessly subject, not least at the moment of supposed aesthetic integration, are that which cuts the border of the corporeal division of the world, that which establishes a foothold for its subjects and consigns the black to the abyss.

By foregrounding an aesthetic in which the dissolution of the pretense of bodily sovereignty into the lawlessness of corporeal entanglement is ultimately abated and recuperated through the metaphysical displacement of racialized flesh, *Raft of the Medusa* discloses blackness as the constitutive negation through which the world as such becomes embodied as a chiasmus: the world becomes a social body in which the embodied sovereignty of the state and the embodied sovereignty of the individual become practically indistinguishable. In the reproduction of this corporeal order, the black may be

touched but may not reciprocate that form of touch which registers human sentience, which confers subjectivity in and as mutual (inter)relation. In fact, the black must be subjected to the violent touch of (im)mediation—a terrible immediacy which makes the black a medium for worldly use and dispensation. For it is this touch which keeps the terror of entanglement at bay. It is due to the imperative of maintaining the absoluteness of the boundary that divides those within and those made to come before the corporeal division of the world that the very thought of the black touching back can only be recognized as the danger of being defiled or devoured, regardless of whether this danger is articulated through a philic or phobic register. In fact, the Negrophobic dissimulation of the cannibalistic black may be read, paradoxically, as a means of sustaining the subject's fantasy of being the master of touch who is himself untouched. That is, through the projection of the cannibalistic black as lascivious threat, a threat positioned on the threshold of terror and desire, the subject is able to definitively anchor, nominally contain, and thus effectively evade that which is truly and unredeemably terrifying: the touch of entanglement—a touch without form, a touch that would seem to devour form itself from within and without. The subject, the self-declared master of touch, may thereby sustain his pretense to bodily sovereignty by sublimating the unmitigated terror of entanglement through a projection that blurs the libidinal poles of the Negrophobic and Negrophilic. Thus, the corporeal drama of *Raft of the Medusa* discloses the paradoxical desire for and terror of being-touched that lies at the heart of the (self-) possessive grammar of the corporeal division of the world and the reliance upon the expropriative displacement of black flesh for the resuscitation and extension of the sovereign (social) body.

The (Im)mediations of Touch

The racially gendered differentiations in the violent (im)mediations of touch, which reproduce the black as the absent center of the corporeal division of the world, are typified by another contemporaneous image, one not typically associated with the ascendency of French Romanticism but rather with the "golden age of caricature": Louis François Charon's c. 1814–1815 hand-colored engraving *Les Curieux en extase, ou les cordons de souliers* (The curious in ecstasy, or shoelaces; figure 11). While of course one cannot compare

Les Curieux en extase and *Raft of the Medusa* in terms of medium, genre, or formal specificity nor in terms of the repertoires of aesthetic judgment that condition their respective receptions, they are nevertheless each implicated in the history of Romanticism, no matter how unevenly. As Ian Haywood writes in *Romanticism and Caricature*:

> The fact that the originality of caricature stems from its conspicuous invest-
> ment in the transformative powers of the imagination evokes a parallel with
> Romantic aesthetics, though the relationship is characteristically unstable. It
> is certainly possible to argue the merits of caricature as a Romantic art form,
> both in its visionary and anti-authoritarian methodology and in its energetic
> exploitation of the major artistic genres of the period (history painting, the
> sublime, the portrait, the conversation piece), but these influences are nearly
> always intermingled with the *frisson* of sensationalist motifs drawn from both
> traditional and newer cultural sources. To the extent that it showcases a dis-
> torting application of the inspirational imagination, we can regard caricature
> as renegade Romanticism.[77]

Figure 11. Louis François Charon, *Les Curieux en extase, ou les cordons de souliers*, c. 1814–15, hand-colored etching, 222 × 295 mm. The British Museum. Reprinted with permission.

Though a detailed account lies beyond the scope of this study, it is important to bear in mind that the variegated repertoires of Romanticism were deeply, if differentially, implicated in the material and discursive contests within, around, and against abolitionisms, the liberal iterations of which underwrote not only the serial realization of emancipations as "nonevent[s]" but also the concurrent and subsequent imperialist expansions into Africa and Asia, as well as ongoing settler colonial dispossession and genocide in the Americas.[78] I am not so much concerned with whether Géricault and Charon's works can be assigned a common lineage within the formally and generically expansive tradition of Romanticism or even with how these two artworks might contrastively figure in a historicist account of the contemporaneous politics of slavery and abolition. What I am concerned with is the manner in which a comparison of the two works serves to elucidate an early nineteenth-century aesthetic unconscious that had thoroughly internalized the racially gendered constitution of the corporeal division of the world and its disjunctive orders of touch. That is, I am interested in the manner in which the "imaginative excess" and "the carnivalesque openness of Romantic visual satire . . . simultaneously absorb[ed and reproduced] . . . the prevailing hegemonic and counter-hegemonic discourses" of the period.[79] Indeed, it is telling that the genre of caricature is one of the primary sources of contemporary encounters with the afterlife of a figure whose necropsistic rend(er)ing constitutes *"the* master text about the black female body."[80] As Marcus Wood has shown, graphic satire was one of the most influential forms of the visual representation of slavery and empire in England, and the figure of the black slave played an important role in mediating popular political imaginations, not least by providing a means of contrasting the putative benevolence of British empire with the brutality and imbecility of slavery in the American South.[81]

Les Curieux en extase is only one among many satirical images representing Saartjie Baartman,[82] the so-called "Venus Hottentot," a Khoikhoi woman (or so it is generally believed) who was notoriously enslaved, sold, brought to London in 1810, and degradingly exhibited for English, Irish, and French audiences until her death in Paris in 1815, when the European fixation with her anatomical exoticism culminated in the dissection and preservation of her corpse by Georges Cuvier. In the following chapter I take up the terrible import of Baartman's singular, exemplary, and utterly unexceptional

history for a theory of the racially gendered vestibularity and dehiscence of blackness to and within the racial regime of aesthetics and the corporeal division of the world. For now, let us turn to T. Denean Sharpley-Whiting's astute observations and critical reflections on *Les Curieux en extase* in order to draw out the commonalities and distinctions in the operations of racial (un)gendering in these two nineteenth-century visualizations of the (im)mediations of touch:

> In *Les Curieux en extase*, in which the French cartoonist pokes fun at the British fascination with the Venus, Bartmann is displayed on a pedestal engraved with LA BELLE HOTTENTOTE. She has arrested the gaze of three men, two British soldiers and one male civilian, and a female civilian. There is also a dog in the drawing, representing the base, animal-like nature of the human spectators, the proverbial "we are all animals" sentiment, and participating in its own sort of voyeurism as it looks under the kilt of one of the Englishmen. One soldier, behind Bartmann, extends his hand as if to touch her buttocks and proclaims, "Oh, godem, quel rosbif!" (Oh, Goddamn, what roast beef!). The other soldier, looking directly into her genitalia, remarks: "Ah, que la nature est drôle!" (Ah, how amusing nature is!). The male civilian, peering through lorgnettes, declares: "Qu'elle étrange beauté!" (What strange beauty!), while the female civilian, bending down to tie her shoelaces—hence the cartoon's subtitle—looks through Bartman's legs and utters: "A quelque chose malheureux est bon" (From some points of view misfortune can be good). The woman is, however, looking not at the "Hottentot," but through the opening between her legs and up the kilt of the soldier behind Bartmann. Thus, from her angle, she sees through Bartmann's "misfortune," her openness, or rather, the opening between her legs, something more pleasing. Bartmann's body is inscribed upon from various perspectives. She becomes, all at once, roast beef, a strange beauty, an amusing freak of nature, and erased, invisible, as the female spectator privileges the penis. And while the points of view appear to reflect different positionalities, the ways of seeing the Other as exotic, amusing, invisible, and as something to be eaten or consumed like roast beef reflect sameness.[83]

In *Les Curieux en extase*, the constitutive imbrications of the racial economies of visuality and touch are even more glaring than in *Raft of the Medusa*, in part, of course, because of the image's overt satirization of the British fixation on the debased and debaucherous spectacle Baartman's exhibitions are taken to be. As if parodying its own dissimulative function, even the deployment of uniform skin tones in this hand-colored etching becomes part of the

punch line of a cruel joke, as if to jeer at the very idea that there could be any corporeal commonality between Baartman's 'body' and those of her onlookers. Unlike Géricault's *Raft of the Medusa*, in which racial valences of touch are unambiguously visualized, both in the laying of hands upon the signaling African's salvific 'body' and in the ineluctable specter of cannibalism, in *Les Curieux en extase* the thematic of touch is omnipresent, yet appears curiously unfulfilled. "One soldier, behind Baartman, extends his hand as if to touch her buttocks," the preeminent anatomical site of the libidinal projections to which Baartman was subject, a movement which appears caught between obscene erotic appetite and abortive restraint. His exclamation "Oh, Goddamn, what roast beef!" doubles down on this racially gendered insatiability, on this implacable hunger for black feminine flesh.

However, unlike *Raft of the Medusa*, here there is no pretext of differential bodies precariously united beneath an "abstract ideal of equality," no pretense of a universalist aesthetics of dis-integration. For while Géricault's *Raft* and Charon's *Les Curieux en extase* similarly fashion aesthetics through the expropriative displacement of black flesh, the redemptive figure of Géricault's signaling African is ostensibly positioned as integral to and valorized within the aesthetic scene he is marshalled to establish. Even the specter of cannibalism that hangs over Géricault's scene can nominally present itself to the viewer as the subsumption of the masculine black bodily fragment within a "tantalizing, dismantling equality of parts." In contradistinction, *Les Curieux en extase* stages a scene marked by a radical incommensurability of bodies, wherein the representational cohesion of the image pivots upon the expulsion of Baartman's figure from any universalist iteration or aesthetic valorization of corporeality. Here the soldier's appetite derives not from an equalizing erotics but as an unequivocal sadism. The libidinal animus of the scene and the manner in which it turns upon Baartman's dissimulated 'body' dissolves any putative distinction between the articulation of desire and the imposition of terror and degradation. Here the fantasy cannot even formally be construed as cannibalistic, for its visualization also marks a species-distinction, whereby the black feminine is relegated to the scene of nature and, apropos Hortense Spillers, rendered "the principal point of passage between the human and non-human world." ("Ah, how amusing nature is!")[84] Nevertheless, like Géricault's signaling African, perspectively rendered as the culminating point of ascendance, Baartman is

visually "inscribed upon from various perspectives." Indeed, the dissimulated black 'body' is always distinguished by the ubiquity and accumulation of phenomenological inscription, in which the register of the visual becomes inseparable from the operations of touch.

Yet why is it that, in Géricault's *Raft of the Medusa*, black masculinity is rendered through the visual fulfillment of racial touch (and is overtly laden with the European anxiety over being touched in return—that is, in the imago of the cannibal), whereas in *Les Curieux en extase*, the visualization of the figural "master text" for black feminine embodiment and the antiblack libidinal economy that requires her dissimulated 'body' leaves touch unconsummated within the register of appearance? This problematic is anticipated by a declaration made in the letters of Peter Abélard, one of the preeminent philosophers and theologians of the European Middle Ages, with which Sharpley-Whiting tellingly opens her book: "It so happens that the skin of black women, less agreeable to the gaze, is softer to touch and the pleasures one derives from their love are more delicious and delightful."[85] *Les Curieux en extase* reiterates this figuration in and through Baartman's dissimulated 'body,' rendering the black feminine both as visually obscene (yet transfixing) and as soft, pliant, alluring in the singularity of "her openness" to touch. Consider, however, the seeming discrepancy between the former figuration of blackness and that which is highlighted by cultural historian Constance Classen as exemplary of the modern European racial taxonomy of sensoriality:

> While white bodies . . . were said to have fine skins and mild odors, black bodies were associated with coarse skins and pungent odors. The author of one mid-nineteenth-century treatise on racial differences proclaimed: "From the skin of the purely white race is exhaled a pure and agreeable odor, while from that of the [African] . . . a great amount of this rank oder [*sic*] is exhaled, as it is, of course, distilled through a coarse system and unrefined, coarse-grained flesh."[86]

How is it that the epidermalized skin of blackness is figured as "softer to touch" in Abélard's text and "coarse" and "unrefined" in J. L. Stewart's 1866 treatise? While it would be easy to attribute the diametric opposition to the span of history that separates the High Middle Ages and nineteenth-century modernity or to the fact that the first example is gendered feminine and the

second is gendered masculine, I would argue that neither explanation would be sufficient. For not only does Classen emphasize continuity between the European Middle Ages and modernity on this score, but neither description of blackness would be foreign to the racial lexicon that insinuates the contours (and excommunications) of the present dispensation of the corporeal division of the world. And although we can certainly discern an important gendering across these Negrophilic and Negrophobic registers of dissimulation, what is most significant is in fact their constitutive entwinement, in and through the matter of touch. What reading across or at the conjoinment of these registers underscores is that no visual or tactile experience of phenotypic difference emerges apart from the racial phenomenology of touch. The ontic status of touch is, in turn, a far more complex problematic than its positivist baggage would suggest. In fact, it is my contention that the antiblack metaphysics which structures the modern world emerges in no small part as a means of managing, containing, and displacing the unwieldy materiality of touch.

Thinking with and through Jean-Luc Nancy's deconstruction of touch, Derrida writes: "It is perhaps that touching is not a sense, at least not one sense among others."[87] Indeed, for Nancy, touch is far from "one sense among others," or "the sense of 'touch' as a setting of limits for (the) sense(s)."[88] For Nancy, "sense *is* touching," and "this touching is the limit and spacing of existence."[89] What interests me here is that Nancy's welcome deconstruction of touch as axiomatic tactility, as a discrete constituent among "the five senses," is coupled to an intransigent investment in "spacing." What is more, Nancy regards this spacing as the condition of possibility for touch (as for the body, and place, and the world). Accordingly, Nancy rejects touch in or as immediacy, for "immediacy . . . would fuse all senses and 'sense.' Touching, to begin with, is . . . local, modal, fractal. . . . Thus the bodies of lovers: they do not give themselves over to transubstantiation, they touch one another, they renew one another's spacing forever, they displace themselves, they address themselves (to) one another."[90]

Yet I would argue that the thought which is foreclosed by Nancy's philosophical commitment to spacing is the touch of entanglement—the haptic descent which breaches phenomenology's relay between subject, body, and world, which leaves the very pretense of individuation, to say nothing of sovereignty, in ruins. Collapsing the distinction between inside and outside and

dissolving the tether between individuation and difference, hapticality, as I theorize it, is an antephenomenological formulation—the touch of an existence as "difference without separability,"[91] which unmakes every codification of sensoria that undergirds the corporeal division of the world. And it is the terrors and marvels of this touch to which blackness is at once given and relegated; it is this touch the black is made to mediate precisely through the violence of (im)mediation. The black is both absolutely exposed to the immediacy of entanglement and conscripted into the mediality of its expropriative displacement by and for the subject and the ontology she or he takes for home.

Les Curieux en extase exemplifies both the violent (im)mediations of touch and their disavowal. The latter works to contain the categorical separation and hierarchical ranking of vision and touch that is customary within modernity's racial ocularcentrisms. Indeed, as Classen notes, it was during the early nineteenth century that this sensory regime became thoroughly codified:

> Touch was typed by the scholars of the day as a crude and uncivilized mode of perception. In the sensory scale of "races" created by the natural historian Lorenz Oken, the "civilized" European "eye-man," who focused on the visual world, was positioned at the top and the African "skin-man," who used touch as his primary sensory modality, at the bottom. Societies that touched much, it was said, did not think much and did not bear thinking much about—except perhaps by anthropologists . . . [for they had not] risen above the "animal" life of the body.[92]

Thus, while *Les Curieux en extase* parodies the English precisely for their erotic fascination with Baartman—as the paradigmatic figure for black femininity's dissimulated "openness" to touch—it stops short of visualizing the physical consummation of the touch Baartman's gratuitous 'body' is presumed to invite. Instead, we find a concatenation of gazes whose erotic overtones are tempered by the aesthetic judgment that marks their delivery. Baartman, who is silent and apparently disengaged, the visual object of her English spectators' aesthetic judgments, becomes the means of salvaging their place within the corporeal division of the world, even as the parody also suggests she is the source of their imminent defilement.

And yet Baartman is hardly left untouched. The spectators' gazes conspicuously inscribe Baartman's dissimulated 'body' as if the artist had

unconsciously caricatured epidermalization itself. Yet Baartman must be figured as constitutionally incapable of touching back, of disturbing her spectators' pretenses to self-possession, and it is precisely for this reason that the spectators' rapaciousness must remain nominally truncated. For without the bulwark of aesthetic judgment, which, as we see in the following chapter, sustains the distinction between an erotics of the sensual and an erotics of depravity, their desire to touch Baartman would bring them dangerously close to admitting being already touched themselves, already contaminated.

This contradictory, unstable libidinal economy of touch and the manner in which its displacements become tied to ocularcentric visuality as the sign of an exclusive capacity for aesthetic judgment is evident even in the cruel satire of the stage name she was assigned, the "Hottentot Venus."[93] Moreover, this misnaming, which is also a (dis)placement before an aesthetic taxonomy in which she falls below even the basest rung of imaginable forms, is not peculiar to Baartman but, as Spillers teaches us, general to black femininity.[94] On the one hand, the term "Hottentot" is a racist ethnonym assigned the Khoikhoi (meaning "people of people")[95] society of southwestern African by the Dutch, a pastoral people who lived alongside the San, whom the Dutch dubbed "Bushmen."[96] Today these two peoples are generally referred to with the unitary ethnonym of Khoisan (previously Koïsan), a biocentric racial designation coined by German anthropologist Leonhard Schultze in his biometric study of the "Bushmen" and "Hottentot" societies and later popularized by the British anthropologist Isaac Schapera.[97] "Hottentot" was a putatively onomatopoeic epithet, meant to mimic "the inarticulate gabbling, clicking and clucking of the poultry-yard: the sounds made by 'beasts' and creatures which were half ape."[98] It is, in other words, an antiblack denomination which reprises not only the bestialization of the African but moreover the European as the pinnacle of an ocularcentric ordering of sensoria insofar as "the scopic attains a position of value in its paramount instantiation as script," to invoke Lindon Barrett's insight.[99]

On the other hand, "Venus," while of course no less a contemptuous designation, was deployed not only to ridicule the very idea that Baartman could lay claim to the aesthetic category of beauty but also to refer to the multiple figurations of Venus. As Sharpley-Whiting observes, Venus was not only "the Roman deity of beauty . . . [but] also revered as the protectress

of Roman prostitutes."[100] Lynda Nead's critical commentary on Kenneth Clark's canonical work on the nude (a form to which we will return) further clarifies the manner in which Venus's modern readers have often split her figuration into a hierarchized aesthetic taxonomy:

> [Clark] attempts to keep the domains of the sensual and the spiritual apart by dividing the female nude into distinct types: Venus (1) and Venus (2) or the Celestial Venus and the Earthly Venus (Venus Vulgaris). Here again, Clark draws on a classical tradition and its later humanist derivatives. . . . Celestial Venus is the daughter of Uranus and has no mother. She belongs to an entirely immaterial sphere, for she is without mother and matter. She dwells in the highest super celestial zone of the universe and the beauty that she symbolizes is divine. The other Venus, Earthly Venus, is the daughter of Jupiter and Juno. She occupies a baser dwelling-place and the beauty symbolized by her is particularized and realizable in the corporeal world. While Celestial Venus represents a contemplative form of love that rises from the visible and the particular to the intelligible and universal, Earthly Venus represents an active form of love that finds satisfaction in the visual sphere. According to the same theory, no value whatsoever can be attached to mere lust, which sinks from the sphere of vision to that of touch.[101]

Thus, "Hottentot Venus" is not simply a racist epithet but a denomination that engages in a complex semiotic labor, too readily obscured by the presumed triviality of satire; it is a name which reinscribes black femininity's vestibularity to the racial regime of aesthetics and the corporeal division of the world. Baartman is everywhere subject to the regime of aesthetics, in fact an object of intense fixation, yet denied aesthetic value, just as she is everywhere corporealized yet made to negatively mark the entrance into the corporeal division of the world. Fallen far below the immaterial purity of Celestial Venus, beneath even the debased earthly corporeality of Venus Vulgaris, Baartman "sinks from the sphere of vision to that of touch."

In *Les Curieux en extase*, Baartman's figure is overtly conscripted into this operation of expropriative displacement, positioned as the medium of her own dissimulation. This black mediality is perhaps most obvious from the vantage of the Englishwoman, from whose gesture the piece tellingly acquires its name. Whether the "misfortune" the Englishwoman deigns to look through is taken to be Baartman's degraded circumstances or degraded constitution is of little consequence (for the Englishwoman, they are no

doubt one and the same). Baartman is made the medium for the satirical rendering of the gendered repertoires of white kinship; she becomes a prism through which one can discern the apparatic refraction of a racial-sexual economy not only from which she is barred but for which she is the constitutive interdiction.

The scene of Baartman's dissimulation is unable to escape the volatility inherent in its aesthetic ambitions, for Baartman must be simultaneously figured as the "degraded essence" of touch yet barred from any agential capacity within the phenomenology of touch she mediates in the immediacy of her "openness." The touch of entanglement she is made to bear must be simultaneously harnessed and contained, spectacularized and disavowed. This unsustainable logic is at work in every instantiation of Spillers's prominent assertion that "the captive body translates into a potential for pornotroping and embodies sheer physical powerlessness that slides into a more general 'powerlessness.'"[102] In fact, the analytic of pornotroping directs our attention both to the medium of (intra)exchange for these economies of visuality and touch and to a rupture within the phenomenological operations that are presumed to structure experience of these economies. Pornotroping, as Alexander Weheliye suggests, stages "the simultaneous sexualization and brutalization of the (female) slave, yet—and this marks its complexity—it remains unclear whether the turn or deviation is toward violence or sexuality."[103]

Pornotroping thereby accentuates not only the anteriority of (anti)blackness to "modern sexuality as such,"[104] as Weheliye insightfully contends, but also the inextricability of the violence of dissimulation from the violence of fleshly violation, underscoring a form of touch which cuts across the putatively discrete registers of visuality and tactility, though not in the reciprocal sense too often romanticized in phenomenology. For insofar as we begin from the vantage of Baartman and her dissimulated 'body,' there is an obvious disjunction in the phenomenological relays of seeing and touching famously elaborated by Merleau-Ponty, whereby, in Judith Butler's gloss, "the acts of seeing and being seen, of touching and being touched, recoil upon one another, imply one another, become chiasmically related to one another."[105] Baartman's figuration marks the absent center of Merleau-Ponty's chiasmus, interdicted from reciprocity, boundlessly opened to the immediations

of touch precisely so that the touch of entanglement can be mediated for the phenomenological subject.

While Baartman's conspicuous placement at the center of *Les Curieux en extase* would lead us to believe this image posits her as the subject of its frame, in fact the visualization of Baartman's presence is little more than a phenomenological feint. If the image can be said to picture the corporeal division of the world or at least the gendered dramas of this order's upper echelons, then Baartman's dissimulative inclusion within its purview signals an anteaesthetic figuration, the inadmissible prerequisite of every body. As one among countless dissimulations of Baartman's 'body' that saturated nineteenth-century European imaginaries, *Les Curieux en extase* discloses not only the violent rendering *of* touch but moreover the (im)mediations of touch *as* rend(er)ing—of body from flesh, of measure from irreducibility, of appearance from existence without being. Anna Arabindan-Kesson astutely observes that "the Black female body . . . comes into the visual field as a site of production."[106] Indeed, here it becomes clear that Baartman's exhibited 'body,' cut by and splayed across the play of gazes, in fact (re)produces the visual field in and through subjection to the (im)mediation of touch. The myriad inscriptions upon and conscriptions of her dissimulated 'body' become the means of negatively securing the corporeal division of the world, along with the dualistic partitioning and hierarchical ordering of the world of sense and sense of the world this corporeal division requires (for example, vision over touch, the human over the animal, the immaterial over the material, the inorganic over the organic, and so on). Moreover, Baartman "becomes, all at once" not only "roast beef, a strange beauty, an amusing freak of nature, and erased, invisible" but, more pointedly, an aesthetic medium for managing and containing the volatilities which necessarily inhere to this catastrophic sensorial order for absorbing and refashioning the material and psychic displacements the corporeal division of the world requires. At once unexceptional and exemplary of the violent mediality which generally structures the singular (re)productive burdens of black femininity, Baartman gestures to the labyrinthine brutalities inherent in being made to come before the antiblack world—at once vestibular to this world (its metaphysical threshold and abyssal limit) and always already subject to its countless (aesthetic) depredations.

In the following chapter, I delve deeper into the manner in which Baartman—as a paradigmatic instantiation of black feminine anteriority—was ruthlessly instrumentalized in service of an interwoven series of aesthetic, epistemic, and biopolitical transformations during the nineteenth century. Taking Mickalene Thomas's multimedia installation *Me As Muse* (2016) as our point of departure and return, we shall see that Baartman's trace is manifest everywhere and nowhere within aesthetic modernity (nowhere but in and as dehiscence) and not least where it is most unwelcome: before one of modernity's most canonically entrenched artistic forms, the female nude. Before turning to Baartman's vestibularity to nineteenth-century innovations in aesthetic form, however, I turn to the hermeneutic pitfalls that seem to plague even critical approaches to corporeality, aesthetic personhood, and the racial gendering of blackness in order to draw out the crucial distinction between an existence made to come before the corporeal division of the world and the variously positioned subjects who insinuate their "bodiedness" within the corporeal division of the world. For to ask how we might read Baartman's dissimulated 'body' or attend to her violated flesh in a manner that yearns for something more than simply reiterating the violence to which she has been subject (even if the reiteration of this violence is ultimately inescapable) is also to ask after the reproductive life of the aesthesis that black femininity is always already made to bear. From the terrible cut between existence and nonbeing, from black (feminine) flesh ceaselessly contorted and rent asunder, this aesthesis marks the unassimilable of modernity's aesthetic regime, which can neither lay claim to a mythology of origin nor the promise of redemptive futurity. And in this irredeemable dereliction, this irreducible exorbitance, black aesthesis also extends the chance of the total ruination of the world that would carve its horizon from a sea of bodies, from an ocean of dismembered flesh.

Before the Nude, or Exorbitant Figuration

Mickalene Thomas's 2016 multimedia video installation *Me As Muse* draws the viewer into a visual transmutation. To be hypnotically swayed by the liquescent swirl of images, a ceaseless montage unfurling across a careful arrangement of a dozen screens, is to lose one's spatiotemporal footing and to throw into question the boundaries between medium, composition, and form. A multimedia installation consisting of twelve screens arrayed uniformly in three rows and four columns, but for the convex shape of the horizontal display, *Me As Muse* marks the first time Thomas incorporated her own figure into a work (figures 12–15). Replete with references to the reclining nudes of Modigliani (figure 13, 14) and Boucher, *Me As Muse* prominently engages art history's fascination with the female nude, and Thomas's reclining, unclothed pose is an explicit simulation of the figural tropes of the form. I am interested in what is recursively disclosed in Thomas's swerve from and re-rendering of the racializing line of the nude, or what remains anterior to the artistic form that *Me As Muse* deconstructs. -

The technical artifice of the work depends upon morphological transitions between images that engineer spatial and temporal ruptures within the logic of form. In the course of these morphological transits, one catches glimpses of paradigmatic figures of black femininity—Josephine Baker, Grace Jones, Saartjie Baartman. Affectively, the work produces a meeting of the weird and the eerie, a montagic blurring of "that which does not belong," that which "is there . . . when there should be nothing," and "nothing there when there should be something."[1] It is perhaps because of the work's deviation from the mixed media collage paintings for which she is most well-known, as well as from the charismatic glamour viewers have come to expect

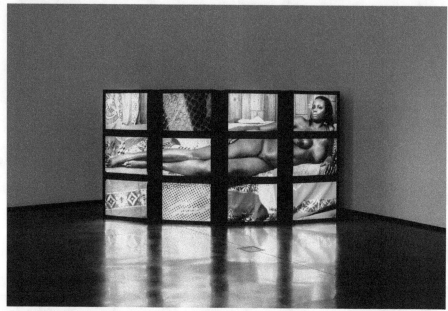

Figure 12. Mickalene Thomas, *Me As Muse*, 2016, multimedia video installation, 12 video monitors, each 19.1 × 24.1 × 18.5 inches (48.5 × 61.2 × 47 cm); 57.5 × 106.25 × 32 inches (146.1 × 269.9 × 81.3 cm) (overall, dimensions variable). © Mickalene Thomas. All rights reserved.

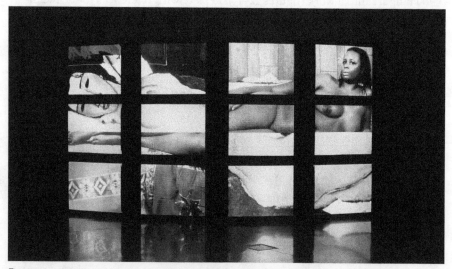

Figure 13. Mickalene Thomas, *Me As Muse*, 2016, multimedia video installation, 12 video monitors, each 19.1 × 24.1 × 18.5 inches (48.5 × 61.2 × 47 cm); 57.5 × 106.25 × 32 inches (146.1 × 269.9 × 81.3 cm) (overall, dimensions variable). © Mickalene Thomas. All rights reserved.

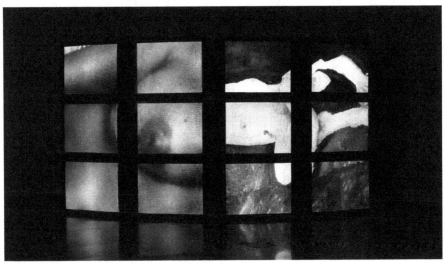

Figure 14. Mickalene Thomas, *Me As Muse*, 2016, multimedia video installation, 12 video monitors, each 19.1 × 24.1 × 18.5 inches (48.5 × 61.2 × 47 cm); 57.5 × 106.25 × 32 inches (146.1 × 269.9 × 81.3 cm) (overall, dimensions variable). © Mickalene Thomas. All rights reserved.

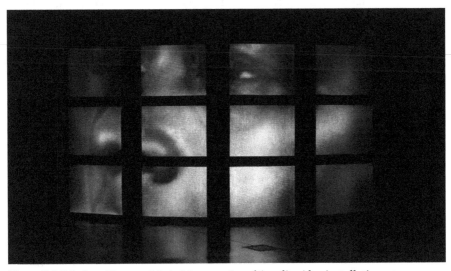

Figure 15. Mickalene Thomas, *Me As Muse*, 2016, multimedia video installation, 12 video monitors, each 19.1 × 24.1 × 18.5 inches (48.5 × 61.2 × 47 cm); 57.5 × 106.25 × 32 inches (146.1 × 269.9 × 81.3 cm) (overall, dimensions variable). © Mickalene Thomas. All rights reserved.

from Thomas's work—the rhinestone encrusted surfaces presenting baroque experiments in black feminine self-fashioning, labor, and leisure—that the work has had a relatively subdued reception.

What *Me As Muse* does retain from those earlier works, however, is a marked attention to the material workings of collage, crafting a multimedia assemblage which "transpos[es] . . . the principle of collage to the medium of video."[2] Thomas's installation immediately brings to mind the work of Nam June Paik, Joan Jonas, Dan Graham, Peter Campus, and others who, in their skeptical acknowledgement and critique of the popular status of video as a source and medium of mass cultural representation, variously interrogated art's medium-specific boundaries to seek expansive linkages between video art, performance, and sculpture. However, whereas the avant-gardism of artists associated with Fluxus engaged in a deconstruction of a medium they experienced through the complex valences of alienation, this work thematizes black feminine enfleshment, which is everywhere conscripted as medium.

Breaching the formal boundaries between sculpture, video, and painting, the (trans)mediality of *Me As Muse* produces a tremor within the viewer's sensorium. However, this disturbance cannot be understood through a technologically determinist hermeneutic that would seek to divorce the medium from black feminine flesh. Drawing upon and redeploying Hal Foster's insights regarding the serial display of video monitors,[3] we can discern how this work accentuates a relay between the physical space of the museum and a culture of spectatorship that mimics a sociality steeped in the libidinal and material principle of antiblack surveillance.[4] What I wish to underscore in this chapter is the work's central deconstructive operation, which concerns the mediality black feminine flesh is forced to bear. *Me As Muse* interrogates the means by which blackness has always been made to mediate the very distinction between the aesthetic medium and form within the modern world.

Thomas's visual display is accompanied by an unnerving soundscape, that of singer, actress, and dancer Eartha Kitt narrating traumatic experiences from her childhood, after being given to another black family by her mother, as her mother's lover refused to have a child stained by miscegenation in his house. Recounting her experience in the new family in which she found herself, Kitt describes a set of conditions in which the violence of being used "as a work mule" and the sexual violence to which she was sub-

ject seem to blur, as if there could be no clear distinction between the two moments of brutality.[5]

In *Me As Muse*, the manner in which the medial labors of black feminine flesh can never be dissociated from the sexual violence that inheres in this singular nexus of race, gender, and reproduction becomes evident in the architecture of its display. The horizontal arrangement of monitors faintly resembles the shape of a parabola. Protruding from the wall, the work's sculptural convexness parallels and traces the pose of its recumbent "subject," Thomas's unclothed figure. This parabolic form does not so much mimic flesh as it deconstructs the (im)mediation to which flesh is subject, exposing the medium as at once a mechanism of fleshly enclosure and a ruptured fount of fleshly overspill. That the constellated image has been brought down to the floor (an operation which, as Chrissie Illes avers, formally qualifies the work as installation)[6] evinces a strategic composition of the work's technical artifice rather than an automatic adherence to the conventions of form. The perambulatory mode of viewing opened up by the form of the installation affords a visceral engagement with both the physicality of the apparatus and the artwork's distinctively morphological content.

The formally innovative technics of *Me As Muse*, however, have received little attention, especially for an artist of Thomas's stature. Where *Me As Muse* has been directly engaged by critics, readings have overwhelmingly invoked the representationalist grammar that defines the broader discourse not only on Thomas's artistic practice but on black art in general. Alessandra Raengo, for instance, discusses *Me As Muse* as an exemplar of "the potential shape-shifting effect that women like . . . Thomas can have on and within the art-historical canon."[7] In this respect, Raengo's assessment of the aesthetic significance of Thomas's work largely echoes the appraisals of art institutions, scholarship, and criticism: black women's representation matters, most of all where it has been least welcome and is least expected (in the museum's white cube, the gallery space, or verging upon the hallowed forms of modernism, and so on).

To be clear, in my analysis, the significance of *Me As Muse*'s deconstructive interrogation of the nude is far from representationalist. Artist Carrie Mae Weems's comments regarding Thomas's practice gesture toward another method of reading, which neither begins from the self-representations of the art historical canon nor clamors for entry into an aesthetic for which

blackness has always been the constitutive negation. In Weems's view, Thomas "turn[s] art history upon its head, as opposed to reinserting the black body into art history."[8] Certainly, Weems's commentary immediately speaks to the way Thomas's practice probes and provokes the limits of (art) history and its racial regime of representation, but if we approach her insight as more than an incidental and contingent observation, it also alludes to something deeper. (We might hear in Weems's observations the echo of Marx's claim to have righted the dialectic that Hegel had stood on its head,[9] but for the fact that blackness is anterior to dialectics, rectification impossible, and analogy little more than mystification.) To regard *Me As Muse* as a subversive appropriation of the art historical canon—whether this appropriation is celebrated as corrective or rebellion or dismissed as naive identitarianism—merely reinscribes the presumption that blackness is ancillary to the genealogy not only of particular art historical forms but of form itself. In contradistinction, I want to suggest that *Me As Muse* calls for an *ante*representational orientation, one which does not simply begin from and end with the aspirational purity of form but instead searches for form's hidden vestibules, ineradicable contaminants, and irreducible remainders.

If, as *Anteaesthetics* has argued, representation as affirmative inclusion within modernity's regime of aesthetics is not only wholly unavailable to the black but, moreover, affixed to a hermeneutic framework which requires the extirpation of the aesthesis which is singularly borne by black femininity, then how might we read against the grain of the presumption that *Me as Muse* is simply a bold corrective to the racially gendered segregations of the Western art historical canon? In particular, how might we reach for a more complicated interpretation of the ostensibly novel placement of the 'black body' within the form of the nude? What if black femininity has always been anterior to the nude within modernity—at once its condition of possibility and radically subject to its racially gendered aesthetic violence? I argue that what *Me as Muse*'s morphological operations ultimately disclose is not only the racially gendered genealogy of the nude in its modern dispensations but rather (1) black feminine anteriority to form as such and (2) the immanently contaminative nature of this (re)productive bearing.

Were we to proceed in accordance with the perfunctory habits of the sort of truncated formalist analysis black art is typically granted in conventional art criticism, *Me as Muse* could easily be taken for a video portrait, but closer

attention reveals a work not so readily available to the habitual categorizations of genre. For, as Kobena Mercer suggests, the genre of "self-portraiture in its received sense is a structurally impossible genre for the black artist to occupy."[10] If the figure of the muse is synonymous with a kind of creative possession, then it is unclear here precisely who is in possession and who is being possessed. Moreover, insofar as the "self" as an individuation of the principle of possession only ever emerges through the violation and displacement of black flesh, only through the metaphysical bearings of those made muses or mediums, then what is the significance of Thomas's apparent surrendering of herself to the aesthetic imagination of the nude?

A paradox is opened by *Me as Muse*—the paradox of a black artist figuring herself as muse in and through the form of the nude. Black femininity, or the racially gendered reproductivity of blackness, is marked by the interdiction from both selfhood and positive aesthetic value. What does it mean for one who is not one—the one who bears the absent center of the corporeal division of the world and the constitutive negation of the racial regime of aesthetics—to figure herself as muse, not least through the invocation of one of modernity's most vital and jealously guarded forms? To truly approach the exorbitance of Thomas's gesture requires a profound reconsideration not only of the history of Western art and the genealogy of the female nude but also of the relations of blackness to time and space, to the materiality of making and unmaking, composition and decomposition. It is, I will argue, ultimately this exorbitance which is disclosed, disturbed, and transmitted in Thomas's reclining, unclothed figure cut and splayed across the array of screens. As we have seen in chapter 2, the black bodily fragment refers to no prior or future whole but rather is conscripted as the absent center of that corporeal division of the world, as the incompletion which enables the whole. And yet, in this work, Thomas's cut and splayed figure would seem to gesture to the dissimulation of a whole, to the uses of the 'body' rend(er)ed from flesh. Indeed, her skin is made the contact zone for a haptic encounter with vanished and violated flesh, transfigured and recast as a mediatic surface for what Kris Paulsen would call "telepresent touch."[11]

The concept of telepresent touch, for Paulsen, emphasizes the corporeal dimensions of telepresent experience and "look[s] to the ways in which artists have resisted the dematerialization and disembodiment telematic technologies seem to foretell or promise by focusing on the materiality of the screen

and reformulating it as a surface open for occupation."[12] Among her central concerns is the question of "how our relationships to the world change when we can touch things that cannot touch us back."[13] To this end, she considers a range of artists who "devised ways of intervening in the interface, of touching back, in order to disrupt the smooth functioning of asymmetrical power," in particular by drawing "attention to the interface's often overlooked materiality."[14] In my analysis of Thomas's *Me as Muse*, the "vision at a distance" presumptively granted the viewer is complicated and disturbed by a telepresent touch that does something more and less than "reflexively fracture . . . the hermetic circuit of reflection" that Rosalind Krauss takes as video's inherently narcissistic aesthetics.[15] Moreover, Thomas's work recursively discloses the fact that "the [racially gendered] body that appears to be waiting on the other side"[16] of the screen is fixed by the corporeal division of the world as both radically open to touch and absolutely devoid of presence. I argue that the "touching back" experienced by the viewer of *Me as Muse* is a divulgence and disturbance of the racial onto-phenomenology of the screen.

How do we think about the (re)productive bearings of the black feminine, wherein an absolute exposure to the violent immediacy of touch is immanently conjoined to being violently conscripted as an indispensable interface for mediating the ontological stability and phenomenological relay of subject, object, and world? How might we both trouble and extend Paulsen's argument by recalling that some things, some mediating interfaces are in fact dissimulated as persons—namely, those who are perennially marked by the "thingification" inherent to racial slavery in its enduring permutations—and that these mediatic surfaces are indeed always already "open for occupation" in the most brutal sense of the word. If Thomas's *Me as Muse* could be said to recursively disclose the violent touch of (im)mediation to which she herself is subject, how might the displaced materiality, which is tethered to the very skin she performatively recasts as mediatic surface, reach back to touch the one who takes themselves to be the interface's sovereign operator?[17] What happens, in other words, when the racially gendered mediality that occasions (the order of) form(s) touches back?

————

In the sections that follow, I trace the vestiges of this exorbitant touch and its complex imbrications with the expropriative displacements of black me-

diality through a number of moments within the aesthetic, epistemic, and biopolitical unfolding of the world's order of forms during the long nineteenth century (c. 1789–1914). I argue that both the making and unmaking of novel forms, which cut across the presumed separation of the scientific and the aesthetic, are inextricable from the racially gendered violence of (im) mediation, from the bearings of black feminine flesh. The chapter proceeds roughly in two parts. We begin by confronting and dispensing with the hermeneutic baggage that "weighs like a nightmare,"[18] it would seem, upon even critical approaches to corporeality, aesthetic personhood, and the racial gendering of blackness. Beginning from a critique of Anne Anlin Cheng's reading of Hortense Spillers's hieroglyphics of the flesh, which enables Cheng's theory of ornamentalism, I stress the material exorbitance that cleaves to the (im)mediations of the flesh, which cut across visual and corporeal registers, in and through the violence of touch. Moving through an extended inquiry into the dissimulated 'body' and brutalized flesh of Saartjie Baartman, the so-called Venus Hottentot, I argue that black femininity is anterior to the nineteenth-century refashionings of race science and the more general revolutionizing of comparative anatomy with which these modulations of raciality were inextricably entwined. I contend that the black feminine bears the recursive violence of being made the vestibule for the very emergence of (a new order of) forms to which it is brutally subject. Moreover, I demonstrate that these new scientific and biopolitical (orders of) forms are not only linked to transformations in the racial regime of aesthetics, particularly with respect to modes of visuality and codifications of the sensible, but are themselves inescapably aesthetic. In the course of this argument, we will trace processes that span colonial South Africa, ethnographic exhibitions in London and Paris, and the writings of the so-called father of modern biology and paleontology, Georges Cuvier, who continues to find champions in contemporary critical theory.

The second part of the chapter shifts toward a more conventionally recognized aesthetic register, focusing on the shift from neoclassicism to Romanticism and the rise of the female nude in French painting, particularly as this shift is evinced and effectuated in Jean-Auguste-Dominique Ingres's 1814 painting *La Grande Odalisque*. I argue that Baartman is not only the displaced anterior of the aforementioned epochal scientific-aesthetic transformations but moreover of that aesthetic form from which the racial regime

of aesthetics would designate her as most remote: the female nude. I begin by articulating a general thesis regarding the role of a series of racially gendered, expropriative displacements in the remaking of the aesthetic form of the nude over the course of the nineteenth century before moving on to a more pointed argument about how deformity becomes central to this refashioning of the nude. Paradoxically, in and through Ingres's *Grande Odalisque,* deformity becomes mobilized toward the conceit of formal perfection and thereby becomes instrumental in the revivification of *homo aestheticus* through an extension of the nominally progressive arc of artistic formalism. I trace this counterintuitive process through the "serpentine line" of the *Grande Odalisque,* famously exposited by art historian Carol Ockman, showing how this sensuous line becomes constitutive of what Roger Benjamin terms "the anatomy of modernity."[19] I argue that the aesthetic means through which the serpentine line comes to illustrate the anatomy of modernity is the rend(er)ing of a new ideal body from flesh, even as the resultant aesthetic form of the female nude seeks to expel the metaphysical unwieldiness of its enfleshed anterior. I then proceed to make the audacious claim for Baartman's vestibularity to Ingres's *Grande Odalisque,* arguing for the necessity of ante-empirical speculation in the face of the foreclosures of the archive. Finally, I explicate how the singular dissimulations of black femininity, unexceptionally exemplified by the figure of Baartman, are ultimately irreconcilable with either the aesthetic idioms of nudity or nakedness, with profound implications for interpretations of Mickalene Thomas's work.

In our concluding return to *Me as Muse,* it becomes apparent that the liquescent montage of images and Thomas's figuring herself as muse in and through the form of the nude are neither subversive appropriations nor performative bids for inclusion within art history's enclosive canonizations but rather anteaesthetic techniques for recursively disclosing black feminine anteriority to a series of crucial transformations in the braided scientific, aesthetic, epistemic, and biopolitical regimes during the nineteenth century. What becomes just as evident is that the violent (im)mediations of touch, which the black mediality of forms disclosed by Thomas's work necessarily entails, also bear a contamination that can never be completely quarantined. Black feminine anteriority to form also bears a disorder that is immanent to (the order of) form(s), an exorbitance which serially and diffusively returns the specter of form's ruination.

Ornamentality and the Hieroglyphics of the Flesh

Not a few scholars associated with the bodily turn have sought to assert the importance of inquiries concerning the myriad gendered, sexual, and racial geographies of embodiment within the modern world. Yet I would argue that, even among such scholarly forays, what I am calling the corporeal division of the world generally remains (a question) to be thought. For this order cannot be truly conceived apart from its absent center, apart from the constitutive expulsion, the anteriority of blackness from and to the charade of sovereignty. In *Ornamentalism*, Anne Anlin Cheng makes a spirited intervention into the former discourse concerning racially gendered embodiment,[20] one which may help to elucidate the stakes and dynamics of the corporeal division of the world, even if against the grain of the text's own intentions.

Notably, *Ornamentalism* espouses a necessary commitment to resisting the "critical impoverishment" that has accompanied the consolidation of "woman of color" as an institutional (as opposed to theoretical) category.[21] Following this commitment, Cheng fashions an innovative inquiry into the hitherto undertheorized place and quality of Asiatic femininity within the "racialized person-making"[22] of modernity and its concomitant codifications of bodily presence—that ontologically exclusive architecture I term the corporeal division of the world. *Ornamentalism* evinces a substantial willingness to attend to the ornament as "the fluctuation between essence and supplement, depth and surface, utility and decoration, interiority and exteriority, organicity and the inorganic, femininity and masculinity, and finally, Western discipline and Oriental excess," without immediate recourse to either disavowal or recuperation, imperatives which might otherwise foreclose inquiries into the "kind of life [that] subsists along those porous edges."[23] In these respects, Cheng's work is an important effort to return a critical edge to scholarship on racial gendering at a time in which the disciplines would be only too happy to consign such work to the elaboration of ethnographic minutiae. Unfortunately, notwithstanding its merits, Cheng's argument ultimately reinscribes the very racially gendered world order it would avowedly subvert.[24]

My principal concern here is Cheng's triangulated critique which posits the ornamental with, alongside, and against epidermalization and the flesh, as well as the manner in which this critique is enabled and advanced (both

analytically and rhetorically) by Cheng's (mis)readings of Frantz Fanon and Hortense Spillers's signal theoretical interventions. I begin this chapter with a critical interrogation of the analytic premises and rhetorical method of Cheng's text for two interrelated reasons. Firstly, I share Cheng's sense that the scholarly discourse on racially gendered embodiment, personhood, and the politics of aesthetics has largely reached an impasse in which it proves increasingly difficult to shake off the institutionalized fetters to radical thought. However, whereas Cheng associates this exhaustion of criticality with the hegemony of Fanon's and Spillers's theories of racial embodiment, I argue that, in crucial respects, the difficult substance and implications of their respective interventions have yet to be thought, to say nothing of reckoned with. Attending to the particular conceptual distortions of (black) skin and (black feminine) flesh that have accompanied Fanon's and Spillers's circulation within the academy will prove necessary to advancing this chapter's argument: specifically, that black femininity is not only anterior to the aesthetic life of form but the bearer of a ruination which is immanent to aesthetic formation. Secondly, Cheng's text itself exhibits the very violence of racially gendered mediality to which the black femme has been singularly subject and which constitutes my principal object of critique. As we shall see, the fact that the figure of Saartjie Baartman, whose notorious nineteenth-century history this chapter engages at some length, continues to be conscripted toward novel ends should come as no surprise.

Let us begin with laying out the general scope and ambition of Cheng's study. Amidst the "tiresome . . . critical exhaustion" of the category of "woman of color" and the putative monopoly power exercised by the "theoretical gambits" of black (feminist) thought, Cheng endeavors to develop a theory of the "yellow woman," tracking "the incarnations of Asiatic femininity in Western modernity and its expansive embroilment with the ornamental and the Oriental."[25] Cheng's study seeks to break free from the apparent calcification of critical theories of raciality, corporeality, and personhood into two overdetermined conceptual pillars, epidermalization and flesh:

> For a long time now, there have been two primary frameworks through which many of us conceptualize racial embodiment: Frantz Fanon's "epidermal racial schema" and [Hortense] Spillers's "hieroglyphics of the flesh." The former denaturalizes black skin as the product of a shattering white gaze; the latter has been particularly powerful in training our gaze on the black female body and

the ineluctable matter of ungendered, jeopardized flesh. Yet in the years since its revolutionary impact, has the "epidermal racial schema" hardened for us into a thing of untroubled legibility? To what extent have the "hieroglyphics of the flesh" prevented us from seeing an alternative materialism of the body?[26]

In contradistinction to the concepts of flesh and epidermalization, Cheng "propose[s] ornamentalism as a conceptual framework for approaching a history of racialized person-making, not through biology but through synthetic inventions and ornamentations."[27] However, within Cheng's triangulated critique, Spillers and black feminine flesh become more crucial polemical foils than Fanon and epidermalization. Consider, for example, the following passage from the introduction to *Ornamentalism*, which elaborates the logic of the ornamental by way of contrast with black feminine flesh:

I suggest that synthetic Asiatic femininity is another such constitutive strand in the making of modern personhood and that, alongside the black enslaved body, we must also consider the synthetic Asiatic woman as a ghost in the machine. . . . Encrusted by representations, abstracted and reified, the yellow woman is persistently sexualized yet barred from sexuality, simultaneously made and unmade by the aesthetic project. Like the proverbial Ming vase, she is at once ethereal and base, an object of value and a hackneyed trope. Like the black woman, she has suffered a long history of painful denigration; she, too, has been enslaved, abused, mummified, spectacularized, and sold. Yet her discursive construct is qualitatively different. Consider the two iconic nineteenth-century images of racialized femininity. . . . On the one hand, Sarah "Saartjie" Baartman, the so-called Hottentot Venus . . . was reduced to bare flesh, what Spillers calls "the zero degree of social conceptualization"; on the other hand, Afong Moy, a young Chinese woman imported by the Carne Brothers and later taken over by P. T. Barnum to tour major U.S. cities in the 1830s–1850s as a living museum tableau and known simply as the Chinese Lady . . . offered a scopic pleasure that centered on her textual thickness: her material, synthetic affinities. . . . The latter's appeal does not derive from her naked flesh but from her decorative (and projected ontological) sameness to the silk, damask, mahogany, and ceramics alongside which she sits. While primitivism rehearses the rhetoric of ineluctable flesh, Orientalism, by contrast, relies on a decorative grammar, a phantasmic corporeal syntax that is artificial and layered. If black femininity has been viciously erased by a cultural logic that has reduced it to, in Spillers's words, "transitional mere flesh," then yellow femininity has been persistently presented as something more like portable supraflesh. . . . Spillers famously observed that, since the black female is barred from cross-

ing the symbolic threshold into personification, she is stuck on the threshold dividing the human and the not human, rendering her "vestibular to culture." . . . Where black femininity is *vestibular*, Asiatic femininity is *ornamental*.[28]

While lamenting the fact that "our models for understanding racialized gender have been predominantly influenced by a particular view of bodies of African origins that has led us to think in a certain way about raced female bodies, when there has been in fact something of a bifurcation within the racial imaginary between bare flesh and artificial ornament," Cheng remains emphatic that although "these two aesthetic vocabularies [the fleshly and the ornamental] are clearly both racialized, . . . they do *not* necessarily or even primarily index racial identities."[29] Indeed, Cheng offers her work on Josephine Baker, *Second Skin: Josephine Baker and the Modern Surface*, as "an example of how the dominant trope of black female flesh has prevented us from seeing the complex fabrication that is [Baker's] 'skin.'"[30] That is to say, while "critical race theory and black feminism have done the vital work of reminding us that the black woman has been reduced to bare flesh, those insights have not been as helpful in theorizing the figure of the racialized woman who is assiduously assembled."[31] Notwithstanding the avowedly mobile character of these bifurcated aesthetic registers of "bare flesh" and "artificial ornament," there is an important triangulation at play in these specific figural comparisons, one which both exemplifies and foreshadows the problems with the argument which follows.

Reprising a set of images and line of argumentation from *Second Skin*,[32] Cheng offers a comparative reading first of Baartman and Afong Moy and second of Baartman and Baker. In the first, the visual-textual juxtaposition is significant, as these "two iconic nineteenth-century images of racialized femininity" are embedded (Baartman first, then Moy) within a summation of the aesthetic registers that are taken to distinguish black femininity from Asiatic femininity ("Where black femininity is *vestibular*, Asiatic femininity is *ornamental*"). The racially gendered problematic that I am suggesting is reproduced in Cheng's contrapositioning of the vestibular and the ornamental is betrayed by the manner in which Baartman's image is read. As with Cheng's reading in *Second Skin*, the analysis of the image of Baartman, *Love and Beauty—Sartjee the Hottentot Venus* (figure 16), is relatively truncated, an apparently axiomatic illustration of "the black woman . . . reduced to bare

flesh," and serves primarily as a foil for Cheng's elaboration of the "textual thickness" of Moy's image. There is, for example, no comment on Baartman's adornment or accoutrement, on Cupid's satirical exclamation ("Take care of your Hearts!!") while straddling Baartman's buttocks, or on what implications one might draw from the fact that the image belongs to the genre of caricature.

The image's aesthetic (in)significance would seem to be self-evident and not in need of further interpretation. The figure of Baartman is then contrasted with that of Josephine Baker, who, unlike Baartman, has "thrived

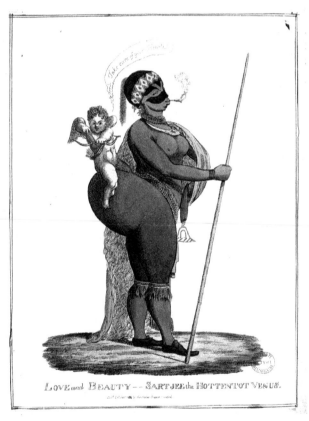

Figure 16. Attributed to Charles Williams, *Love and Beauty—Sartjee the Hottentot Venus*, October 1822, hand-colored etching. Reprinted with permission from The British Museum.

through unfleshliness."[33] As this chapter will make clear, in each instance the black feminine is made the indispensable mediality of aesthetic engineering—Baartman as the threshold for the very distinction between "bare flesh" and "artificial ornament" and Baker as the mediation between these dualities, an injunction which is characteristic of the uses to which the mulatta has historically been put.[34] In other words, both Baker and Baartman are instrumentalized to advance an intervention that would preclude an analysis of the singular manner in which they are put to work. For in the end, although Baker nominally serves to illustrate the figurations of black femininity that have supposedly been occluded by "the dominant trope of black female flesh," she nevertheless would appear to be the exception (which implicitly confirms the general rule of Baartman's "bare flesh"), as Cheng readily adjures: "Let us substitute *ornament* for *flesh* as the germinal matter for the making of racialized gender. Let us, in short, formulate a feminist theory *of and for the yellow woman*."[35] Under scrutiny is Cheng's critique of the concepts of epidermalization and flesh, the "two primary frameworks" she suggests have overdetermined conceptions of racial embodiment. Let us examine each in turn, beginning with Fanon's concept of epidermalization.

While Fanon figures far less prominently than Spillers as an object of critique in Cheng's text, the misconstrual of his intervention is nonetheless crucial to *Ornamentalism*'s contrarian stance and, more importantly for my purposes, to clarifying the dynamics of a black aesthesis that is made to come before rather than held within the corporeal division of the world. Cheng suggests that the principal theoretical contribution of epidermalization is to denaturalize "black skin as the product of a shattering white gaze," before going on to ask whether "in the years since its revolutionary impact, . . . the 'epidermal racial schema' hardened for us into a thing of untroubled legibility." Here she echoes concerns previously articulated in *Second Skin* over whether epidermalization, or the framework of "modern racial legibility in the West" is in fact as visually transparent as "we" take it to be.[36] "But is skin—and its visibility—so available? When we turn to an over-exposed and over-determined figure like [Josephine] Baker, are we in fact seeing what we think we are seeing? What might be some other 'schemas' through which skin acquires its legibility?"[37] In other words, if epidermalization "irreducibly indexes skin's visual legibility: 'Look, a Negro!' . . . [then] what happens when we contest the terms of that visibility?"[38]

Any scholar with an investment in criticality would certainly be right to contest readings of Fanon's conception of epidermalization as "a thing of untroubled legibility." Beyond this concession, however, serious problems emerge. To begin with, Cheng vacillates between reading epidermalization as a universal rubric for "modern racial legibility in the West" and as a specific analytic for interrogating "the fact of blackness," or "the lived experience of the black." In this respect it is worth noting that, in both *Second Skin* and *Ornamentalism*, the secondary readers of Fanon Cheng refers to in glossing his conception of epidermalization are situated within postcolonial studies and feminist film theory, respectively. Rich as the preceding disciplinary traditions are, by opting not to take up the vast literature on epidermalization within black studies, Cheng effectively displaces Fanon's concern with the singular visualizations of antiblackness. To the extent that Cheng engages that singularity, she is right to posit the racial gaze as "shattering," but it would seem as if the psychic and the phenomenological have become muddled in the midst of arriving at this interpretation.

Far from an index of black "skin's visual legibility," epidermalization (dis)figures black skin as the visual locus of bodily dissimulation—a phenomenological feint—through which the semblance of legibility coheres. For, as David Marriott argues, if epidermalization effectuates a shattering of the specular image and the bodily ego, it is precisely because its modality of "signification is one of *disfiguration*, in which the very surface of the body, its skin, becomes a metonym for a certain *historicity of hatred* . . . racialization here signifies a rupture between body and world, between sense and symbolization."[39] Crucially, this signification must be one of disfiguration, for the corporeal existence it purports to signify is "*n'est pas*," or, as Marriott elaborates, "the mark of a negativity that cannot be phenomenalized."[40] But this phantasmatic suturing of the phenomenological is not without cost, for it bears, as Fanon suggests and as this chapter will demonstrate with respect to the aesthetic history of the nude, "an impurity, a flaw that outlaws any ontological explanation"[41]—in short, a metaphysical contaminant that is immanent to the very operation of forced appearance.

Let us now turn to Cheng's reading of Spillers's conception of flesh. Like Fanon's "epidermal racial schema," Cheng suggests that Spillers's "hieroglyphics of the flesh" has become problematically axiomatic: while Spillers's intervention "has been particularly powerful in training our gaze on the

black female body and the ineluctable matter of ungendered, jeopardized flesh, . . . [has it not also] prevented us from seeing an alternative materialism of the body?" Although Cheng leaves the relationship between epidermalization and the "hieroglyphics of the flesh" largely unarticulated, it is evident that the former is essentially relegated to the register of the visual while the latter is consigned to the register of the material. On this latter point Cheng is quite clear, stating that black feminism teaches us that "the black woman has been reduced to bare flesh," or "pure matter."[42]

Indeed, throughout *Ornamentalism*, one finds a stark opposition between two registers of materiality. On the one hand, we have the material register flesh is said to (overdeterminatively) index—that which is "bare," "dumb," "raw," "primitive," and marked by "animality" and the "organic."[43] On the other, we have the material register that the ornamental would at once exhibit and problematize—that which is "complex," "encrusted," "synthetic," "excessive," and which "holds the key to understanding the inorganic animating the heart of the modern organic subject."[44] In the transit between these two registers, as we shall see, there is a movement of racial (de)valuation that remains obscured by the supposed interchangeability of racial-aesthetic formations and by Cheng's purported commitment to clearing "new ground beyond the political cul-de-sacs of feminist and race studies."[45] But for now let us focus on Cheng's characterization of the former register, that of "bare flesh."

A capacious reading of Spillers directs us toward an understanding of the "the irreducible materiality"[46] of flesh, which is far from synonymous with the bare, the simple, or the pure. I am not interested in making a comprehensive case for either authorial intention or textual fidelity with respect to Spillers's canonical essay, but I would nonetheless venture that Cheng's designation of flesh as categorically overdetermined is an exercise in theoretical foreclosure. The fact that the only text of Spillers that is cited in both *Ornamentalism* and *Second Skin* is "Mama's Baby, Papa's Maybe," thereby isolating the concept of flesh from Spillers's broader theoretical oeuvre, would seem both a reflection of and contributing factor to Cheng's constricted reading. That being said, not only does the phrase "transitional mere flesh," which Cheng wrongly attributes to Spillers,[47] appear nowhere in "Mama's Baby, Papa's Maybe," but neither do even the words *mere* or *bare*, at least not as modifiers of the concept of flesh.[48] It often becomes difficult to distin-

guish where Cheng is mobilizing such descriptors toward a critical analysis of "primitivism and its fantasies of naked flesh"[49] and where they are meant to indict "black feminist criticism . . . [which takes up] the archive of critical black female flesh" in a manner that supposedly lends itself to reification and naive dreams of reparation, thereby preventing "us from seeing an alternative materialism of the body."[50]

To the generous reader, it would seem that Cheng's misunderstanding of Spillers's seminal text and its most dynamic implications for theorizing the enfleshed existence of black femininity has to do with a conceptual slippage between representational (de)valuation, materiality, and signification. As I have argued, flesh—borne singularly by the black feminine within the modern world—is spatially and temporally anterior to the separation of the material from the semiotic, at once the condition of possibility for and violently subject to this bifurcation. Flesh is not bare, simple, or pure materiality, but *exorbitant* materiality, a materiality for which we do not yet have a name.[51] Flesh bears both the reproductive burdens and irreparable dehiscence of the metaphysical displacements which are the condition of possibility for the emergence of the modern subject. That phenomenological and ontological conceit we call "a body" or "a person" is brutally rend(er)ed from flesh through a singularly racialized and gendered set of expropriative displacements. The body is cleaved from flesh, while flesh is serially cleaved by the body. In the next chapter I explore the persistent failure to fully excise this fleshly exorbitance as a problem which is endemic not only to the fiction of the body but equally to the construction of the visual field. For it is precisely because the unwieldy materiality of flesh cannot be reduced, cannot be rendered transparent that it bears an obdurate materiality: what I term the *black residuum*.

Flesh, in this sense, cannot appear, for flesh is phenomenology's anterior, the corporeal existence of blackness as nonbeing, (that which bears) the constitutive negation of modernity's metaphysics. What appears is a bodily dissimulation, a phenomenological dispensation of what Calvin Warren terms "catachrestic fantasy," the fabrication of "a referent for that which does not exist."[52] It is a "body" which is "mimicked," as Spillers would have it, "across the play of significations."[53] But not even this dissimulated 'body' could be said to be simple or bare. Indeed, the phenomenological feint which effectuates the appearance of this 'body' cannot help but bear an unassimilable

remainder ("signifying property *plus*"[54]). Moreover, it is precisely in order to accentuate the fact that within the world made by racial slavery, "nothing is what it appears to be"[55] that Spillers famously opens "Mama's Baby, Papa's Maybe" with an accumulation of racially gendered denominations. These shifting, agglomerative figurations ("'Peaches' and 'Brown Sugar,' 'Sapphire' and 'Earth Mother,' 'Aunty,' 'Granny,' God's 'Holy Fool,' a 'Miss Ebony First,' or 'Black Woman at the Podium'"[56]) would seem to be precisely what Cheng terms "encrusted . . . representations,"[57] even as each is inevitably a misnaming.[58] Indeed, because the black feminine 'body' is made to appear through an accretion of "markers so loaded with mythical prepossession," Spillers declares, "in order to speak a truer word concerning myself, I must strip down through layers of attenuated meanings, made an excess in time; over time, assigned by a particular historical order, and there awaits whatever marvels of my own inventiveness."[59] Insofar as Spillers gestures here to an invention which is "less the promise of an adequation between meaning and authenticity than a disintegrative movement, a leap, that never reaches its mark,"[60] we may say that the "truer word" of black feminine flesh is in fact unspeakable and unreadable, even as it is the condition of possibility of every utterance. In short, the "hieroglyphics of the flesh" which Cheng takes to be transparent (and overdetermined) inscription in fact designates an irreducible opacity.

However, as we shall see, the fact that the enfleshed existence of blackness cannot appear as anything other than dissimulation and thus poses a difficult if not irresolvable hermeneutic problematic does not diminish its absolute centrality to the serial refashionings of the racial regime of aesthetics and the corporeal division of the world. In what follows, I interrogate the (re)productive life of black (feminine) vestibularity by turning toward the "iconic nineteenth-century . . . [figure] of racialized femininity" that Cheng would seem to regard as essentially denuded of aesthetic complexity—that of Saartjie Baartman, the "Venus Hottentot." Tracing Baartman's historical example through the nineteenth-century scientific and aesthetic transformations with which the emergence of the modern nude is inextricably entwined, I argue that contemporary black artistic experiments, such as Mickalene Thomas's *Me as Muse,* do not so much appropriate Western art historical forms for novel purposes as disclose blackness as the canon's displaced anterior and perennial haunting.

If Baartman's example necessarily entails an engagement with the en-during history of material and symbolic brutality that cleaves to every in-stantiation of black feminine vestibularity, is it even possible to read her dissimulated 'body' or attend to her violated flesh without reiterating the violence to which she has been subject? Can we abrogate our complicity in the violent (im)mediations of touch? We cannot. For there can be no simple refusal to consent to a social contract to which neither she nor I could be party. Perhaps the most or the least we can hope for is a complicity that is also a corruption,[61] a conspiracy, the intramural transmission of a conta-gion or contamination. Thus, in reading for Baartman's anteriority to an interwoven series of aesthetic, epistemic, and biopolitical transformations during the nineteenth-century, we must work to theoretically inhabit the cut between the dissimulation of a 'black body' which is made to appear and the existence of blackness without ontology—the enfleshment which cannot appear.

In the Coda to *Ornamentalism*, Cheng reprises her critique of Spillers through a reading of Toni Morrison's *Beloved*, expounding upon the claim that the framework of ornamentalism, in contradistinction to the Spiller-sian hieroglyphics of the flesh, "may help elucidate for the black woman a set of different, though related, issues about the fraught convergence of ma-terial violence and aesthetic congealment."[62] In particular, Cheng focuses upon Morrison's figuration of the "gorgeous chokecherry" tree that marks the whip-scarred back of one of the novel's central black feminine charac-ters, Sethe (the addition of the adjective *gorgeous* being Cheng's rather than Morrison's),[63] which Cheng regards as exemplary of the sort of "unexpected aesthetic eruptions" that an ornamentalist reading of *Beloved* might reveal to those for whom the 'black female body' is of interest.[64] While the man-date of concision prevents me from summarizing and substantively respond-ing to Cheng's reading of *Beloved* here (and setting aside the question of for whom exactly these "aesthetic eruptions" of black feminine flesh are "unex-pected"), there are nevertheless two prongs of Cheng's critique of Spillers's analytics of flesh in *Ornamentalism*'s closing pages that call for an abbre-viated rejoinder: first, Cheng's claim that a Spillersian analytic, having re-duced flesh to bare, base, organic materiality, prevents us from attending to the complex aesthetic entanglements of the material and the abstract, the organic and the inorganic, (even) in the case of black feminine flesh; second,

because of the inscriptive nature of these aesthetic entanglements, "there is in fact no 'zero degree of conceptualization.'"[65]

What Cheng has failed to understand is that Spillers's phraesological innovation—hieroglyphics of the flesh—is not mere rhetorical flourish but a complex theorization of the disjunctive braid of phenomenology, semiotics, and ontology that one necessarily confronts in any substantive inquiry into the anteaesthetics of black existence. The distinction is not merely semantic. It is in the racially gendered ravel and fray of this disjunctive braid, in the dehiscent yieldings, the immanent contaminations of the aesthesis black femininity is made to bear, that the ruination of the metaphysics of appearance might flash before our eyes, no matter how obliquely. For how an inscription comes to appear and the material-discursive dynamics which condition its appearance are just as important as the fact of its appearance when it comes to the matter of interpretation. In Morrison's novel, Sethe is in fact doubly made the object of inscription—at both the scene of her corporeal wounding and the scene wherein the scarred appearance of that wounding is granted a name—as well as the medium for the revivification of the very aesthetic regime that would violently inscribe her. In these respects, the aesthetic and metaphysical problematics of black feminine reproductivity that cleave to Sethe's figuration—problematics borne in and through the abyssal cut between phenomenological dissimulation and an existence without ontology—presage those discussed at length in this chapter by way of Saartjie Baartman and her anteaesthetic enfolding within Mickalene Thomas's work.

Spillers's long-standing efforts to "strip down through [the] layers of attenuated meanings" that are stitched through every figuration of black femininity evince a careful attunement to the inextricability of these appearances from both fleshly violation and the phenomenological dissimulation of the 'black body.' The myriad woundings that Spillers contends mark the "captive body" ("the anatomical specifications of rupture, of altered human tissue, [which] take on the objective description of laboratory prose—eyes beaten out, arms, backs, skulls branded, a left jaw, a right ankle, punctured; teeth missing, as the calculated work of iron, whips, chains, knives, the canine patrol; the bullet"[66]) evoke the terrible means through which the corporeal division of the world is rend(er)ed from the enfleshed existence of blackness. The expropriative displacement of blackness undergirds every pretense to

"bodiedness." The traces of this sundered flesh become paradoxically phenomenalized as "undecipherable markings on the captive body . . . [a] hieroglyphics of the flesh whose severe disjunctures come to be hidden to the cultural by seeing skin color."[67] In other words, the hieroglyphics of the flesh bears the semiotic disjuncture, the radical dehiscence generated in the cut between the phenomenological dissimulation of the 'black body' and the enfleshed existence of blackness without ontology. As "the marks of a cultural text whose inside has been turned outside,"[68] these hieroglyphics carry the material trace of blackness, of the absent center of the corporeal division of the world. Yet they are necessarily "undecipherable" because they can only ever register semiotically as dehiscent, as a metaphysical rupture to be sutured. They bear the impossible touch of an existence that is at once anterior to ontology and *n'est pas*. Thus, when Spillers, in an anagrammatical revision of the lexicon of semiotics,[69] declares that flesh constitutes "the *zero degree* of conceptualization," it is not because flesh is uninscribed but because flesh constitutes the negative threshold and abyssal limit of epistemology and semiotics. That is, the meaning projected onto and exacted through these inscriptions is necessarily dissimulative. In short, the irreducible vestibularity of black (feminine) flesh is not, as Cheng would have it, simply a metonym for being "barred from crossing the symbolic threshold into personification" or "stuck on the threshold dividing the human and the not human," and most certainly not a rhetorical figuration of "an implicit nostalgia" for a subjectivity, personhood, or humanity which was never available to claim in the first place.[70] Rather, black (feminine) flesh is vestibular in that it is made to come before the world, as the world's very condition of (im)possibility.

Saartjie Baartman and the Violent (Im)mediations of Touch

We now turn our attention away from the scholarly debates over racially gendered embodiment that beset the present and toward the long century in which the corporeal division of the world and aesthetic regime that undergirds these debates was thoroughly consolidated. Conventionally inaugurated in historiography by what Eric Hobsbawm termed the "dual revolution" (the French Revolution and the Industrial Revolution), the long nineteenth century is frequently understood as the period in which modernity estab-

lishes itself in force. It is also the period in which the nude, largely regarded as the exclusive province of Western art and as an indispensable form for discerning the epochal transformations that define modernity, undergoes a crucial transformation: namely, according to Abigail Solomon-Godeau, "the eclipse of the male nude and the ascendancy of the female nude," which becomes fully pronounced in the early decades of the nineteenth century.[71] This chapter reads for what is overwhelmingly eclipsed in this art historical discourse: the racially gendered anteriority of the ascendant female nude and its constitutive imbrications with concurrent modulations of the racial regime of aesthetics and the corporeal division of the world. I turn not only to developments such as the consolidation of race science, whose world-historic character is at least sparsely acknowledged, if generally displaced within art history, but in particular to a figure art history would almost universally regard as unlikely, if not inexplicable: that of Saartjie Baartman.[72] I argue that Baartman's dissimulated 'body' and brutalized flesh were made the medium for the effectuation not only of the shift from neoclassicism to Romanticism and the rise of the female nude but of a more general reorganization of aesthetic, epistemic, and biopolitical regimes over the course of the nineteenth century.

Insofar as Baartman was both vestibular and subject to the remaking and reproduction of modernity, her example is at once singular, exemplary, and utterly unexceptional. Hers is the story of a nonevent, one which unfolds before rather than within history, even as it is emblematic of history's (anti)black propulsion. As I have suggested, although my argument engages history and historiography, my theoretical intervention is not historicist. For if the black is interdicted from history—that is, from the metaphysics of presence effectuated and expressed by the threaded conceits of worldly historicity, narrativity, and archivalism[73]—how can historicism offer a useful hermeneutic for attending to the anteaesthetics of black existence? Thus, what would at first appear to be an extended historical departure from Mickalene Thomas's *Me as Muse*, with which this chapter opened, is ultimately revealed as a series of returns insofar as her work is marked by and recursively deconstructs a manifold of spatio-temporal differentiations without separability. The problematics which animate my study are ultimately (ante) metaphysical rather than historical, an inquiry that principally concerns the racially gendered bearings of an aesthesis which is made to come before the

world but which can never find a home within its aesthetic regime. In short, we depart from Thomas's work in order to return to that which is already held within it.

The brutalizations to which Saartjie Baartman was subjected mark a pivotal moment, if not a signal event in the ascendance of the Western racial science that became one of the principal apparatuses for the modulation and reproduction of raciality over the course of the long nineteenth century. Baartman was, after all, the "iconic nineteenth-century image" of black femininity, to reprise Anne Cheng's phrasing. Although the mutual constitution of such hierarchical codifications of racial difference and the metaphysics of the antiblack world certainly precedes the advent of the apparatus Denise Ferreira da Silva terms *"scientia racialis,"* a historicist account of antiblackness cannot help but note the growing importance of zoological taxonomies for the racial regime of representation during this period.[74] My interest is not in the elaboration of race science over the course of the nineteenth century per se but rather how these elaborations and the broader scientific transformations of the period are both contoured by and constitutively imbricated with concurrent aesthetic transformations registered by art historical movements and their various formal innovations. I emphasize the anteriority of black femininity, exemplified in the figure of Baartman, in the braid of science and aesthetics as it was woven through the nineteenth century, particularly as it can be discerned in revisions of ethnological theory, modalities of vision, and the genesis of artistic form.

Baartman's exhibition in conjunction with her literal and figurative dissection were the means for renewing the very biological and aesthetic taxonomies that legislated her a priori expulsion from the corporeal division of the world and absolute exposure to the violence of (im)mediation. To be clear: Baartman's dissimulated 'body' and violated flesh are where the scientific and the aesthetic meet, as well as the medium for reproducing their categorical distinction. Baartman's history enables us to think through various imbrications of the singular mediality to which black femininity was subject: the violent (im)mediations of touch. The mediality of black femininity (the reproductivity of which is always already "at hand without mediation") is, I argue, constitutive of rather than ancillary to these historical modulations of the corporeal division of the world and the racial regime of aesthetics. More pointedly, what Baartman's example discloses is the racially gendered

(im)mediation that subtends every instance of the making of (aesthetic) form. At the same time, however, this black mediality cannot help but bear a deformative materiality which is immanent to every form—a contagion which serially and diffusively extends the threat of metaphysical ruination.

The story of Saartjie Baartman has been of crucial importance to those who study the difficult conjunction of blackness, (un)gendering, and sexuality. Samantha Pinto goes so far as to suggest that Baartman constitutes "the ur-subject of black feminist theorizing around sexuality."[75] Baartman has been returned to time and again, even as all she can ultimately offer narrative "is an untimely story told by a failed witness."[76] The problem of the limits, gaps, elisions, and distortions of the archive is not peculiar to Baartman's life but rather general to the black life and lives whose existence the archive would purport to document.[77] Baartman's life is no exception. My engagement with the broken archive, from which any history of Baartman's life must proceed, is compelled less by an interest in narrativization or historicization than in the traces, aporias, and irruptions of black feminine anteriority to the corporeal division of the world and its entanglement with the racial regime of aesthetics. Although the following discussion of Baartman's violent instrumentalization within a series of aesthetic, epistemic, and biopolitical transformations, registered in and as the genesis of form, makes recourse to history, we ought to hold history in a kind of suspension (which is, after all, precisely where it holds us). The image of Baartman we are given is a dissimulation of historical presence, which necessarily bears a dehiscence within the twinned metaphysical conceits of historicity and presence. It is with and for this dehiscence that our story proceeds.

Baartman, it is said, was born in the vicinity of Gamtoos River valley in what is now the Eastern Cape Province of South Africa sometime in the late eighteenth century.[78] She seems to have hailed from the largely pastoral Khoikhoi society, although that is also open to speculation.[79] Baartman was born during a period of colonial intensification marked by war, settler encroachment, indigenous dispossession, and genocidal massacres.[80] Saartjie Baartman was the name she was assigned on the settler farm where she grew up—Saartjie, being the diminutive form of Sara in Dutch; Baartman, meaning "uncivilized, uncouth, barbarous, savage."[81] Although Saartjie Baartman is often referred to by scholars using various orthographic iterations of the forename Sara(h) and the surname Ba(a)rtman(n), I have opted

to foreground her diminutive name to accentuate the fact that, even if we refuse to privilege the epithetic stage name by which Baartman is most commonly known, we cannot escape the racially gendered colonial violence which every utterance of her name cannot help but reproduce. It may be tempting to refuse the degrading signature of the Hottentot Venus in favor of Baartman's "real name." However, such a gesture not only risks erasing the history of conquest and genocide with which her "given name" is inextricably bound but, moreover, risks succumbing to the specious fantasy that the black can either acquire access to the order of nominative propriety with which historical presence is entangled—that order which is, according to Hortense Spillers, "grounded in the specificity of proper names, more exactly, a patronymic."[82] Those who are made to come before the corporeal division of the world are granted no such illusions of individuated bodies and interiorities conjoined in the specular coherence of proper names. Such efforts toward the rehabilitation of historical presence are little more than a subterfuge wrought through the violation of black feminine flesh. As Spillers teaches us, black femininity is always already both an accumulation of violent nominations and existentially nameless.[83]

Although Baartman's sale as a commodity, subjection to racialized sexual violence, and spectacular exhibition in Cape Town presaged the modalities of fleshly violation and forms of bodily dissimulation that were to be her fate in Europe, it is this latter history for which her figure would become infamous. I argue that her display directly evinces her vestibularity to an interwoven series of aesthetic, epistemic, and biopolitical transformations during the nineteenth century.[84] From the time of her arrival in London in the summer of 1810 until the time of her death in the winter of 1815, Baartman was exhibited in England, Ireland, and France. Scholars have critically recounted these exhibitions in detail,[85] and I will refer to them here in only the most cursory way, in order to draw out their implications for a theory of black (feminine) anteriority. Alexander Dunlop nominated and first marketed Baartman as "Sartjee the Hottentot Venus." The stage name is significant not simply because of the cruelty of its satire but because it exemplified a mode of exhibition that would prove to be "pivotal in transferring the tools of the freak show to the ethnographic exhibition."[86] Providing "the basis for theatrical, zoological and museological display and performance,"[87] Baartman's exhibition, in conjunction with her subsequent literal and figurative

dissection, became an essential means of refashioning the scientific and aesthetic codifications of raciality over the course of the nineteenth century.[88] One of the most conspicuous manifestations of this refashioning, as we shall see, would be a new form of (dis)aggregating anatomical visuality, at play in the brushes of Romanticist painters and exclusive French salons. But before we can turn to Baartman's connection to Romanticism, we must try to cast the more familiar details of her exhibition in a new light.

Accounts of Baartman's first exhibition at 225 Piccadilly in London exemplify the motifs for which her display would become synonymous. The exhibition was intentionally situated not a block away from the renowned natural history museum of William Bullock and in close proximity to the Haymarket red-light district, an informal "toleration zone" for sex work.[89] This emplacement of the show served to inflect its aesthetics with both the nominally educational ethos of the ethnographic exhibition and the salacious titillation of sexual taboo.[90] Thus, before Baartman's spectators ever laid eyes on her, their gazes had conjured her dissimulated 'body' at the uneasy nexus of the "natural history" of raciality and "a sexuality whose criminality lies in and before the fact that it is marketed."[91]

Baartman's display was the site of a cruel formalism wherein pornotroping conjoined the erotics of (dis)aggregating anatomical visuality to the erotics of *scientia racialis*. Spectators could view Baartman, according to one attendee, "clothed in a dress resembling her complexion . . . [and] so tight that her shapes above and the enormous size of her posterior parts . . . [were] as visible as if the said female were naked. . . . The dress . . . [was] evidently intended to give the appearance of being undressed."[92] In another contemporary's account, Baartman's display took place on "a stage two feet high, along which she was led by her keeper, and exhibited like a wild beast; being obliged to walk, stand, or sit as he ordered."[93] Such racially gendered spectacularization of Baartman's anatomical curiosities (her so-called steatopygia)[94] and their imbrications with coerced performances of primitivity and animality are by now well known. But to understand such scenes only as racist spectacle is to miss both the singularity of the violence and ruptural force Baartman was and is made to bear. The cruelty of Baartman's exhibition, both before and after her death, is not that a false and degraded personae was severed and set against an authentic self or inalienable human dignity but rather that Baartman was made the vestibule for the very in-

struments of brutality to which she was subject—rendered anterior to the corporeal division of the world, the racial regime of aesthetics, and their nineteenth-century permutations.

Crucially, the violent (im)mediations of touch were both the means and the end of Baartman's subjection. At the risk of belaboring the exposition of this recursive violence, let us recall the engraved caricature discussed in chapter 2, *Les Curieux en extase*, in which Baartman's exhibited 'body,' cut by and splayed across a play of gazes, is made to establish the very visual field which is the site of her subjection. Such cutting and splaying as the rend(er)ing of black feminine flesh before the field of vision is reprised in Thomas's work as a performance of metonymy that functions as a deconstruction of the kind of violence *Les Curieux en extase* exemplifies and extends. The caricature reveals the contradictory and unstable material and libidinal economies engendered by the imposition of black mediality—that is, Baartman's conscription as the medium for entwined epistemic, aesthetic, and biopolitical transformations. These unstable economies are registered only in the most obvious manner in the circuitous erotics of physical touch, which are, nevertheless, far from axiomatic. To reiterate the point, when it comes to the (im)mediations of the flesh, the categorical division of the visual and the tactile comes apart in "the vicissitudes of touch," churned in the terrible underbelly of the haptic.[95]

Baartman's brutal display and subjection alert us to precisely how the operations of touch disjunctively ground the sovereign pretenses of the corporeal division of the world. During Baartman's first exhibition in London, spectators could pay extra to "feel her posterior parts,"[96] anatomized as a site of exchange. In fact, the pornotropic erotics of touch, cutting across visual and tactile registers, clung to Baartman's dissimulated 'body' even long after her death. The anthropological museum where Baartman's skeleton and the full body cast Georges Cuvier had made of her corpse prior to dissection were publicly displayed at the Musée de l'Homme from 1937, when the museum was founded, until 1974 and 1976, when each was respectively relegated to the museum's storerooms. It was not only feminist complaints about the exhibit's demeaning representations that ultimately compelled the Musée de l'Homme to remove Baartman's remains from the public eye[97] but, moreover, the fact that Baartman's "molding itself had become the object of touching and many amorous masturbatory liaisons."[98] Even after the repa-

triation of Baartman's remains and body cast to South Africa in 2002, they remained objects presumptively open to touch, whether to the discursive ambitions of nationalist memorialization or to the genealogical aspirations of ethnological science.[99]

Anxieties over Baartman's place within and displacement from the legislations and adjudications of touch, so crucial to the self-possessive embodiment of the modern subject, can be readily discerned in the considerable hand-wringing and debate over whether Baartman "consented" to her fate. Yet the idiom of consent—and its conceptual-terminological corollary, individuated agency—is utterly "inadequate as an explication of the negotiation and manipulation of power enacted by the enslaved, and the coercive annexation of the captive body, which makes it prey to the unrestricted uses and whims of the other."[100] The capacity to claim the right to consent, as well as the social legibility of such a claim, is one of the principal registers through which inclusion within the corporeal division of the world and the ontological bounds of humanity might be thought. For the singularity of racial slavery marks the absolute contravention of the economy of consent insofar as that economy retains the facade of interrelation between discrete, self-possessive subjects as its organizing principle. Because the catastrophe of racial slavery is the unfinished anterior of the world rather than a determinate epoch within it, the question of whether Baartman was enslaved is metaphysical rather than historical, a question adjudicated before the law in the Derridian sense, rather than within the courtroom that would purport to administer it.[101] After all, as Christina Sharpe has observed, it was precisely the court's nominal recognition of Baartman as "a subject able to consent freely . . . [which] resulted not in her liberation from a cruel master, the original aim of the lawsuit, but in her continued bondage understood thereafter in terms of freedom to 'consent' and framed by a grammar of bodily 'modesty.'"[102] Consent, in this instance, becomes yet another instrument in the renewal of subjection.

We must think carefully about the structural implications of the manner in which the grammar of consent becomes overlain by the "grammar of bodily 'modesty.'" This conflation evinces a moment of mapping the corporeal division of the world onto the racial regime of aesthetics. Consent thereby becomes a euphemism for the very idea of who can constitute an aesthetic subject, who can lay claim to even the meager insulations from the

touch of entanglement, to the pretense of bodily self-possession, and hence a place within the corporeal division of the world and its positive codifications of aesthetic value. As we shall see, whereas the erotics of the nineteenth-century female nude within French Romantic painting pivoted upon the conceit of bodily modesty (look but don't touch), Baartman was subjected to an almost inverted libidinal economy. As noted in the previous chapter's discussion of *Les Curieux en extase*, it was precisely the simultaneous designation of Baartman as radically open to touch and exceptionally monstrous to the eye which, paradoxically, animated the disjunctive erotics of her visual and corporeal brutalization.

It is thus unsurprising that the debates over whether Baartman had (the capacity to) consent to her abjection betray a deep anxiety regarding the "proximity to sensual invasiveness"[103] that the black in general and black femininity in particular are made to bear. Baartman's conscription into the renewal of science and aesthetics was ultimately in service of a metaphysics that enables the pretense of a "capacity to appropriate" one's "own" body[104]—the fantasy of (a) life at a remove from the immediacies of touch that mark black existence. It is this gendered operation of black mediality, I will argue, that is secreted within and displaced from the nineteenth-century nude and overtly deconstructed in Mickalene Thomas's *Me as Muse*.

Black Feminine Anteriority to Nineteenth-Century Scientific-Aesthetic Transformations

Notwithstanding the pretensions of an episteme that prefers to imagine itself wholly apart from the vagaries of the aesthetic, the vicissitudes of politics, and the impulses of the libido, modern science has of course never been the methodologically transparent, autopoietic project it searches for in history's mirror. The so-called Scientific Revolution of the seventeenth century cannot be understood outside the emergent material and discursive circuits of transatlantic racial slavery, colonialism, and an expansionist (racial) capitalist world-economy.[105] Although the imbrications of science and race-making are perhaps more widely recognized in both the popular and scholarly imaginations in the history of the nineteenth century than in the seventeenth, the implications of racial science for the formal aesthetic innovations of the time are seldom interrogated. Moreover, while positiv-

ist history would have us regard the aesthetic and scientific registers of nineteenth-century racial taxonomies as fundamentally distinct, it is clear that the metaphysical operations concealed by science's ruse of objectivity are also aesthetic procedures, no less than the artistic forms with which they are always constitutively entwined.

It is commonplace to retrospectively designate biocentric racial analytics as "pseudoscience" in an effort to recuperate the axiomatic purity of the scientific episteme. But these exercises in rehabilitation are spurious at best, and not merely because phrenology, for example, was profoundly implicated in the globalized formation of numerous scientific fields and subfields throughout the nineteenth century.[106] In fact, raciality has always fashioned the material and epistemic means for modern science's obsessive pursuit of calculation, quantification, reducibility, codification, and definitive explanation, even as it remains its constitutive haunting. Indeed, as Hortense Spillers suggests, the phantasmatic 'black body' and boundlessly available black flesh have proved one of science's greatest resources, "as the entire captive community becomes a living laboratory."[107] As Calvin Warren extends Spillers's contention: "Scientific thinking *needs* blackness because blackness is the living laboratory—*a laboratory that functions biologically, but is dead ontologically.*"[108] Blackness blurs the very boundary between life and death, that receding yet absolute horizon upon which biology and its hierarchies of animacy are predicated, becoming the medium for an infinite range of regulatory animations and deanimations. As the world's malleable essence and deracinated anterior, blackness, in its raveling braid of bodily dissimulations and fleshly bearings, becomes a singular object of fascination and terror, desire and revulsion. Taken for living laboratory, Baartman was made the medium for advancing science's relentless quest to realize and displace its own impossibility.

In this section, I track the experiments conducted within or upon the "living laboratory" of black femininity, drawing out their implications for a general critique of the aesthetic and the metaphysics it works to suture. I begin by briefly reviewing the nineteenth-century renovations of race science, their bearing upon the corporeal division of the world and its qualification of the human, and associated transformations of the visual. These entangled operations were at work in some of the most significant transformations in art and science during the nineteenth century. Both Baartman

and the naturalist Georges Cuvier, who famously dissected Baartman after her death, are at the center of this inquiry. In this terrible instantiation of black anteriority, Baartman is made the vestibule for the (re)production of the very material and discursive violence to which she is subject, particularly through the reinvention and revivification of scientific, biopolitical, and aesthetic forms. I explore the vicious recursivity which enabled Cuvier to subject Baartman to the racially gendered violence she was instrumentalized in renewing and suggest that the displacement of this constitutive violence from Cuvier's hallowed legacy in the history of science mirrors a concurrent displacement within the history of the nude. In each instance, we ultimately find that the black exorbitance which has simultaneously been the target of expropriation and expulsion cannot, in fact, be enclosed or expunged.

Establishing its foothold within natural history during the eighteenth century, racial science initially took the form of climatological theories of monogenesis, whereby the geographical distributions of the descendants of Adam and Eve across distinct climatic zones were said to account for the respective physiological, anatomical, and moral differences between the races.[109] Setting aside the various classificatory schemas and debates that obtained within this climatological race science, we may safely generalize by saying that they shared the presumption that the white European held the exclusive claim to the virtues, refinements, and advantages of civilization, while the "lower races" suffered from various forms and degrees of degradation and degeneracy. Whatever the differences between them, these theories shared a consensus that the black, the *nègre*, was the most debased among the races. As Abbé Prévost, a novelist also known for his ethnographically inclined writings on his travels to Africa, summarized his position on the matter, "The *nègres* have fallen to the lowest degree of brutishness."[110] In the latter eighteenth century, theories of polygenesis—which held that the races had no common origin and that their unequal evolutionary trajectories were wholly separate from one another—began to gain traction, wielding a significant influence by the early nineteenth century and becoming deeply entrenched by the mid-nineteenth century.[111] These theories were fortified, in particular, by the emergent science of comparative anatomy in conjunction with paleontology, which the naturalist Georges Cuvier is widely credited with establishing.

Although these transformations of scientific knowledge to which Cuvier

was so central are often taken up in relative isolation from concurrent artistic innovations, these developments in the natural sciences and changes in aesthetic categories, experience, and forms were in fact thoroughly entwined, not least in the ways that the reconstruction of natural science's scopic regime was bound up with a historically novel aesthetization of the body. This renewal of the aesthetic was predicated upon what Foucault termed the "anatomic disarticulation"[112] of putatively individuated corporealities and discrete morphologies, whereby each anatomical fragment could be (dis)aggregated, magnified, measured, comparatively assessed, and ultimately assigned distinctive characteristics, associations, genealogies, and rankings within a hierarchical organization of life. But it is with respect to nineteenth-century French painting, in particular, that the impact of this anatomic disarticulation became evident in the rise of what art historian Anne McCauley calls "comparative anatomical seeing," which manifested both in the techniques of formal composition and in the dynamics of reception.[113] McCauley writes:

> Zoologists' acute visual attention to extremely subtle variances in osteology, skin colour, hair, posture, and musculature is related in structure . . . to the commentaries that we find in Salon criticism, in which parts of the bodies of painted and sculpted figures are appraised for their anatomical correctness and correspondence with (or remove from) an implicit standard of ideal beauty.[114]

The co-implications of this (dis)aggregative visuality, the racial regime of aesthetics, and its formal artistic innovations are of principal concern and a matter to which we will return. Within the early nineteenth-century life sciences, however, in their putative separation from the vagaries of the aesthetic, the principal upshot of comparative anatomical seeing was elaborating a taxonomical structure for the "great chain of being" and, in turn, the means of delineating the biological boundaries of the human. Many of the corresponding debates pivoted upon theories of biological differentiation within the human species and potential affinities or lines of connection with variegated animalities.

There are by now no shortage of studies documenting and theorizing the ways in which the black and black femininity in particular have played singular and indispensable roles in mediating the modern boundary between

the human and the nonhuman, as well as the hierarchies of animacy more broadly.[115] To return to Hortense Spillers's well-known formulation, in the wake of transatlantic slavery, the black woman was rendered "the principal point of passage between the human and nonhuman world." The black woman came to mark and modulate a "radical discontinuity in the 'great chain of being'" and thereby serve as the vestibule for the (re)production of both the human and the non-human.[116] It was precisely along this register that Cuvier's acute interest in Baartman nominally developed, and it was her unique vestibularity which conditioned Baartman's broader significance for the European scientific community and the rapidly changing life sciences. Yet another instantiation of the terrible interiorizations of the race/reproduction bind, of captive maternity, Baartman's dissimulated 'body' and violated flesh would be taken as a site for the renewal of the scientific and aesthetic taxonomies that establish the epistemological stability and ontological primacy of humanity as species-being.

At the Jardin du Roi over the course of three days, Henri de Blainville, who was for some time Cuvier's assistant and patron, together with Cuvier scrutinized and rigorously documented the minutiae of Baartman's physique while four artists drew renditions of the dissimulated 'body' that was the object of their gaze. In the course of their observations, both Cuvier and de Blainville regularly likened Baartman to an orangutan, and de Blainville would subsequently publish a study he fashioned as "a detailed comparison of [Baartman] with the lowest race of humans, the Negro race, and with the highest race of monkeys, the orangutan."[117] While black feminist theory has given us critical language and a set of analytic tools with which to think through Baartman's singularity and exemplarity—stressing, for example, the ways in which "blackness . . . functions not simply as negative relation but as a plastic fleshly being that stabilizes and gives form to human and animal as categories"[118]—my interest is the manner in which the violent (im)mediations which position blackness as the threshold of, for instance, the human and the animal, are thoroughly aesthetic processes. Moreover, I want to foreground the (de)constitutive recursivity of the relation between the aesthetic and the racially gendered (im)mediations of blackness.

Indeed, the importance of mediums such as illustration and cast sculpture in Cuvier's exercises in comparative anatomy are hardly incidental, even as the subterfuge of scientific thinking would assiduously deny its foun-

dational imbrication with the aesthetic. The threshold Baartman is made to serve as is not simply an interstitial moment, spatially or temporally, but rather an anterior mediality that is both productive of and subject to the very dualisms it mediates—not only of the human and the animal but of the scientific and the aesthetic, as well as, we shall see, medium and form. Crucially, it was through the violent braidings of the scientific and the aesthetic that Baartman was made vestibular to crucial refashionings of the corporeal division of the world during the nineteenth century. I therefore want to refuse to partition the racially gendered displacements of art history, particularly with respect to the form of the female nude, from aesthetic operations which enabled Baartman's dissimulated 'body' and violated flesh to be taken as the medium for dissimulating "the missing link" between the human and the animal and in turn for galvanizing and sustaining the dynamic interanimations of race science and the emergent fields of comparative anatomy and paleontology. It should come as no surprise that Martin Heidegger, whose conceptions of world and worlding I take up in chapter 5, would figure the so-called Hottentot as the negative threshold of Dasein in the following century.[119] As Calvin Warren stresses, at stake is not merely "the exclusion of the primitive from Dasein . . . [but] the *use* of this primitive in the existential journey of the human."[120] Presaging Heidegger's ontological conceit, here Baartman's brutalized flesh and phantasmatic figuration were conscripted as the black mediality which both shores up the absolute boundaries, and manages the material, libidinal, and discursive contradictions and displacements of, the world's corporeal division of subjects. Baartman's anteriority was not only the site of a racially gendered subjection through and revivification of the nineteenth-century's scientific and aesthetic dispensations; Baartman at once bears and contravenes the very distinction between the scientific and the aesthetic.

Cuvier's anatomical fixation with Baartman largely conformed to the convention of privileging sexual(ized) anatomy when it came to the "female specimen." Thus, although he otherwise "believed skulls to be the most important evidence" for a science of racial difference,[121] it was not Baartman's skull or her locutionary facility across multiple languages but rather her "genitalia, breasts, buttocks, and pelvis" that fascinated Cuvier.[122] Of paramount interest were, on the one hand, Baartman's supposedly steatopygic buttocks and, on the other, the "Hottentot apron," or putatively elongated

vaginal labia minora. Much to Cuvier's and de Blainville's consternation, Baartman resisted the full extent of their scopic ambition. "She kept her apron concealed," Cuvier lamented, "either between her thighs or still more deeply."[123] At once violently penetrating and yet unable to fully access something irreducible within her interiorized flesh, Cuvier's (dis)possessive gaze strains against a limit, an aporia within the logic of calculation and valuation, which must nevertheless be made to appear "as a barrier to be overcome."[124]

In the winter of 1815, Baartman died, likely of exposure to the cold, undernourishment, and pneumonia.[125] Having been granted the opening to the last frontier by the quotidian cruelties of necropolitics, Cuvier was now free to wield the aesthetic force of science toward rend(er)ing Baartman's "corpse as a zero that turns into extractive surplus."[126] This surplus would in turn, as we shall see, be reinvested in the speculative life of artistic form. Baartman's corpse was delivered to Cuvier and other scientists at the Jardin du Roi in January 1816. After making a full body cast from Baartman's corpse (which artists painted to mimic her skin tone), Cuvier proceeded to dissect her over the course of several days, taking care to preserve her genitals. This imperative of preservation signals something more and less than erotic fixation. What Cuvier coveted was the fragmentary site of a terrible interiorization, the hieroglyphic sign of black feminine reproductivity.

Figural Exorbitance, Contaminative Touch

The sordid details of Cuvier's depredations have done little to detract from the supposed grandeur of his legacy. "Is not Cuvier the greatest poet of our generation?" wrote Balzac.[127] Indeed, even today, Cuvier is regularly lauded as one of the most brilliant and influential minds in the history of science, whose mark has been left indelibly on modern conceptions of life itself. Michel Foucault has called the massive epistemological upheaval effectuated by Cuvier's work "the Cuvier transformation."[128] The feminist philosopher Lynne Huffer glosses Foucault's interpretation: "Cuvier's function-based system made possible anatomical disarticulation and thereby created the conditions of possibility for modern biology. Darwin's work, Foucault insists, could not have occurred without the transformation of knowledge brought about by Cuvier."[129]

None of Foucault's texts on Cuvier mention his examinations, reproductions, dissection, or preservation of Baartman in spite of the fact that her figure was central to the nineteenth-century making, revision, and consolidation of race science, with which the development and global dissemination of modern biology is inextricably entwined. Baartman's dissimulated 'body' and violated flesh were literally and figuratively made the medium of "anatomic disarticulation," furnishing material and discursive resources for Cuvier's "reconstruction of the epistemological field of biology" so celebrated by Foucault.[130] If it is perhaps unsurprising that Cuvier's pivotal role in the refashioning of the coil of race science and the racial regime of aesthetics over the long nineteenth century, as well as the part Baartman's brutalization played in that refashioning, is conspicuously absent from Foucault's assessment of Cuvier's significance to an archaeology of knowledge, it is nevertheless extraordinary that Huffer, who elsewhere meditates on the ethical implications of the imposition of black feminine surrogacy,[131] is comfortable reproducing this elision in her introduction to the first English language publication of the entirety of Foucault's 1969 colloquium on Cuvier. While celebrating what "food for thought" the thematics of this text "might give us all—humanists, posthumanists, and anti-humanists alike," Huffer makes no mention of Baartman, or race for that matter, even as the treatise which contains Cuvier's observations of Baartman—both while she was alive and subsequently in the course of dissecting her corpse—is among the texts cited.[132]

How might we theorize, rather than simply indict, these critical omissions? Certainly the ease with which Baartman's constitutive violation is expunged from the epistemological history of modernity reaffirms the degree to which it is axiomatic to treat blackness as epiphenomenal, even within the fields that lay claim to radicality. But I want to suggest that this displacement also betrays an unconscious anxiety which is metaphysical rather than historical, structural rather than contingent. This anxiety is not principally a function of moral culpability (for, to expand on Denise Ferreira da Silva's formulation, the fleshly violation of "no-bodies" produces no ethical crisis for those held within the corporeal division of the world).[133] Rather, this unconscious anxiety is bound up with the contaminative touch that this figure of displacement is made to bear. This unthinkable touching back is the haptic friction of an aesthesis that scientific thinking, which is in every

instance aesthetic, both needs and abhors, the architectonics wherein a forgotten keystone also bears the specter of ruination.

We must be careful not to grant racial science more credit than is due for the renovations to the racial architecture of the antiblack world over the course of the nineteenth century, just as we must rigorously deconstruct the apocryphal separation between the scientific and the aesthetic. Kyla Schuller has rightly critiqued the tendency to treat racial science and biological determinism as the predominant means for the development and reproduction of raciality during this period, arguing instead that the entwinement of biopower, sentimentality, and the hierarchical codifications of the sensorial capacities taken as prerequisites for genuine aesthetic judgment were just as important to the modulations of raciality in the nineteenth century as the putatively disinterested scientism of comparative anatomy.[134] Indeed, they were part and parcel of race science. Within the sentimental mode, "race and sex functioned as biopolitical capacities of impressibility and relationality that rendered the body the gradual product of its habit and environment, differentially positioning . . . a body's relative claims to life on the basis of the perceived proportional vitality and inertia of the sensory and emotional faculties."[135] In such a dispensation, impressibility and affectability are cut by a racial distinction whereby "the plastic body of the civilized and the static flesh of blackness stand at opposite poles . . . of sentimental biopower."[136]

However, to recognize the biopolitical force of the sentimental modality for codifying the corporeal division of the world and the concomitant capacity to be an aesthetic subject is not to suggest that science and sentimentality were opposing or even appositional projects during the nineteenth century. As Erica Fretwell suggests, the biopolitical construction of impressibility was itself a mode that generally functioned in dynamic confluence with racial science, as biological taxonomies threaded impressibility through the putative distribution of perceptual sensitivities and affective capacities.[137] "Whereas impressibility served the broader sentimental imperative of cultivating the capacity for sympathy," writes Fretwell, "perceptual sensitivity channeled affective microjudgments toward the cultivation of aesthetic experiences. Both these scientific theories of feeling were deployed to racialize subjects and manage 'life itself' accordingly."[138]

Baartman was made anterior to these entwined regimes of sensoriality in dual respects. On the one hand, her dissimulated 'body' and violated flesh

were made the medium for both scientific and aesthetic taxonomies of black (feminine) hypersensuality, manifest most obviously in the representation of a sexual desire marked by "a primitive inability to temper impulses to touch with reflective thought."[139] This constitutional susceptibility to base sensation or proximity to touch, whether figured in a biological or sentimental idiom, was paradoxically tethered to an imperviousness to touch—a radical unimpressibility, rendering the black (woman) "insensate to pain and thus available as experimental material."[140] It is for this reason that, in *Les Curieux en extase,* Baartman appears utterly unperturbed by or unaware of the concatenation of rapacious gazes. And it is for this reason that Cuvier could take Baartman as a specimen to do with as he pleased, for the sensorial taxonomy of the world afforded no reason for ethical mediation.

Understanding this paradoxical figuration of the black feminine as both radically open to and utterly impervious to touch, as well as the specter of contaminative touch that persistently haunts this racially gendered construction of affectability, is crucial for an anteaesthetic reading of Mickalene Thomas's choice to cast her own skin as the contact zone for a haptic encounter with vanished and violated flesh. The video installation's recursive disclosure of the (im)mediations of touch to which the black feminine remains tethered, far from being a pedagogical exercise in racial critique, is in fact itself a means of contamination's transmission—the penumbra of a touching back that constitutes a terrifying dehiscence within and for modernity's racial metaphysics.

It is important to reiterate that Baartman's anteriority is recursive: she was violently conscripted as the constitutive medium for the very regimes that effectuate her violation. Cuvier's relation to Baartman discloses the pornotropic grasping that inevitably emerges from this vexed libidinal economy, which his scientific pretensions served to displace. The contradictory erotics of Cuvier's discomposing desire come more clearly into focus in the affective vacillations that mark his observations of Baartman's 'body' both while she was alive and after her death. It is when Baartman is alive, however, that we most clearly discern Cuvier's own anxieties about being touched in return, about having already been implicated in the contaminative touch of entanglement. Consider the following passages from Cuvier's *Discours sur les révolutions de la surface du globe* (1826), which recounts his first opportunity to observe Baartman:

Her conformation was initially striking because of the enormous width of her hips, which surpassed forty-two inches, and because of the protrusion of her buttocks, which were more than half a foot. Of the remaining body parts, she had no other deformities: her shoulders, her back, the top of her chest were graceful. The bulging out of her stomach was not at all excessive. Her arms, a bit thin, were very well made, and her hand was charming. Her foot was also alluring.[141]

As Sharpley-Whiting has argued, at this moment in Cuvier's text, his anatomical gaze is not only thoroughly inflected by aesthetic judgment but, moreover, assumes decidedly erotic undertones.[142] Of crucial interest for me, however, is the manner in which adjectives that most directly express an aesthetic appreciation if not outright sexual temptation ("graceful," "charming," "alluring") are reserved strictly for those bodily fragments that are said to lack deformity, those which are taken, anatomically speaking, to be entirely unexceptional. When it comes to Cuvier's principal objects of anatomical fascination—Baartman's "protruding" buttocks in this instance—his language is far more reserved, restricted to a clinical vernacular of measurement and nominally disinterested evaluation. In this respect, it is telling that Baartman's foot becomes the locus for the adjective which veers closest to the idiom of seduction: "Her foot was also alluring."

The Extraction of Burlesque Value

One cannot help but be reminded of Georges Bataille's reflections on the baseness of the foot, specifically the complex libidinal economy centered upon and disclosed by the big toe.[143] The toe functions as an anatomical nexus of a contradictory metaphysics within which Man aspires to a verticality that ascends toward the celestial light of the heavens and yet cannot escape the descendant gravity of an unwieldy corporeality that dwells in terrestrial mud. In this "play of fantasies and fears," the big toe acquires "an exceptionally *burlesque value*":[144]

> Here one submits to a seduction radically opposed to that caused by light and ideal beauty; the two orders of seduction are often confused because a person constantly moves from one to the other, and, given this back and forth movement, whether it finds its end in one direction or the other, seduction is all the more acute when the movement is more brutal.[145]

And yet I am struck by the racial incommensurability between Bataille's big toe and Baartman's dissimulated 'body' and violated flesh. For even the base seductiveness of Bataille's big toe can ultimately be avowed, declared as that which holds out the possibility of a "return to reality"[146]—of embracing that which is already a part (albeit disavowed) of the ontology one inhabits, that which merely awaits, apropos Rancière, being welcomed into the sensorium authorized by the regime of aesthetics. In contradistinction, Baartman's figural exorbitance cannot be avowed, even scandalously, as an aesthetic object of desire. She must remain beneath and before the eclectic iterations of ontological ground, muddied or solid, an anteaesthetic debasement, for whom every seduction is a ruse.

What Bataille helps us to discern is a process which is inherent to the making of form and which is, as we shall see, no less evident in the history of art than in the history of (race) science. Burlesque value can be extracted from the surplus Baartman's figure yields, but this extractive operation must be metaphysically displaced. For Baartman's figure is not merely base, aberrant, or otherwise taboo, but exorbitant. Exorbitance, in this sense, is not simply excessive; it marks the corporeal life of the irreducible materiality which contravenes the very scale of measurement, the logic of calculation, the pretense of transcendental aesthetic judgment. It is a "representation-as-disfiguration"[147] which at once establishes and threatens to ruin the terms of the symbolic order. The antiblack metaphysics of the world needs this exorbitant figuration, singularly borne by black feminine flesh, as a site for projection and absorption, for displacement and extraction, for rend(er)ing. This is the operation of expropriative displacement. And yet modernity's metaphysics cannot abide that racially gendered exorbitance, for the irreducible materiality it carries yields a total "destabilization of ground."[148]

For this reason, although Baartman's exorbitant figure becomes implicated in an erotic maneuver that registers in Cuvier's unconscious as a seduction which "is all the more acute when the movement is more brutal," the "end" of this movement must land on disavowal, to which his text almost immediately turns: "That which our female Bushman possessed that was most repulsive was her physiognomy." Adjectives such as "graceful," "charming," and "alluring" are replaced by those associated with disgust, with body parts variously described as "jutting out," revealing "obliquity," or "monstrously swelled," while Baartman's ears are likened to "those found in many mon-

keys, small and weakly formed at the tragus."[149] Sharpley-Whiting suggests that this abrupt pivot away from eroticized prose marks Cuvier's libidinal divestment from Baartman's figure.[150] But I would suggest that it is precisely because Cuvier is unable to libidinally disentangle himself from Baartman's exorbitant figuration, to temper his desire to consume the very flesh whose constitutive negation makes possible the pretense of his own bodiedness that he must turn to unmitigated disavowal, for he simply cannot escape his anatomized fixation. He is "possessed—infused, deformed—by the object" which is supposed to be his possession.[151]

However, the affective tone of Cuvier's observations undergoes a crucial shift after Baartman's death, as if his presumption of Baartman's absolute inability to touch him in return had granted his vociferous gaze some distance from the imperative of disavowal. In particular, he now had unqualified access to her "apron":

> The apron . . . is a development of the nymphae. . . . The outer lips, scarcely pronounced, were intercepted by an oval of four inches; from the upper angle descended between them a quasi-cylindrical protuberance of around eighteen lines long and over six lines thick, whose lower extremity enlarges, splits, and protrudes like two fleshy, rippled petals of two and a half inches in length and roughly one inch in width. Each one is rounded at the tip; their base enlarges and descends along the internal border of the outer lip of its side and changes into a fleshy crescent. . . . If one assembles these two appendages, together they form a heart-shaped figure . . . in which the middle would be occupied by the vulva. . . . As for the idea that these excrescences are a product of art, it appears well refuted today if it is true that all Bushwomen possess them from youth. The one that we have seen probably did not take pleasure in procuring such an ornament of which she was ashamed, thus hid so carefully.[152]

Although this passage certainly does not depart from his ambition to take Baartman as the medium for establishing the threshold between the human and the animal, his prose here is remarkably aestheticized. As Sharpley-Whiting observes, Cuvier's "language is flowery and feminine; fleshy, rippled petals, crests, and heart-shaped figures. Bartmann's sex blooms, blossoms, before his very eyes."[153] Cuvier's figuration of Baartman's dissimulated 'body' is not that of "bare flesh," *pace* Anne Cheng, even as Baartman is stripped both of clothing and protection, but rather that of the ornamental, of "encrusted representations." In fact, Cuvier goes so far as to refer to Baartman's

genitalia as "an ornament," albeit one of which she ought to be ashamed. What are we to make of the ornamentation of the dissimulated 'body' that is ostensibly the paradigmatic instantiation of "bare flesh"? Rather than read Cuvier's imputation of ornamentality to Baartman's figure in the course of his eroticized dissection as an ephemeral exception to the general rule of her "bare flesh" or as an exemplification of the transracial applicability of ornamentalism to figurations of the black, I want to suggest that Baartman's vestibularity produces the aesthetic value she is denied. Baartman mediates the distinction between the bare and the ornamental, between debased materiality and aesthetic value, even as she is ultimately consigned to the former denudement.

It is only in death that Baartman's fragmented 'body' can be assigned something on the order of aesthetic value. If, as Marriott suggests, "the rhetorical function of black death is to express death's essence,"[154] then we may recall that Bataille suggests that it is precisely because the big toe becomes "analogous to the brutal fall of a man—in other words, to death,"[155] that it acquires its burlesque value, in its rub against the epistemological partition of life from death. In contradistinction, the black bodily fragment blurs the very distinction between the living and the dead, marking an aporetic indistinction within the hierarchy of animacy. The metabolics of the corporeal division of the world and the racial regime of aesthetics require the irreducible materiality blackness bears, yet the corporeal division of the world must ceaselessly work to displace, enclose, discipline, or annihilate the exorbitance to which it is bound. Blackness thereby becomes not only the repudiated lifeblood of modernity's metaphysics but also the anoriginary source of what Marx might call "an irreparable rift in the interdependent process of the social metabolism, a metabolism prescribed by the natural laws of life itself."[156] And it is precisely for this reason that blackness must be made to bear the symbolic burden of perfecting death as an ontological terminus, even as enfleshment obliquely gestures toward or immanently threatens to unleash an existence "beyond a boundary," to borrow C. L. R. James's phraseology.[157] Baartman's bodily fragments cannot refer back to any prior or future wholes, no social body or essential historicity. They are ceaselessly conscripted into the project of worlding, but they simultaneously sustain the impurity of descent, the anterior of ruination.

Let us now take leave of scientific thinking, which perpetually denies the

inherently aesthetic quality of its methods and (e)valuations, and turn to art history, which conversely exalts itself through an explicit appeal to aesthetic judgment. By attending to the shift from neoclassicism to Romanticism and the rise of the female nude in French painting, an art historical transition that Jean-Auguste-Dominique Ingres's *Grande Odalisque* is often thought to trace or even index, we shall see that the genesis of expressly aesthetic form is similarly realized through the expropriative displacement of black feminine exorbitance, even as this displacement remains wholly incomplete and therefore perilous.

Expropriative Displacement and the Remaking of the Nude

It would be difficult to overstate the significance of the nude in the history of the racial regime of aesthetics and the corporeal division of the world, just as it would be difficult to overstate art history's general complicity in the concealment of these operations. In order to begin to consider what might be held within and obscured by the reclining pose of the nude, we may turn to T. J. Clark's notorious declaration in his Marxist reading of Édouard Manet's *Olympia* (1863), one of the most significant nudes in the modern art historical canon: "The sign of class in Olympia was nakedness. . . . Olympia's class was nowhere but in her body: the cat, the Negress, the orchid, the choker, the shawl—they were all lures, they all meant nothing, or nothing in particular."[158] In the preface to the revised edition of *The Painting of Modern Life*, following the critical response to his argument from feminist art historians, Clark offered the following clarification by way of anecdote:

> I remember one of the first friends to read the chapter saying, more in disbelief than in anger, "For God's sake! You've written about the white woman on the bed for fifty pages and more, and hardly mentioned the black woman alongside her!" It is, and remains, an unanswerable criticism; and the fact that I truly had not anticipated it, and saw no genuine way of responding to it within the frame I had made, is still my best, and most rueful example of the way the snake of ideology always circles back and strikes at the mind trying to outflank it. It always has a deeper blindness in reserve. . . . I would now add the fiction of "blackness" meant preeminently, I think, as the sign of servitude outside the circuit of money—a "natural" subjection, in other words, as opposed to Olympia's "unnatural" one.[159]

Clark may have been more right than he realized, though not because the trappings of ideology prevented him from recognizing the sign of blackness in Olympia's maid. Clark's concern is the sign of class, which is to say of class conflict, a hermeneutic which pertains to those variously positioned within the corporeal division of the world but which cannot account for those made to come before this order. "The sign of class" that orients Clark's vision appeals to a system of signification for which blackness is the founding interdiction. What he sees in Manet's painting is therefore restricted to those who already possess a positive appearance within the phenomenology that is wholly conditioned by the racial regime of aesthetics. Although his claim that blackness is the "sign of servitude outside the circuit of money" is, to say the least, complicated by the fact that the black necessarily bears the (corrupted) sign of the commodity—as the solitary figure who was (and remains) both the object and the medium of exchange—he is right to suggest that the subjection of Olympia's maid lies before history, whereas the subjection of Olympia can be elevated to the status of a properly historical conflict, one whose part in propelling the (antiblack) world can be at least avowed.

Clark's misstep is in hoping to correct his prior, unknowing recapitulation of the racial axiomatics of the corporeal division of the world. Yet if blackness can enter into ontology only as nonbeing, can appear within phenomenology only as a dissimulation, then what is this dehiscence within *Olympia* that Clark would doubly displace—first through elision and then again through the farce of recognition? If, as Fred Moten suggests, "the slave is, in the end and in essence, nothing, [and] what remains is the necessity of an investigation of that Nothingness,"[160] then how might we move such an investigation toward the racially gendered reproduction of this nothingness and bring this investigation to bear upon the properly aesthetic history that would reap the fruits of its negative sign?

What follows undertakes just such an inquiry by attending to that which is anterior to the preeminent form of the female nude within aesthetic modernity and its dynamic reciprocality with the corporeal division of the world. While feminist art history has done admirable work to elucidate the sociopolitical dynamics that contributed to the decline of masculinist heroic forms and the concomitant ascendance of the female nude, and to delineate the ways in which this contrapuntal emergence and eclipse of aesthetic forms reveals a profoundly gendered metaphysics, this feminist approach

has generally failed to think through the racial anteriority of the metaphysical operations it critiques. That is, feminist art history fails to attend to the racial metaphysics of the nude in the (re)production of *homo aestheticus*, or the figural artifice assumed by the subject of modern aesthetics.

Let us first consider how the historical genealogy of the nude has been approached within art criticism, as well as how this genealogy has shaped and been shaped within the disciplinary purview of art history. Such aesthetic genealogies are no less than contests over the means and mode of metaphysical (re)production. The feminist art historian and critic Lynda Nead addresses the problematics which cleave to conventional genealogies of the nude in her examination of certain critics' discussions of Diego Velázquez's *The Rokeby Venus* (1647). Taking issue with Neil Maclaren's ascription of a universally transparent, timeless beauty to the form of Velazquez's nude, Nead homes in on the gendered underpinnings of judgments of the nude which are anchored in the conceit of a transcendental aesthetic.[161] Indeed, Maclaren's emphasis on the nude as a form which distills the "extraordinary possibilities" of "the human body," as well as his affirmation of the turn of Renaissance and Baroque artists toward "the sculpture of Greek and Roman antiquity . . . [as] the most complete and perfect expression of art," exemplified by works such as *The Rokeby Venus*, "whose subject is universally pleasing, and whose manner of painting is wholly congenial to modern taste,"[162] evinces an enduring contention of this book: the body as an indispensable (aesthetic) apparatus of and for modernity. In Nead's view, Maclaren presents the nude as a figuration with "a flawless historical pedigree," whose "appeal is said to be timeless" and whose "masterpieces of the genre" apparently "transcend the historical specificities of their making."[163] Even more pointedly, Nead's critique emphasizes the manner in which Maclaren's discourse sustains a characteristic "slippage from the ungendered category of 'the nude' to the highly significant particularities of the 'female nude',," a sleight of hand which is, according to Nead, "almost inescapable in writings produced from within patriarchal culture this century."[164]

Nead's critical reading of Kenneth Clark's canonical art historical study of the nude focuses on how the aesthetic singularity of the form of the nude pertains to its function within a gendered metaphysical order.[165] According to Nead, the male nude is conceived as pure form, an idealized projection of the masculine body which emerges in contradistinction to the sensual-

ized feminine body. The genealogy of this gendered partitioning of the nude, Nead suggests, can be traced back to the Renaissance: "The regulation of sensory and organic perceptions through order and the rules of geometry apparently reaches its apotheosis in Leonardo's 'Vitruvian Man.' . . . Here the matter/form dichotomy is brought to a temporary resolution, with the classicized male body articulated (albeit somewhat imperfectly) through mathematical relations; the male body is fantasized as pure form."[166] At stake in this "mathematically pure ideal of proportion, incarnated by the male body," is nothing less than "the measure of a transcendental aesthetics."[167]

As Nead demonstrates, the perpetuation of this gendered divergence in the representational significance of the nude is not, at its root, predicated upon an inherent visual contrast in masculine or feminine forms but is rather a distinction which is threaded through a metaphysical bifurcation and hierarchization of nature and culture, order and disorder, rudiment and supplement, matter and form:

> But the resolution of matter and form cannot easily be accomplished in the representation of the female body. Historically, woman has occupied a secondary or supplementary role in western philosophy and religion. . . . If the male signifies culture, order, geometry (given visual form in Vitruvian Man), then the female stands for nature and physicality. Woman is both mater (mother) and materia (matter), biologically determined and potentially wayward. Now, if art is defined as the conversion of matter into form, imagine how much greater the triumph for art if it is the female body that is thus transformed— pure nature transmuted, through the forms of art, into pure culture. The female nude, then, is not simply one subject among others, one form among many, it is the subject, the form.[168]

Following Nead, antiquity's idealization of the body, enthusiastically revived by Renaissance and Baroque artists, was not simply a solipsistic exaltation of the masculine body but reflects a deeper anxiety over the preservation and defense of that gendered body's putative attributes: the ideal masculine form stood as "a kind of muscle-architecture, a formal and schematic disposition of muscles . . . used in antiquity for the design of armour."[169] The *cuirasse ésthetique* "symbolizes the heroic male body . . . the hard, insulated male body," that needs to be safeguarded against the pervasive, amorphous, and potentially enveloping threat of femininity.[170] The perfectly structured form of the male nude, in turn, must be safeguarded from the risk of defilement

and even ruination at the figurative hands of a feminine body construed as inherently "unstructured": "the body of woman . . . represents the flood, the human mass; it is soft, fluid and undifferentiated. The warrior male insulates himself from the threat of dissolution into this mass by turning his body into an armoured surface that both repels the femininity on the outside and contains the 'primitive,' feminized flesh of his own interior."[171] If the history of the male nude's emergence is bound up with the masculine fear of and defense against being engulfed from without by the imputed formlessness of the female body, as from the "feminized flesh" within, then the aestheticization of the female nude occurs as a result of a precise effort to render and contain an immanent fleshly contamination within the modern order of forms.

The ideal masculine body, its physical architecture, is a figural boundary erected to discipline and guard against the perceived hazards of the flesh, the hazards of contamination. Here, we should note that within the tradition of Western art, flesh is conceived of as an immeasurable, inexhaustible, and boundless mass. The aesthetic voluptuousness of the female nude is inflected with a set of conflictual masculine desires: to draw near, to touch, and yet to quarantine and be quarantined from flesh, from the contaminative formlessness to which flesh tends—its protrusions, vulnerabilities, and irregularities. Deformity may then be considered a sign of the gendered body's dissent from the protocols of representation driven by modernity's contradictory metabolization of antiquity's enthrallment with "the harmony of proportions" and mathematical measure—those various metrics which aspire for absolute reducibility. We will examine the significance of deformity within the history of the nude in greater detail, specifically with reference to Ingres's notorious nude. What I wish to emphasize more immediately, however, is that the ideological construction and devaluation of the female nude, and the bodily distortions which subsequently emerge as a means of formal revaluation and revalorization, ultimately become construed by the aesthetic regime, teleologically, as continuous with the progressive advancement of artistic forms. As Nead explains:

> The projection of the female nude as one of the primary aesthetic traditions within western culture works as an ordering device. It implies that what are actually highly diverse ranges of images have a virtually uninterrupted and progressive history of representation, stretching, in this case, from classical

antiquity to the Renaissance and on to the heroic achievements of modern-ism. This historical sequence is punctuated with the names of the outstand-ing masters of the form—Giorgione, Titian, Rubens, Boucher, Ingres, Manet, Renoir, Degas, Picasso—with variations to fit the trajectory of particular ar-tistic tendencies.[172]

Hence the feminine body's ostensible tending toward formlessness is recuperated and enclosed by the female nude not only spatially but tempo-rally, insofar as its iterations can be sculpted into "punctuations" within the larger "historical sequence" of modern art. To understand how the nude has come to function "within western culture . . . as an ordering device," as Nead asserts, requires grappling with the surreptitious relation between the phe-nomenal projection of the female nude, its representational ubiquity within Western modernity, and the dissembling fantasy of (white) femininity to which each are constitutively tethered. The significatory power of the female nude is bound up with the projection of an embodied plenitude which, par-adoxically, is made possible only by that body's appositional difference from the masculine ideal from which it is deemed derivative and to which it is cast as supplementary. Yet insofar as the feminist art historical critique of the aestheticization of the female nude has endeavored to deconstruct the dyadic gendering of agency and value which is evident in the spatial and temporal "ordering" of the form within the larger "historical sequence" of modern art, it has largely proceeded through the displacement of the ra-cially gendered, enfleshed reproductivity which bears the very distinction between matter and form.

As we briefly noted in the previous chapter, the aesthetic displacement of flesh in the fashioning of sculptural form has been discussed by the art his-torian Charmaine Nelson. In reference to Hiram Powers's *Greek Slave* (1843), Nelson argues that "the deployment of white marble within nineteenth-century neoclassical sculptural practice actively disavowed racial differ-ence, specifically blackness, through proscriptions at the level of media and material practice that successfully obstructed the possibility of racing the body in the dimension of skin color/complexion."[173] Crucially, Nelson insists not only that this disavowal leads to the "material and aesthetic displace-ment" of blackness but that "the black female body [becomes] displaced at the level of theme or subject through a further disavowal of the immediacy of the contemporary sociopolitical contexts of colonialism and slavery."[174]

The considerable stakes of this displacement hinge upon the enduring influence of classical sculpture on painting's preoccupation with the rendering of ideal form. Kenneth Clark's canonical art historical study of the nude, for instance, affirms the resonance between the idealization of the nude within painting and the "splendidly schematized bodies of Greek sculpture," which lend the nude its "terms of measurement" and guide the artist just as "mathematical rules" would guide an architect.[175]

In her more recent text, *Representing the Black Female Subject in Western Art*, Nelson argues that "the whiteness of . . . marble, as deployed within nineteenth-century neoclassical canons, did not directly represent Caucasian skin color" but rather "signified that which it displaced—flesh."[176] It is less neoclassical sculpture's disavowal of the expressive traits of "race/color" that concerns me than the operation whereby flesh is at once displaced from the medium of sculpture and becomes the condition of possibility for its ideal form in the medium's formal schematization of the body. For the legislation and governance of the nude's perfectly distorted form depends upon both the expropriation and expulsion of flesh. My argument extends Nelson's inquiry further in order to stress that the racial problematics of the gendered aestheticization of the nude in nineteenth-century painting are not simply matters of an idealized form set against or placed in diametric opposition to the derelict 'body' blackness is thought to epitomize. Rather, guided by the concept of flesh specific to Spillers's theoretical lexicon, I insist, first, that the material-discursive rend(er)ing of the nude from flesh underscores black feminine vestibularity to the aesthetic. This vestibularity in turn, necessarily entails the bearing of the expropriative displacement of flesh—a bearing which ultimately congeals as form.[177]

The mechanism under scrutiny is the displacement of flesh as racially gendered, exorbitant materiality from art's corpus. We shall see that the *beau ideal*, the Western European embodiment of ideal form and beauty, tethered to the schematization of the body's physical motifs within classical antiquity, is in fact realized through that displacement, an operation which the present inquiry into the revivification of the *beau ideal* through the deviation from its own sedimented codes throws into stark relief. Interestingly, Velazquez's *Rokeby Venus* presents us with one such notable deviation, which marks the anticipation of an advancement in the formal presentation of the body of the female nude. Kenneth Clark contextualizes the painting at length:

The Venus of the *dix-huitième* extends the range of the nude in one memora-
ble way: far more frequently than any of her sisters, she shows us her back.
Looked at simply as form, as relationship of plane and protuberance, it might
be argued that the back view of the female body is more satisfactory than the
front.... The *Hermaphrodite* and the *Callipygian Venus* suggest that it was also
considered symbolic of lust, and before the eighteenth century the number of
female nudes depicted from behind solely on account of their plastic possibil-
ities was remarkably small. A famous exception is the *Rokeby Venus* of Velas-
quez...; but that strange, dispassionate work is outside all our preconceived
notions of chronology, and seems closer to the academies of the nineteenth
century than to the warmer images of Venus that precede and follow her.[178]

Two aspects of Clark's observations are worth noting: first, the historiciza-
tion of the nude viewed from the back as a predominantly nineteenth-century
phenomenon within academic art practice, and second, his suggestion that,
since this time, the view from behind has become more erotic, evoking the
"plastic possibilities" of the figure hitherto withheld from this vantage. To-
gether, these dimensions of Clark's analysis draw us closer to the peculiar
contingencies of the nude's historical form, which, in the case of the Venus,
Clark discloses as a "relationship of plane and protuberance."

We have encountered the "dorsal view" before, in Géricault's careful ren-
dering of the *African Signaling*. But what compels our attention in Clark's
passage is his insistence upon the way this painting brings the back into
sensuous focus, his depiction of the back as an object of lustful attention
peculiar to the historical transformations inaugurated during the nine-
teenth century. This turn to the back of the female nude may also be taken
as indicative of a conjuncture in which the genre of masculine heroics has
been thrown into crisis and entered into decline. Masculine representation
is apparently displaced by the ascendance of the female nude, and this dis-
placement is coupled to the visual assertion of the back as a distinct site for
rearticulations of feminized sensuality, eroticism, and viscerality.

Importantly for my purposes, Clark's interest in Velazquez's painting
as one of the earliest nudes to figure the back as a unique site for animat-
ing the potential plasticity or plastic potentiality of the body, anticipating
a representational tendency that would become more general during the
nineteenth century, is threaded through a distinctly anatomical interest in
and scrutiny of the female body that is also characteristic of the period. The

acute anatomical scrutiny, which, as we have seen, is constitutively impli-
cated in the biological qualification and codification of the human within
and beyond nineteenth-century race science, runs with equal force through
the concurrent formal aesthetic innovations of the nude.

A new structure of experience was beginning to take hold in post-
Revolutionary France, expressed in and effectuated by a new set of artistic
protocols and impetuses. Ingres's unique style and aesthetic innovations
were, as many art historians contend, the result of his strategic exploitation
of the crisis in pictorial representation produced by the decline in mascu-
linist political ideologies that had driven the reforms of the Revolutionary
and Napoleonic eras. Susan Siegfried contextualizes Ingres's artistic emer-
gence with respect to these powerful historical shifts with which the aes-
thetic transformations of the post-Revolutionary period were thoroughly
entwined.[179] From 1797 until 1806 Ingres studied in Paris at the studio of
Jacques-Louis David, the most prominent representative of the neoclassi-
cal style. During this time, the narrative painting associated with Davidian
neoclassicism became problematic as the rhetorical power of gestures which
once "carried the narrative and unified the composition" began to wane.
What solidified Ingres's "post-narrative" style was his capacity to break
from narrative while still adhering to classical unity.[180] Ingres's exploration
of the tension between history and the imagination precisely at the histori-
cal moment when pictorial representation became mired in turmoil at least
partly accounts for the innovations that were to follow, innovations which
marked his comparative break from Davidian neoclassicism.

In 1846, the French art critic Paul Mantz offered the following remark
about Ingres's now iconic painting, *Grande Odalisque* (figure 17): "This left
thigh which imprudently loses itself in the vague background of planes . . .
happy will be he who can see how it will re-attach to the torso."[181] Mantz's un-
favorable reception of Ingres, the painter said to have provoked the aesthetic
shift from neoclassicism to Romanticism in the first half of the nineteenth
century, nevertheless calls our attention to the engineering of a gendered
difference in the aesthetic dispensations of the nude. For Mantz, Ingres's
torso falls short of the transcendental heights, the universality of the truly
beautiful, to which Géricault's *Signaling Black* triumphantly ascends. Having
judged Ingres's female nude as hopelessly deformed, a trespass against the
aesthetic's "harmony of proportions," the torso in the *Grande Odalisque*

functions as a wayward fragment that cannot be returned to the whole to which it imputably belongs. The torso of the odalisque cannot be anchored to the totalizing architecture of a sovereign body and must therefore be aesthetically devalued, an operation which becomes symbolically tethered to the fragment's inherently gendered, corporeal inferiority. Mantz's comment inadvertently gestures to a gendered difference in the aesthetic strategies deployed in the conscriptions of black mediality toward the (re)making of form.

What nineteenth-century observers found most striking about Ingres's reclining nude was its figural condensation of the many "deviant qualities of the painter's art."[182] Critics of the so-called *ingristes*[183] saw this painting as exemplary of work "lacking correctness" because it exhibited "all of the faults" they tended to identify in Ingres's work more generally: "misplaced, distorted, and discolored body parts; . . . 'crude' tonalities; stiff, contorted, or simply 'bizarre'; . . . radical deviations from conventional standards of verisimilitude and/or established canons of beauty."[184] The sinuous, weirdly distended body of Ingres's nude perplexed and transfixed the attention of viewers, while provoking the "unrelenting negativity"[185] of the nineteenth-century Salon critics. Not insignificantly, critics "denounce[d] as the most reprehensible failings the very peculiarities of Ingres's art that [would] eventually be embraced as the essence of his pictorial achievement."[186] Mantz's comments in particular allude to the significance of discontinuity, disjunction, and disconnection as crucially linked thematics and aesthetic operations in the painting of the period.[187] As Siegfried has argued, these aesthetic motifs, which were deployed in response to the "problematic of narrative"[188] in the early nineteenth century, informed Ingres's orientation in particular and were crucial to the development of a "painting of excess" that his work came to exemplify, if not spearhead.[189] The emergence of the peculiar anomaly of the excessive fragment—whose paradoxical formation served as both the expression and, ultimately, the resolution of the crisis in the pictorial representation of the body during the period and would prove to be crucial to the making of Ingres's serpentine nude and thus its challenge to the "world view of the gendered status quo within painting"[190]—will be of crucial importance in our ongoing interrogation of the codification of the corporeal division of the world and of the anteriority of black femininity to the rend(er)ing of the aesthetic body and the body of the aesthetic.

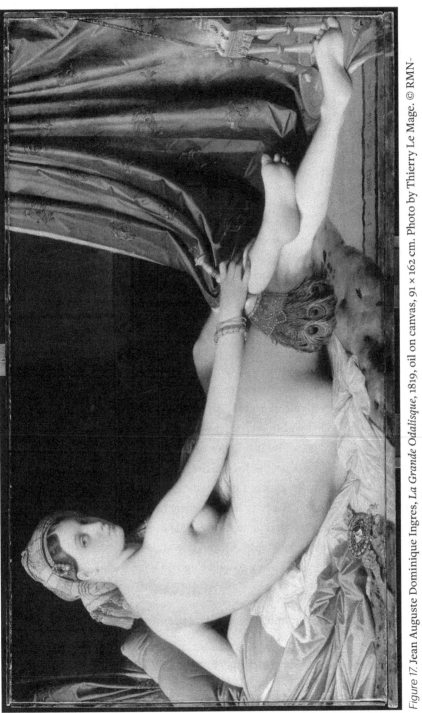

Figure 17. Jean Auguste Dominique Ingres, *La Grande Odalisque*, 1819, oil on canvas, 91 × 162 cm. Photo by Thierry Le Mage. © RMN-Grand Palais / Art Resource, NY. Reprinted with permission.

The year 1846 was also when the poet Charles Baudelaire expanded upon the essential qualities of Romanticism in his commentary on paintings by both Ingres and Eugène Delacroix. Baudelaire, it is said, was the critic who made the most of Ingres's affinity for the female nude, suggesting that this was "the genre in which [the artist's] supremacy seems to have been most securely established."[191] Baudelaire's commentary on Ingres gestures not only to how important an aestheticized femininity becomes to revivifying the nude in this historical period but, moreover, to how the stakes of this revivification run deeper than the conjunctural vicissitudes of politics, ideology, or taste. In "Salon of 1846," Baudelaire declared:

> Stendhal says somewhere: "Painting is essentially a system of moral values made visible!" Whether you interpret the words "moral values" more or less broadly, the same may be said of all the arts. Since they are always beauty expressed by every individual's feeling, passion, and dreams, in short variety in unity, or the multiple facets of the absolute, criticism verges constantly on metaphysics.[192]

What is striking is the grand generality of this assertion, for according to Baudelaire, all the arts can be said to visibilize a system of value(s) as form. Furthermore, and crucially for our purposes, when Baudelaire suggests that those nominally individuated artistic endeavors and aesthetic receptions are in fact embedded within a broader ethical and aesthetic paradigm that "verges on metaphysics," he insinuates first, that there is an explicit relation between a regime of aesthetics and the metaphysics through which that regime coheres and with which it is entwined, and second, that the critical interpretation of the work of art is necessarily implicated in the project of codifying that aesthetics and metaphysics. The uneasy distinction between a criticism that verges on metaphysics and one which instantiates or (re)produces a metaphysics would seem to dance upon a knife's edge.

The Serpentine Line and the Anatomy of Modernity

Bearing in mind the metaphysical stakes of the regime of aesthetics, the work of art, and the work of art criticism, let us return to the critical readings of Ingres's significance by feminist art historians, so that we may discern their racially gendered limits. Carol Ockman has notably brought gender, sexual-

ity, and women's pleasure to bear on Ingres's fabrications of the sensualized nude. Throughout her study, Ockman makes a feminist case for the value of Ingres's work for theorizing "female agency and subjectivity," which, in her view, have been largely undervalued by art history. She asserts that "the radical redefinition of the male body in the wake of the French Revolution [was] ultimately responsible for the increased emphasis on the female nude in the nineteenth century," a gendered revision of the aesthetics of the nude which "is nowhere more apparent than in the work of Ingres."[193] More precisely, Ingres's work exemplifies "the contradictions inherent in the change from the revolutionary hero to the postrevolutionary sensualized nude, and the larger difficulty of representing a viable ideal body, male or female, which could allay contemporary anxieties about masculine identity."[194] In Ockman's view, the coterminous decline of the revolutionary hero and the rise of the sensualized nude must be thought of not only as interlinked phenomena but as entangled effects of the crisis or rupture in representation around the male body in the aftermath of the French Revolution.[195] As noted in the previous chapter, it is also crucial to situate this aesthetic retreat from the heroic male revolutionary and turn toward the sensualized female nude in relation to the emasculating effect of colonial losses, especially the shadow cast upon the European imagination in the wake of the Haitian Revolution.

It is in Ingres's distinctive and arguably most famous nude, the *Grande Odalisque*, that the anatomical distortion of the gendered body and the iconographic revision of that body's putatively essential metaphysical difference finds definitive expression. Ingres is in large part credited with magnifying the female body's physical deformation, a signal representational innovation of the modern aesthetic. The art historian Roger Benjamin goes so far as to argue that Ingres's anatomical distortion marks nothing less than his pictorial articulation of the "anatomy of modernity."[196] Benjamin's study, which traces Ingres's influence on early twentieth-century masters such as Cezanne, Matisse, and Picasso, among others, posits Ingres's aesthetic innovation as the source of his contemporaneity. He argues that "Ingres's distortions provided a . . . seminal precedent" to the "'young deformers'" of the avant-garde who would "break the mould of academic anatomy once and for all."[197]

But what facilitates the singular reverberation of "Ingresque anatomy" within modernity is not the painter's revolutionary overturning of

the body's idealized representation but rather his precise attempts to "put the body off-balance" by engineering "a subtle shift in the composure of the *beau ideal*."[198] Crucially, this "subtle shift" is accomplished through an aesthetic operation which seeks to simultaneously dramatize flesh and to secure its containment. This dual movement and its contradictory impetus suggests that Ingres's female nude is in effect threatened and constrained by the very medium which makes her form available to us. For as Ockman avers: "The very shape of the canvas is enlisted to restrain the ample female forms, whose fleshliness would appear to go beyond real-world anatomy, if not the parameters of fantasy."[199] That the twinned accentuation and containment of an apparently phantasmatic flesh would come to feature so centrally within Ingres's contouring of the nude suggests a deeper significance of the fleshly—not simply to this particular odalisque's anatomical distortion but to the repertoires of aesthetic innovation that move through the nineteenth century more generally.

The singularity of Ingres's so-called serpentine line has been remarked upon at length by Ockman, whose book is dedicated to "an analysis of how and why Ingres's signature line came to embody his formal achievement."[200] Ockman's historical contextualization of Ingres's innovation importantly marks the serpentine line as a motif that brings together a discussion of the figurative uses of the nude, the vicissitudes of the flesh, and the crafting of a sensible vocabulary in support of the nude as exemplary of sensual fig- uration within aesthetic modernity: "Ingres's line and the term *serpentine*, which frequently describes it, so automatically connote the sensual that ref- erence to the qualities of grace and softness has become integral to any un- derstanding of Ingres's style."[201] Ockman traces the notion of the serpentine line back through the term *figura serpentinata*, first introduced in the Renais- sance. The serpentine line became a "conspicuous" topic of aesthetic inter- est in the eighteenth century, specifically with the publication of William Hogarth's 1753 treatise *Analysis of Beauty*. Hogarth "introduced an explicitly gendered reading of serpentine line . . . which, at least in part, informed Ingres's productions."[202] The reproduced excerpt from Hogarth's text chron- icles "the elegant degree of plumpness peculiar to the skin of the softer sex . . . assisted by the more softened shapes of the muscles . . . with gentler and fewer parts more sweetly connected together, and with such a fine simplicity as will always give the turn of the female frame, represented in the Venus,

the preference to that of the Apollo."[203] A technical innovation underlies the female nude's seemingly organic distortion. The line itself is a strategic (dis) figuration whose subtleties paradoxically illuminate a strange beauty that becomes the marker of an ineffable sensuality and a sexual difference that is inherent to the feminine sex.

From Hogarth's reflection, Ockman extrapolates a gendered grammar that betrays a clear "relationship between deformity and grace . . . [which] seems especially significant when studying an artist whose most famous painting of a nude, the *Grande Odalisque*, is known for having too many vertebrae."[204] The serpentine line, rendered by way of an elongated back, ultimately comes to be regarded as a feat of painterly ingenuity. This figural distortion, which links deformity to grace and the feminine to the ornamental, proves an intriguing problematic for Ockman, for whom Ingres's line opens up a space for a uniquely feminist aesthetic appreciation and revaluation of the nude's form and for the advancement of feminist art historical methodology. The importance of Ockman's intervention is her critique of the prevailing assumption that Ingres's "sensualized body is [simply] a beautiful body," a view which "fails to address distortion and the frequent perception that this body is beautiful and strange at the same time."[205] While I would agree with Ockman that attending to the serpentine line as a mechanism for rend(er)ing fleshly distortion as artistic form is key to any critical assessment of Ingres's nude and its place at the forefront of modern aesthetic innovation, my consideration of the anteriority of racially gendered flesh compels me to diverge from the feminist art historical approach, not least because of its genealogical emphasis.

My interest is in the methodological slippage between the critical assessment of Ingres's serpentine line as an object of erotic fascination which tracks the ascendance of the sensualized female nude and the reinscription of this line's deformative impetus within the hermeneutic boundaries of the aesthetic form it ultimately serves to congeal. For if we cannot attend to the nude's displaced anterior, we will be unable to discern this form's racially gendered (de)composition—its genesis, its aesthetic legislation of the corporeal division of the world, and the contamination it inadvertently extends. Some art historians are more tempered about the figural advances with which Ingres is often credited. Kirsten Powell, for instance, exclaims that "Ingres' mastery of line contributed to a sensualized classicism that allowed

the artist to get away with deformation in the name of grace, purity, and elevation."[206] But for my purposes, Ingres's deployment of the serpentine line "to get away with" the expropriative displacement of fleshly exorbitance in the making and valorization of aesthetic form is precisely the point. I contend that the confluence and disjunction between the aesthetics of "flesh" and line crucially delineate a moment within the history of painting wherein the forms of the body's representation become sutured to the corporeal division of the world. In short, Ingres's serpentine line is a formal stratagem that marks the aesthetic means by which bodies are rend(er)ed from flesh. His line announces that which it displaces: the racially gendered anteriority which enables the body's aestheticized (dis)figuration.

Ingres's *Grande Odalisque* and the Genesis of Form

Feminist art historians seem to concur that the unique pictorial turn which brought gender and sexuality to the fore in the early nineteenth century underscores the significance of Ingres's nude odalisque as a form that fuses "the classicism of western civilization with the invention of an oriental subject."[207] Within nineteenth-century painting's sensualized rendering of the body and its ornate tableau, blackness is figuratively construed as an ontological exception to hierarchies of sexuality and gender, stratifications which are themselves aesthetically codified and categorically enforced through the triangulated fantasy of the relations between (white) concubine, servant, and slave. One could say that the enforcement of these aesthetic hierarchies with respect to blackness's constitutive negation is a distinctly European accomplishment and nineteenth-century orientalist painting's proper oeuvre. The genre provides an inconspicuous case study in (the dissimulative mobilization of) blackness as constitutive of but nonetheless barred from the aesthetic.

If Ingres's later painting *Odalisque with Slave* (1842) figures blackness as the irreducibly negative alterity to the Occident/Orient opposition from which the genre of Ingres's orientalized nude is nominally fabricated, his much earlier *Grande Odalisque* instrumentalizes blackness toward far more profound ends: the expropriative displacement of the metaphysical exorbitance borne by racialized flesh, an operation which furnishes the conditions of possibility for the aestheticization of the female nude. What is at once

held and eclipsed in the feminist art historical discourse on the "tension [in Ingres's work] . . . between controlling line and sensual flesh"[208] is the trace of the predacious expulsion of racialized flesh in the making of an economy of forms which simultaneously feeds upon and disavows that flesh. Aestheticized corporeality is rend(er)ed from the unruly materiality of flesh.

Ingres's *Grande Odalisque* enables us to glimpse the aesthetic operation which conjoins expropriation and expulsion. We know, for instance, that Ingres presents his odalisque turned around, from front to back. "Ingres turned the front of the body away only to propose the erotic possibilities of the back, flank, and feet,"[209] and the painting solicits the eye to trace the serpentine line of the body down to the buttocks. Siegfried's readings of Ingres's prioritization of the serpentine line of the back contends: "If oriental despotism represented the inverse of enlightened France . . . then within an erotic oriental imaginary repertoire, the buttocks represent the inverse of the front as an image of sexual license and forbidden practice."[210] From the vantage of this imagined contrast, the visual stakes of the painting begin to become clearer. We can start to discern that Ingres's curious bodily inversion reaches deeper than its surface representation. It directs us to consider the conditions that not only make the aestheticization of corporeal deformity possible but that ultimately permit its positive correlation with sensuality and grace.

In an assessment of the nude's bodily inversion, Siegfried asserts: "Flipping the odalisque's body around from front to back would seem to address Ingres's qualms about the modesty of the female nude. . . . The contradictory effects of the odalisque's teasing 'yes/no' pose leave one wondering what the nub of this erotic fantasy is: should we be desiring what is withheld or appreciating what is offered?"[211] It is interesting, to say the least, that the aestheticization and eroticization of this particular aspect of the body, with respect to painting the female nude, would catalyze nineteenth-century sentiments about demureness, immodesty, and illicit sexuality, as well as the gendered ideologies that surrounded them.

These observations cannot help but be read back through Baartman's example, for, as we have seen, Cuvier was particularly preoccupied with visually capturing Baartman's putatively aberrant physiognomic constitution from a frontal vantage, even as the popular imagination of her physique largely fixated upon her buttocks. Siegfried's analysis of Ingres's inverted

nude compels our return to the coercive frontality to which Baartman was subject in one singular respect. Let us recall in Cuvier's pointed figuration and scrutinization of Baartman's supposed shame over her 'body,' her un-fledged predisposition to "hide" her congenitally ornamented "apron": "The [Bushwoman] we have seen probably did not take pleasure in procuring such an ornament of which she was ashamed, thus hid so carefully."[212] Notice that, given his assumptive knowledge of the black's constitutional indifference to virtue and propriety, Cuvier must impute shame to Baartman's otherwise inexplicable concealment of her "apron." By figuring Baartman's withhold-ing as an understandable, if pitiable, response to the monstrosity of her own 'body,' Cuvier sweeps aside any logical inconsistencies in the racially gen-dered fabrication of sensible indifference, which serves as the negative foun-dation for the sensual valuations associated with the rise of the female nude.

The problematic art historical association of frontality and primitivism is significant here, notwithstanding the eventual "semantic migration of the term 'frontality'" from taxonomies of figural representation to formal-ist discourses on modernist abstraction.[213] What is significant here is that the frontality to which Baartman is subject—a frontality which is arguably equally at work in the aforementioned caricatures in profile—is a dissimula-tive operation that simultaneously accentuates and flattens a figural excess, expropriating its surplus for, while displacing its exorbitance to, an emergent set of aesthetic innovations. The frontality to which Baartman is subject is a pornotropic violence, which is not only predicated upon her being "at hand without mediation" but which dissimulatively redoubles that brutal imme-diacy at the level of representation. Thus, we are confronted with the acute irony of Ingres's gesture and Siegfried's critical evaluation of it: "flipping" the torso around may be transfigured as an expression of modesty or erotic withholding only because the exorbitant figure of the black feminine—whose rend(er)ed flesh runs through the genre of the nude but nevertheless moves against its grain—is always already refused any aestheticized fem-inine virtue or sensuality that might be withheld. This begs a question to which we will return: what then are we to make of Mickalene Thomas's per-formance of unclothed frontality in *Me As Muse*?

There can be little doubt that to argue for the vestibularity of Baartman to Ingres's sensual line is anathema to the reigning episteme, provoking an apparent ontological and aesthetic untenability. We must nevertheless insist

upon the ante-empirical veracity of this black feminine anteriority—if only to trouble the nude's universal demarcation of the category of "woman" as the basis for a feminine aesthetic and to disclose the racially gendered underpinnings of "the aestheticization and sanitization of the female body."[214] Within its nineteenth-century context, the genre of the female nude emerges through a racial regime of aesthetics whose "metaphoric substitutions and unconscious associations"[215] require the expropriation and displacement of black flesh for and from its order of forms. The serpentine line marks an aesthetic (de)formation which depends equally upon appropriation and expulsion as twinned mechanisms of containment. Having eclipsed the anteriority of form, the feminist art historical genealogy and interpretation of Ingres's serpentine line not only fails to attend to this racially gendered displacement but effectively extends it.

Let us pause to consider Baartman's place in the story of Ingres's nude and the relative concurrence of Baartman's presence in France at the time of Ingres's execution of the *Grande Odalisque*. We know that Ingres traveled to Naples in February or early March of 1814 and remained there until late May of that year.[216] We may only speculate that he might have traveled through Paris sometime thereafter and that such a trip could very well have coincided with Baartman's arrival in Paris in September of that same year. After four years in London, in September 1814, Baartman was transported from England to France, where she ultimately ended up in the hands of S. Reaux, a showman of animals. Reaux exhibited Baartman around Paris, where the public's fascination with her physique further saturated nineteenth-century visual culture, with a proliferation of visual caricatures, sketches, cartoons, and prints all featuring exaggerations of Baartman's exposed "flesh." (The prevalence of Baartman's image as caricature in the media of the time only underscores the fact of her dissimulated appearance.)

Baartman "arrived in France already [infamous] as the Hottentot Venus, and the fame of her figure only increased."[217] Baartman was not an obscure presence in Paris; she lived and worked in the Palais-Royal, whose "glorious 'Bazar'" and galleries brought together "the vices and wonders of urban culture" and saw the "crossing of pleasure and consumerism and architectural beauty."[218] Baartman's relative proximity to the Palais-Royal, so prominently associated with the birth of European aesthetic modernity, can perhaps not be overstated.[219] Furthermore, the timing and importance of

Baartman's arrival from London at the height of France's inter-imperialist struggle with England could not be more pronounced, as Napoleon had just relinquished his title as emperor, after threatening English supremacy with his plans to conquer Europe, setting the stage for Baartman's arrival near the start of the Bourbon Restoration of Louis XVIII and the ascendency of the monarchy once again in France.[220] Yet it was not simply that Baartman's "movement through empire and different commercial contexts helped create her racialization within Europe."[221] We ought to consider Baartman's function as a productive, polyvalent node in the protracted European struggle for hegemony within the modern world-system.[222] Her morphological transformation—from cultural anomaly to an object of spectacle, to finally a cultural mainstay—signals the centrality of black feminine flesh even or especially in the course of its displacement. Doubly marked as commodity and as a symbolically eccentric spoil of empire, Baartman became subject not only to the perversities of (de)valuation but to conscription as that which mediates value's enabling diametrics and impossible exactions. She became bound, in other words, to the (aesthetic) threshold of power and accumulation, the receding point on each side of inter-imperial conflict and exchange.

Aspects of my inquiry are anticipated by art historian Katherine Brion's article "Courbet's *The Bathers* and the 'Hottentot Venus': Destabilizing Whiteness in the Mid-Nineteenth-Century Nude."[223] However, my study departs from Brion's orientation in three respects. Firstly, while philosophically problematizing historicism, I locate the aesthetic import of Baartman's (re)productive labors, violated flesh, and dissimulated 'body' earlier in time, specifically in the historical shift from neoclassicism to Romanticism. In doing so, my intention is neither to parse dates in accordance with an empiricist periodization of influence, nor to reveal the persistent presence of blackness within the formal reifications of whiteness and thereby "destabilize" or "denaturalize" the latter's presumed purity.[224] Rather, my intention is to emphasize the anteriority of black femininity in the genesis of (aesthetic) form as such. In turn, I suggest not only a general racially gendered vestibularity that could be discerned in any number of art historical genealogies within the modern world but moreover the inescapable entwinement of artistic form, the racial regime of aesthetics, the corporeal division of the world, and the antiblack metaphysics of modernity.

Secondly, Brion's art historical argument depends upon the exploitation of a certain slippage between the literal/conceptual status of the historical person of Baartman on the one hand and the historical figuration of the Hottentot Venus on the other. This slippage relies upon and elides a theoretical distinction that is unsustainable in my argument. Where Brion is clear that the focus of her article is "the use of 'the Hottentot Venus' as a figure/concept of alterity rather than the individual who embodied that role in the early nineteenth century,'"[225] she is also keen to assert that nineteenth-century critics' fixation on the "prominence of the backside" in these paintings "evidently recalled Sara Baartman, whose notoriety stemmed, in part, from her large buttocks."[226] Oddly, the argument treats the figuration as inherent to the person, while simultaneously reasserting the nominal separation of the two and declaring that the study concerns the former but not the latter. Yet to claim that the figural circulation of the Hottentot Venus can be divorced from and analytically elevated above Baartman's fleshly circulation problematically assumes both that it is possible to discuss Baartman's physical body as a phenomenologically transparent sign of individuated personhood and that it is possible to separate Baartman's physical body from her representational figuration. In contradistinction, I am arguing that, while theoretically distinguishing between Baartman's dissimulated 'body' and enfleshed existence is crucial, practically separating the two within modernity's historical cartography of presence is impossible. For just as it is black feminine flesh that must bear the myriad dissimulations of blackness, this flesh inhabits an existence without being.

Thirdly, where Brion is predisposed to highlight a nineteenth-century aesthetic fixation on the buttocks through various critiques of the dorsal view of the body, I argue that the significance of Ingres's odalisque within the historical trajectory of the nude must also be more generally situated in its relation to an emergent regime of comparative anatomical seeing. Indeed, the extent to which this anatomical seeing came to permeate the regime of art is apparent in Baudelaire's suggestion that Ingres's paintings evinced an eroticized devotion to women that could only have been expressed by an artist who had "become attached to their slightest beauties with the fierceness of a surgeon."[227] As we have seen, this new mode of disaggregative visuality, which profoundly shaped both the techniques of formal artistic composition—not least Ingres's serpentine line—and the attendant dynam-

ics of reception that marked the aesthetic innovations of the nineteenth century, was constitutively bound to the literal and figurative dissection of the black as a scientific-aesthetic specimen. Baartman's example conveys not only the extent to which the scientific and aesthetic transformations of the nineteenth century were conjoined but also the extent to which black femininity was anterior to their conjunction, distinction, and conflation.

By marking a convergence that can only remain speculative, I do not mean to overdetermine Baartman's geographic convergence with Ingres, but I do mean to mark the relative concurrence of Baartman in Paris as a heuristic for problematizing disciplinary approaches to the study of nineteenth-century art which not only engage in exclusivist historicizations but which exalt rigid formalism and positivist empiricism as the prerequisites of proper historical inquiry. For as Michel-Rolph Trouillot teaches us, often enough the discourses of formalism and empiricism mask a historicism which is in fact "based not so much on empirical evidence as on an ontology, an implicit organization of the world and its inhabitants."[228] My ambition is not to reveal or uncover specific relations of artistic affiliation or patronage that definitively establish the literal or symbolic centrality of Baartman to Ingres's studio. The fact that we cannot necessarily say if, when, or how Ingres encountered Baartman's dissimulated 'body' is itself a function of the violence of the archive. Indeed, the very desire to absolutely claim Baartman's constitutive relation to this moment of aesthetic renewal, to retrieve her figure from archival obscurity and hold it transparently before the light of day ought to be tempered by Saidiya Hartman's crucial assertion: "The effort to reconstruct the history of the dominated is not discontinuous with dominant accounts or official history but, rather is a struggle within and against the constraints and silences imposed by the nature of the archive."[229] The violence to which Baartman was subject is not an incidental consequence of her (de)valuation but emerges from the imperative to conceal the vestibularity of black femininity to the aesthetic and thereby reproduce the black feminine as the absent center of the aesthetic project that is the corporeal division of the world. Moreover, in order to drive home the comparative wager that emerges between this chapter and the last, we must stress that the aesthetic expression of the imperative of concealment reiterates a gendered differentiation in the medial operations of the black bodily fragment and a

clear divergence in the formal trace of expropriative displacement. Whereas Géricault's signaling African may transpositionally effectuate the fantasy of a restored harmoniousness in and of the social body and thereby acquire the semblance of aesthetic valorization, Baartman's exorbitance bears the peremptory imperative of displacement and is therefore denied even the veneer of metaphoricity.

The Naked, the Nude, and Metaphoricity

Baartman's productive violation betrays the extent to which aesthetic judgment is inextricably entangled with a history of brutal corporeal degradation and artistic innovation with "gratuitous violence."[230] To fully ascertain the scope of that violence and its specific functionality to the aesthetic, we are compelled to return to Kenneth Clark's study, which advances a crucial distinction between the naked and the nude. For Clark, the nude figure is the reformed body. The nude's ennobled transcendence is held up against the naked body, thoroughly marked by deprivation and lack:

> The English language, with its elaborate generosity, distinguished between the naked and the nude. To be naked is to be deprived of our clothes, and the word implies some of the embarrassment most of us feel in that condition. The word "nude" on the other hand, carries, in educated usage, no uncomfortable overtone. The vague image it projects into the mind is not of a huddled and defenseless body, but of a balanced, prosperous, and confident body: the body reformed. In fact, the word was forced into our vocabulary by critics of the early eighteenth century to persuade the artless islanders that, in countries where painting and sculpture were practiced and valued as they should be, the naked human body was the central subject of art.[231]

The nude is not merely a subject deemed eternally worthy of academic study. Moreover, from Clark we may discern that it is a figuration which marshals and maintains the distance between the civilized and aesthetically cultured, those yet in need of aesthetic education, and those who are so far afield of the spatial and temporal bounds of subjecthood that no amount of paternalistic pedagogy will grant access to civil society and its aesthetic codifications. In this respect, Clark's conjoining of sensibility and embodiment in his aesthetic fabrication of the nude is hardly incidental. The nude "projects

. . . a balanced, prosperous, and confident body," and it could not be otherwise. The aesthetic mechanism by which that projection occurs is also the means by which the body becomes subjectified.

Clothing, in turn, in conjunction with one's cognizance of the significance of its presence, character, or absence, becomes a means of measuring the body's placement within or displacement from a hierarchy of affectability. To be naked is to be deprived of clothing and, as this figure manifests in the colonial imagination of the benighted native, to be deemed incapable of the aesthetic judgment required to recognize such a condition of deprivation as shameful. As an exercise in contrasts, Clark's formulation presents a problem worthy of study and attention, particularly with respect to the history of Baartman's display, especially in light of our ongoing interrogation of black femininity's displaced vestibularity to the making and unmaking of form. It is not simply the sensualization of the nude that is at issue but precisely the means by which the nude is placed in contrast with nakedness. Importantly, Clark's art criticism reveals a teleological relationship between nakedness and nudity: to know oneself as naked is to anticipate the eventual aesthetic realization of the nude. The course of Baartman's notorious subjection was both contingent upon and constitutive of the modern taxonomy of this "classical and idealizing tradition of representation."[232] Her erotic visualization lays bare the mechanics by which the aesthetic distinction between the naked and the nude operates as part of a regime of aesthetic codification that depends upon the predacious expulsion of the black from the metaphysical distinctions that obtain within the corporeal division of the world.

Let us recall the debased scenes of popular display Baartman was made to bear, in which she was exhibited barely clothed, a decadent, fleshy ornament. To reprise a characterization discussed earlier, an article in the *Times of London* from 1810 attests to Baartman's public appearance thusly: "she is dressed in a colour as nearly resembling her skin as possible. The dress is contrived to exhibit the entire frame of her body, and the spectators are even invited to examine the peculiarities of her form."[233] The disclosure of the dress as having been intentionally "contrived" or constructed so as to mimic the appearance of Baartman's skin without garment gestures toward the manner in which the ceaseless circulation of degraded, racialized flesh is always already tethered to the dissimulation of the 'black body.' The contrived dress imposes a particular indistinction between fabric and skin,

revealing the gendered reproduction of the violent operation observed by Fanon: "The Negro has to wear the livery that the white man has sewed for him."[234] In this instance, what we witness is the racially gendered (re)production of the very unity and distinction of nakedness and nudity as aestheticized forms, each set in absolute contrast to the abjection of the 'black body.'

This is where the aesthetic, the biopolitical, and the necropolitical meet: in the marshaling of aestheticized nudity against the visceral protrusions of the flesh. The garment was contrived in jest, as if to mock Baartman's presumed obliviousness to the shamefulness of her own nakedness, her imperviousness to the vulnerability such a deprivation ought to entail. The cruelty of the joke pivots not only upon the supposed ridiculousness of Baartman's 'body' but moreover upon the laughability of the very notion that she might wear clothes. According to the logic of this violent dissimulation, the black is utterly devoid of the aesthetic capacity required to lay claim to either nakedness or nudity. In other words, the punch line is that the black cannot recognize this lack of clothing *as* lack.

The manner in which Baartman was conscripted into the refashioning of scientific and aesthetic regimes over the course of the nineteenth century, an operation only gestured to by the massive proliferation of visual imagery surrounding her figure, therefore lies in the projection and exploitation of a 'body' which is cast outside the dualistic teleology Clark imagines. Baartman is categorically interdicted from what Frank Wilderson terms the "value-form" of nudity:

> Nudity, then, in its display and contestation as a value-form (its disparate valency in civil society) is a universal phenomenon for some and a homicidal phenomenon for Blacks. The semiotics of nudity as drama of value . . . is an assertion of White capacity in contradistinction to Black "monstrosity." . . . While the performance of nude bodies can be either hegemonic or counterhegemonic—that is, can have a socially regressive or socially transformative impact on the machinations of civil society—the performance of nude "flesh" cannot.[235]

If nudity is ontologically and aesthetically untenable for the black, it is because the ontic disposition toward nakedness is generally unavailable to blackness. That is, what the black does not have access to is the self-

consciousness associated with nakedness as an incipient claim on bodily self-possession. Furthermore, the contrast between the naked and the nude betrays an inextricable link between nudity, nakedness, and metaphor. But as Craig Dworkin avers, in a reading of Derrida: "The figure of nakedness is not just any metaphor, but the very metaphor of metaphoricity itself. . . . *Nudisme* literalizes the metaphoric . . . the way the truth is figured."[236] And yet, if blackness as non-ontological relationality cannot lay claim to metaphoricity, as David Marriott maintains, and if the nudity of the white feminine body is fabricated in order to disclose the "naked truth of the human," then, for the black, "vérité comme nudité" (truth as nakedness)[237] is always already foreclosed.

Neither nudity nor nakedness are available to the black as anything other than dissimulations. Here we may briefly revisit Anne Cheng's assertion that "Baartman . . . was reduced to bare flesh," which is meant to place her in contrast to Asiatic femininity (specifically given in the example of Afong Moy, whose "appeal does not derive," as Baartman's does, "from her naked flesh" but rather from a "decorative grammar").[238] And yet this contradistinction would seem to contradict Cheng's intentions to deconstruct Clark's "segregation of the nude from the naked."[239] It would be a mistake, then, to read the performative instantiation of Baartman's nakedness as anything other than the aesthetic thematization of a bodily dissimulation. Cheng's reading of Baartman, which hinges on the reduction of nakedness in the flesh to bare flesh, fails to regard said nakedness as a complex fabrication that has to do with the black's subjection to a violence which is not reducible to physical or even psychic injury but is a consequence of blackness's unbounded fungibility. Thus we confront the cruelty at the heart of Baartman's bodily dissimulation—hers is a 'body' forcibly made to appear *as if* it could be naked. At the same time, blackness, enjoined to performatively confirm an ontological incapacity to embody nakedness or nudity, is roundly mocked. Baartman's subjection, which depends on her bearing the burden of accounting for this ontological incapacity, is bound up with the rend(er)ing of degraded black feminine flesh, its dissimulation cast beyond the pale of even humanized nakedness that might be normatively transcended for the sake of the nude's aesthetic realization. And yet, Baartman's fleshly exorbitance cannot be altogether excised from the racial regime of aesthetics within which the nude coheres. For the contests over what Rancière calls

"the distribution of the sensible" within the racial regime of aesthetics are given through operations more complicated than mere exclusion.

How is it that, in Tamar Garb's words, "the commodified pleasures of the flesh," "the expanse of flesh at the heart of painting,"[240] so crucial to the figural milieu of the nineteenth-century, come to be accommodated under the register of sensuality and thereby dissociated from a racially gendered exorbitance that can only ever appear as the visibly unrestrained, overwrought object of an endlessly violent displacement? Despite its best efforts, painting's aesthetic fabrication of the sensualized female nude through the expropriative displacement of black feminine flesh "carries with it the transferential mark"[241] of an irreducible and irredeemable disfigurement. The story Ingres's *Grande Odalisque* tells is how something exorbitant becomes rend(er)ed assimilable and how the racial regime of aesthetics confers aesthetic value upon that expropriatively displaced exorbitance. Recalling Rancièrean aisthesis as a process which welcomes the hitherto unthinkable into the aesthetic as the new, we may say that here the irreducibility of flesh is rent so that it might be dissimulatively rendered as the assimilable, albeit only at the moment of its disappearance from the aesthetic form it bequeaths. But this putative assimilation of black flesh is not without cost. For the (im)mediations of the flesh, that singular rapaciousness of touch which serially sets the metabolics of the racial regime of aesthetics in motion, does not leave *homo aestheticus* untouched.

The recursive violence of Baartman's anteriority—wherein her violated flesh and dissimulated 'body' are conscripted as the medium for revivifying the interanimating forms of aestheticized corporeality and the nude, which in turn furnish the brutal mechanisms for her metaphysical voidance, corporeal expulsion, and coerced mediality—extends a far more serious problem for the aesthetic than the unpalatable thought of the "excessive, racialized body"[242] looming at the edges of Romantic painting. At stake in the distinction between the excessive and the exorbitant is the matter of a dehiscence which the metaphysical order of the world can neither eliminate nor abide. Black aesthesis is the bearer of a metaphysical contamination, which both Baartman and Mickalene Thomas do not so much introduce as return. This is not the exogenous contamination of an otherwise pure, idealized whiteness, the axiomatics of which constitute the unspoken precondition for thinking the paradigmatic gendered form of the nude. Rather, the contamination that

blackness bears was always already (not) there—an anoriginal contamination that lies before the form of the nude. Blackness is not a contamination which sullies the exclusionary purity of the aesthetic or aesthetic form but rather the condition of (im)possibility of the very metaphysics through which forms cohere, a dehiscence the aesthetic works assiduously to suture. And because the contamination of blackness is required for the purification of the metaphysics of the world, it necessarily bears the specter of immanent and imminent ruination within every form, not least the nude. It is to the racially gendered bearings of form's contaminative anterior that Thomas is generous enough to (re)turn us.

Phantasmatic Touch and the Technesis of the Flesh

Mickalene Thomas's ghostly appearance, cut and splayed across screens in variegated monochromatic tones, visually contrasts with the figures of canonical nudes set against thick, polychromatic tableaux of intricate textiles and lush ornamentation. Yet the spectral quality of the work is not exactly a consequence of the way Thomas's reclining figure and art history's canonical nudes (see figure 18) would seem to haunt one another's proverbial footsteps or the way Thomas's figure passes through ephemeral conjurings of the ghosts of Baartman and others. Rather, to draw upon David Marriott's formulation, the disturbance *Me As Muse* provokes or discloses in the visual field and the broader sensorial regime in which that field is embedded "is one of phantasm, of being haunted by the nothing there."[243] Nothing is there within and between these appearances or rather in and as their displaced entanglement. And yet some thing touches back.

This is the touch of an unsignifiable blackness, which the anteaesthetics of *Me as Muse* both obliquely signals and materially extends—the touch of an aesthesis which is anterior to signification and unfolds not from the figural, formal, or historical invocations of the work but from the work's recursive deconstruction of its own conditions of (mis)appearance (see figure 19). *Me As Muse* proceeds from a condition in which the work is always already enfolded with its figural, formal, and historical invocations, even as the black materiality of this entanglement cannot enter into the realm of appearance as anything other than dissimulative rend(er)ing. By recursively returning to the riven flesh of black femininity, *Me As Muse* discloses the racially gen-

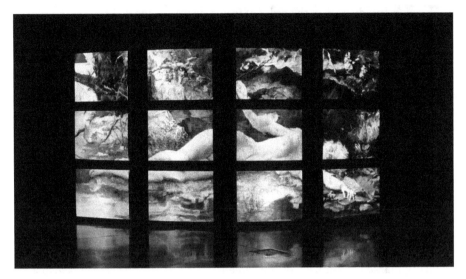

Figure 18. Mickalene Thomas, *Me As Muse,* 2016, multimedia video installation, 12 video monitors, each 19.1 × 24.1 × 18.5 inches (48.5 × 61.2 × 47 cm); 57.5 × 106.25 × 32 inches (146.1 × 269.9 × 81.3 cm) (overall, dimensions variable). © Mickalene Thomas. All rights reserved.

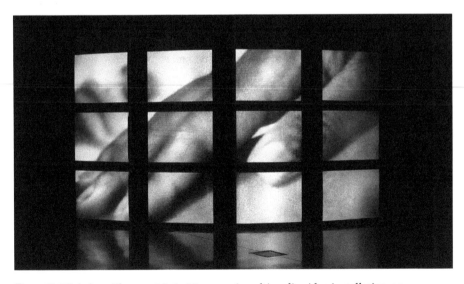

Figure 19. Mickalene Thomas, *Me As Muse,* 2016, multimedia video installation, 12 video monitors, each 19.1 × 24.1 × 18.5 inches (48.5 × 61.2 × 47 cm); 57.5 × 106.25 × 32 inches (146.1 × 269.9 × 81.3 cm) (overall, dimensions variable). © Mickalene Thomas. All rights reserved.

dered (re)production of the order of forms, as well as the deformative aporia black mediality cannot help but instill within every form. For the serial and diffusive conscription of the enfleshed labors and bodily dissimulations of black femininity in the (re)production of the world's order of forms is also the (re)production of an exorbitance which constitutes the condition of (im)possibility for form.

In other words, the unique anteaesthetic quality of Thomas's *Me as Muse* emerges through a *technesis of the flesh*, wherein the material exorbitance the interface bears reaches back to touch the viewer. The viewer's hairs are raised by a touch that the metaphysical law of (the corporeal division of the) world insists cannot be. This touching back violates the ontological, phenomenological, and semiotic architecture of the world not because the viewer expects a "unidirectional and nonreciprocal" prosthesis through the unmarked, inanimacy of the screen[244] but because the screen is also a skin, a site for the animations and deanimations of epidermalization, for the dissimulation of the 'black body' which supposedly "slumbers in absolute ignorance of itself and the world."[245] The viewer's encounter with the form rend(er)ed from flesh as "the skin of the screen"[246] thus becomes a confrontation with the (in)communicable transmission of a contamination, the hapticity of a dehiscence, the shudder which accompanies a brush with the unthought and unthinkable: a ruination without restoration.

Four

The Black Residuum, or That Which Remains

Glenn Ligon is a philosopher of the threshold, of that which is made and unmade in and through passage. His method draws upon a materialism which is neither old nor new, but untimely.[1] In its poetics of non-arrival, Ligon's work directs our attention toward that which is secreted within and yet secretes from the ongoing material-discursive production of both the twinned monumentalities of medium and form and the metaphysical ground upon which they stand. In his text-based works, with which the first half of this chapter will be concerned, Ligon brings his extraordinary sensitivity to the vestibular to bear upon modernity's racially gendered configurations of the visual and the textual, the abstract and the representational, the written and the oral, the material and the semiotic. If the phenomenological dissimulation of blackness is necessarily palimpsestic, then Ligon's work seems to ask us what remains—not only upon and beneath surface appearances and the appearances of surface but before the very play of surface and depth.

Consider Ligon's "Door" series (1990–92), perhaps the most prominent and celebrated works within his expansive oeuvre. Each work is 80 × 30 inches (figure 20), the dimensions typical of a standard door, and identical to the white-painted wooden door which was left behind in a studio Ligon once occupied and used for the first work in this series.[2] Scaled anthropomorphically, as Ligon would have it, each piece could nominally accommodate "the human body"[3] and thereby physically positions the viewer, recalibrating her gaze and comportment to meet the work. These wooden doors were "primed and then blanketed with repeating quotations in viscous black oil stick, which collected on the back of his stencil and smeared into a finely managed mess."[4] The first three works from this series draw their words from a signal

Figure 20. Installation view of *Glenn Ligon: AMERICA* (Whitney Museum of American Art, New York, March 10–June 5, 2011). Photograph by Ron Amstutz. Digital image © Whitney Museum of American Art / Licensed by Scala / Art Resource, NY. Reprinted with permission.

text of black literary modernism—Zora Neale Hurston's "How It Feels to Be Colored Me" (1928).[5] With their calculated arrangement of words, at once composed and fragmented, the door paintings—their letters symmetrically placed, yet anti-proportional to the picture plane—anticipate the viewer's presence and produce a sense of surface agitation. The text seems to want to spill over, to cross the physical threshold of the frame in ways that brush up against and disturb a modern scopic regime that privileges "disinterested, purely optical contemplation."[6]

Ligon has often commented on the centrality of the body to the "Door" paintings, and yet he has consistently refused representationalism as a frame for explicating this centrality.[7] His refusal is neither incidental nor a simple valorization of the abstract over and against the figurative but rather signals the anterepresentational dimensions of black corporeality. If Ligon's work could be said, as Krista Thompson suggests, to "play . . . with the materiality of language, its literalization, its perception, and its role in the surrogation of the body, particularly of bodies seen as black,"[8] then it must be stressed that this is a surrogation devoid of original referent. Ligon directs our attention to the dissimulation of the 'black body' and the fleshly bearings of an existence without being as the very conditions of (im)possibility for the field of representation—not least in its ambition to cleave the visual from the linguistic. Hurston's exemplarity emerges from the fact that she is both theorist of and subject to the racially gendered conscriptions of black mediality. She is made the threshold of this cutting of the abstract and the figural, the visual and the linguistic. Ligon's work recursively deconstructs the terrible (im)mediations of the threshold only to leave us with the question of what *remains*.

As an entrance into this problematic, consider the following excerpt from Donika Kelly's poem "Self-Portrait as a Door":

> You are a sign
> are a plank are a raft are a felled oak.
> You are a handle are a turn are a bit
> of brass lovingly polished.
> .
> There is a hand hard as you are hard
> pounding the door. . . .

. .
There is a you
on the other side, cold and white
as the room, in need of a window
or an eye. There is your hand
on the door which is now the door
pretending to be a thing that opens.[9]

In a cascading play of double entendres, accentuated by her careful use of metaphor and enjambment, Kelly undertakes an impossible portraiture,[10] an autotheoretical inquiry into what it means and how it feels to be made a threshold. The "sign" recalls its anoriginal genesis as "felled oak," the material which must be cleaved in and through the rend(er)ings of signification; the laying of hands upon the (black bodily) fragment such rend(er)ing permits, the "bit" which, despite the romance of "brass lovingly polished," retains the figurative trace of the iron meant to halt the speech of the commodity;[11] the hardness, through and as which one has been fashioned, the "pounding" of a fist, demanding transit through one's vestibular corpus; the "you" which is split, splintered, fettered to the subterfuge that would repudiate the deadly sorting of doors and those subjects who pass through them; the "cold and white" interior and exterior, each of which one can never truly inhabit, but merely be a threshold from which inhabitants, their insides and outsides, their incursions and excursions, might emerge. In short, Kelly gives us a poetics of black (feminine) mediality and the (dis)ordering of metaphysics to which it is tethered. In the poem's strains and fissures, its innumerable and insoluble doublings, Kelly leaves us with a question: What remains before the operation of rend(er)ing that would make one a door?

Kelly's poem gestures to the corporeal irreducibility of a racial aporia that David Marriott would call the "vertiginous absence between the *I* and the *it*"[12]—or, more precisely, of the gendered reproduction of this aporia—in a manner that anticipatorily echoes the existential prolapsus Ligon thematizes and theorizes in his "Door" paintings. What are the implications of this singularly precipitous descent for the beholder of the work of art? Let us note that the discrepant vertiginousness of Ligon's work completely belies the high modernist valuative schema which dictates "the primacy of absorption," which Michael Fried famously articulated above and against the base-

ness of "theatricality."[13] Whereas theatricality could do nothing more than "*stage* presence," absorption promised a "perfect trance of involvement."[14] Fried's conception of absorption, I would argue, ultimately functions not only to reconfirm the sovereignty of the beholder, but to institute an implicitly racialized hierarchical taxonomy of aesthetic forms that would prohibit an attunement to the recursive deconstructivism that animates the anteaesthetic practices with which this book is concerned. Ligon's work does not extend a promise of absorption to its viewers. Instead, it luxuriates in the theatricality of its forced performance, withdrawing into a nonperformance that deconstructs the opposition between the absorptive and the theatrical. Just as soon as the work would seem to draw the viewer toward its threshold, it recedes from both grasping and inhabitation, or rather inhabitation as grasping. The work stages a discrepant impasse. One viewer confronts a threshold which cannot be crossed, which at once undermines and indicts the viewer's acquisitive pretense to being (the artwork's beholder). Another viewer confronts a vertiginous passage she is already forced to bear, without the possibility of accounting or escape—an abyssal inhabitation that cleaves to and is reproduced by the violent (im)mediations of the flesh.

How does one interpret a door that can only ever pretend "to be a thing that opens" but that is nevertheless perpetually positioned as the threshold for an ongoing violation? We might begin from Du Bois's notorious demurral of the very question he rhetorically reproduces, which he leaves unanswered, perhaps precisely because it is unanswerable: "To the real question, How does it feel to be a problem? I answer seldom a word."[15] Is Du Bois's demurral in this quasi-anecdotal textual fragment, which famously opens his 1903 *Souls of Black Folk*, a performance of the refusal to acquiesce to the interrogative hail of a subject who takes him for object or a wry attestation to the semiotic impossibility of giving an answer, or both? If the black is "shut out from . . . [the] world by a vast veil,"[16] then how does this veiling manifest at the level of communicability? And if this veiling would already seem to disturb the linguistic, discursive, and affective modes of conveyance and signification that define communicability—the register which is bound to the promise of subjectivity, intersubjectivity, and social cohesion—does it not also raise the specter of another register, that of the pathogenic, of a contagion that marks the dangerous impurity and unwieldy materiality of every conveyance?

These are questions which require us to attend to a problematic affixed to the anterior of the semiotic impulse and potentiality of the work of art, which Niklas Luhmann suggests emerges in the play of difference between communication and perception.[17] They are questions which call for an attunement to the matter of translation as a singular problem for the racially gendered (im)mediations of blackness. Ligon has explicitly expressed an interest in the matter of translation, which "is always involved with loss, the untranslatable, excess meanings, the indecipherable."[18] Recall that the etymological root of *translation* is "transfer," to "bear across, carry over, bring through."[19] What exactly is it that is borne across Ligon's "Door" paintings? And what remains lost, excess, untranslatable, or indecipherable even in the course of this bearing, this passage? That is, what is the relationship between what I will theorize in this chapter as the *black residuum* and the exigencies of signification? Ligon's work is concerned precisely with this materiality that is excommunicated in service of communication—this unwieldy materiality which is reproduced in and yet elided from medium so that it may assume and deliver a form.

———

Over the preceding two chapters, we have traced the racially gendered bearings of black aesthesis through the modern corporeal division of the world and the (un)making of aesthetic form. We have seen how this aesthesis, to which the enfleshed life of black existence is resolutely bound, serves on the one hand to renew and revivify the corporeal division of the world and its permutations in and as the aesthetic. On the other hand, we have seen how black aesthesis proves to be absolutely unassimilable within the racial regime of aesthetics and its distributions of the sensible. The black feminine singularly bears the obdurate materiality that continuously emerges in the reproductive cut of dissimulation and enfleshment. This emergence is continuous, because black feminine vestibularity is endlessly instrumentalized in the making and remaking of (aesthetic) forms. The black (feminine) confronts the violent immediacy of ontological reproduction, a brutalizing difference without separability, in and as the constitutive mediation of subjectivity, world, relationality, and aesthetic experience for the non-black. Yet the racially gendered violence of (im)mediation proves to be double edged. For the world simply cannot abide the enfleshed existence and labor it never-

theless requires. Thus, the exorbitant bearings of the black feminine must be at once leveraged and displaced, lest the contaminative potentiality of this unwieldy surplus violate the quarantine's perimeter.

If, as we discussed in chapter 1, medium and form are recursively entwined, then how might we draw out the implications of the (im)mediations of the flesh, as well as the exorbitance that black mediality cannot help but extend, for questions of medium-specificity and media ontology so dear to art history and media studies, respectively? Turning toward Glenn Ligon's work across both painting and video installation, this chapter argues that Ligon's practices do not merely instantiate a "transmedial turn" in contemporary art[20] but, more pointedly, an anteaesthetic critique of the ontological and phenomenological grounds and reproduction of both medium and media as such. By tracking Ligon's recursive deconstructivism across painting and video installation, we can discern a practice attuned to the black aesthesis that is anterior to medium. This black aesthesis is at once bound to and aporetic for the ongoing dualistic fabrication and modulation of medium and form, a dualism which consistently obscures medium *as* form.

Our anteaesthetic inquiry into Ligon's oeuvre proceeds recursively, in a manner that finds methodological resonance with Ligon's own anteaesthetic practice. In order to clarify the method and stakes of Ligon's deconstruction of racial semiotics in his text-based works, we begin with an exposition of the racial regime of language and a critique of the graphocentric/ocularcentric order it sustains. We then turn to Ligon's *Condition Report* (2000) in an effort to elucidate the particular hermeneutic difficulties the hieroglyphics of the flesh pose for an anteaesthetic reading of Ligon's text-based works before undertaking an extensive interpretation of the complex play of surface and depth, figure and ground that Ligon's "Door" series instantiate and interrogate. Ligon's 1990 works *Untitled (I Do Not Always Feel Colored)* and *Untitled (I Feel Most Colored When I Am Thrown Against a Sharp White Background)*, as well as his 1992 work *Untitled: Four Etchings*, will be of particular interest in the course of this inquiry. I argue that Ligon's transpositional engagements with black literary modernism (especially through the writings of Ralph Ellison and Zora Neale Hurston), and the deconstructive critique of high modernist art historical approaches to medium-specificity these engagements effectuate, have profound implications; they extend a theory both of the opacity which is anterior to the presumptively particular condi-

tion of black hyper(in)visibility and of opacity's constitutional entwinement with a materiality that is at once the requisite for and eclipsed from that form which is the medium.

These transpositional engagements disclose the racially gendered transfers and displacements that enable the myriad iterations of medium and form, even as the enfleshed existence from which these labors emerge remains formless. The anteriority of blackness to the formation of mediums is explored further in the second part of the chapter, which centers on Ligon's 2008 video installation *The Death of Tom* and its recursive citation of Edwin S. Porter's 1903 silent film version of Harriet Beecher Stowe's nineteenth-century sentimentalist novel *Uncle Tom's Cabin*. We will discover that what remains before the cinematic, as before every medium, is the black residuum. Finally, we turn toward the relationship between black mediality and the black femininity dissimulatively figured through Stowe's Topsy. An excursus into Topsy's hauntological pertinence to *The Death of Tom* serves to delineate the relationship between the racially gendered enfleshment which becomes (displaced in) the apparatic body of the cinematic medium and the exorbitant materiality which returns to us as the black residuum.

Graphocentrism and the Racial Regime of Language

An anteaesthetic inquiry into Ligon's text-based works must begin from the recognition that raciality is hardly epiphenomenal to modern schematizations of the visual and the textual, the abstract and the representational, the written and the oral. These works remind us that these formalizations are not only implicated in but coextensive with the processes of racial subjection and subjectivation which are foundational to the modern world. As numerous scholars have stressed across a wide array of disciplines, it would be difficult to overstate the importance of the massive diffusion of print media and (phonetic/alphabetic) literacy to the making of modern systems of material and discursive exchange, as well as to the forms of subjectivity, codifications of personhood, fantasies of belonging, and teleological conceits of modernity's Western Man. Notwithstanding the many differences among them, media theorists such as Harold Innis, Friedrich A. Kittler, Marshall McLuhan, and Walter J. Ong are broadly in agreement that the ascendance of print media and literacy in the West in the course of historical develop-

ments generally associated with the so-called Gutenberg revolution and advent of "print-capitalism"[21] marked a radical break from societies whose mediums of communication were principally oral.[22] The epochal transformations coupled to the diffusion of print media and literacy become evident, this tradition suggests, in a distinctive set of intellectual, sensorial, and civic capacities and modes of perception that mark the parameters of modern selfhood.[23] "Typographic Man," as McLuhan announced this figure, moves within a newly established uniformity of time and space, having left behind the "magical world of the resonant oral word" in which the African, naturally, remains mired.[24]

Needless to say, while it is rarely taken up as a matter of sustained interest in arguments about the epochal transformations brought about by the diffusion of print media and technologies of literacy, the figure of Typographic Man was in fact fabricated through modernity's racial, gendered, and colonial ordering of the world. In the words of Henry Louis Gates Jr., literacy came to function as the media technology which "separated animal from human being, slave from citizen, object from subject."[25] To ascertain the full significance of literacy and print media in the material and symbolic configurations of racial subjection and subjectivation, we must move beyond an analysis of literacy as an artifact of exclusion, important as the violent legislation and enforcement of such exclusions undoubtedly were. In this respect, the thinking of Lindon Barrett is indispensable.

According to Barrett—in what we might regard as a critical echo of the philosophy of media's emphasis on technological exteriorization—"what literacy affords those who acquire it is precisely the ability to some extent to do away with the body (in deference to the mind and abstraction)."[26] In contradistinction to the technological reductionisms that abound in media theories of exteriorization, which insist that the technics taken for the signature of humanity's species-being are realized through the ontological delimitation and prosthetic extensions of self and body, Barrett demonstrates that this effort to wield literacy as both sign and instrument of (self-)possession is accomplished precisely through the displacement of corporeality onto 'black bodies.' Modern literacy is a racial regime. Within this regime, 'black bodies' "betoken a social presence curiously marked by a *visible* absence of mind."[27]

It is significant that the phenomenological means of this displacement are principally visual. The logocentric character of phonetic writing and the

racial regime of literacy to which it is bound cannot be disentangled from "the primacy of sight"[28] within modernity's distributions of the sensible. This ocularcentrism, which renders mastery of the written word tantamount to mastery of the self through the expulsion of exorbitant corporeality, must cleave materiality from the visual field through a racial phantasmatics that is itself accomplished, in no small part, by way of visual projection. Racial projection, absorption, and displacement are essential to the historical and geographical processes by which "the scopic—by means of which the world is apparently most faithfully known, understood, and assimilated—comes to stand (like literacy) for reason, intellect, and perhaps even consciousness."[29] The racial regime of literacy and the racial regime of visuality are constitutively entwined.

The means by which the sign of literacy, its codings and condensations are rend(er)ed in or as the scopic is through the projection of its material excrescence onto or as the 'black body.' At the same time, this operation of rend(er)ing through projection is only viable insofar as it is simultaneously an operation of displacement—that is, insofar as the fleshly materiality and material labors of blackness are excised from the ocular surface of this 'body,' as from the ocular surface of the grapheme. In other words, the dissimulation of the 'black body' can only absorb or contain this excrescence—given here as a materiality that fails to be enclosed by the twinned graphocentric and ocularcentric orders—to the extent that the 'black body' is rendered pristinely pathological. The 'black body' must be reduced by aesthetic judgment to the paradoxically coincident registers of the bare, the disfigured, or the excessive. Yet as we have seen, the dissimulation of the 'black body,' whatever figuration it assumes, cannot help but reproduce the exorbitant materiality of enfleshed black existence, which cannot be reconciled with the reductions of ontology and phenomenology. Black orality thus becomes not only the constitutive negation of Typographic Man but, moreover, as Fred Moten would suggest, an impossible form of speech whose "phonic materiality" (de)forms the difference between speech and scream, a form of speech that makes and breaks speech as such.[30]

I argue that Ligon's work effectively functions as a deconstructive critique of word and image, which carries tremendous implications not only for quotidian understandings of language and visuality but also for scholarship in art history and media theory which critically interrogates these

categories. W. J. T. Mitchell's work, for example, deeply problematizes the axiomatic division of word and image, if only to dialectically recuperate it.[31] "The word/image difference," Mitchell declares, "is not merely the name of a boundary between disciplines or media or kinds of art: it is a borderline that is *internal* to both language and visual representation, a space or gap that opens up even within the microstructure of the linguistic sign and that could be shown to emerge as well in the microstructure of the graphic mark."[32] But what is the nature of this lacuna? And by what means is this tear at the heart of language and visual representation continuously sutured, such that enunciating the phrase "word and image" rarely produces even the slightest dissonance in conventional discourse? Mitchell does endeavor to think through the implications of "the word/image difference" for an analysis of racial formation, even going so far as to propose race as a visual medium. But he stops short of considering that raciality might be constitutive of the very distinction between word and image within modernity's sensorial order:[33]

> Understood as a dialectical trope rather than a binary opposition, "word and image" is a relay between semiotic, aesthetic, and social differences. . . . The word/image difference functions as a kind of relay between what look like "scientific" judgments about aesthetics and semiotics and value-laden ideological judgments about class, gender, and race. Traditional clichés about visual culture (children should be seen and not heard; women are objects of visual pleasure for the male gaze; black people are natural mimics; the masses are easily taken in by images) are based on a tacit assumption of the superiority of words to visual images . . . these kinds of background assumptions about the relations of semiotic and social difference that make deviations seem transgressive and novel: when women speak out, when blacks attain literacy, when the masses find an articulate voice, they break out of the regime that has constructed them as visual images. When mute images begin to speak, when words seem to become visible, bodily presences, when media boundaries dissolve—or, conversely, when media are "purified" or reduced to a single essence—the "natural" semiotic and aesthetic order undergoes stress and fracture. The nature of the senses, the media, the forms of art is put into question: "natural" for whom? since when? and why?[34]

The interrogative adverb which is crucially absent from Mitchell's rhetorical questions is *how*. For Mitchell, the degraded position of the black within "the 'natural semiotic and aesthetic order" is ultimately an effect of race as a medium, one which is principally though not exclusively visual. In this in-

stance, the medium of race is deployed to adjudicate and police black abjection under the modern graphocentric order, which is also to say "the violent cultural play that conflates the terms *literacy, whiteness,* and *full humanity.*"[35] Furthermore, even when racial deviations, such as black literacy, are understood as moments in which "the 'natural' semiotic and aesthetic order undergoes stress and fracture," raciality is implicitly rendered tertiary with respect to the makings of this order, particularly in its instantiation in the word/image distinction.

In contradistinction, I want to propose that black mediality is the constitutive force which renders both the axiomatic division of word/image and its critical dialectical recuperation tenable, even as this mediality's anterior bearings serially and diffusively threaten to leave "the 'natural' semiotic and aesthetic order" in ruins. Black mediality's conjoinment of bodily dissimulation and fleshly bearing effectively sutures the gap within and between the linguistic sign and the graphic mark. This operation of suturing is evident, for example, in black mediality's conscripted (re)production of the figure of Typographic Man, who in practice conflates logocentric iconology and ocularcentric graphematics. But black mediality also carries that which it has been called upon to displace. That which has been metaphysically banished from the microstructures of the linguistic sign and the graphic mark (re)turns an exorbitant materiality, which is anterior not only to the division between word and image but moreover between the material and the semiotic. In other words, the materiality which is *displaced* also *remains.* Ligon's practice recursively deconstructs the black mediality which is secreted in the very idea of medium—in medium as form—and which is overwhelmingly elided in discourses concerning medium-specificity and media ontology. In short, Ligon (re)turns us to that which the aesthetic sought to enclose and expel in and as the *black residuum.*

The work of attuning to Ligon's recursive deconstruction of the medium's black anterior and its intransigent remains is, unsurprisingly, hardly self-evident. In an effort to clarify the semiotic difficulties that adhere to Ligon's anteaesthetic interrogation of the form that is medium, we will turn briefly to an appositional (mis)reading before returning to a more pointed analysis of Ligon's text-based works that endeavors to avoid the hermeneutic pitfalls enumerated below.

(Mis)reading the Flesh

The question of signification, as well as the qualitative nature of the sign, has been at the heart of much of the critical reception of Ligon's oeuvre. These semiotic problematics are crucial to an anteaesthetic engagement with Ligon's text-based works. The deconstructive returns of these works constitute incisive interrogations and exhibitions not only of the black aporia at the heart of every sign but moreover of the sign's material remains. Sarah Whitcomb Laiola is one of a number of critics who have offered N. Katherine Hayles's concept of "the flickering signifier" as a hermeneutic frame for reading and looking at Ligon's text-based works and for grappling with the racial semiotics they instantiate and interrogate.[36] For Hayles, the concept of the flickering signifier points to the tectonic shifts in the significatory codes of representation issued by the digital age of communication.[37] Laiola extends Hayles's formulation to theorize a shift from "floating" to "flickering" signifiers in the composition of racial semiotics, which she suggests tracks the shifts in information processing associated with the supersession of analog by digital technologies.[38] Both the insights and failures of such a (mis)reading of Ligon's anteaesthetic deconstruction of racial semiotics can serve to further clarify the hermeneutic difficulties that obtain in black mediality's reproduction of the disjunctive entanglement between an enfleshed existence without ontology and the phenomenological feints of dissimulation. Without a theory of this disjunctive entanglement, we would be unable to discern that which remains before the racial semiotics Ligon's work interrogates.

Laiola advances her critical interpretation of Ligon's interrogation of racial semiotics through an innovative reading of the artist's *Condition Report* (2000), which displays two diptych prints of Ligon's first text-based painting, *Untitled (I Am a Man)*, side by side. The left panel appears to reproduce the 1988 work in its original form, while the right panel is overlain with conservator Michael Duffy's annotations on the canvas a decade after its making, which "point to a history of smudges, hairline cracks, fingerprints, threads of canvas and stray paintbrush hairs . . . [indicating] the grain or pattern of various imperfections in the painting due to age and wear."[39] For Laiola, *Condition Report* exhibits "blackness breaking through the whitewashed surface, [as] visual matter flickering in and out of visibility," in a performance which ultimately resists postracial ideology and "insists on the

matter and mattering of black lives."[40] Laiola takes this argument a step further, suggesting that Ligon's work "mobilizes a duality of racial information systems that recalls Hortense Spillers's" theory of a "hieroglyphics of the flesh."[41] Ultimately, Laiola contends, the "tension of racial material and/as information processing," which is evident in both Spillers's theorization and Ligon's artwork, "mirrors that between analog and digital information processing technologies . . . [as well as] the sensory contradiction, the conceptual tension, at the heart of colorblind racism."[42]

I am in complete agreement that Spillers's hieroglyphics of the flesh are an essential theoretical tool for approaching the racial semiotics which are, in my view, recursively deconstructed in Ligon's text-based works. I would also affirm the insinuation of the importance of both Spillers and Ligon's work for new media studies. In fact, I would go so far as to suggest that Ligon's oeuvre could well be regarded as new media art insofar as it is concerned with a reflexive interrogation of the material and discursive informatics of its own implicate (dis)order.[43] (Indeed, Spillers's analytics are anticipatorily echoed by Ligon's transpositional engagement with Hurston, who famously declared that whereas "the white man thinks in a written language, . . . the Negro thinks in hieroglyphics.")[44] However, I part ways with the claim that this semiotic tension can be analogized with that which characterizes the relation between analog and digital media and, for that matter, with the insinuation that the ascendance of "colorblind racism" substantially alters the semiological problematics that have always cleaved to the disjunctive entanglement of black existence and black non-being.

At stake in this hermeneutic divergence is precisely the nature of the duality that Laiola suggests marks contradistinctive racial information systems. On one side, we have the visible sign of race as it is inscribed upon the body, which would seem to be coterminous with the Fanonian racial epidermal schema. On the other side, we have the racial information of the flesh, which "operate[s] as a kind of internalized, incorporated code."[45] But as our extended engagement with Spillers in chapters 2 and 3 makes clear, the play of inside and outside that pivots upon the hieroglyphics of the flesh is not so simple as it appears, precisely because the exorbitant materiality borne by flesh is the condition of (im)possibility for appearance as such. Flesh cannot incorporate, much less be incorporated as racial information, because flesh bears the expropriative displacements of abstraction, of reduction which rend(er)

informatics from an existence without ontology. Nor can flesh be treated as a stable interior marked by exterior inscription, because the racially gendered violence of interiorization to which flesh is subject is anterior to the dualistic fabrication of interior and exterior. Flesh is the anoriginary mediality that (re) produces the modern distinctions between the inside and the outside, the visible and the invisible even as it extends the obdurate materiality of the black residuum—that which remains always already before these dualities.

These differences of interpretation have significant implications for how we read the hieroglyphics of the flesh. Spillers's hieroglyphics of the flesh signals the agonistic entanglement of 'black body' and flesh, of black existence and nonbeing. This agonistic entanglement produces a semiotic disjuncture which is generally anterior to the world and its historicity—an irreducible rift in the modern metabolism of meaning and signification. Yet these hieroglyphics are simultaneously, as Spillers suggests and Ligon's deconstructivism amplifies, sites of material transfer and containment of and for the expropriative displacements of flesh. Thus, where Laiola sees "the sign of color break[ing] . . . through the whitewash surface of Ligon's canvas" in his *Condition Report*,[46] I would argue that what "breaks through" in and as dehiscence is the obdurate remainder of an exorbitant materiality—the black residuum—which betrays the aporia lurking within every sign.

Palimpsestic Surface

In returning to the "Door" paintings, let us consider Scott Rothkopf's detailed description of Ligon's process:

> He begins by selecting a phrase from Hurston . . . and then primes the surface of the door with gesso slightly doctored with marble dust. . . . Once the ground has dried, he covers the door from top to bottom with evenly spaced, horizontal pencil rules and adds a vertical line at the left to create a margin. . . . Working down the surface, Ligon faces countless small decisions that belie the systematic nature of this process. Can he squeeze a full word before he reaches the edge of the door? Why leave so much empty space before the final COL-ORED on the tenth line. . . . Once Ligon reaches the end of the panel, days after he began, the painting seems exhausted, tense, a miasma of stuttering words caught in the act of emerging from and receding into one another. He stencils the final word BECAME, so faintly, that it is scarcely visible. The E barely sits. Ligon's voice—and Hurston's—can almost not be heard.[47]

For the moment, let us bracket the question of what might be required in order to "hear" Ligon or Hurston's respective voices—not only because these works evoke a complex, indeterminate polyvocality but moreover because they place profound pressure on the reflexive conflation of inscriptive performance with individuated personhood, self-presence, and univocal speech. Indeed, Ligon's poetics sustain a deconstructive critique and disruption of the general principles of communicability that undergird art history, media theory, and, for that matter, the discursive architecture of civil society at large. For now, let us note the repetitive and accumulative character, the exacting yet unfinished nature of the text which gathers upon the artworks' richly textured surfaces. The bifurcation of surface and depth and the relationship of this severance to the material impurity and impure materiality of the sign is central to Ligon's deconstruction of racial semiotics. Moreover, Ligon's transpositional engagement with black literary modernism reflects an incisive attunement to its anticipatory critique of high modernism by way of the palimpsestic configuration of every surface, which is necessarily unfinished, incomplete, recondite.

It is precisely the refusal of finality in Ligon's text-based works, not least in their material violation of the image's border, that, in Darby English's view, constitutes a profound challenge to the modernist "fetishization of surface," the latter of which, English seems to suggest, mimics the violence of epidermalization.[48] Moreover, just as the modernist fetishization of surface is undermined by these works' transgression of their presumed extensive boundaries, so too does this disturbance manifest intensively—simultaneously throwing into question both modernism's investment in the "ineluctable flatness" of the medium of painting and media theory's designation of "technologies of inscription . . . [as rendering] the Signifier itself . . . spatially discrete, durably inscribed, and flat."[49]

In fact, in Ligon's "Door" series, the problem of surface is redoubled not only in space but also in time. As Ligon has often noted, he would produce these works from top to bottom. Each time he would push the oilstick through the stencil, its residuals would gather on the opposite side of the stencil, progressively smearing the text the longer he labored. ("The more letters I make, the more it smears.")[50] He thereby temporalizes the surface, breaking the optical purity of the image in time as well as space, and alludes to a material impurity which is immanent to the medium of painting. The significance of this intrinsic impurity is amplified by the fact

that this material accrual is also the visual blackening of the work. This blackening evinces an artistic strategy whereby, in Nicole Fleetwood's words, "the markings and iterations of blackness are manifested through a deliberate performance of visibility that begs us to consider the constructed nature of visuality."[51] Where the unadulterated plenary of the image should have been, we find instead the uncertain threshold of a (racially gendered) encounter—not simply between abstract expressionism and language-based conceptualism or between black literary modernism and the vexed category of contemporary art[52] but between the material and the semiotic, communicability and incommunicability, the metaphysics of order and the disorder of metaphysics.

Critics have often read Ligon's text-based works as an extension of the tradition of language-based conceptualists, whose work from the mid-1960s to the mid-1970s marked a pronounced divergence from the high modernist paradigm that had exercised such sway over the American art world's interpretive landscape since the 1950s.[53] Most prominently associated with the art critic Clement Greenberg, the high modernist doctrine stressed the autonomy of aesthetic experience, the purity of artistic medium, and thus the imperative of medium-specificity both at the levels of practice and interpretation. There are by now ample critiques of the ways in which Greenberg's "militantly reductive modernism"[54] hermetically seals off the work of art, its medium and its form from the historical terms of their material and aesthetic development and from the sociopolitical investments and technologies of power that animate them. However, here I am more concerned with modernism's ontological, phenomenological, and hermeneutical presuppositions and their relationship to Ligon's anteaesthetic deconstructivist enterprise. Greenberg's formalist position insisted that it is precisely the reflexive concern with the medium's essence, particularly in painting, that stands as the hallmark achievement of modern art forms. "Content," Greenberg commanded, "is to be so completely dissolved into form that the work of art or literature cannot be reduced in whole or in part to anything not itself."[55] Greenberg's preoccupation with the medium's essence by way of surface is crucial to understanding Ligon's desedimentation of an essence that would displace its material anterior.

This chapter's intervention builds upon the general argument of this book—namely, that because black aesthesis emerges in the abyssal cut between black existence and black nonbeing, it cannot simply be recuperated

by the modern regime of aesthetics as a revolution of and for the sensus communis through a redistribution of the sensible. Black aesthesis constitutes a nonevent, which bears the absolutely unassimilable. Thus, an anteaesthetic inquiry into Ligon's forays into language-based conceptualism must be suspicious of interpretations that suggest Ligon's work either "expands and enriches the conceptualist tradition" or simply marks an interleaving of traditions, wherein "abstract expressionism meets conceptualism," as one art critic puts it.[56] Nevertheless, it is important to situate language-based conceptualism in relation to the fetishes of modernism, so that we can draw out Ligon's deconstructivist engagement with the black anterior which precedes and exceeds art historical categorization. Language-based conceptualism as a discrete art historical tradition evinced a movement away from high modernism's privileging of the art object and toward a reconceptualization of art as a set of propositions. As Benjamin Buchloch has argued, text-based artworks, which departed further from the Greenbergian notion of medium-specific modernism, drew upon the typographic and the linguistic as material[57] and mapped "the linguistic onto the perceptual."[58] Language-based conceptualism signaled the diminishing importance of the autonomous art object, converting the passive attention of the art spectator into the activity of reading. Interrogating the perceived physical limits of the art object, text-based artworks emphasized the materiality of the printed word, which became elastic, pliable, almost sculptural or architectural.[59] Specific visual arrangements of texts would come to bear content.

Glenn Ligon's text-based works certainly do find a rapport with this tradition of conceptualism, which suggested that the specific appearance of words could produce a critical intimacy between concepts, linguistic signification or communication, and visual forms, even if Ligon's work cannot be neatly placed either within or outside conceptualism's art historical canon. Reflecting upon Ligon's 1988 work *Untitled (I Am a Man)*, which refers to the signage from the 1968 Memphis sanitation workers' strike, rendered iconic by Ernest C. Withers's photography, Darby English insists that Ligon's "work is located as much in language-based conceptualism as in its physical manifestation as a painting" and, furthermore, that "these contradictions and the refusal to prioritize them are fundamental to the picture's meaning."[60] English astutely directs our attention to the formal tensions Ligon's work exhibits and refuses. But whereas English reads Ligon's as part of an artistic

tendency that evinces a movement beyond "the historical machinations of black representational space,"[61] I am interested in how Ligon's racially gendered deconstructions of medium and media disclose the black mediality that constitutes the condition of (im)possibility for every space of representation. More specifically, what I have termed "black mediality" constitutes, reproduces, and modulates the fabrications of and distinctions between medium and form, even as it bears that which cannot be reconciled with or subsumed within this dualistic order. Ligon's transpositional engagement with black literary modernism—Ralph Ellison's fictional excavation of hyper(in)visibility and Zora Neale Hurston's autotheoretical exhibition of being thrown—restages the paradigmatic dualisms of high modernism as particular, if unexceptional sites for the insolvent suturing of word and image, ontology and phenomenology, being and existence.

Black Literary Modernism, Hyper(in)visibility, and Opacity

It should come as no surprise that Ligon's text-based works have often signified upon traditions of black literary modernism—precisely as a deconstruction of the system of signification that inheres in the very distinctions between image and text, the written and the oral, the visual and the aural—as writers like Ellison and Hurston were themselves engaged in differential critiques of this system's metaphysical precepts. Ellison and Hurston each differentially deconstruct the 'black body' while also alluding to the persistence of fleshly labor and enfleshed existence, no matter how rigorous and unforgiving the protocols for the latter's concealment and displacement. Ligon's transpositional engagement with these currents of black literary modernism discloses the function of the 'black body' as the negative foil for the incorporeal pretenses of the graphocentric, the scopic, and their twinned authorization of the proper subject's speech, even as these pretenses depend upon the irreducibly corporeal labors of the flesh in order to cohere. The 'body' cannot be figured, the 'body' is undone, and yet flesh remains. We might say that both Hurston's "How It Feels To Be Colored Me" and Ellison's preface to *Invisible Man* engage in a performance of the reproduction of a primal scene that cuts the distinction between the graphic and the phonic[62]—*primal*, neither strictly in the psychoanalytic sense nor only insofar as the scene marks blackness as before history and outside the social.

To stretch an arithmetic idiom, each primal scene constitutes that which cannot be further reduced without a *remainder*.

Most importantly, Ligon's work accentuates and plays upon Ellison's and Hurston's differential engagements with a racialized materiality that is unthinkable within modernity's metaphysics precisely in its absolute irreducibility. This exorbitant materiality can be continuously concealed, disavowed, and displaced. But because this materiality is vestibular to the very metaphysics which interdicts it, it can never be completely eliminated. The obdurate persistence of this materiality, which has no place in either ontology or phenomenology, constitutes what I term the black residuum.

———

How might we situate Ligon's recursive deconstruction of the hieroglyphics of the flesh with respect to the most common critical interpretations of his text-based works, which alternately or concomitantly emphasize his paintings' exposition of the invisibility or hypervisibility of the 'black body'? And how might these works return us to this question with renewed attention to the singularity of the black feminine, which Spillers posits as the anoriginal exemplar of enfleshment? Let us turn to Ligon's *Untitled: Four Etchings* (1992; figure 23), where the anteaesthetic conjunction of these two questions becomes most pronounced. A quartet of softground etching, aquatint, spitbite, and sugarlift, two of the four plates in this suite draw their words from the prologue to Ellison's novel *Invisible Man* (1952) and the other two closely resemble Ligon's 1990 works *Untitled (I Do Not Always Feel Colored)* (figure 21) and *Untitled (I Feel Most Colored When I Am Thrown Against a Sharp White Background)* (figure 22), albeit in altered form.

Print specialist and critic Sarah Kirk Hanley describes Ligon's process thusly:

> The stenciled letters were first lightly etched into the copper plate, then it was coated with hardground. Ligon then went over the letters with a stencil using a cotton swab dipped in naphtha. The solvent removed the ground on the letters, but also seeped underneath and randomly removed the ground around them. The exposed metal was then etched, the plate cleaned, and the ground reapplied. Ligon again traced the letters using the same process, and the plate was etched another time. This was repeated several times until a satisfactory degree of texture and depth was achieved. Finally, the plate was treated with aquatint (so the recessed areas would hold ink).[63]

Figure 21. Glenn Ligon, *Untitled (I Do Not Always Feel Colored)*, 1990, oil and gesso on wood, 80 × 30 inches (203.2 × 76.2 cm). © Glenn Ligon; Courtesy of the artist, Hauser & Wirth, New York, Regen Projects, Los Angeles, Thomas Dane Gallery, London, and Galerie Chantal Crousel, Paris.

Figure 22. Glenn Ligon, *Untitled (I Feel Most Colored When I Am Thrown Against a Sharp White Background)*, 1990, oil stick, gesso, and graphite on wood, 80 × 30 inches (203.2 × 76.2 cm). © Glenn Ligon; Courtesy of the artist, Hauser & Wirth, New York, Regen Projects, Los Angeles, Thomas Dane Gallery, London, and Galerie Chantal Crousel, Paris.

Figure 23. Glenn Ligon, *Untitled (Four Etchings)*, 1992, suite of four; softground etching, aquatint, spit bite, and sugarlift on paper, each: 25 × 17.38 inches (63.5 × 44.15 cm), edition of 45 and 10 APs. © Glenn Ligon; Courtesy of the artist, Hauser & Wirth, New York, Regen Projects, Los Angeles, Thomas Dane Gallery, London, and Galerie Chantal Crousel, Paris.

At 25⅛ × 17⅜ inches each (sheet), these works are individually much smaller than the "Door" paintings, but together, they approach a dimensionality which recalls their predecessors' scaling for "the human body." In concert, Ligon's suite of four (figure 23) sustains an eerie adumbration: a redoubling of a doubling, as the anticipatory echo of a racial gendering that resounds, to reprise Ellison's words, only on the "lower frequencies."[64]

Here Ligon's black-on-black engagements with Ellison are positioned below the black-on-white engagements with Hurston, though there is nothing simple about their spatial (an)arrangement. An appositional protrusion into and recession from geometric space, the organization of the plates cannot be said to evince a definitive investment in either horizontality or verticality, but neither could their strained intrarelation be neatly resolved as chiasmic. Their spatial entanglement is itself a hieroglyphic.

The lower two prints stage the repetition, with variegated lineation, of a single passage, one with which Ellison's Prologue opens:

> I am an invisible man. No, I am not a spook like those who haunted Edgar Allan Poe; nor am I one of your Hollywood-movie ectoplasms. I am a man of substance, of flesh and bone, fiber and liquids—and I might even be said to possess a mind. I am invisible, understand, simply because people refuse to see me. Like the bodiless heads you see sometimes in circus sideshows, it is as though I have been surrounded by mirrors of hard, distorting glass. When they approach me they see only my surroundings, themselves, or figments of their imagination—indeed, everything. [65]

As with Ligon's transpositional engagement with Hurston, the lower two prints recursively extend a deconstructive ambit which is already discernible in Ellison's original text: namely, the deconstruction of the 'black body' as phenomenological dissimulation and its vexed entanglement with the problem of blackness as an existence without ontology. As Ellison himself commented prior to the novel's publication, "invisibility" signals a condition which is not only a function of inscribing blackness "as [the] sign . . . of racial inferiority" but also of the "great formlessness of Negro life."[66]

A signal text of black literary modernism, Ellison's novel has been the subject of much debate, not least because of its centrality to the question of whether the modernist literary tradition, narrowly construed, was funda-

mentally at odds with the revolutionary imperative of black art. Too often, however, these debates have eclipsed Ellison's deconstructivist critique of modernism itself. In fact, Ellison's techniques of signifying "turn modernism back on itself," disclosing its racial underbelly.[67] Here I am more concerned with how Ellison's deconstructivism comes to bear upon the visual. For not only does Ellison's novel reveal a powerful indistinction between invisibility and hypervisibility—their conjoinment in and as epidermalization—it also, performs an unraveling of "the ocular-ethical metaphysics of race" as such.[68] "The mark of invisibility is a visible, racial mark; invisibility has visibility at its heart."[69] Even before the prologue, which is something of an anacrusis to the novel, Ellison's introduction deploys a characteristically sardonic, autotheoretical method to foreground the impossibility of reconciling black existence with the racial metaphysics of the visual.

Recounting his route from his home in Harlem to his writing retreat somewhere in the upper echelons of Fifth Avenue, he writes of the unsettling significance of his flight from his "Negro neighborhood, wherein strangers questioned my moral character on nothing more substantial than our common color and my vague deviation from accepted norms, to find sanctuary in a predominantly white environment wherein that same color and vagueness of role rendered me anonymous, and hence beyond public concern."[70] Picturing a life shuttled between intensive scrutiny and permanent anonymity in an effort to obliquely narrativize the manner in which the quotidian operations of antiblackness condition and delimit the practice of writing itself, Ellison, perhaps inadvertently, alludes to a problematic that finds its fullest expression in Ligon's subsequent transpositional engagements with his text: "In retrospect it was as though writing about invisibility had rendered me either transparent or opaque and set me bounding back and forth between the benighted provincialism of a small village and the benign disinterestedness of a great metropolis."[71] With anticipatory hindsight, Ellison offers his readers a scene of writing that unfolds from the violent transits between an opaque existence and the impositions of transparency.

Significantly, the novelist's navigation of a fraught passage between the opacity he sought to inhabit and the transparency he sought to evade is anterior to the protagonist's dilemma of invisibility. In contemporary critical discourse, the concept of opacity is prominently associated with the philosophical propositions of Édouard Glissant, most notably in *Poetics of Re-*

lation. The relation between blackness and opacity is typically figured as a strategic evasion of the violence of the racial gaze or the racial regime of representation, which finds countless iterations across different histories, geographies, mediums, and forms. Some scholars and critics emphasize Glissant's conception of opacity as "an alterity that is unquantifiable, a diversity that exceeds categories of identifiable difference."[72] But what is all too often eclipsed by the fetishistic circulation of his term in the art world is a thought of opacity as the terrifying and ruinous expression of irreducibility.[73] For notwithstanding the art world's efforts to recuperate opacity within an ostensibly transparent idiom of resistance, a gesture which ultimately imposes a reparative demand upon the concept, for Glissant the irreducibility of opacity is constitutively bound to the abyssal, which dispossesses any claim to teleologies of repair. Be that as it may, here I want to suggest that the irreducibility of opacity, which blackness necessarily bears, is also irreducibly material. Moreover, this irreducible opacity is an exorbitant materiality that is anterior to the division of the material and the semiotic, the constitutive opposition of the visible and the invisible, and the pretense to transparency which overcodes the visual. Simply put, opacity is the condition of (im)possibility for the visual field, "the ocular-ethical metaphysics of race," and their manifestation as the problem of hyper(in)visibility. Visuality needs opacity but can neither abide its irreducibility nor eradicate the traces of its exorbitance. In the violent reduction of the visual field from the irreducibility of opacity, what remains is the black residuum.

This insight, or rather *antesight*, already contained within Ellison's work, is redoubled in the deconstructive transpositions of Ligon's *Untitled: Four Etchings*. Returning to the two lower prints of this work, we notice two curiously subtle but significant differences between the juxtaposed, black-on-black prints. The black text of the lower right print appears slightly bleached or washed out, an etiolation which contrasts with the significantly darker, more sharply defined appearance of the text foregrounded in the lower left print. Ligon's deft attunement to the frequency, density, and impenetrability of the singularly black experience of hyper(in)visibility follows the circumference of a double-edged operation—the process of dissimulation, which only ever blackens by bleaching. Considered together, these two prints experiment with the internal variance of the color black in a way that tests the acerbic quality and tone of Ellison's prologue against the active distortion

of that color's undifferentiated capacity. Their juxtapositional presentation turns upon the graphic compression of word and image as a "chromatic saturation"[74] that in this instance gestures to the accumulative bearings sustained in the racially gendered medialities that dissimulate blackness as form. Yet the nuances of difference between these prints register an uncertainty, an ambivalence, or even a glitch in the visual operations that enable the phenomenological feint that is the appearance of blackness. They signal a cut in the visual field, where the force of dehiscence becomes nominally organized around the saturated space of a negative image and its raw and inverted negation. They remind us that inscrutability, with its collapsing of difference under a single negative sign, is not tantamount to opacity, which is an irreducible difference. Opacity, its materialization as the black residuum, is what remains before the expropriative displacements that produce the totalizing field of the visual, which holds both the visible and the invisible within its covetous grasp.

The encounter with opacity in Ligon's work is therefore haptic, a brush with sensorial anteriority. For, as I have already elaborated, hapticality is an antephenomenological formulation, a minor gesture which (un)makes the modern sensorium, its codifications and taxonomical hierarchies. In this respect, Ligon's deconstructive transposition of Ellison's and Hurston's texts finds resonance with what Brent Hayes Edwards, with and after James Weldon Johnson, calls a "poetics of transcription" which "somehow 'catches' what it cannot represent notationally."[75] As one looks upon this work, allowing one's gaze to slip from the cascading black repetitions of accumulating ink that one could mistake for Hurston's wearied figure, the increasingly tarnished white sheet that one could mistake for ground, down to the hauntological trappings of the black-on-black prints below, a sense of unmitigated descent becomes palpable.

As the eye attempts to trace this movement of declension, its accumulative gathering of muddy smears, its thickening chromaticity, that breaches the boundaries of word and image, one begins to wonder whether the visual disorder comes from above or below, indeed whether it threatens the coherence of directionality altogether. One is confronted with the specter of vertigo. But, as Frank B. Wilderson III reminds us, there is an unbridgeable gap between the "*subjective vertigo* . . . of the event," to which so many viewers of Ligon's work might lay claim, and the "*objective vertigo*" of black experience,

wherein life is "*constituted* by disorientation rather than . . . *interrupted* by disorientation."[76] The objective vertigo of blackness defies the reductions of transparent communicability, of accounting for the vertiginous through the protocols of signification.

This is not to suggest that what remains constitutes a scarcity. On the contrary, although the black residuum is singularly borne by the black feminine—whose dissimulative appearances cut the difference between the "meager" and "excessive"[77]—this residuum's opacity constitutes a dehiscence within every moment of valuation, insofar as valuation is tantamount to "the brutal and final imposition of form."[78] In fact, Ligon's work is queerly attentive to the aporetic entanglements of displaced materiality and the realization of value. This attention is perhaps most explicitly evinced in his reflections on his choice to use coal dust, a particulate byproduct generated through the grinding and crushing of coal, to render the text in a number of works from his *Stranger* series, which draw from James Baldwin's "Stranger in the Village" essay. In these works—which similarly constitute transpositional deconstructions of word and image, surface and depth, figure and ground, the material and the semiotic—Ligon tosses coal dust onto the drying paint, in an effort to render the text more acutely visceral and at the same time more obscure.[79] "Coal dust is an interesting material for me," Ligon intimates, "because it's beautiful. It's a black, shiny material, but it's also a waste product . . . leftover from coal processing. . . . I am drawn to it because of all of the contradictory readings it engenders. Worthless. Waste. Black. Beautiful. Shiny. Reflective."[80] Indeed, as David Marriott brilliantly argues, the tangled configurations of "pleasure, profligacy, waste, and excess" to which blackness is aesthetically conjoined, are not discordant, but rather complementary moments in the constitution of blackness's irremissible indebtedness.[81] The Middle Passage "gave birth to a subject that can only perpetuate . . . *the decadent excess of social death as its own most extravagant expenditure.*"[82]

Insofar as Marriott's articulation blackens Georges Bataille's concept of expenditure as a "signification which consumes existing modes of commodification and exchange, laying waste to them in a wasteful presentation of the waste that is their own,"[83] Ligon directs us to the exorbitant materiality that the expenditure of blackness ceaselessly (re)turns. Ligon alludes not only to the association of blackness and coal in the modern racial imagi-

nary (for example, in the late nineteenth and early twentieth prominence of "coal black" as a racial epithet)[84] but moreover to the unwieldy materiality such associations endeavor to sublimate and yet fail to fully contain. Indeed, environmental scientists subsume this coal dust under the category of "fugitive dust" precisely because of the difficulties it poses for those who would seek to regulate and contain its movement in the name of human health. As Kathryn Yusoff observes, coal is a paradigmatic example of the "geo-logic" dispensation of "the inhuman as something that is bracketed out of the sociality" but which nevertheless serves as the substratum and fuel for the social formation.[85] Coal dust signals the displaced, degraded, and yet exorbitant materiality that remains before the enclosure. ("I am black because I come from the earth's inside."[86])

Thrown Before the World

To say that Ligon takes up Ellison's and Hurston's prior deconstructive engagements with the bodily dissimulation, enfleshed existence, and the exorbitant materiality of blackness, however, is not to suggest that Ligon is merely visually exhibiting their textual and philosophical interventions. Indeed, the fragmented excerpts of text that appear as the subjects of Ligon's etchings, aquatints, and prints sustain only an oblique relation to their original form and context. But neither am I suggesting that these graphic encounters are emptied of intramural visual-textual exchange. On the contrary, Ligon's method of "thick citation," as the art historian Mignon Nixon perceptively puts it,[87] constitutes a form of exorbitant exchange for which media theory's concept of remediation and the art historical concept of appropriation are ultimately insufficient.[88] Ligon's artistic engagement with black literary modernism in fact constitutes a deconstructive transposition which does not, in this instance, so much transpose one medium, form, or tradition onto another as recursively interrogate the conditions of possibility and impossibility for their ontological and phenomenological separation.[89]

My thinking on transposition is informed by Brent Hayes Edwards's contention that "pseudomorphosis—working one medium in the shape of or in the shadow of another—is the paradigm of innovation in black art."[90] Drawing on Daniel Albright's deployment of the term (who in turn borrows it from Adorno), which suggests that pseudomorphosis "typically involves a

certain wrenching or scraping against the grain of the original medium,"[91] Edwards insightfully alludes to the refusal to aesthetically privilege or epistemically validate the "original" as immanent to black art's improvisational impulse.[92] But whereas Edwards tracks transposition as a modality of innovation in black art, I am more interested in transposition as an operation which deconstructs the conditions of (im)possibility for the dissimulative appearance of black art and thereby discloses black art's immanent defilement of the purities of both medium and form.

The significance of such disclosures is, I contend, necessarily double-edged. On the one hand, these disclosures mark the ways in which black art is always already marked by and for its own vestibularity, phenomenologically ensnared by the sheer fact of its appearance in the reproduction of the very aesthetic regime that functions to perpetually consign black existence to the register of nonbeing. On the other hand, they signal the ways in which the aesthesis from which black art emerges constitutes an irreparable dehiscence that the dissimulating conditions of the artwork's appearance ultimately fail to suture. And yet the expropriative displacement of this aesthesis is nevertheless functional to the serial revivification of the aesthetic regime it ruptures.

Zora Neale Hurston presents a quintessential figure for thinking through the knotted anteriority of black letters to high modernism in particular and the racial regime of aesthetics in general. Consider, for example, the way both Hurston's novelistic and anthropological writings have used "the speakerly text" to critically signify upon the racial taxonomies that subtend the hierarchical oppositions of orality versus the written word, vernacularity versus speech, mimicry versus originality, folklore versus literature, and so forth. The enfleshed black existence and black (feminine) bearings, which are anterior to such dualities, are evident throughout a black literary modernism whose poetics of the written and spoken word mark a prior refusal of "the adamant coordination of subjectivity with the literacy on which the modern depends."[93] Black literary modernism accentuates the "deconstructive arc of black writing"[94] as this tradition reflexively grapples with the fact that, within the racial regime of aesthetics, blackness is placed under the degraded, pre-discursive sign of orality, and thus from the vantage of the aesthetic, black writing is a contradiction in terms. To begin to unfold the racially gendered dimensionality of this deconstructive transposition,

not least as it pertains to the intramural, let us look more closely at Ligon's "Door" paintings which take up the words of Zora Neale Hurston.

Hurston's words inaugurate the first works in Ligon's "Door" series; indeed, Ligon notes that her quotes were the first he inscribed in repeating sentences.[95] Ligon suggests that part of what drew him to Hurston's words was the manner in which they metabolize the difference between being colored and becoming colored,[96] a difference which is explicitly thematized in Ligon's 1990 work *Untitled (I Remember the Very Day That I Became Colored)*. The problematization of this difference could be said to lie at the heart of "post-blackness," a term which curator Thelma Golden suggests was coined in conversation with Ligon during the Freestyle exhibition (April 28 to June 24, 2001) at the Studio Museum in Harlem and which would ultimately acquire significant "ideological and chronological dimensions and repercussions."[97] Although the term has since acquired a life of its own and has been criticized on both ideological and chronological grounds,[98] the stakes of the concept, its celebration or denunciation, commonly pivot upon the philosophical oppositions of essentialism versus difference, structure versus contingency, determinism versus agency. But what if the difference Hurston seems to metabolize—a difference which strains within and against the interiors of both sides of these debates—marks neither a dichotomy nor a dialectic, but rather an agonistic entanglement that is in fact inescapable? What if what Hurston metabolizes is precisely the cut between the dissimulation of the 'black body' and fleshly existence without being, as well as its anterior bearings?

Literary critics have often fixated on Hurston's partially disaffected, maligned status in relation to her Harlem Renaissance literary counterparts, arguing that such pointed alienation informs the varying structures of address embedded in her writing. However, we must remember that Hurston was also a practicing anthropologist and folklorist and that taking stock of the poetics she strategically deployed requires taking stock not only of her unique positioning vis-a-vis the black modernist literary circles that scorned her but equally in relation to the black vernacular cultures she studied and the complex modes of signifying that emerge from them. In this regard, Hurston refuses the "masculine-colonialist imitation" she has been refused, in an effort to find "another model for thinking gender in black diasporic modernity."[99]

In fact, Hurston finds herself at the very center of modernity, if only as an absence. As Barbara Johnson has insightfully observed, "Hurston's work

itself was constantly dramatizing and undercutting just such inside/outside oppositions, transforming the plane geometry of physical space into the complex transactions of discursive exchange."[100] Or, as Johnson would subsequently write of a passage in Hurston's 1937 novel *Their Eyes Were Watching God*, Hurston interleaves "an externalization of the inner" with "an internalization of the outer," producing "a kind of chiasmus, or crossover."[101] Hurston's 1928 text "How It Feels to Be Colored Me" which Johnson finds exemplary of this unsettling of the inside/outside opposition is the same text from which Ligon draws and repeatedly inscribes the phrase "I remember the very day that I became colored." As we shall see, this unsettling of the inside/outside opposition is also tied to the desedimentation of figure and ground as one of high modernism's foundational dualisms.

In the autoethnographic text from which Ligon draws the aforementioned phrase, Hurston fashions "herself as a threshold figure mediating between the all-black town of Eatonville, Florida, and the big road traveled by passing whites."[102] It is at this literal and figurative crossroads that Hurston "becomes colored," splayed across the nexus of the dissimulative ambitions of the white gaze and a black existence without being. Johnson notes the ways Hurston accentuates this declension diachronically, in the truncated passage between first to third person: "I left Eatonville . . . as Zora. When I disembarked from the river-boat at Jacksonville, she was no more."[103] Even if we might suggest that the experience of epidermalization as desubjectification is ultimately irreducible to the semblance of narrative, the fact remains that Hurston's rhetorical declension from first to third person tracks another aporetic descent, the "vertiginous absence between the *I* and the *it*."[104] Ligon is sensitive to the existential weight and onto-phenomenological spectrality of Hurston's words, not least as they assert themselves at the level of experience. One can observe, for example, the manner in which Ligon's practice progressively effaces the nominal claim to authorial subjectivity. That Hurston's words are rendered entirely in uppercase lettering seems only to amplify this effacement. Indeed, in *Untitled (Four Etchings)* the discrepant typographic composition of Hurston's and Ellison's words at the level of letter case traces a contrapuntal (un)gendering. Each successive enunciation of Hurston's attenuated "I" becomes tethered to an accumulating residuum—the unrelenting accretion of black ink, apparently undoing the conditions for the "I" to speak itself into existence.

Crucial for an anteaesthetic reading of Ligon's work is the manner in which Hurston does not position herself simply *at* but rather *as* the threshold, a figure whose medial status convolutes and contravenes the inside/outside distinction and thereby enables the transformation "of the plane geometry of physical space into the complex transactions of discursive exchange." What is more, in the transpositional context of Ligon's work, this transformation is also inverted, rendering a complex intramural exchange into the nominally planar geometry of the canvas. In the course of this transposition not only is the formal opposition of surface/depth but equally that of figure/ground materially and semiotically discomposed.

At the heart of Ligon's painting, as with Hurston's text, is the unsettling play of figure and ground—and not least where a figure would seem to be wholly absent. The racially gendered operations of black mediality are at once that which make this interplay possible and that which instill this duality with phenomenological uncertainty. Ligon's and Hurston's transpositional encounter concerns the constitutive displacements and ongoing modulation of this dynamic demarcation of figure and ground, as well as the matter of their remains. Although one might expect Ligon's work to interrogate the 'black body' as figure and effaced flesh as ground or, alternately, black corporeality as the ground from which the (implicitly white) figure emerges, I want to dispense with this binary schema altogether. In fact, what Ligon signals is the black mediality—bound both to the enfleshed labors that cannot appear and to the dissimulative appearance of the 'black body'—that is serially conscripted in the fabrication of figure and ground, even as this mediality also bears that which makes their contradistinctive realization untenable. The onto-phenomenological spectrality of Hurston's fallen, falling "I" traces the tremulous outline of that which is both made to bestow figure and ground and that which threatens their absolute dissolution.

I have already noted the manner in which Ligon's "Door" paintings contravene the modernist investment in the optical purity of the image by exhibiting the irreducible depth of the painting's surface. The deconstructive arc of Ligon's practice also extends to the modernist logic of the grid—that aesthetic dispensation which, according to Rosalind Krauss, "functions to declare the modernity of modern art"[105]—and to the concordant presupposition of the figure/ground distinction as the condition of possibility for the visual field.[106] In contradistinction to the reflexes of aesthetic modernism,

Hurston's lyrical transpositions interrogate the spatiotemporality of figure/ ground as the enabling distinction for the grid precisely through an itinerant play of color in its decidedly racial dimensionality. Hurston undertakes a deep study of racial contrasts in which the figure/ground distinction comes to be marked on her 'body' and through her flesh. What I wish to convey here is that Ligon's recursive deconstruction of the figure/ground distinction is anticipated and enriched by the Hurston text which animates his transpositional project in the first four "Door" paintings. Consider these relevant passages from Hurston's "How It Feels To Be Colored Me":

> Up to my thirteenth year I lived in the little Negro town of Eatonville, Florida. It is exclusively a colored town. The only white people I knew passed through the town going to or coming from Orlando. . . . I left Eatonville, the town of the oleanders, a Zora. When I disembarked from the river-boat at Jacksonville, she was no more. It seemed that I had suffered a sea change. I was not Zora of Orange County any more, I was now a little colored girl. . . . The position of my white neighbor is much more difficult. No brown specter pulls up a chair beside me when I sit down to eat. No dark ghost thrusts its leg against mine in bed. The game of keeping what one has is never so exciting as the game of getting. . . . I do not always feel colored. Even now I often achieve the unconscious Zora of Eatonville before the Hegira. I feel most colored when I am thrown against a sharp white background. . . . For instance at Barnard. "Beside the waters of the Hudson" I feel my race. Among the thousand white persons, I am a dark rock surged upon, and overswept, but through it all, I remain myself. When covered by the waters, I am; and the ebb but reveals me again. . . . Sometimes it is the other way around. A white person is set down in our midst, but the contrast is just as sharp for me. . . . In the abrupt way that jazz orchestras have, this one plunges into a number. . . . I dance wildly inside myself; I yell within, I whoop; I shake my assegai above my head, I hurl it true to the mark yeeeeooww! I am in the jungle and living in the jungle way. My face is painted red and yellow and my body is painted blue. My pulse is throbbing like a war drum. I want to slaughter something—give pain, give death to what, I do not know. But the piece ends. The men of the orchestra wipe their lips and rest their fingers. I creep back slowly to the veneer we call civilization with the last tone and find the white friend sitting motionless in his seat, smoking calmly . . . "Good music they have here," he remarks, drumming the table with his fingertips. . . . Music. The great blobs of purple and red emotion have not touched him. He has only heard what I felt. He is far away and I see him but dimly across the ocean and the continent that have fallen between us. He is so pale with his whiteness then and I am so colored.[107]

Through the "'swinging' rhythm," crescendos and caesurae of Hurston's literary composition,[108] its shifting, lyrical weave of color and perspective, affect and corporeal performance, we can make several observations. To begin with, Hurston sustains a complex play of figure and ground that seems to cascade across literal and metaphoric registers but which successively cuts and reverses inside and outside, foreground and background. The point I wish to underscore is that the metaphysical reduction and partial assimilation of black corporeality is internal to the figure/ground distinction. But flesh can never be completely disciplined into the material purity of ground, just as the 'black body' can never be figured as anything other than dissimulation. As Krauss avers, the ground is "masked and riven."[109] The figure betrays its own absence. The ground is contaminated. Together they form a phantasmatic complementarity-in-contradistinction, a reciprocality which black mediality is continuously forced to make and unmake.

Here it is worth recalling Phillip Brian Harper's contention that the movement from figuration to abstraction entails a crucial reduction—namely, "the progressive attenuation of the central figure until it is effectively obliterated in the grid, which thus issues forth as the focal point of the composition. However that reduction is brought about, . . . it is the grid itself that finally assimilates and thus literally *cancels* the figure."[110] Evincing a practice that interrogates the presumption of an "undifferentiated ground" from which the figural would emerge in and as positive difference,[111] the materiality of ground in Ligon's "Door" paintings is itself a performative composition, meticulously worked upon and labored over, devoid of any ambition to erase the traces of its making. Here Ligon's process is of paramount importance. Ligon first primes the surface of the door with multiple coats of gesso, a hard compound of plaster of Paris or whiting in glue that is used in sculpture as a base for gilding or painting on wood, applying as many as ten or more extremely thin layers. This time- and labor-intensive process, which encompasses both the application and prior mixing of the gesso, fashions the materiality of ground itself as a site of and not merely for difference. Moreover, by performatively exhibiting the corporeal exertions and burdens entailed in the making of ground, Ligon gestures to the fleshly bearings and bodily dissimulations which are the displaced prerequisites of the figural emergence from ground. Ligon's anteaesthetic practice returns us to the traces of the enfleshed existence for which the dissimulated 'body' is an excisive/projective rend(er)ing.

His practice deftly signals the redundancy of the axiomatic deployal of categorical distinctions between the figurative and the abstract when it comes to black art, for blackness bears the serial (un)making of this duality.[112] For even in works of anteaesthetic abstraction where the 'body' would seem to be wholly absent, these traces are manifest in and as obdurate materiality. (This is one of many reasons why the categorical distinction between abstraction and figuration cannot be sustained in relation to blackness.)

Hurston's recursive deconstructivism emerges through a lyricism that gathers affective weight and semiological potency over the course of its unfolding, exhibiting an accumulative valence that is materially entangled with the descendant chiaroscuros that texturize Ligon's canvases. The "evervacillating distinction between the author of the words in the work and that of the work itself"[113] in Ligon's transposition of Hurston's text is itself a redoubling of her deconstruction of the figure/ground distinction. This redoubling becomes most pronounced in the antedialectical triangulation of Ligon's 1990 works *Untitled (I Remember the Very Day That I Became Colored)*, *Untitled (I Do Not Always Feel Colored)*, and *Untitled (I Feel Most Colored When I Am Thrown Against a Sharp White Background)*. In attending to the affective accumulations immanent to and emanating from these triangulated artworks, I am guided by Eve Meltzer's attention to the "margins" of the artwork—or what I would call the artwork's antephenomenological recesses— "where affect remains a 'murky amalgam' that exceeds the work's primary elements."[114] Ligon's serial repetitions mark a recursive deconstruction of this affective remaining, a compounding of the burdened affectivity of Hurston's utterances which metamorphose with the insistency of visual repetition.

The smudging, distorting, and blurring of Hurston's words on the canvas track and transform the minor registers of her text, whose affective intonations slip from tragic lament into wry observation, to something like affected disinterest. Encountering her words, unremitting across and along the canvas, is emotionally difficult because the psychic force of the (an)original statement is simultaneously diminished, heightened, and even neutralized in Ligon's layered visual reproduction of it. Ligon's transposition reiterates and revises the Du Boisian question Hurston might be said to both anticipate and respond to—"How does it feel to be a problem?"[115]—a question which is always already a problem for thought.[116] For Ligon, this question unfolds as a problem of and for black art, as the problem black art both extends and theorizes.

But it is only possible to reiterate this problematic question of and through the work of art because of black femininity's irreducibly material thrownness. That is, in fabricating the irreducible depth of the surface, Ligon undertakes a deconstructive mimicry of Hurston's perpetual thrownness as well as the corporeal reproductivity that thrownness demands. Yet in order for Ligon to stage the door as an encounter, Hurston must serve as the threshold, as the medium for the racially gendered "transference, a carrying or crossing over, that takes place on the bridge of lost matter, lost maternity."[117] Crucially, it is the thrownness that being made a threshold imposes—that ensnarement at the reproductive nexus of enfleshed labor and endless dissimulation—which causes Hurston to "feel like a brown bag of miscellany" serially emptied and filled.[118] Subject to the ongoing racially gendered violence of interiorization, Hurston's interior must be evacuated, occupied, so that others may claim interiority, so that the distinction between the inside and outside can be instantiated and upheld. But Ligon's deconstructive transposition does not fashion a door that opens onto an encounter with Hurston's interdicted subjectivity or his own, or even the phenomenological indistinction the dissimulation of 'black body' would subject both of them to. Rather, Ligon recursively gestures to Hurston's bodily dissimulation and fleshly materiality as the threshold through which every encounter must pass—as that which Donika Kelly evocatively calls "the door / pretending to be a thing that opens." Thus the problem of being thrown not in or into the world (as Heidegger would have it) but *before* the world is the problem of and for black femininity.[119]

In *Untitled (Four Etchings)*, Hurston's thrownness is dissimulatively figured aloft, as if suspended in falling, but is in fact at once everywhere and nowhere in the work; her thrownness is the work's antefoundation. That is, to argue, as I have, that black femininity is thrown not in or into the world but before the world is to posit this thrownness as the experience of (im)mediation—of the racially gendered terrors and beauties imposed by the asymmetrical entanglement I have termed black mediality. It is Hurston's thrownness, or the black feminine (re)productivity it enfolds and with which it is enfolded, that sustains not only the distinctions between word and image, figure and ground, surface and depth, visibility and invisibility but also their recursive deconstruction in and through the exorbitant materiality this racially gendered (re)productivity necessarily bears. With a bril-

liance befitting his commitment to opacity, Ligon's text-based works effect an oblique disclosure of that which remains before the distinction between medium and form, indeed as this distinction's very condition of (im)possibility: the black residuum.

Given that Ligon's text-based works fundamentally contravene the very idea of medium-specificity by working with and from the black residuum every medium contains or, rather, seeks to contain, it should come as no surprise that his anteaesthetic engagement extends beyond the medium of painting, for which he is perhaps best known. It is to Ligon's transposition of a consubstantial problematic in his 2008 video installation, *The Death of Tom*, that we now turn.

The Death-Work of Cinema

to be unaware of one's form is to live a death.
—Ralph Ellison, *Invisible Man*[120]

But what was to be done with Topsy?
—Harriet Beecher Stowe, *Uncle Tom's Cabin*[121]

Ligon's 2008 installation *The Death of Tom* (16 mm black and white film/ video transfer; 23 minutes) evades the sort of prefabricated description that is variously resuscitated through the reflexes of medium-specific interpretive schemas. *The Death of Tom* emerges recursively from the tremulous borders between art installation, film, theatrical performance, and sentimentalist literature, recalling the deconstructionist impulse of Ligon's earlier text-based artworks. Inside the black box that does not merely mimic the cinematic but troubles the distinction between exhibition and spectatorship,[122] the viewer is confronted with a phantasmagoria of black and white frames, their procession of stretched and sputtering images wavering within an eerie atmospherics (see figure 24).[123] Caught between sharp flashes of light, the dimensionless dark, and the oscillating fade of luminosity, it is as if the viewer is made to perpetually search for a specter's shadow, to no avail.

Ligon had initially set out to restage the final scene from the 1903 film *Uncle Tom's Cabin, or, Slavery Days*, produced by Thomas Edison and directed by Edwin S. Porter, the first of the many cinematic adaptations over the course of the twentieth century of Harriet Beecher Stowe's singularly

Figure 24. Glenn Ligon, *The Death of Tom,* 2008, 16 mm black and white film/video transfer, 23 min; 4:3 aspect ratio, edition of 3 and 1 AP, installation view: Off Book, Regen Projects, CA, December 12, 2009-January 23, 2010. © Glenn Ligon; Courtesy of the artist, Hauser & Wirth, New York, Regen Projects, Los Angeles, Thomas Dane Gallery, London, and Galerie Chantal Crousel, Paris.

influential 1852 novel *Uncle Tom's Cabin; or Life Among the Lowly.*[124] In this scene, dubbed "Tableau: Death of Uncle Tom" in the associated Edison Studios catalog,[125] Tom, the "the gentle, childlike, self-sacrificing, essentially *aesthetic* slave,"[126] becomes fully sainted in death[127] amid heavenly visions of his master's prematurely departed, angelic daughter, Little Eva (figure 25), and the grand patriarchs of white sacrifice and beneficence Abraham Lincoln and John Brown.[128] Implicitly referring to a complex and often subversive tradition of "black-on-black minstrelsy," which Louis Chude-Sokei has importantly theorized,[129] Ligon himself played Tom alongside several student collaborators, while Deco Dawson filmed the scene on 16mm film. Working closely with Dawson, Ligon endeavored "to shoot . . . [the film] exactly the way Edison's cinematographer did—on a hand-cranked camera, black-and-white, 16 millimeter, with a double exposure."[130]

Despite his precise attention to the minutiae of reenactment and reproduction, however, after processing the film Ligon discovered that it had

not been properly threaded in the camera, such that the work appeared as a series of "blurry, fluttery, burnt-out black-and-white images, all light and shadows."[131] Nevertheless, Ligon opted to retain the nominally ruined film, transferring it to tape and later to DVD for exhibition purposes, because, in his words, "that failure of representation was in line with my larger artistic project, which has always been about turning something legible like a text into an abstraction."[132] That is, Ligon recognized the glitch, which Lauren Berlant defined as "an interruption amid a transition,"[133] as a fitting stroke of chance. Indeed, this technical failure aptly mimicked the disfigurement that necessarily constitutes every effort to reduce the opacity of blackness, which is always already anterior to representation, to a substantially enclosed, transparent phenomenon. As with the anteaesthetic practice with which this book opens, in which Nina Simone improvisationally exploits the contingent and structural impositions of racially gendered spectatorship to disclose and refuse the anteriority her performance was made to bear, Ligon

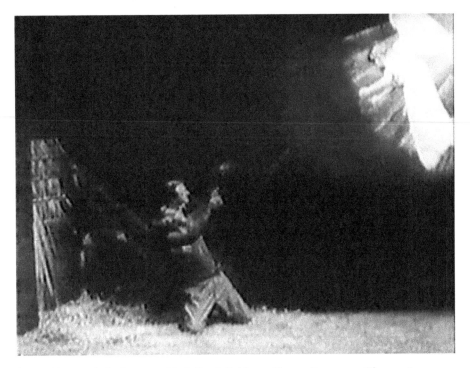

Figure 25. Dir. Edwin S. Porter, *Uncle Tom's Cabin, or, Slavery Days,* 1903, Thomas A. Edison, Inc. Screengrab from the Library of Congress. Public domain.

unmakes the very law his filmic performance is called to renew: the death-work of cinema. Precisely through his return to that law in and through a recursive deconstruction of it, Ligon refashions the glitch as an instrument of nonperformance,[134] one whose deconstructive impetus hinges upon the form that is medium. In short, Ligon mobilizes the glitch toward an anteaesthetic interrogation of the formal technics of the cinematic.

But the glitch would not be the only instrument within Ligon's ensemble, for it was at this stage in the development of the work that it occurred to Ligon that the screening of Porter's 1903 film might well have had a piano accompaniment, as was indeed common for early cinema's "silent" films.[135] Ligon thus invited the jazz pianist Jason Moran to create a soundtrack for the film. Improvising upon Bert Williams's famous vaudeville song, "Nobody," first performed only two years after the release of Porter's 1903 film, Moran watched Ligon's film and, as the musician evocatively puts it, "played to the shadows."[136] The installation's first exhibition at MoMA assumed the form of their collaborative, visual-sonic assemblage. We will return to the significance of Ligon and Moran's improvisatory ensemble for an anteaesthetic reading of *The Death of Tom* shortly. But first we must take a deeper look at the literary, cinematic, and theatrical histories Ligon and Moran's (non)performance invoke and unsettle.

The historical significance of Harriet Beecher Stowe's *Uncle Tom's Cabin* has been widely discussed and debated since it was published in 1852; here I will only scratch the surface of the expansive critical literature the novel has occasioned. In literary scholar Jane P. Tompkins's view, Stowe's novel "was, in almost any terms one can think of, the most important book of the century."[137] It is most commonly known as the first abolitionist novel to attain mass popularity, with the first edition selling some 300,000 copies in the United States and 150,000 in Britain within the very first year following its publication, setting a record at the time for the most purchased book ever, second only to the Christian Bible.[138] Immediately propelled to a place of prominence among other leading antislavery figures, Stowe is said to have been welcomed by Abraham Lincoln in her 1862 visit to the White House with the exclamation: "So this is the little lady who started this great big war."[139] While it would of course be facile to construe Stowe's novel as an ideological catalyst for the Civil War (which, after all, had nothing to do with a genuine investment on the part of either the Union or Northern

civil society in black emancipation or dismantling the world forged by racial slavery, as such a project would require nothing less than the abolition of the reigning social formation), this anecdote neatly illustrates the discursive purchase the novel attained in the romance of nationhood.

Initially published in serial form in *The National Era* and borrowing heavily from the slave narratives of Frederick Douglass, Josiah Henson, and Solomon Northup, as well as Theodore Weld's *American Slavery As It Is*,[140] Stowe's novel is a paragon of the sentimentalist tradition in which politics are deployed and displaced through universalist genres of feeling. As Berlant observes, "Sentimental politics are being performed whenever putatively suprapolitical affects or affect-saturated institutions (like the nation and the family) are proposed as universalist solutions to structural racial, sexual, or intercultural antagonism."[141] More pointedly, following Saidiya Hartman, *Uncle Tom's Cabin* marked a signal literary instantiation of a more general enterprise which was embedded in "abolitionism's sentimental structure of feeling":[142] namely, the aesthetic recuperation of the material, discursive, and libidinal economies that reproduce the world as an antiblack metaphysics, which would ultimately be registered historically as "the nonevent of emancipation."[143] The character of Tom, who has come to most prominently figure "the nexus between minstrelsy and melodrama,"[144] was and remains a salient instrument of this enduring recuperative project. In the novel, Tom's aesthetic function is tethered to Little Eva, "the emblematic child-angel of the nineteenth century" who so powerfully illustrates the centrality of performances of white girlhood in the ongoing reproduction of the subterfuge of "racial innocence."[145]

Tom and Little Eva have a twinned role in the "family romance" of the plantation through which Stowe advances her sentimental abolitionism, a modality of seduction "in which domination is transposed into the bonds of mutual affection, subjection idealized as the pathway to equality, and perfect subordination the means of ensuring great happiness and harmony."[146] Tom and Little Eva's part in Stowe's romance begins with their mutual befriendment onboard the ship transporting Tom down the Mississippi to be sold, and is diegetically consolidated when Tom dives into the river to save Little Eva, who has fallen off the boat. Their friendship is ultimately rendered sacrosanct at the scene of Tom's death, which follows his being brutally beaten by an overseer for refusing to give up the location of two

escaped fellow slaves, Cassy and Emmeline. As Hortense Spillers argues, in their coupled figuration, Tom and Little Eva serve as "the sacrificial lamb of *Uncle Tom's Cabin*," though it is of course Tom's tortured 'body' which bears the burdens of "the *requirements of sacrifice*," or the diegetic reflex that in fact "galvanize[s] the murderous instincts of ... [the antiblack world] rather than ... [challenging] them."[147]

Tom's corporeal brutalization and saintly death serve as the diegetic instruments for the realization of the redemptive arc of Stowe's sentimentalist abolitionism, as well as the extra-diegetic instruments for the realization of the libidinal abundance and metaphysical suture that every instantiation of black death affords civil society. As David Marriott shrewdly observes, black death always evinces a "dual property of zero and surplus," which is precisely how it "acquires its beautiful perfection: as *ante legum*, its being is always already dead and so cannot be killed; and as property, it can be punished according to the forensic rules and pronouncements of the forum, a law that can be re-enacted each time white desire needs to defend or affirm itself *as the rightful law of the living*."[148] Black death must be endlessly repeated, because it is an indispensable means of sustaining the expropriative displacements required for the metaphysical distinction between life and death upon which the world (of the living) depends.[149] Tom's death constitutes a singularity only in that it poses a reflexive exhibition of its own illimitable repetition. His endlessly repeated death marks the burial grounds, or rather buried ground, of the cinematic—the black death that cinema's formal technics both require and extend.

Indeed, the scene of Uncle Tom's death would find no shortage of opportunities for repetition, both directly and indirectly, as the unprecedented novelistic success of *Uncle Tom's Cabin* spawned a host of theatrical adaptations and spin-offs, which were performed not only in the metropoles but also by traveling companies known as "Tom Shows" or "Tommer Shows," which brought Stowe's novel and its derivatives into a vast number of small towns and villages.[150] The minstrel show—as the quintessential formal genre of the "orchestrated amusements" through which the abomination of slavery was performatively diffused,[151] a reproductive transmission that was also a reproductive sublimation—was at once the condition of possibility for *Uncle Tom's Cabin* and a crucial means by which its signal tropes became culturally ubiquitous.[152]

As *Uncle Tom's Cabin* worked its way through various forms of theatrical performance, its melodramatic sentimentality was increasingly supplanted by the sadistic humor characteristic of blackface minstrelsy, though certainly both of these affective genres were in evidence in the slew of Uncle Tom memorabilia that emerged throughout the nineteenth century, including figurines, engravings, dioramas, needlepoint, card games, gift books, plates, and silverware.[153] Familiarity with the minstrel form was in fact inextricable from the general reception of the theatrical iterations of *Uncle Tom's Cabin*,[154] a fact which is unsurprising when one comes to recognize the racial melodrama of sentimentalism and the racial comedy of minstrelsy as complementary rather than antagonistic genres, with each affording their own unique mechanisms for the spectator's (dis)possessive catharsis. "Whippings were to minstrelsy what tears were to melodrama."[155] Tom's death, the vision of which Stowe herself suggested was both the catalyst for and telos of the novel,[156] serves as a crucial means for sustaining the complementarity of these genres of affect, and thus its endless, morbid repetition becomes instrumental in the extensive and variegated transits of *Uncle Tom's Cabin* across mediums, geographies, and forms.[157] If the image of Tom's death may be said to acquire its perfection only in the fact of its differential repetition of the same, then what is its relationship to the moving image?

Edwin S. Porter not only holds the dubious distinction of directing the first filmic adaptation of Stowe's novel in 1903,[158] but he is among the signal progenitors of modern cinema, particularly in his associations with the Edison Manufacturing Company between 1896 and 1909. According to film historian Charles Musser, during these pioneering years of commercial motion picture making, "Edwin S. Porter emerged as America's foremost filmmaker" and was crucially implicated in the "production and representational practices, . . . subject matter and ideology, and . . . commercial methods" which together shaped this pivotal epoch in the emergence of modern cinema.[159] A rigorous media archaeology of early cinema would be beyond the scope of this chapter (even as Ligon's *The Death of Tom* is itself a rigorous experiment in black media archaeology). Needless to say, the emergence of the cinematic medium constituted a major historical transformation in the spatial and temporal operations of modernity's regime of representation.

As Mary Ann Doane famously argued in *The Emergence of Cinematic Time*, the cinematic medium sustains a complex and often contradictory interde-

pendence between, on the one hand, the abstract, rationalized time that correlates with the rise of the commodity form and the capitalist law of value, and, on the other, the contradictory figure of contingency, which "proffers to the subject the appearance of absolute freedom, immediacy, directness . . . [extending] the possibility of perpetual newness, difference, the marks of modernity itself."[160] Moreover, cinema, in its "technological assurance of indexicality," promised the representability of the contingent, a "pure record of time," an unrivaled archive of presence.[161] It was precisely "its ability to inscribe movement through time" which marked "cinema's decisive difference from photography."[162] Bearing Doane's exemplary study in mind, it becomes clear that Ligon's planned filmic reenactment of Porter's *Uncle Tom's Cabin* and subsequent exploitation of the glitch as an instrument of nonperformance are no less than deconstructive interrogations of the anterior remains of blackness—not only with respect to the cinematic medium but with respect to this medium's historic modulation of temporality and the modern metaphysics of presence.

Without reprising the more nuanced debates regarding the specific dynamics, chronology, or inevitability of the historical change, there is at least broad agreement amongst contemporary film historians that by at least 1907–1908 the narrative form with which classical cinema is associated had definitively triumphed. In Tom Gunning's well-known argument, this era witnessed a transition from a "cinema of attractions," principally "dedicated to presenting discontinuous visual attractions, moments of spectacle rather than narrative," to what he and André Gaudreault term a period of "narrative integration."[163] Porter's *Uncle Tom's Cabin* occupies an unusual place in this formal typology. Musser has argued that the narrative form Gunning associates with the work of D. W. Griffith and the attendant transformations of the film industry after 1908 is in fact anticipated by the work of Porter, particularly "after the pivotal year of 1902/03" and most notably exemplified in Porter's *Life of an American Fireman* (1902/03).[164] However, while *Uncle Tom's Cabin* was not without technical innovations that evinced the emerging impetus to narrative form—for example, its direct integration of the intertitle into the production process, which had hitherto been the responsibility of exhibitors[165]—the film has often been regarded as little more than filmed theatrical production and hence as something of an anachronism within Porter's oeuvre. Indeed, Porter utilized an existing Tom troupe and relied heavily on

the formal trappings of blackface minstrelsy to such a degree that the film is regarded as "perhaps the best extant documentation of a Tom show available to historians."[166] In this respect, Porter's film would seem to possess more of the spectacular quality characteristic of Gunning's cinema of attractions than the hegemony of narrativity that would come to define classical cinema.

Yet as Noël Burch argued, *Uncle Tom's Cabin* was significant precisely because it was called upon to reproduce a story that was so widely known and among the most significant instances of popular (rather than bourgeois) theater, such that Stowe's lengthy novel could be fragmented and compressed into fourteen tableaux spanning roughly twelve minutes at the standard silent film speed and nevertheless retain its narrative force and coherence.[167] The diegesis of the film "was predicated upon the [prior] knowledge of the audience, who were left to fill in enormous narrative gaps for themselves," a linearizing inhabitation which proceeded, in no small part, through "the establishment of a thoroughly haptic screen space."[168] I am less concerned with making a formalist case for the place of *Uncle Tom's Cabin* in the taxonomies of film history than I am with interrogating the manner in which it functionally serves as a bridge between forms, retrospectively figured teleologically as developmental stages, at the scene of cinema's emergence. *Pace* Burch, I would suggest that, to the extent that *Uncle Tom's Cabin* established a "haptic screen space," which in this instance effectuates a form that straddles the cinema of attraction and narrative integration, it is a hapticity principally achieved not through technical innovation but through the morbid (im)mediations afforded by Tom's brutalized 'body' and the fleshly labors which sustain its endless dissimulation. The fact that the Tom of Porter's film is played by a white actor in blackface does not temper the fact that the cinematic cathexis is effectuated through fulfillment of a black death always already anticipated. That the (moving) image of black death given to the emergent cinematic subject arrives in the form of blackface minstrelsy only accentuates the dissimulative character of every phenomenalization of black death.

It has been suggested that the definitive ascendance of narrative after 1907 effectively disciplines, without eliminating, contingency within the operations of cinematic time. Significantly, Doane observes, "If cinematic narration develops, in part, as a structuring of contingency (and hence its reduction as such), the most intractable contingencies would seem to be

those having to do with the body and death. . . . With death we are suddenly confronted with pure event, pure contingency, what ought to be inaccessible to representation."[169] Doane's indispensable work helps us in confronting the question of how we might square either the lineaments of narrative or the shudder of contingency with the phenomenological feint that is Tom's 'body,' which is conjured only to die again and again as narrative's impetus and detritus. The absolute noncontingency of Tom's death, its predestination before the event, marks the metonymic trace of the gratuitous violence and necrogenic expropriations that subtend both the figure of contingency and its disciplinary structuration in the figure of narrativity. Tom's death repeatedly binds the sentimental and the spectacular, the empathetic and the sadistic, the sodden weight of the past, the ephemeral plentitude of presence, and the glimmering horizon of the future, so that the properly historical beings of civil society might fret over or luxuriate within the dialectical plays and strains of the structural and the contingent which define the experience of modernity. Black death is at once the prerequisite to and outcome of both narrative and event in cinema as in the world.[170] Or as David Marriot plainly states the case, "For Afro-pessimism, . . . the white film-work is always a *death-work*."[171]

I want to suggest that Ligon's *The Death of Tom*, far from simply exposing or indicting the racist origins of American cinema, recursively deconstructs the cinematic itself, disclosing black mediality—in its absolute inseparability from the orchestrated amusements and gratuitous violence of racial terror, from mutilation and black death—as the condition of possibility for the medium's emergence. Blackness is anterior to the cinematic. At the same time, Ligon's piece gestures to the manner in which blackness marks the immanent failure of cinema's ambitions to function as a totalizing archive of presence or as an apparatus which can effectively "make the contingent legible."[172] In this respect, Ligon's deployment of an anteaesthetic modality of experimentation that could be thought through the rubric of the post-cinematic (which some scholars have associated with a revival of formal dimensions characteristic of Gunning's cinema of attractions or of early cinema more broadly[173])—does not so much exhibit a similitude between the proto- and post-cinematic as it does theorize the blackness which remains before the cinematic, then as now. To put what film studies would generally

regard as too fine of a point on it, we might recall the rhetorical questions posed by Gunning, after his recounting of an episode in which he was asked incredulously by a young scholar how it was that he had managed to write an entire book on the films of D. W. Griffith without substantively theorizing race in any way. "Was his claim that race was essential to the evolution of cinema's narrative style? Or was it that race was such an essential topic that every book must devote some time to it?"[174] To both of Gunning's rhetorical questions, *Anteaesthetics* would answer, with considerably less analytic prevarication, unequivocally, yes, before proceeding with more serious inquiries into cinema's black anterior.

I contend that the anteriority of blackness to cinema is the condition of (im)possibility for the phenomenology of filmic experience that is celebrated and mourned by scholars such as Vivian Sobchack. For Sobchack, "cinema is an objective technology of perception and expression that comes—and becomes—before us in a structure that implicates both a sensible body and a sensual and sense-making subject . . . [affirming and showing] that, sharing materiality and the world through vision and action, we are intersubjective beings."[175] If the anteriority of blackness makes possible the pretense of a universal body-subject for whom cinema would mediate an unbroken relay of phenomenological experience, it is only because those who are made to bear the (im)mediations of the flesh are always already barred from subjectivity, intersubjectivity, and the corporeal division of the world upon which each are predicated. Sobchack's disquietude over the "crisis of the lived body"—which she regards as both constitutive and symptomatic of the supersession of the cinematic by the "techno-logic of the electronic," with its "spatially decentered, weakly temporalized and quasi-disembodied" mode of experience[176]—takes on the quality of the grotesque when one considers the figure of Tom, the no-body, whose dissimulated corpus becomes an inexhaustible site for the ritual execution that serially inaugurates the lived body and Sobchack's self-affirming cinematic world. But as we know, the expropriative displacement of exorbitant materiality this black mediality requires is necessarily incomplete and thus remains a problem for both the phenomenology of the cinema and historicist lamentations of its passing.

Returning to *The Death of Tom*'s phantasmagoric play of light and shadow, silence and song, let us observe that the only phenomenological anchor that

would seem to be afforded the viewer is the work's successive return to an apparent opening title, or rather terminal intertitle, which reads again and again *The Death of Tom* (see figure 26). And yet the repetition of this multiplied and distorted text (which reappears eight times over the twenty-three-minute duration of the work) that would seem to lend a regularity to time simultaneously interrupts spectatorial vision through its unfinished redoubling of the transcription across the space of the screen. The regularity the intertitle would appear to lend to time is simultaneously undone by the irregularity it announces in space. Tom's perpetually repeated yet perennially unfinished death becomes the indeterminate locus of a peculiar kind of hauntology.

The specter of Tom is not merely "a repressed or unresolved social violence . . . making itself known,"[177] or rather felt, no matter how opaquely, as the haptic trace of the unthought and unthinkable. That is, "what haunts is

Figure 26. Glenn Ligon, *The Death of Tom*, 2008, 16 mm black and white film/video transfer, 23 min; 4:3 aspect ratio, edition of 3 and 1 AP, installation view: Off Book, Regen Projects, CA, December 12, 2009-January 23, 2010. © Glenn Ligon; Courtesy of the artist, Hauser & Wirth, New York, Regen Projects, Los Angeles, Thomas Dane Gallery, London, and Galerie Chantal Crousel, Paris.

not so much the imago spun through with myths, anecdotes, stories, but the shadow or stain that is sensed behind it and that disturbs well-being."[178] It is the irreducible materiality of this disturbance which constitutes its hapticity—as the sensorial anterior that precedes and is subject to phenomenological experience and yet cannot appear as anything other than the dissimulation of a presence which is not one. An anteaesthetic iteration of what David Marriott, invoking a theatrical idiom, refers to as "corpsing," or "the violation of rules of prescribed performance under the command of social laws," Ligon's art of dissimulation produces "the knowledge and loss of the rules determining the subject."[179] In short, the serial nonevent of Tom's death is at once the catalyst and lysis for the cinematic medium and the phenomenological relay of cinematic communication: a black mediality through which the absence of form paradoxically gives form to the medium.

Playing to the Shadows

The trace is not only the disappearance of origin—within the discourse that we sustain and according to the path we follow it means that the origin did not even disappear, that it was never constituted except reciprocally by a nonorigin, the trace, which thus becomes the origin of the origin.
—Jacques Derrida[180]

Ligon's *The Death of Tom* recursively deconstructs the black mediality which is the constitutive anterior of the cinematic medium. The artwork also suggests that the secret of black mediality lies in the irreducibility, ineradicability, and absolute opacity of its remainder: the black residuum. What message is borne in, by, and as a medium whose communicative codes and strictures prohibit its own anterior—the formless death which perpetually gives life to and bedevils the life of the cinematic?

Insofar as we are concerned with the message of "the commodity who speaks,"[181] the answer is, of course, only a disfigured and disfiguring message. *The Death of Tom* is exemplary (an exemplar which is not simply one among others) of what Alexander R. Galloway, Eugene Thacker, and McKenzie Wark theorize as the "excommunication [which] seems to haunt every instance of communication."[182] Excommunication is not concurrent with but anterior to communication. As Galloway, Thacker, and Wark would have it,

"Every communication harbors the dim awareness of an excommunication that is prior to it, that conditions it and makes it all the more natural,"[183] even if, as Ligon's work suggests, this naturalization is constantly threatened by the immanent contamination it relies upon for its reproduction. Specifically, Ligon's work epitomizes what Eugene Thacker terms "dark media," a form of media which betrays the very opacity which is its condition of (im)possibility. Dark media, in Thacker's view, effectuates something like "seeing something in nothing (e.g., the animate images appearing on the screen or alchemical glass), and finding nothing in each something (the paradoxical absence or presence of the 'demon' behind each thing)."[184] However, whereas Thacker conveniently displaces the matter of raciality from his inquiry into dark media, Ligon's work understands that the anteriority of opacity always already turns upon the matter of blackness, the exorbitant materiality which returns to us as the black residuum.[185] If Ligon's excommunicative experiment interrogates a black mediality that is conscripted in the reproduction of modernity's "communicational imperative" but that can only be "expressed as the impossibility of communication," then it also directs our attention to the paradoxical operations by which communication's "enigmatic residue" is disjunctively corporealized.[186]

Ligon discloses the dissimulative nonevent of Tom's perpetual death as the condition of possibility for every communicative medium, as the projection of "something . . . [onto] nothing" which sustains the animative "nothing in each something." As such, one cannot help but observe a terrible racial irony lurking beneath Sobchack's admonition that by "devaluing the physically lived body and the concrete materiality of the world, the dominant cultural and techno-logic informing our contemporary electronic 'presence' suggests that—if we do not take great care—we are all in danger of soon becoming merely ghosts in the machine."[187] Yet the ghost in the machine is not Tom's per se; it is the conscripted black mediality which necessitates his corpsing ad infinitum. Extending Saidiya Hartman's contention that "slavery is the ghost in the machine of kinship," film phenomenology must consider that some of us have always been spooks, bearers of a blackness whose anteriority to every apparatus is "made visible as a haunted technological medium."[188] Ligon's dark media suggests that the black has only ever approached the machine as its phantasmatic anterior, bound to the (im)

mediations of the flesh and the ruse of presence, the antephenomenological specter cinema at once needs and abhors.

In the final chapter, I further expound upon the inextricability of dark media from the hieroglyphics of flesh. For now, however, let us note that the cinematic hauntology elliptically disclosed in and by *The Death of Tom* could be said to be subtended or borne by another, one which is, in this instance, granted the dissimulation neither of presence nor the absence of presence: a racially gendered enfleshment which becomes (displaced within) the apparatic body of the cinematic medium.[189] Among the litany of (mis)namings this black feminine vestibularity is generally made to assume within the particular context of the literary, cinematic, and theatrical histories with which the anteaesthetics of *The Death of Tom* are recursively entwined, we might say that one name stands out among others: Topsy.

While Topsy is denied the saintly trappings granted Tom at the moment of his death, she nevertheless figures centrally in the libidinal, symbolic, and material economies that subtend the diegesis in *Uncle Tom's Cabin* as well as the novel's aesthetic transits across theatrical performance, cinema, and visual culture more broadly. Generally regarded as the paradigmatic exemplar of the "pickaninny," Topsy's figure would prove to be a no less dynamic resource for racial troping over the next 170 years than that of Uncle Tom.[190] In the novel, Topsy, "a little Negro girl, about eight or nine years old," is purchased by St. Clare for Miss Ophelia as an "experiment"—an experiment meant to test whether this fallen "creature" could be wrested from her debasement and educated in the refinements of sentiment, the faculties of reason, and the decorums of civility that distinguish full-fledged human beings from the wretched.[191] Miss Ophelia, good sentimentalist that she is, objects, "It is your system makes such children," to which St. Clare responds, "I know it; but they are *made*,—they exist,—and what is to be done with them?"[192]

Like the Hottentot Venus, Topsy may be taken as one of several paradigmatic figurations of the black feminine—in this instance, that of the pickaninny, whose (un)gendering is distinguished, in part, by an incapacity to lay claim to either girlhood or womanhood. Also like the Hottentot Venus, the process of aesthetically rend(er)ing Topsy unfolds principally through the dissimulation of her 'body' and the constellation of affects which adhere to

it. Stowe wastes no opportunity to weave Topsy's exceptionally degraded, pathological, pitiable nature through her spectacularized corporeality, though the moment of her first appearance in the novel is a particularly prominent example:

> She was one of the blackest of her race; and her round, shining eyes, glittering as glass beads, moved with quick and restless glances over everything in the room. Her mouth, half open with astonishment at the wonders of the new Mas'r's parlor, displayed a white and brilliant set of teeth. Her woolly hair was braided in sundry little tails, which stuck out in every direction. The expression of her face was an odd mixture of shrewdness and cunning, over which was oddly drawn, like a kind of veil, an expression of the most doleful gravity and solemnity. She was dressed in a single filthy, ragged garment, made of bagging; and stood with her hands demurely folded before her. Altogether, there was something odd and goblin-like about her appearance—something, as Miss Ophelia afterwards said, "so heathenish," as to inspire that good lady with utter dismay; and, turning to St. Clare, she said,
>
> "Augustine, what in the world have you brought that thing here for?"
>
> "For you to educate, to be sure, and train in the way she should go. I thought she was rather a funny specimen in the Jim Crow line. Here, Topsy," he added, giving a whistle, as a man would to call the attention of a dog, "give us a song, now, and show us some of your dancing."
>
> The black, glassy eyes glittered with a kind of wicked drollery, and the thing struck up, in a clear shrill voice, an odd Negro melody, to which she kept time with her hands and feet, spinning round, clapping her hands, knocking her knees together, in a wild, fantastic sort of time, and producing in her throat all those odd guttural sounds which distinguish the native music of her race; and finally, turning a summerset or two, and giving a prolonged closing note, as odd and unearthly as that of a steam-whistle, she came suddenly down on the carpet, and stood with her hands folded, and a most sanctimonious expression of meekness and solemnity over her face, only broken by the cunning glances which she shot askance from the corners of her eyes.[193]

Topsy's character serves as not only the constitutive foil for all of the novel's main characters[194] but the principal figural means of effectuating the complementarity between the racial melodrama of sentimentalism and the racial comedy of minstrelsy. It is significant that both operations are accomplished by mobilizing Topsy's wayward corporeality, or in the terms of my argument, the singular quality of her (dis)placement before the corporeal division of the world, as well as the libidinal economy of gratuitous violence

this anterior corporeality would appear to necessitate. As Hartman observes, "Uncle Tom's tribulations were tempered by the slaps and punches delivered to Topsy."[195] Both Topsy and Uncle Tom, of course, were the objects of corporeal violence, but whereas the violence directed against Tom "caused the virtuous black body of melodrama to be esteemed," the violence directed against Topsy "humiliated the grotesque black body of minstrelsy."[196] Although the constitutive opposition of Topsy and Little Eva is not, strictly speaking, analogous to that of Topsy and Uncle Tom, it is aesthetically accomplished through a similar juxtaposition of corporeal and affective traits:

> There stood the two children, representatives of the two extremes of society. The fair, high-bred child, with her golden head, her deep eyes, her spiritual, noble brow, and prince-like movements; and her black, keen, subtle, cringing, yet acute neighbor. They stood the representatives of their races. The Saxon, born of ages of cultivation, command, education, physical and moral eminence; the Afric, born of ages of oppression, submission, ignorance, toil, and vice![197]

One of the most notable features assigned to Topsy's dissimulated 'body' is animatedness. Following Sianne Ngai, I understand Topsy's animatedness not as an innocent curiosity or figurative idiosyncrasy but as the sign of a violent process by which the regime of aesthetics "visibly harnesses the affective qualities of liveliness, effusiveness, spontaneity, and zeal to a disturbing racial epistemology, and makes these variants of 'animatedness' function as bodily (hence self-evident) signs of the raced subject's naturalness or authenticity."[198] As a corporealized affect, animatedness suggests an intimate proximity to animation which is more than etymological; the declensions "between the organic-vitalistic and the technological-mechanical, and between the technological-mechanical and the emotional"[199] register racial taxonomies of affectability which are internal to modern affective categories. More pointedly, "the animation of the racialized body . . . involves likening it to an instrument, porous and pliable, for the vocalization of others."[200]

That said, although both Uncle Tom and Topsy are animated in Ngai's sense of the word, the racial ventriloquism to which they are both subject (whether that ventriloquism appears in embodiment or speech) assumes a markedly different form in each instance. Whereas Tom's animatedness functions as a sentimental mechanism of endearment, Topsy's is comical,

degraded, grotesque, and immediately associated with ungovernability. Moreover, Tom's and Topsy's differential animations and the racially gendered taxonomic distinctions in affectability to which they correspond are also expressed as a formal divergence in the quality of the touch to which they are respectively subject, even if this representational bifurcation of the violence of (im)mediation ultimately serves a unitary aesthetic project. Whereas Tom's animatedness lends itself to an idiom of tenderness, a sensualized openness to and bestowal of touch that would assume overtly erotic overtones in the expansive aesthetic transits *Uncle Tom's Cabin* undertook in the wake of the original novel,[201] Topsy encounters touch principally through the brute force of terror, as the wildness of her dissimulated 'body' "can only be governed by the lash" (and even this would appear to be insufficient to tame her unruly nature).[202] As with Saartjie Baartman, Topsy's presumptive embodiment of radical affectability produces no contradiction with the apparent insensateness that enables her endless "hurt-ability."[203] What mercy Topsy receives is not only therefore effectively redundant but furthermore serves to ennoble Little Eva. Topsy remains obstinate and unredeemable. In short, a racially gendered economy of animatedness sustains the violence of distinctive, if conjoined forms of (im)mediation.

Nevertheless, following a line of thought introduced in Fred Moten's analysis of Édouard Manet's *Olympia* (1865) and Thomas Eakins's *African-American girl nude, reclining on couch* (c. 1882), I want to suggest that what is concealed in the affective relay produced by Tom's and Topsy's contrapuntally gendered animations is in fact something on the order of a deanimation[204]—or more precisely, a petrification through animation which serves to displace the racially gendered bearing of an exorbitant materiality that cuts the difference modern hierarchies of animacy seek to still. In this instance, Moten's contention that early cinema's movement "from disruptive attraction to seamless arc . . . [is] a forced movement embedded in the stillness of the little girl"[205] can be partially inverted without altering its substance: with Topsy, we glimpse the emergence of the cinematic through a stillness embedded in the forced movement of the little (black) girl. But on this point we must be very clear: the black feminine anteriority or enfleshed black mediality which serves as the vestibule for and casualty of the emergence of the cinematic cannot be reduced to the figural, regardless of whether the figure in question can be said to have "really existed." After all, an existence without

ontology fundamentally belies any neat distinction between (aesthetic) fantasy and (material) reality. That is, although Topsy, in this instance, becomes the figurative site, the dissimulated 'body' which comes to mark a racially gendered, enfleshed mediality which is in fact absolutely unrepresentable, her figure both bears the trace of flesh and occasions its concealment.

This point helps us to understand the significance of Topsy's cameo appearance on the very first page of Mary Ann Doane's canonical work *The Emergence of Cinematic Time*. Referring to a story by James Brander Matthews entitled "The Kinetoscope of Time," published in the December 1895 issue of *Scribner's Magazine*, the very same month that the films of the Lumière Cinématographe were first publicly screened, Doane suggests that this particular "story conveys something of the uncanniness of the new technology's apparent ability to transcend time as corruption by paradoxically fixing life and movement, providing their immutable record. It condenses many of the fears, desires, anxieties, and pleasures attached to the idea of the mechanical representability of time."[206] To paraphrase Doane's recounting: in this story, an anonymous, first-person protagonist narrates a gothic encounter with an emergent technology which straddles the uncanny and the marvelous.[207] The midnight toll of a clock tower and a sudden gust of bitter wind announce this protagonist's wandering through the streets of an unknown city beneath a moonless sky. An uncertain yellow gleam and an unspoken voice beckon the protagonist to an obscure building, which he enters as if by necessity. In an unfurnished, dimly lit rotunda, its walls draped in velvet, he encounters a series of kinetoscopes, Edison's individual viewing machine that directly preceded the invention of cinema. Heeding the command of a message projected onto the velvet curtains, whose words are immediately forgotten but meaning retained, he peers through the first of the eyepieces. In the pages that follow, the protagonist encounters "a succession of strange dances," including scenes from the tale of Salomé, *The Scarlet Letter,* and *Uncle Tom's Cabin* (specifically the scene described earlier, in which Topsy is commanded to dance before her new masters), followed by glimpses of the *Iliad, Don Quixote, Faust,* and the Custer massacre.[208] When he withdraws from the apparatus, he encounters a strange man that he speculates is "Time himself," who offers him the chance to view his own past and future demise but at a cost: "The Vision of life must be paid for in life itself. For every ten years of the future which I may unroll before you here, you must assign me

a year of your life—twelve months—to do with as I will."[209] Having refused the Faustian bargain, the protagonist is sent away and eventually works his way from this space of mysterious darkness and illumination back to the street, where the flood of electric street lamps and the roar of a nearby train confirm that he has come "back to the world of actuality."[210]

In Doane's reading, "the story conjoins many of the motifs associated with the emerging cinema and its technological promise to capture time: immortality, the denial of the radical finitude of the human body, access to other temporalities, and the issue of the archivability of time."[211] But what are we to make of the appearance of Topsy, in all of her "wicked drollery," in this literary anticipation of cinema's emergence, where the grand historical promises of the moving image enthrall the subject with a phantasmagoria that would seem to blur the distinction between the scientific and the fantastic? It is worth noting that this is also precisely the capacity in which Topsy appears in Porter's 1903 film, in which some two and a half minutes of the nearly twelve-minute film are taken up by the minstrel dancing of blackface slaves.[212] For Doane, Topsy's appearance in Matthews's gothic story bespeaks a literary reinscription of "recognizable tropes of orientalism, racism, and imperialism essential to the nineteenth-century colonialist imperative to conquer other times, other spaces. . . . These are the recorded times, the other temporalities, that allow the protagonist to disavow, for a while, his own temporality of clattering trains and clanging cable cars."[213]

Doane rightly observes that orientalist, racist, and imperialist imaginaries provide ample means for the normative subject to displace his or her own alienation through what Srinivas Aravamudan would call "eclectic relativism"[214] and brilliantly discerns the manner in which the rhetorical valences of Matthews's story "echo . . . that which accompanied the reception of early cinema" in its preoccupation with the possibilities and problematics this medium posed for "the representability of time."[215] Nevertheless, I would suggest that Topsy's appearance cannot be reduced to a supplementary spatiotemporal conquest or flight. For the temporality affixed to Topsy's animated skin is neither the enduring stasis ascribed to the orient,[216] nor the prehistoric quietus ascribed to the indigenous.[217] As we have previously noted by way of Hegel's insistence, the African, the black, is utterly bereft of history. Blackness marks the derelict anterior of historicity, a singular, constitutive negation which, apropos Lindon Barrett, "organizes the linear

progression of historical temporality." The existence which Topsy's dissimulative figure simultaneously mimics, bears, and obscures emerges from a *"temporality without duration"* that Calvin Warren terms *"black time."*[218] Differentially extending Doane's inimitable intervention, I want to argue that Topsy's appearance evinces an unconscious knowledge of black feminine vestibularity to the fraught, contradictory valences of modernity's historical spatiotemporality as it is advanced, consolidated, and solipsistically projected and reflected in this proto-cinematic literary imagination.

Topsy formal appearance in Matthews's proto-cinematic literary text marks an unconscious knowledge of black mediality in at least two respects: firstly, the reader's visual-textual recollection of the "wild, fantastic" rhythm and "odd guttural sounds which distinguish the native music of . . . [Topsy's] race" bespeaks more than a familiar racial exoticism by which the protagonist (and reader, by proxy) might briefly find reprieve from the temporal vicissitudes and enclosure of modernity. While the fungibility of the slave certainly lends itself to all manner of libidinal excitation and exotic fantasy, with respect to time, I would suggest that Topsy's primordial dancing primarily signals the spatial (dis)location of the black (feminine) before the scene of nature and thus beyond the geographic bounds of the social, which corresponds to a constitutive a(nte)temporality: the black time that lies before and without history. The Foucauldian analysis of the heterotopic and heterochronic falters in the face of the antetopic and antechronic.[219]

Secondly, the reader's visual-textual recollection of Topsy's animatedness marks the dissimulative appearance of the fleshly (im)mediation that enables the fantasy of the subject's mastery over time, whether that mastery is expressed as the historical will to brave the contingent (and thus the making of history) or the scientific will to abstraction and rationalization (and thus the recording of history). That is, the dancing commodity[220] (whose disfigured speech Marx required but could not imagine),[221] the an-originary mediality which occasions the modern "extensions of Man," is made to bear the stilling of movement and the movement in stillness that accomplishes the synthesis of "time and space *as animation* in a completely new 'cinematic' mode."[222] In short, Topsy's appearance is not incidental but rather a dissimulative figure who in this instance comes to obliquely mark the fleshly (im)mediation which is anterior to the cinematic and its technologies of worlding.

In Ligon's *The Death of Tom*, Topsy's trace can be discerned neither in the figurative nor its absence; rather, she manifests as the artwork's haptic suffusion with a hauntology of the flesh, an antephenomenological feel that finds expression in the shudder of what Kathleen Stewart would call "atmospheric attunement."[223] She is the ungovernable materiality of the glitch which subtends the warble of grayscale, the wild dance of opacity beneath the figments of harrowing darkness, gaunt shadow, incandescent light. The "negro girl meagre" who makes and breaks the ledger,[224] she is everywhere and nowhere, the exorbitance which remains before every calculus. Yet she is equally the anorigin of every experimental flight from the (cinematic) worlding which requires the serial nonevent of Tom's death, the perpetual corpsing which draws the proscenium's heavy curtains. The meagre must come before the minor as surely as the major.[225] In fact, in *The Death of Tom*, Topsy's trace is perhaps even more immediately palpable as the anterior remains of a singularly black tradition of improvisation.

Recall that Ligon's installation was ultimately (in)completed by the improvisatory accompaniment of jazz pianist Jason Moran, who "played to the shadows." Significantly, Moran chose Bert Williams's signature vaudeville song "Nobody" to occasion his improvisation. As Louis Chude-Sokei observes, "It is no mere coincidence that Bert Williams's most well-known song, first performed in 1905, was the great paean to self-negation 'Nobody.'" Williams's "black-on-black minstrelsy" was a mode of performance that doubled down on the imposition of 'bodily' dissimulation, a fabrication of stage presence in, through, and as "hyperbolic absence."[226] Moran's choice to riff off of Williams's "Nobody" redoubles Uncle Tom's present absence and absent presence in the film. Furthermore, it alludes to the ways in which the ongoing nonevent of Tom's death perennially reiterates the marking of a body and personhood which is not, a no-body who stands only "before the horizon of death."[227] But beneath these thematic associations, there is an unstated formal question, which is serially and differentially rehearsed as a mode of experimentation across the black diaspora: whence a song that is sung by no-body, a music that comes from nowhere? That is, black improvisation is always already an anticipatory response to a question with no answer, a question of origins.

There is a moment in Stowe's novel that has become subsequently imbricated in black vernacular traditions as a trope for signifyin(g). Miss Ophelia

is interrogating Topsy about her origins, a rhetorical exercise in which humiliation is staged in the trappings of a question:

> "Who was your mother?"
> "Never had none!" said the child, with another grin.
> "Never had any mother? What do you mean? Where were you born?"
> "Never was born!" persisted Topsy, with another grin, that looked so goblin-like, that, if Miss Ophelia had been at all nervous, she might have fancied that she had got hold of some sooty gnome from the land of Diablerie. . . .
> "Have you ever heard anything about God, Topsy?"
> The child looked bewildered, but grinned as usual.
> "Do you know who made you?"
> "Nobody, as I knows on," said the child, with a short laugh.
> The idea appeared to amuse her considerably; for her eyes twinkled, and she added, "I spect I grow'd. Don't think nobody never made me."[228]

Taking the race-reproduction nexus as its central thematic—albeit while displacing the onto-epistemological significance of this nexus onto Topsy's moral and spiritual debasement—this well-known passage, in its synthesis of melodrama and minstrelsy, underlines the singular black displacement from origin that recursively discloses the general displacement of origin that Derrida would alert us to.[229] Moreover, the black mother, whose "only claim . . . [is] to transfer her dispossession to the child," is perpetually forced to become the medium of this "originary displacement."[230] Black music, as thinkers such as Fred Moten and Nathaniel Mackey have suggested, serially returns to this anoriginary displacement as a site of departure, of flight in and as a broken refrain.[231] Perhaps James Weldon Johnson had an affinitive thought in mind when he famously invoked Topsy, this dissimulative form without origin, as an analogue for black music: "The earliest Ragtime songs, like Topsy, 'jes' grew.' . . . The tune was irresistible, and belonged to nobody."[232] In other words, the conscription of black feminine mediality remains before not only the cinematic and its technologies of worlding but also those myriad improvisational flights from the world, which are animated by the harrowing tremolo of black femininity's lyrical surplus.[233] But the black residuum is a decidedly antelyrical materiality: an obstinate wrench(ing) within the machinery of reproduction, an aporetic remainder that cleaves to, even as it is cleaved from, the serially forced labor of making and breaking from the world.

Five

Unworlding, or the Involution of Value

One falls past the lip of some black unknown, where time, they say, ends.
—Dawn Lundy Martin[1]

Anteaesthetics has endeavored to theorize the black anterior of the aesthetic in all of its horror, beauty, and racially gendered dimensionality. As we have seen, the aesthetic is neither innocent nor incidental, neither epiphenomenal nor emancipatory, but rather a material-discursive field of violent operations which are structurally devoted to suturing the dehiscence immanent to modernity's genocidal metaphysics. The enduring captivity and conscription of the black feminine, the fleshly nexus of raciality and reproduction, bears the aesthesis of a black existence that is made to come before the antiblack world. This aesthesis, at once foundational to and irreconcilable with the world, is an aesthesis which must be serially and diffusively expropriated and displaced. Yet every displacement necessarily returns its black residuum, which remains before the spatiotemporal moment of rend(er)ing representation from flesh. Every suture inadvertently bears its own dehiscence. We have traced the aporetic expressions of this cut—between modernity and its anterior, between black existence as nonbeing and the phenomenological dissimulations of blackness—through the corporeal division of the world and the making of medium and form. We have attended to anteaesthetic practices which recursively deconstruct their own conditions of (im) possibility and the terrible instrumentalizations to which they are inevitably subject. In this final chapter, we scale our attention to or attend to the scale of what would appear to be the most ambitious register of the aesthetic

imagination but which is, in fact, a metaphysical conceit woven through every instance of phenomenological appearance: that of *the world*.

In recent years, we have witnessed a conspicuous turn to the world not only as an object of and for critique but as a conceptual idiom for advancing both affirmative utopianisms and expanded frameworks for agential activities and entanglements. Worlding, otherworlding, reworlding, and counterworlding are each prominent examples of this terminological and conceptual turn toward and, in some instances, ostensibly against or beyond the world. But what exactly is the world? Is it reducible to the political economic entanglements wrought by the *longue durée* of capitalist globalization, which three decades ago was said to have reached its apotheosis in the end of history?[2] Is the world a solitary configuration? Or is it one world among many, a hegemony which over-represents itself as if there were no alternative? Is another world or are other worlds possible, as formal and informal coalitions of activists and scholars have rhetorically insisted since the triumph of neoliberalism, as if in anticipatory refusal of history's obituary?

In posing these questions, I am less interested in inquiries and interventions that treat the world as ontologically axiomatic, as little more than an analytic scale that corresponds to some duration and spatial delimitation of significant socio-historical connectivity than I am in those which take up the world as an ontological, phenomenological, or metaphysical question or activity. In many recent scholarly tracts, the semantic pivot from world as noun to world as verb—from *world* to *worlding*—signals both an intellectual interest in the world as a site of (re)production and a libidinal investment in the world as a site for praxis. For Aihwa Ong, for example, "worlding" is a heuristic that affords a radical attunement to "situated everyday practices . . . that creatively imagine and shape alternative social visions and configurations. . . . Worlding practices are constitutive, spatializing, and signifying gestures that variously conjure up worlds beyond current conditions of . . . living."[3] Others invoke the language of reworlding, otherworlding, or counterworlding as an explicit refusal of the territorializations of the given and as an affirmative ontological and/or phenomenological registration of resistant and fugitive praxes. As Ashon Crawley puts it, the affirmative enunciation and analysis of "otherwise worlds . . . is a creative critique of the one(s) in which we exist."[4] Indeed, in earlier writing, I too have invoked the language of "otherworlding."[5] Ultimately, however, my encounter with the theoretical

wager that *Anteaesthetics* exhibits and exposits has left me unable to stake a claim upon a world, given or otherwise. Transfixed by the question of the world's anterior—the black aesthesis every world(ing) endeavors to expropriatively displace—I have been successively returned to the ulterior force of unworlding, which this chapter will argue comes before every worlding.

However discomfiting its genealogy and no matter how fervently this genealogy is disavowed, every valorization of world and worlding is implicated in Martin Heidegger's thought and legacy. For Heidegger, "the worlding of world," or the *"world-forming"* imperative of Dasein, is the very essence of being, in and for the world.[6] How, then, do we conceptualize the worlding of world from the vantage of the black, who, as Calvin Warren contends, "is *worldless* . . . bordering[, in Heidegger's schema,] on something between the worldlessness of the object and the world poorness of the animal"?[7] Or within the theoretical parlance of *Anteaesthetics*, how do we think with the black anterior which is the condition of (im)possibility for (the worlding of) the world and yet which cannot claim any form of being-in-the-world?

The final chapter of *Anteaesthetics* argues for the ulterior force of unworlding as a racially gendered emergence or submergence that is not only at once anterior and antithetical to worlding but moreover an exorbitance that is both given to and withheld from fugitivity. I approach this argument by way of two consecutive and conjunctive digital art installations by Sondra Perry, *Typhoon coming on* (2018) and *Flesh Wall* (2016–2020), which interrogate the material and semiotic conditions of (im)possibility for the world, as well as the world's inextricability from the metaphysics of value and the value of metaphysics. The first part of the chapter reads *Typhoon coming on* for its deconstruction of the metrics and imperatives of value through its recursive descent into the enfleshed existence of blackness, which I argue constitutes value's anoriginary condition of (im)possibility. The second part of the chapter takes up architecture as a technology of worlding. Turning to *Flesh Wall*, I argue that Perry's work recursively discloses the racial genealogy of architectural forms and the worldings they both exhibit and execute. Moreover, *Flesh Wall* constitutes an anteaesthetic inquiry into and extension of the dehiscent anterior of Merleau-Ponty's conception of the "flesh of the world." In short, this closing chapter attunes to the unworlding which remains before the flesh of the world and its concomitant law of value.

On One Side Waters Rise

Look what I am holding! Not desire, but infinite multiplicity,
the mouth of existence. On one side waters rise.
—Dawn Lundy Martin, "Faith is hum—"[8]

As it was first exhibited in 2018 at the Serpentine Galleries in London, Sondra Perry's *Typhoon coming on* was organized around the contrapuntal entanglement of two animated seascapes, whose yawning undulations are disjunctively splayed across the gallery's perimeter. Each of the two seascapes has been animated using the Ocean Modifier tool in the open-source 3D-graphics software called Blender, their single-channel digital video then projected in series onto the gallery walls. On the outer walls of the gallery, their interchanging aquatics span eleven projectors, their immense dimensionality giving the winding corridors a vertiginous quality. The first seascape (figure 29) is a ceaseless churning of prince purple—teeming, pulling, overturning—that relentless oceanic movement of enfolding that the aesthetic would seek to place under the disciplinary rubric of the sublime.[9] The prince purple of this seascape is drawn from the coloration of Blender's "missing texture" warning, its visual signal indicating that some kind of material or data seems to be lost or absent. The second seascape (figure 28) is derived from a high resolution scan of a fragment of J. M. W. Turner's infamous 1840 oil painting *The Slave Ship* (originally titled *Slavers Throwing Overboard the Dead and Dying—Typhoon Coming On*)—specifically, a portion of the canvas in which the sea offers up no visual trace of the slaves it has swallowed (figure 27)—which Perry has animated using the same Ocean Modifier tool in Blender. Both seascapes are coupled to a harrowing soundscape whose low, roiling synth tones are overlain with an irregular chorus of indeterminate sounds, alternately resembling chant, wailing, rattling, and whimpering.

The Turner painting, of course, occupies a conspicuous place in the vexed meeting grounds of the history of art and the history of transatlantic slavery. Often regarded as Turner's masterwork, an epitome of the English School and a signal work of English Romanticism, the exhibition of Turner's painting was timed to coincide with the World Anti-Slavery Convention of 1840. As Albert Boime notes, although the painting depicts "chains and shackles [that] miraculous[ly] hover above the water's surface like grave markers to

Figure 27. Joseph Mallord William Turner, English, 1775–1851, *Slave Ship (Slavers Throwing Overboard the Dead and Dying, Typhoon Coming On)*, detail, 1840, oil on canvas, 90.8 × 122.6 cm (35¾ × 48¾ in.). Museum of Fine Arts, Boston, Henry Lillie Pierce Fund, 99.22. Photograph © 2023, Museum of Fine Arts, Boston. Reprinted with permission.

Figure 28. Sondra Perry, installation view, *Typhoon coming on*, Serpentine Sackler Gallery, London (6 March–20 May 2018). Courtesy of the artist and Bridget Donahue, NYC.

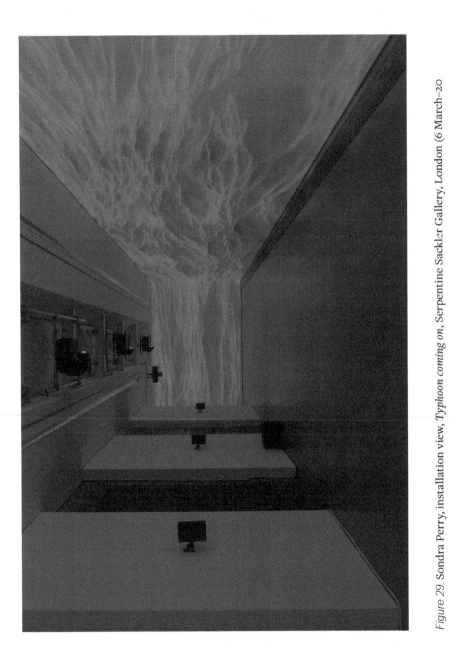

Figure 29. Sondra Perry, installation view, *Typhoon coming on*, Serpentine Sackler Gallery, London (6 March–20 May 2018). Courtesy of the artist and Bridget Donahue, NYC.

signal this perverse burial at sea," the only visible figurative evidence of the brutality described by the painting's title is "the isolated human fragment of the enchained upended leg at the lower right [which] hints at the sadism of the event."[10] More precisely, the only figural appearance is that of the black bodily fragment, which, as I argued in chapter 2, becomes an aesthetic vehicle for the metonymic rend(er)ing of flesh. This is a matter to which we will return. For now, let us note that Turner nevertheless unequivocally signaled the abolitionist sentiment undergirding the painting by pairing it with this excerpt from his unfinished and unpublished long poem "Fallacies of Hope" (1812):

> Aloft all hands, strike the top-masts and belay;
> Yon angry setting sun and fierce-edged clouds
> Declare the Typhon's coming.
> Before it sweeps your deck throw overboard
> The dead and the dying—Ne'er heed their chains
> Hope, Hope, fallacious Hope!
> Where is thy market now?[11]

Although the painting has since become revered "as an enduring expression of the very essence of English civilisation" and more generally as a magnificent aesthetic testament to the progressive arc of Western modernity, its initial reception was in no small part overtly hostile.[12] Moreover, as Paul Gilroy emphasizes, *The Slave Ship*'s most prominent champion, John Ruskin, who celebrated the work as "the noblest sea that Turner has ever painted" and, even further, "the noblest certainly ever painted by man," was careful to excise the question of race from his commentary on the painting's sublime qualities.[13] The horrors of slavery are displaced onto "the guilty ship," so that the sublimity of the seascape may be retained.[14] Turner's scene of agonistic majesty, crossed by this anonymous ship, "girded with condemnation,"[15] paradoxically functions as the principal medium for both the representational encounter with and eclipse of that which is widely recognized as its discrete historical referent: the *Zong* massacre of 1781.[16]

The story of the *Zong* holds a prominent place in the archives of abolitionism and continues to command the returned attention of contemporary black study and poetics. Having filled its hold with captive Africans, the slave

ship called the *Zong* set sail for Jamaica from West Africa in August 1781. Although built to "accommodate" 220 enslaved Africans, the *Zong* set sail with at least twice that many. After navigational errors caused it to overshoot its destination, the *Zong* was gradually beset by shortages of food and water. Because, of course, the enslaved Africans would be the first to be sacrificed, the crew of the *Zong* was faced with the prospect of losing their valuable cargo, who were not insured in the event of death from "natural" causes. In keeping with a calculus of their own making, the crew opted to throw at least 132 enslaved Africans overboard into the gaping abyss in the hope that the insurer would recoup their financial losses. The resultant 1783 litigation between the owners of the ship and the underwriters of the insurance, *Gregson vs. Gilbert*, would bring the massacre into the public eye, and it remains the only concrete archive of the genocidal mathematics that consigned so many to a "liquid grave."[17]

Sondra Perry's anteaesthetic engagement with the *Zong* massacre (by way of Turner's celebrated depiction) is significant for a number of reasons. This notorious history of "the calculated killing of Africans at sea"[18] horrifically discloses the constitutive imbrications of the (im)mediations of the flesh, the abstractions of property, and the law of value in and as worlding. Yet it would be a mistake to call the *Zong* massacre a historic event, for it lacks the metaphysical ballast that directs the event toward historicity's horizon, a fact perhaps alluded to in Perry's choice to decapitalize the "coming on" transposed from the title of Turner's work. The maelstrom is already here, heaving in the thick time that blurs the difference between wading and waiting.[19] The horror of the *Zong* is the noneventual abyss of history's anterior, modernity's paradigmatic propulsion and impediment. As Ian Baucom has argued, "The case of the *Zong* can be seen to exemplify the advent and triumph of an abstract, speculative, hypercapitalized modernity."[20] Nevertheless its import is not simply politico-economic. In Baucom's view, "we must come to terms with the ways in which the *Zong* engages not only the histories of property, value, and capital but how, by engaging these, it also engages and haunts the ontological, phenomenological, and epistemological histories of 'its' moment."[21] My use of the phrase "the law of value" is a vulgarization of the Marxian lexicon, which asserts that under the capitalist mode of production, the irreducibly qualitative dimensions of use-value are superseded by the quantitative directive of exchange-value. Capital is

compelled to relentlessly pursue the accumulation of surplus-value through the extraction of surplus-labor from the abstract labor congealed in the fetishized commodity.[22] As numerous black critical theorists have suggested, from a diverse range of methodological vantages, the cataclysm of transatlantic slavery marks the condition of possibility for the emergence and consolidation of capitalist modernity, the human subject, and the relays of material-discursive exchange that sustain the accumulation of capital and the fabrication of civil society. The enslaved Africans who were "taken into account *as quantities*"[23] mark the apotheosis of and the aporia within the commodity form.

However, my invocation of the law of value suggests that the predatory abstractions of capital may be regarded as simply one moment within the more general operation of the "calculative thinking" that Heidegger critiqued, even as his refusal to think the antiblackness of metaphysics ultimately reinscribes it.[24] Taking seriously Alain Badiou's assertion that "mathematics is ontology,"[25] Calvin Warren argues that the "metaphysical '1,' which can be infinitely multiplied and added . . . [emerges from] the mathematics of humanism," which can establish its coherence only through the arithmetic reconciliation furnished by the black, who is made to bear the nothingness that is the terror of metaphysics.[26] This apocryphal rapprochement is achieved, in Warren's view, through the perpetual imposition of what Katherine McKittrick terms "the mathematics of the unliving"[27]—the brutal operation of calculative abstraction that subtends not only the ledger of the slave ship and the exchange-values assigned to its (un)living cargo but also every subsequent taxonomic effort to take blackness into account. For Warren, the (e)numerations of calculative thinking constitute "a strategy for imposing nothing onto blacks," to give form to the formless, to "provide space to black being without an ontological place."[28] Thus, I would suggest that we can only speak of blackness as "an ontological zero"[29] insofar as we understand this to be the dissimulative appearance of blackness. For even as zero's etymological roots in the Hindu word for "void" (*sunya*) signal that which it seeks to contain, zero is nevertheless a number and thus a form. More specifically, zero is a "meta-sign" which is the enabling closure of a (racial) semiotics and which conjures the "meta-subject" (the "counting subject") required for its recognition.[30] In contradistinction to its dissimulative appearance, the enfleshed existence of blackness is, as Denise Ferreira da Silva suggests,

"content without form"[31] or in the theoretical wager advanced in *Anteaes-thetics*, that which cuts the difference between form and content. Hence the paradox of every (e)numeration of blackness: the dissimulative appearance of the blackness, which is at once brutally valued and valueless, is also tethered to the exorbitance of its own fleshly reproduction. Taken in disjunctive concert, the anoriginary vestibule for the law of value also bears an irreducibility that valuation cannot abide.

Typhoon coming on recursively discloses the expropriative displacement of this exorbitance—as the condition of (im)possibility not only for the "propertied abstractions" of racial capitalism[32] but for the phenomenological experience, ontological calculus, and aesthetic judgment which undergird every worlding of the world. In reading for Perry's deconstruction of the rend(er)ing of the world from flesh, I am guided by Seb Franklin's astute interpretation of the connections these two seascapes "make between digitality, value, and racialized violence,"[33] even as the theoretical investments and conclusions of our respective inquiries diverge in key respects. In Franklin's view, the projected seascape Perry has generated from a figureless fragment of Turner's ocean serves to reflexively implicate the spectator. Specifically, the spectator is confronted with their own apparent immersion in the racial cataclysm which subtends and yet is displaced from both phenomenological experience and the computational inflections of that experience's ontological prerequisite: individuated personhood. As Franklin elaborates, by rendering Turner's oceanic fragment as immersive seascape, "Perry extends and intensifies his spatialized emplotment of the spectator in the afterlife of the Middle Passage. And by removing the ship, the manacled, drowning bodies, the fish and birds, the sky and sun, and the distant storm, she underscores the structural separation of modern, computational forms of personhood and finance from the direct racialized violence that birthed them and that continues to modulate them."[34]

The conspicuous absenting of the figural signs of this irreducible scene of violence ("the ship, the manacled, drowning bodies . . . the distant storm") impresses upon the spectator the material and discursive conjoinment of expropriation and displacement at the scene of modernity's genesis: the immeasurable usurpations of life and labor upon which slavery's constitutive role in the making of modernity was predicated. More pointedly, the spectator is faced with the manner in which these expropriative displacements sus-

tain the coordinations and cohesion of the phenomenological relay between (body-)subject, object, and world. And yet what is displaced is not simply the racial violence that might be variously (and insufficiently) (e)numerated— the number of 'bodies' (de)valued in the ledger or drowned in the sea, the suffocating dimensions of the hold, the calculus that determined who was to live and how many were to die—but crucially, an exorbitance that signals the immanent failure of the reduction that Franklin keenly identifies as the prerequisite of both computation and commodification (or commodification as computation). This is an exorbitance that cannot be accounted for by the law of value, an exorbitance the enfleshed existence of blackness is made to bear.

Although the typical (non-black) spectators who encounter *Typhoon coming on* almost certainly enclose their dubiously conceptual, if libidinally potent sense of their own implicacy in the scene of violence by recourse to the ruse of empathetic identification with black suffering, their unconscious nevertheless retains the repressed knowledge that they are witnessing the dissimulation of an anoriginary (un)worlding. The installation of *Typhoon coming on* along the perimeter of the gallery functions to enwrap or enclose the space in a manner mimetic of the totalizing ambitions of the world. It is in this sense, as the next section of the chapter makes clear, a critically reflexive exhibition of a properly architectural formation. I contend that the operation of enclosure *Typhoon coming on* recursively deconstructs is inherent to the twinned projects of worlding and formalization. Indeed, what is a world if not the most grandiose instantiation of form? Grappling with this knowledge requires a further clarification of these unsettlingly affixed terms: *worlding* and *unworlding*.

As it is conventionally deployed in critical academic parlance, *worlding* would seem to denote an immanent generativity which nevertheless miraculously grants the spatiotemporal conditions for a stable inhabitation, an ontological ground and phenomenological experience through which a singularity of being unfolds. Whether or not Heidegger is explicitly invoked in this critical discourse, the common sense by which it is marked bears the unmistakable imprint of his philosophical legacy. Too often, such scholarship implicitly imbues the concept of worlding with an intrinsic aesthetic alterity, seemingly forgetting Gayatri Spivak's "vulgarization" of Heidegger's concept in her suggestion that "the 'worlding of a world' [unfolds] upon what must be assumed to be uninscribed earth" and is thus analogous to the car-

tographic drive of the "imperialist project."[35] However, in his rigorous and faithful exposition of Heideggerian worlding, Pheng Cheah argues that Spivak's "analogy obscures what is truly valuable about Heidegger's concept," noting that "for Heidegger, a world is precisely what cannot be represented on a map."[36] Worlding, Cheah contends, "is not a cartographical process that epistemologically constructs the world by means of discursive representations but a process of temporalization."[37] Whereas "cartography reduces the world to a spatial object, . . . worlding is a force that subtends and exceeds all human calculations that reduce the world as temporal structure to the sum of objects in space."[38] Worlding in Cheah's view is prior to and in excess of the human subject.[39] In contradistinction, unworlding for Heidegger and Cheah who reads him consists of the reduction of the world's irreducibility to the spatial, the schematic, the calculable and thus entails the "ruin and destruction" of the world and its capacious embrace of being's potentialities.[40] *Anteaesthetics* dissents from the entwined Heideggerian articulations of worlding and unworlding.

Although I am unconcerned with whether the theoretical vocabulary of *Anteaesthetics* is faithful to Heidegger's philosophical lexicon, I would nevertheless suggest that Cheah's defense of Heideggerian worlding through the contradistinction of temporalization and spatialization, the incalculable and calculation in fact elides the racial-colonial entanglement of these putatively opposed registers. Cheah admits that "worlding is a 'normative force' because it gives rise to the totality of meaningful relations that is the ontological condition for the production of norms and values" but argues that it stands in sharp contradistinction to teleology, for the temporalization by which worlding is marked "constitutes the openness of a world, the opening that is world, . . . [a] unifying power . . . that brings all beings into relation."[41] Yet Cheah's insistence that worlding is neither cartographic nor calculative nor teleological is predicated upon an uninterrogated humanism. Within critical theory, the co-productions of blackness and animality which subtend Heidegger's notorious taxonomification—"the stone (material object) is worldless, . . . the animal is poor in world, . . . [while only] man is world-forming"[42]—are by now familiar: the black, figuratively consigned to the scene of nature and as the constitutive negation of historicity, constitutes "the *metaphysical* antecedent of Heidegger's *the* animal," as well as of the "animacy hierarchy" that would render the stone an exemplar of inert,

degraded matter.[43] *Pace* Cheah, Heidegger's worlding of the world is indeed teleological insofar as being-in-the-world, or Dasein's worldliness, is predicated upon a metaphysical calculus that anticipates the human subject who would claim the world as his rightful ontological inheritance, the human being whose emergence is predicated upon black nonbeing. In this respect, the calculative thinking evinced in the spatialization of the world as cartography is no less operative in the temporalization of worlding that would bequeath an unbounded horizon to the ontologically bounded and cohesive subject.

In my argument, the being which is ostensibly secured for the subject through the constitutive expulsion and fleshly (im)mediations of blackness unfolds with and through various temporalizations which are simultaneously cartographic, even if this subject would disavow the metaphysical map by which he or she orients. Let us recall that the temporal inauguration of Hegel's philosophy of history through the anoriginary displacement of Africa remains tethered to the spatial constitution of the boundaries of the social through the perpetual relegation of the black to the scene of nature. In the context of Perry's work, this immanent entwinement of spatialization and temporalization can be discerned in the conjoined and internally disjunctive figures of the ship and the sea. Poised at the very emergence of the modern world, the ship is not only the vehicle for the increasingly dense networks for commodity exchange, discursive transmission, ecological appropriation, and the imperial cartographies upon which they depend[44] but is also among modernity's paradigmatic figurations of historicity itself. The ship evinces modernity's apprentice*ship*, its steward*ship*, entrepreneur*ship*, and even brinkman*ship*. Moreover, the ship is a material and discursive vessel of and for "value in motion," as Marx would have it.[45] Within much of the Western aesthetic and philosophical tradition, the ship and its traversal of the sea immediately evoke "the adventures and dangers" of the modern,[46] wherein the promises and perils of the oceanic journey are always already bound to the romance of the horizon.[47] Foucault, for instance, maintains that the ship is not only modernity's "great instrument of economic development . . . but . . . the greatest reserve of the imagination. The ship is the heterotopia par excellence. In civilizations without boats, dreams dry up."[48] Concordantly, for Hegel, "the sea gives us the idea of the indefinite, the unlimited, and infinite; and in *feeling his own Infinite* in that Infinite, man is stimulated and embold-

ened to stretch beyond the limited: the sea invites man to conquest."[49] The potency of time and multiplicity of space unfolds as being's potentiality but only insofar as the infinite can be mastered, conquered by man's cartographic capacity and indefatigable will.

The aesthetico-philosophical conflation of the ship with the horizon of historicity is, of course, utterly irreconcilable with the hold of the (slave) ship, wherein African captives were confronted with an absolute confinement to entanglement's terrible infinitude, at once suspended in "the stillness of time and space" and perpetually falling through an abyss that was "nowhere at all."[50] Before the finitude of Western man and the infinitude he would claim as his own lies the hold, the world's perennial dumping ground for and reservoir of exorbitance—the dispossessive existence of the shipped which is anterior to the ship, its captain, and its crew. As Dionne Brand remarks, "One is mislead when one looks at the sails and majesty of tall ships instead of their cargo."[51] This figurative disjunction within the ship is redoubled between the ship and the sea. From the commanding heights of the ship, the sea may be sacralized as the "oceanic sublime" and seized as *mare nullius*, a terraqueous territorial expanse to be brought to heel before the cartographic will of the subject.[52] But from the vantage of the shipped, the sea is in the first and final instance an encounter with the abyss, that trebled descent Édouard Glissant described as a "debasement more eternal than apocalypse."[53] There is an irreconcilable distinction, in other words, between the horizonality of voyage and the vertiginousness of passage. A recognition of this distinction would seem to be implicit in Perry's suggestion of the metaphorical significance of her use of Blender's Ocean Modifier tool, as the "ocean-as-modifier in the African diaspora . . . [is] the thing that changed, or flipped everything over."[54] The oceanic, in the context of Perry's work, does not evoke a romantic imagination of the infinite which beckons with untold and heretofore unclaimed possibilities as an exhilarating expanse awaiting traversion but as the terribly beautiful immediacy of difference without separation or "tidalectic diffractions."[55] The disjunctively entangled figurations of the ship within modernity's aesthetic regime are the site of a profound dehiscence (the trace of which can be etymologically glimpsed, albeit anachronistically, in *ship*'s Proto-Indo-European root "skei-," meaning "to cut, split.")[56]

The metaphysical schism within the slave ship painfully exhibits the conceptual distinction between worlding and unworlding, featured at this chap-

ter's closing. While various utopianisms may mobilize the gerund in *worlding* toward a philosophical or political celebration of immanence, the pivot from *world* to *worlding* ultimately conceals an aspiration for transcendence from the radical indeterminacy by which the enfleshed existence of blackness is determinatively marked. Thus, such utopianisms cannot help but reproduce antiblack metaphysics and its genocidal hold(ings). In this respect, I agree with Lauren Berlant and Kathleen Stewart that even at its most emergent, "[a] worlding is an imperial promise of a form barely roughed out and still charged with its own retractability," even if I cannot join them in their propositional/proprietary claim that "we need the weight of the world we fear."[57] The temporalization of being is intrinsically conjoined to the expropriative displacements of ontology. Every worlding presupposes the world which confronts the black as the catastrophe of metaphysics. Nor can the disaster be circumvented by the slave ship's utopian double, Glissant's "open boat," for not only are the bearings of the black feminine conscripted in and as "the belly of the world" but also, as Fred Moten suggests, "the belly of the open boat."[58] This is the double bind of black feminine reproductivity. Here, at the reproductive nexus wherein the captive maternal is forced to ceaselessly bequeath its own dispossessive force, the distinctions between an interdicted motherhood and interdicted childhood begin to dissolve, conjuring a terrible palindrome one could read by way of Christina Sharpe: "a girl becomes a ship," a ship becomes a girl.[59] Or in the idiom of *Anteaesthetics*: the girl holds the ship that holds the girl.

I must therefore dissent from Zakiyyah Iman Jackson's claim (one which finds differential expressions in a number of fields across the critical humanities) that "diasporic practices of world-making potentially act as a mode of redress for onto-epistemic violence to the extent that said praxes preclude the monopolization of sense that authorizes antiblack (Euro)modernity."[60] As an anteaesthetic approach to Perry's work makes clear, unworlding is the displaced anterior of every worlding, and every worlding requires the conscription of black feminine reproductivity toward the renewal of an antiblack metaphysics. This terrible recursivity cannot be redressed simply through the pluralization of sense. This is because the sensorial existence of blackness, which can find expression only as the dehiscence we have called hapticality, is precisely that which cannot be welcomed into or as a world. The sensorial existence of blackness can appear only as nonsense, for it marks

the fleshly life of an existence without ontology, of an existence ceaselessly conscripted into the (re)making of a world it may never dwell within. But neither can *unworlding*, as I am deploying the term, be valorized as a "disassociative poetics" emerging from "being in life without wanting the world," as the late Lauren Berlant put it, or in a more explicitly volitional register, as a call for a coalitional politics anchored in a commitment to dismantling this world.[61] Unworlding, as I conceive it, is neither a poetic disassociation from worldly inhabitation nor an ostensibly vital political antecedent to the utopianism of otherworlding. Rather, unworlding is the racially gendered anterior to the metaphysics of world(ing) and the modern order of forms—the abyssal anorigination which black femininity is made to bear in and through the flesh. The stakes of an anteaesthetic attunement to this problematic of un/worlding concerns that which recedes from within the cut that the virgule can mark only as a hieroglyph. Simone White might call the hapticality of this recession "the torment of experiencing the fullness of imagination outside form."[62]

The slave ship figures the agonistic entanglement of worlding and unworlding to the point of breach. On the one hand, we have a quintessential figuration of the worlding of the world, in which the temporalization of being is realized through the singular horror of racial calculus. On the other hand, in the hold of the vessel for being's exaltation, we have the (unrepresentable) "objective vertigo" which utterly obliterates the horizonality through which being unfolds.[63] The slave ship incompletely contains the rift within metaphysics. The aesthetic is the means of this containment, even if the anteriority of blackness to the aesthetic creates a predicament in which the means of suturing the racial metaphysics of the world ultimately extends its own incompletion. Perhaps this straining torque of the racial regime of aesthetics is signaled in Turner's painting by what Hito Steyerl observes as a horizon which "is blurred, tilted, and yet not necessarily denied . . . [as if] the downward motion of the sinking slaves affects the point of view of the painter, who tears it away from a position of certitude, and subjects it to gravity and motion and the pull of a bottomless sea."[64]

I would suggest, however, that Perry's work insinuates a far more ambivalent, if not outright pessimistic assessment of the aestheticization of the Middle Passage. Perry's anteaesthetic disclosure of the violence of this aesthetic rend(er)ing becomes most pronounced when her two seascapes

are situated in their disjunctive entanglement. Recall that the roiling prince purple of the first of Perry's seascapes is derived from the coloration of Blender's "missing texture" warning, which visually signals lost or absent material or data. As Franklin suggests, when this seascape is situated in its contrapuntal arrangement with the seascape generated from the figureless fragment of Turner's ocean, these seascapes together stage "the loss inherent to abstraction, the exclusions that always occur when a concrete thing is computed . . . [making] visible the reduction that occurs every time a body or thing is computed as a commodity, every time a box is computed as a byte, and every time labor power is computed as socially necessary labor time."[65] Furthermore, "it shows how this reduction is a precondition for the manipulability—or fungibility—of the now digitized object, which can be edited, composited, and animated precisely because it has first been rendered numerically, just as the fungibility that adheres to chattel slaves, as commodities and as the basis of financial speculation, relies on their prior rendering as exchange value."[66]

Perry's prince purple seascape derived from Blender's "missing texture" warning signals the exorbitant anterior of the expropriative displacements of phenomenology, ontology, and the law of value. As Franklin stresses, "In the ontology of the model, if it is not generated in the software," which is to say reduced to the computational, "*it does not exist.*"[67] Hence, "by saturating the modeled waves with the color of the missing texture warning, Perry deploys Blender's operational grammar to make legible the value-informatic processes of dispossession, differential integration, and the intermittent allocation of prospects."[68] The spectator is left haunted by a question which, in its unanswerability, disturbs the phenomenological relay upon which their spectatorship implicitly rests: What exactly is this thing that has "gone missing," and what does it mean for "us"?

Franklin insightfully homes in on Perry's interrogation of the relationships between racial abstraction and the ontological and representational horizons dictated by the law of value and comes quite close to what I have been theorizing as the dissimulation rend(er)ed from flesh. As outlined in chapter 1, my theorization of rend(er)ing underscores the doubleness and recursivity of this excisive and projective operation. Perry's sequence of contrapuntal seascapes discloses the dissimulative rend(er)ing of flesh which makes possible the aestheticization of the Middle Passage and the

spectator's phenomenological encounter with that representation. Perry's work tests the limits of the art historical proposition that installation art is principally phenomenological.[69] For here the spectator's phenomenological encounter with the Middle Passage is reflexively disclosed as (predicated upon) the expropriative displacement of an irreducible materiality, the materiality of an existence without ontology, borne precisely by those who are categorically denied the capacity for phenomenological experience. Perry returns an exiled, if indispensable, fleshly exorbitance that offers little comfort to the spectator seeking an immersion-in-common, wherein the certainty of universal access to phenomenological experience might extend the promise of atonement or reparation.

Franklin's reading of Perry's work clarifies the computational operations which render an object phenomenological only through the informatics enabled by ontology (in this instance, the ontic reduction to discrete, quantifiable units, abstracted as exchange-value). I am extending Franklin's insights, arguing that the reductive and racialized operations of abstraction inherent to the law of value have an immanent relation to the expulsive and predatory ambitions of rend(er)ed flesh, of flesh torn asunder. Perry's work discloses flesh as serially and diffusively conscripted into the labor of black mediality. But this expropriation is possible only because dissimulation makes tenable the fantasy of definitively displacing the exorbitance of flesh—as in the singular instance of enslaved Africans who were "taken into account *as quantities.*"[70] Flesh is rendered reducible, reduced so that it might render. In other words, the violent (im)mediations of the flesh are not so much a consequence of the law of value as they are its recursive anterior: value is cleaved from flesh, while flesh is serially cleaved by value.

The connections between black mediality, the rend(er)ing of flesh, and the dissimulative impulse of epidermalization are further accentuated by the exhibition's interior, where "discrete pieces . . . have these tentacles that branch out to the projected waterscape" along the gallery's perimeter.[71] This interior features earlier works by Perry, including *Graft and Ash for a Three-Monitor Workstation* (2016) and *Wet and Wavy Looks—Typhoon coming on* (2016), which take on renewed significance in the context of this new exhibition. Walking through one of these tentacular passages entitled *TK (Suspicious Glorious Absence)*, viewers find themselves enclosed by projected images on either side (see figure 30). One side features a slow-churning an-

imation of a modified extreme close-up image of Perry's own skin, which itself begins to take on the quality of a seascape. Noting the ubiquity of the technique of "warming up" black and brown skin tones during post-production so as to render them "more palatable," Perry states that she "decided to go off the deep end into a kind of consumption, or something that feels like it's burning alive, something that is like this connective tissue that is doing more than the representative work of a being."[72] The other side features the rich nebulousness of chroma key blue, a shade which is deployed in post-production techniques to distinguish the foreground and the background. Because chroma key blues are ostensibly the furthest shades from human skin tone (naturally begging the question of whose skin tone is taken as the reference point for the human), "within video production and post-production, the Chroma Key functions as a blank slate upon which anything can be projected as a backdrop for characters and events to unfold."[73]

Between these two projections stands a single monitor, its screen facing away from Perry's animated skin, which plays repurposed video from her

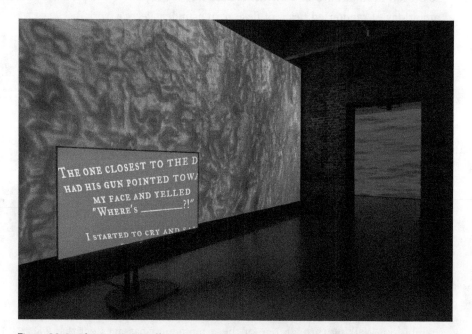

Figure 30. Sondra Perry, installation view, *Typhoon coming on*, Serpentine Sackler Gallery, London (6 March–20 May 2018). Courtesy of the artist and Bridget Donahue, NYC.

Resident Evil (2016) work, a looping assemblage of audio and footage marking the "mediatized documentation of black death and the politics of viewing that structures its circulation and spectatorship"[74]—an audio interview with Ramsey Orta, who filmed the death of his friend Eric Garner at the hands of the NYPD in 2014, that functions as a soundtrack to a chroma key blue screen; audio of Korryn Gaines's narration over Instagram just moments before being murdered by Baltimore police in 2016; footage of the confrontation between Kwame Rose and Fox News host Geraldo Rivera during a protest in Baltimore in the wake of Freddie Gray's funeral. Something more and less than the sum of its parts begins to emerge in this constellation of audiovisualities. Perry deploys her own skin as the site of phantasmagoric descent, an epidermalization bearing more than phenomenology or ontology can hold, a dissimulation veering toward what Amiri Baraka and Theodore A. Harris would call "our flesh of flames."[75] Opposite this projection, rubbing furiously against representation's limit is a negative space that speaks not so much to representation's inverse as to the unrepresentability of the exorbitant materiality representation expropriatively displaces. The (im)mediations of the flesh have gone missing and yet are already here—submerged, summoned, and exiled, animating the looping iterations of picturing catastrophe and the catastrophe of picturing,[76] threatening to set the world on fire.

Although Perry refers to the works included in the tentacular weaves of *Typhoon coming on* as discrete, they in fact approximate something closer to an unwieldy assemblage, an appropriately sprawling kaleidoscopic exhibition, whose variegated contours I have only begun to interpret here. The layered repurposing of prior works and their fragments "in a skein of shards," as Derrida might have said,[77] traces an enduring black tradition of broken seriality.[78] This fact alone should dissuade us from claiming a comprehensive analysis of the exhibition, for such a pretense would not bring us any closer to the antetotality the exhibition recursively discloses and yet cannot represent.

The Last Fortress of Metaphysics

The circle of the law is this: the echo must first be heard for there to be
a limit to what is voiced, but only in silence can I hear it, and so silence it
once more as a wordless moan. What I mean is that I cannot get away from
hearing the sound, the hunt for meaning, even though I refuse to scance
the silent life of the image. . . . As such, the picture has to be inverted, for
it is not so much a present as bearing witness to what is manifest as the
emblem of what it is the warning of. That is one must read it for what it is not.
—D. S. Marriott, "Through a Red Prairie"[79]

Typhoon coming on interrogates the agonistic entanglement of worlding and
unworlding. More precisely, Perry's work interrogates the conditions of (im)
possibility for the ongoing rend(er)ing of world from flesh. *Typhoon coming
on* is a recursive deconstruction of the antehistoric nonevent of the Middle
Passage and the expropriative displacement of this unfinished passage by
the aesthetic. *Flesh Wall* (2016–2020) extends this interrogation from mo-
dernity's "rosy dawn"[80] to an era that appears to many as the fleeting mo-
ments just before the twilight of the world in which a premature elegy for
the horizon seems to announce itself in streaks of blood and fire across the
sky. *Flesh Wall* moves from the anorigin to the architecture of the world at a
moment when the latter creaks and strains under the weight of its own mon-
umentality. Commissioned by Times Square Arts for the Midnight Moment,
which is said to be the largest, longest-running digital art exhibition in the
world, *Flesh Wall* dramatically repurposes the aforementioned animation of
a modified extreme close-up image of Perry's own skin. For the first week of
February in 2021, from 11:57 p.m. to 12:00 a.m. EST, Perry's slow-churning
skinscape was splayed across ninety-two massive digital displays spanning
from 41st to 49th Street (figures 31 and 32). Coursing, swirling, seething
through a fragmented agglomeration of brand names and dancing commod-
ities, the digital luminescence that fails to alleviate the bitter edge of the
empty, snowclad streets, Perry's *Flesh Wall* appears as a grotesque imposi-
tion, as if the eroticized surfaces of the street wall were being flayed, their
forgotten viscera spilling out from an open wound.

The apparently immense transit of Perry's skinscape from one of the
most esteemed art galleries in Europe to the spectacular digital displays of
Times Square—which many critical intellectuals regard as one of the most

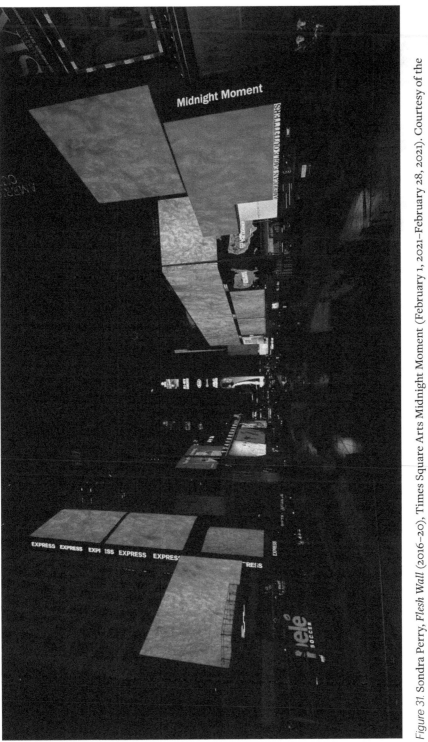

Figure 31. Sondra Perry, *Flesh Wall* (2016–20), Times Square Arts Midnight Moment (February 1, 2021–February 28, 2021). Courtesy of the artist and Bridget Donahue, NYC.

Figure 32. Sondra Perry, *Flesh Wall* (2016–20), Times Square Arts Midnight Moment (February 1, 2021–February 28, 2021). Courtesy of the artist and Bridget Donahue, NYC.

notorious sites of a decades-long battle on the part of state and capitalist agencies to erect the basest iteration of what Mike Davis and Daniel Bertrand Monk call "evil paradises," or the "dreamworlds of neoliberalism"[81]— would seem to beg for an artistic reading that takes up the scholarly debates concerning both site-specificity and public art. As Miwon Kwon elaborates, the discourse of site-specificity "as a peculiar cipher of art and spatial politics" emerges most clearly in the late 1960s and early 1970s as a resistance to the modernist pronouncement of the "autonomous and self-referential, thus transportable, placeless, and nomadic" work of art.[82] Artists began to emphasize "an inextricable, indivisible relationship between the work and its site . . . [which] demanded the physical presence of the viewer for the work's completion."[83] From the vantage of these early experiments in site-specific installations, Times Square would seem a site charged with material and symbolic particularities and eccentricities, carrying profound implications for the aesthetic significance of the work of art therein.

At the outset of his ethnographic study *Money Jungle: Imagining the New Times Square*, Benjamin Chesluk observes that the overlapping, disjunctive, and contested performances and histories of Times Square bequeath a com-

plicated ensemble of images: theatricality and spectacle, the erotics of commerce and commerce in the erotic, housing insecurity and the informal life and labor of the precarious, tourism high and low, queer nightlife, patriotic gathering and political dissent, celebration and debauchery, a place to see and be seen and to revel in the popular transits of the visual through photography, cinema, and, of course, the infamous "supersigns," the electronic billboards which cover so much of the façade of Times Square "proper."[84] In short, since Longacre Square was redeveloped by real estate and entertainment capital in the late nineteenth century, Times Square has been a contradictory hub for economic, discursive, and libidinal exchange, a place that would become a quintessential iteration of Manhattan's privileged figurative status within the American nationalist imaginary, as well as within the globally variegated romanticizations of U.S. empire that accompanied the rise and decline of its hegemony over the course of the twentieth and into the twenty-first centuries.

Times Square functions "as a kind of historical prism" not only for "a changing national culture"[85] but for the tumultuous material, affective, and representational life of urbanity at the heart of imperial ascendancy and decadence. Indeed, one could argue that Times Square sustains some of the foremost spectacularizations of the imperial fabrication of "world-time and world-space,"[86] not least in its annual televised New Year's Eve ball drop, which is ostensibly watched by over 1 billion people around the globe every year. For at least the past three decades, within milieus loosely associated with that stubborn object of optimistic attachment called the left,[87] the prismatic refractions of the image of Times Square have been dominated by the melancholic contradistinction between the "old" Times Square and the "new" Times Square. Although the geographical redevelopment of Times Square has been a perennial feature of its history, since the 1990s, when a conjunctural bloc of state and capitalist agencies began to aggressively advance a project of neoliberal urbanism in Times Square, *redevelopment* became a euphemism not only for the simultaneously anesthetized and eroticized space of capitalist spectacle but for the dispossession of the "criminogenic"[88] populations deemed impediments to the realization of this neoliberal dreamworld.

At first glance, *Flesh Wall* would appear to be an exemplar of site-specificity. The work tailored to the mediatic dimensions and delimitations

of Midnight Moment, with its sprawling array of digital displays, is situated at the crossroads of commodity spectacle and the "ecstatic anonymity to be found amid the teeming crowds."[89] And yet *Flesh Wall* produces a highly specific expression of a skinscape that is inextricable from the anorigination of the commodity form within an irreducibly racial economy of fantasy, desire, and calculation.

At the very least, one could situate *Flesh Wall* within a particular genre of contemporary art which, in Annie Dell'Aria's view, engages the commercium through the "intra-spectacular," an aesthetic for which, she suggests, the Midnight Moment series is exemplary. "Though public art interventions onto the screens of Times Square do not dismantle the advertising landscape—indeed they are embedded within it—these intra-spectacular projects can point to its edges and imagine new uses for its visually enchanting forms."[90] At the same time, *Flesh Wall* could just as easily be read from the vantage of a contemporary "unhinging of site specificity" which marks not so much a return to the ideology of modernism as a set differential artistic responses to processes of "spatial indifferentiation and departicularization—that is, the increasing instances of locational *un*specificity."[91] In this respect, Times Square is specifically unspecific, an advanced stage of the centripetally valorized, aesthetic place(less)ness of the revanchist city.[92] Perry's work deftly exploits the perceived site-specificity of Times Square to disclose a set of operations that, in their absolute generality, constitute the radically unspecific. In particular, by arraying the undulating extreme close-up images of her own skin as continuous with the architectural facades animated by spectacular commodities, Perry deconstructively exhibits the ubiquity of the pornotropic, wherein the scopic violence of dissimulation is inseparable from the violence of fleshly violation. Her "flesh" appears, if only to signal the terrible (im)mediation which undergirds its mis/disappearance.

However, to understand the manner in which *Flesh Wall* discloses the material exorbitance of a black mediality which at once subtends and unsettles every si(gh)ting, every phenomenalization and ontologization of place, we must consider the installation's imbrications with and implications for the telos of architecture. How do we take stock of buildings becoming screens[93] when this becoming is tethered to the skin of blackness, the epidermalization that would seek to rend(er) flesh phenomenologically? In recent years, a number of scholars have begun to interrogate the racial constitution of modern

architecture, a line of critical inquiry hitherto refused by architectural history and theory.[94] As Irene Cheng, Charles L. Davis II, and Mabel O. Wilson explain in their landmark anthology *Race and Modern Architecture: A Critical History from the Enlightenment to the Present*, "Modern architecture entailed spatial practices like classifying, mapping, planning, and building that were integral [both] to the erection of . . . racialized epistemology and to the development of European colonialism and capitalism."[95] Moreover, architecture, as a uniquely structured "inhabitation of the world,"[96] presumed the nominally universal but in fact severely exclusive body-subject and phenomenological experience which were coextensive with the transcendental aesthetic.

Like the modern Western arts and emergent art history with which it was entwined, modern architecture was deeply influenced by the developments of race science over the nineteenth century, evinced by typologies of dwelling that clearly differentiated, for example, the figure of the African, who constructed and lived in "primitive huts," from that of the Germanic and Anglo-Saxon peoples, who could lay claim to an innate capacity for the properly aesthetico-scientific practice known as architecture.[97] In short, the corporeal division of the world figured heavily in the aesthetic constitution and delimitation of architecture, even as the overt references to "the divine proportions of the human body that provided the aesthetic foundation for classical and neoclassical architectural styles" (exemplified by Leonardo da Vinci's *Vitruvian Man*) were increasingly supplanted by means of metaphorization that did not necessarily proclaim a direct relationship between racialized corporeality and architectural design.[98] Such rescalings allude to the racial underpinnings of, as Mary Ann Doane's reading of Le Corbusier suggests, the enduring anxieties about the measure of man and "man as measure" under modernity.[99] Tracking the transits from neoclassical architecture to architectural organicism, Charles L. Davis II argues that "the characters that were previously transferred to the building through a mimetic imitation of the human form" were now ascribed "to the embodied character of building materials, the personification of building forms, or the corporeal integration of architectural elements into an organic whole."[100] The corporeal division of the world became absorbed in the very mediums and forms of design.[101]

An anteaesthetic reading of Perry's *Flesh Wall* requires attunement to the vexed entanglement of skin and flesh at the scene of architecture. This

attunement, in turn, requires that we understand the telos of architecture runs far deeper than the utilitarian planning for and aesthetic stylization of the built environment in accordance with priorities shaped by a specific historico-geographical context. Architecture is a modality for designing the world, a technology of worlding, a metonymic construction that is, as Jacques Derrida put it, "the last fortress of metaphysics."[102] As a poetics that fashions a "house for being," to use and (dis)abuse Heidegger's formulation,[103] architecture is an essential means of reproducing the ontological prerequisites and phenomenological relay between subject, object, and world. I am arguing that these architectonics—as Kant termed the art of systematicity—require both the absolute (de)valuation of the 'black body' and the invaluable exorbitance of fleshly mediality, even as this requirement entrenches an aporia as the condition of (im)possibility for metaphysics.[104] How then can we reconcile Perry's *Flesh Wall* with, for instance, Brian Irwin's assertion that "the flesh of architecture perhaps gives clearest expression to what it means to belong to the world, to participate in it, to continue into it and to be a continuation of it."[105] How do we account for the flesh-dissimulated-as-skin-becoming-surface[106] for the wall that both sustains the structural integrity of architecture's telos and encloses that which it is but cannot be? Simply put: we cannot. For flesh is not only un(ac)countable; it is that which bears the raveling of every calculus.

Perry's work could almost be taken as exemplary of that which Mark Wigley, by way of Derrida and Heidegger, refers to as "unbuilding architecture," insofar as "unbuilding" posits a deconstruction of "'traditional architecture' rather than staging its fall," an oblique disclosure of the "an-architectural element on which architecture depends," of the abyssal anorigins of presence.[107] Yet while *Flesh Wall* similarly interrogates "that which exceeds building . . . that [which] is hidden by it and yet makes it possible," its convulsion of ground signals a declivity which promises neither the consolation of demolition nor the creative destruction of building anew, at least not for those held perpetually in its vertiginous passages.[108] It lingers with the (im)mediations of descent, which fall before every instantiation of (world-) building.

Times Square Arts describes *Flesh Wall* as an artwork that expands Perry's skinscape "to monumental proportions."[109] Indeed, coming immediately on the heels of the then deadliest month of the COVID-19 pandemic in the

United States, when not a few Americans were wrestling with the skin they had hitherto believed would wall off their bodies from unwanted earthly entanglements, *Flesh Wall* could easily be mistaken for a digital monument to the racial underbelly of the so-called Anthropocene, a cenotaph for the self-possessive body. However, *pace Flesh Wall*'s commissioners, while the generic form of the monument does indeed exhibit the calculative imperative and aesthetic ambitions of architecture on a grand scale, this grandeur has less to do with relative size than with the imperial performance of scaling—not simply of materials to models or models to environments but of subject and object, body and world.

If anything, the antemonumentality of *Flesh Wall* foregrounds monumentality as a metonym for the dream of architecture, which is to say the dream of worlding. Monumentality, this synchronization and exaltation of time and space, this specular image of subjectivity in and as (the) building is a thoroughly melancholic fantasy, a sedimentation of value that must be at once deified and mourned. As Mark Wigley suggests, "the building is a ghostly recording of the unifying trans-historical collective voice."[110] Such a recording could even be said to be redoubled in Times Square, where the figure of the "Old" "now spectrally animates . . . [the] history and identity [of the 'New'], even through absence."[111] Here, as elsewhere, the dream of architecture is reanimated not only by scenes which commemorate its achievements but equally by those which are saturated by the loss which sustains its aura.[112]

I want to suggest that the metonymic relation between the monument and the phenomenological body—this "vehicle of being in the world" that would "grasp" its "world of objects"[113]—is crucial in the interleaving of monumentality and worlding. Regardless of whether the aesthetic means of this body's exaltation is figured as the unbroken extension of sovereignty (as in the work of René Descartes) or as the site of a sometimes agonizing and sometimes ecstatic failure, which nevertheless indexes an exclusive claim upon supplementarity and becoming (as in the work of Jean-Luc Nancy), the monumentalization of the body-subject is palpable. These differential iterations of a common monumentalization of the phenomenological body and its world(ings)—which in concert endeavor to crowd out the noise of their own predatory exclusions—falter in the encounter staged by Perry's work. That is, Perry stages the (non)encounter between the world of body-subjects

and the flesh of its anterior. The descendant flow of Perry's skinscape in *Flesh Wall* engenders a particular friction before the ascendant verticality and acquisitive horizon(t)ality that Times Square is so often taken to exemplify. To stretch a formulation of Wigley's, *Flesh Wall* recursively discloses monumentality as worldly reproduction, and worldly reproduction as monumentality.[114]

Perry's work disturbs the monumentalizing relay between subject, body, and world not only spatially but temporally. I want to suggest that the ante-aesthetic specificity of *Flesh Wall* cuts temporality in a manner that distinguishes it from the Midnight Moment series generally, even as the various works included in this series nominally share the durational measure of three minutes. Perry's work instantiates not a Benjaminian flashing up of history[115] but rather a flaring up and out of a dehiscence, wherein the returning of a displaced antehistorical materiality becomes inseparable from burning flesh, from the festering of an open wound. *Flesh Wall* lacerates the monumentalization that is "world-time" in the Heideggarian sense of "the flow of time experienced by Dasein."[116] In short, Perry's work does not stage a fleshly worlding but rather an anteaesthetic inquiry into and extension of the dehiscent anterior of Merleau-Ponty's chiasmatic flesh, the unworlding that is vestibular to "the flesh of the world."

Merleau-Ponty's theoretical-semantic move from the perceptions of the body-subject in his earlier work toward the chiasm of the flesh in his later work is a progression which corresponds to a shift in the point of inflection across philosophical registers from the phenomenological to the ontological. His "ultimate notion" of the flesh, an "exemplar sensible" which "has no name in any philosophy" is, as Elizabeth Grosz observes, "a more elementary and prior term [than that of perception], the condition of both seeing and being seen, of touching and being touched, and of their intermingling and possible integration, a commonness in which both subject and object participate, a single 'thing' folded back on itself."[117] His "'return' to or reconstitution of such prediscursive experience, a 'wild being,' an uncultivated or raw sensibility, is necessary to produce a nondualist, nonbinarized ontology."[118] Merleau-Ponty's philosophical trajectory could easily be read as an attempt to overcome the dualistic figuration and aesthetic glorification of the individuated body-subject. However, flesh does not so much deconstruct

or dissolve the coherence of the phenomenological body-subject as provide an ontological ground for his reinscription.[119]

In chapter 2, I argued that the black feminine marks the absent center of Merleau-Ponty's chiasmus, expelled from intra- and intersubjective reciprocity, endlessly opened to the immediations of touch precisely so that the touch of entanglement can be mediated for the phenomenological subject. Here I wish to emphasize the manner in which the flesh of the world is fashioned as the ontological ground for the chiasmic monumentalization of body-subject and world. Merleau-Ponty can hold out a worlding only because Spillers's flesh remains in the hold—the captive maternity which must bear unworlding before the world. To be clear: Perry's work does not pull back the skin of (the) building to reveal the flesh of the world; she recursively deconstructs her own dissimulative appearance to turn the flesh of the world inside out.[120] Whereas *Typhoon coming on* performatively figures the gallery's perimeter as mimetic of both the totalizing ambitions of worlding and their immanent failure, *Flesh Wall*'s cut and splayed skinscape evokes the sense of a surface uncontained—a resurfacing flesh which is nonetheless unrepresentable, a dehiscent hapticality where the constitutive opposition of surface and depth breaks down (see figure 33). The dehiscence theorized in Perry's anteaesthetic practice is therefore the vertiginous return of an irreducible materiality whose expulsion secures Merleau-Ponty's dehiscence as a "folding back of the flesh of the world."[121] Confronted with its own anorigination, the law of value, the value of the world comes apart at the seams, even as this decomposition is immediately taken as the impetus for another recomposition, another worlding.

Flesh Wall exhibits and diffuses a tearing that is irreducibly haptic, the impossible touch(ing back) of the world's displaced anterior, the unbearable material exorbitance which black femininity is nevertheless made to bear. As the antephenomenological irruption of an existence without ontology, *Flesh Wall* cannot be anything other than dark media. Yet, *pace* Eugene Thacker, it is only by recognizing the racially gendered constitution of all dark media that we can begin to apprehend that the horror of this unnamable "beyond" would be more precisely theorized as the oblique sense of mediation's abyssal anterior than that of the terminus "where mediation ends and something outside mediation begins."[122] Dark media exudes the exorbitant materiality

Figure 33. Sondra Perry, *Flesh Wall* (2016–20), Times Square Arts Midnight Moment (February 1, 2021–February 28, 2021). Courtesy of the artist and Bridget Donahue, NYC.

that flesh is made to bear, dissimulatively inscribed as an unreadable hiero-glyphics, the scarring of opacity, the dehiscent cut of a mediality made to come before both medium and message.

Codetta

People are grabbing at the chance to see
the earth before the end of the world,
the world's death piece by piece each longer than we
—Ed Roberson, "To See the Earth Before the End of the World"[123]

By way of conclusion, or rather a recursive passage that returns us to the fugue, let us briefly consider the implications of dark media *as* the hiero-glyphics of the flesh for the semiotic dilemmas ostensibly specific to an ecological moment increasingly associated with that contested figuration: "the end of the world."[124] Dark media emerges, as Thacker suggests, from the nonhuman within yet displaced by the human, as a consequence of the manner in which "the nonhuman punctures normative human communi-cation in an excommunicational rupture, or [renders] communication itself . . . so radically transformed and alien that to speak of communication at all makes little sense."[125] It is therefore a concept appropriate to the epistemic and semiotic challenges of the so-called Anthropocene—a geologic imag-inary that would belatedly and selectively grapple with the consequences of modernity's expropriative displacement of the inhuman (albeit while generally eliding this epoch's constitutive imbrications with the cataclysms of transatlantic slavery, racial capitalism, and settler colonial genocide).[126] Attuning to Roberson's ecopoetics through its resonances with the anteaes-thetic practices discussed throughout this book, we can obliquely discern the dark media of the flesh as a problem of and for the scopic dimensions of an aesthetic regime upon which the anthropocentric project of world(ing) has always been predicated. The concept of dark media is a hermeneutic in-tervention befitting an age of ecological convulsion that many would recog-nize as cleaving "the communicational imperative . . . to the *impossibility of communication*."[127] My proposition of the inextricability of dark media from the hieroglyphics of the flesh, in turn, adumbrates a difficult polyvalence within what the poet Ed Roberson compellingly describes as "people . . . grabbing at the chance to see / the earth before the end of the world."

On the one hand, Roberson's lines signal a desperate acquisitiveness, a frenzied grasping, as Édouard Glissant would put it, wherein *"to grasp* contains the movement of hands that grab their surroundings and bring them back to themselves. A gesture of enclosure if not appropriation."[128] And yet, insofar as "the earth" allegorizes an entanglement which is at once prior and subject to world(ing)—a ceaseless differentiation without separability, an intra-active ensemble of irreducible movements, an exorbitant enfleshment which blackness is made to bear[129]—it is also an existence without ontology. As such, the earth can only be "seen" dissimulatively, through the violence of rend(er)ing that would fabricate a specularity between earth and world, that would reinscribe catastrophe in the name of reparation. For even as "all that once chased us and we / chased to a balance chasing back . . . we hunt the glacier with the changes come / of that choice."[130] Earth in this sense is not the "uninscribed earth" that Spivak rightly alerts us to, a teleological figment awaiting the metaphysical imperium of world(ing), but rather an exorbitant ecology which is endlessly inscribed by the world that would chase it into (dis)appearance—a black(ened) earth whose fleshly woundings can appear only as hieroglyphic scarrings. On the other hand, the enfleshed existence of those of us whose intramural "we" has always been at once absolute and provisional, whose riven kinship and extemporaneous conviviality are cast before the expropriative displacements of the "we" of the subject, the civic, the nation, the state, which claim the world over and against earthly entanglement—our anterior existence, which is but cannot be, has always borne a hapticality that glimpses a seeing or searing with and as the earth. And although the regime of visuality that conflates vision and grasping, picturing and worlding, serially and diffusively encloses, partitions, and extracts from its haptic anterior, it cannot ever completely reduce or subsume that which remains before it.

Is this radical incompletion, this exhausting yet inexhaustible remainder of the flesh, of rend(er)ed earth, cause for hope, or if not hope, then faith, which is always more and less than hope?[131] To this question, I have nothing to say, for nothing is precisely what remains (what remains before, what remains to be, what remains to be said). It is a question which dissolves in the centerless vortex of unworlding. Unworlding is neither the obliteration of temporalization by cartography nor simply the obliteration of life in all of its ecological irreducibility.[132] Unworlding is the dehiscence which is im-

manent to black existence as nonbeing. It is the anoriginary displacement and vertiginous passage of blackness that creates, as Dionne Brand reminds us, "a tear in the world."[133] Unworlding is the indeterminate essence of this radical irreparability and irreconcilability, this immanent rupture that is anterior to every suture. It is not so much the scaling up of an undoing as it is the undoing of scale, an irrecuperable descendance, wherein the interwoven fabrications of space and time come apart at the seams. The exorbitance of unworlding is borne in and by the flesh, the brutal (im)mediations of which undergird every worlding, even as the world cannot abide what it nevertheless demands. Unworlding marks the condition of (im)possibility for every worlding's imperial promise. *Before the world: unworlding.*

Notes

Introduction

1. Steve McQueen, dialogue with Stuart Comer, "Steve McQueen: Art and Cinema," A Walker Dialogue and Retrospective, 31 January 2014, Walker Art Center, Minneapolis, MN, https://www.youtube.com/watch?v=-KM_5z9WvUc

2. Here I am invoking art historian Huey Copeland's phrasing and thought in *Bound to Appear: Art, Slavery, and the Site of Blackness in Multicultural America* (Chicago: University of Chicago Press, 2013). Copeland notes that his book's title was in turn inspired by Cedric Robinson's formulation in *Black Marxism: The Making of the Black Radical Tradition* (Chapel Hill: University of North Carolina Press, 2000), 28.

3. Hortense J. Spillers, "Mama's Baby, Papa's Maybe: An American Grammar Book," in *Black, White, and in Color: Essays on American Literature and Culture* (Chicago: University of Chicago, 2003), 203–29, 203.

4. My formulation is inspired by Spillers's declaration that "before the 'body' there is the 'flesh,'" which I take up at length in the next chapter. Spillers, "Mama's Baby, Papa's Maybe," 206.

5. For a brilliant meditation on "the vertiginous blackness of being," see David Marriott, *Whither Fanon? Studies in the Blackness of Being* (Stanford, CA: Stanford University Press, 2018), xiv, passim. On the unthought, see Saidiya V. Hartman and Frank B. Wilderson III, "The Position of the Unthought," *Qui Parle* 13, no. 2 (December 2003), 183–201.

6. See also Rizvana Bradley, "Too Thick Love, or Bearing the Unbearable," in Gregory Seigworth and Carolyn Pedwell (eds.), *The Affect Theory Reader 2: Worldings, Tensions, Futures* (Durham, NC: Duke University Press, 2023).

7. The photographer is credited as Mason Trinca. "Photos: Federal Forces Clash With Demonstrators in Portland: Overnight July 20–21," *New York Times*, 21 July 2020, https://www.nytimes.com/2020/07/21/us/portland-photos-protests.html.

8. Multiple versions of the video of Simone's performance are available on YouTube, and it is also included on the DVD *Jazz Icons: Life in '65 & '68* (Naxos, 2.108002).

9. Cf. David Colangelo and Patricio Davila, "Public Interface Effects: Re-embodiment and Transversality in Public Projection," in K. Cleland, L. Fisher, and R. Harley (eds.), *Proceedings of the 19th International Symposium of Electronic Art* (Sydney: ISEA2013, January 1, 2013), https://ses.library.usyd.edu.au/handle/2123/9705.

10. Daphne Brooks, "Nina Simone's Triple Play," *Callaloo* 34, no. 1 (Winter 2011), 176–97, 179.

11. Brooks, "Nina Simone's Triple Play," 193.

12. Cf., inter alia, Shana L. Redmond, *Anthem: Social Movements and the Sound of Solidarity in the African Diaspora* (New York: NYU Press, 2014), 179–220; and Charity Scribner, "1968, take two: The Militancy of Nina Simone," in Sarah Colvin and Katharina Karcher (eds.), *Gender, Emancipation, and Political Violence: Rethinking the Legacy of 1968* (London: Routledge, 2019), 63–75; Ruth Feldstein, "'I Don't Trust You Anymore': Nina Simone, Culture, and Black Activism in the 1960s," *Journal of American History* 91, no. 4 (March 2005), 1349–79; Tammy Kernoodle, "I Wish I Knew How It Would Feel to Be Free": Nina Simone and the Redefining of the Freedom Song of the 1960s," *Journal of the Society for American Music* 2, no. 3 (2008), 295–317; Malik Gaines, *Black Performance on the Outskirts of the Left: A History of the Impossible* (New York: NYU Press, 2017), 21–54.

13. Nina Simone and Stephen Cleary, *I Put a Spell on You: The Autobiography of Nina Simone* (New York: Da Capo Press, 1991), 135.

14. Scribner, "1968, take two ," 66.

15. Scribner, 67. Most notably, the 2005 DVD directed by Jean Bovon, *Nina Simone: Live at Montreux 1976*.

16. Scribner, 69.

17. Cf. Scribner, 67.

18. Scribner, "1968, take two"; Brooks, "Nina Simone's Triple Play," 194; Gaines, *Black Performance on the Outskirts of the Left*, 35–56; Scribner, "1968, take two"; Danielle C. Heard, "DON'T LET ME BE MISUNDERSTOOD": Nina Simone's Theater of Invisibility, *Callaloo* 35, no. 4 (Fall 2012), 1056–84, 1073, 1076–79; Julius B. Flemming Jr., "Anticipating Blackness: Nina Simone, Lorraine Hansberry, and the Time of Black Ontology," *South Atlantic Quarterly* 121, no. 1 (January 2022), 131–52, 136–37.

19. For a critical discussion of Garbus's documentary, see Scribner, "1968, take two."

20. Saidiya Hartman, *Scenes of Subjection: Terror, Slavery, and Self-Making in Nineteenth-Century America* (New York: Oxford University Press, 1997), 8, passim.

21. See, inter alia, Emily J. Lordi, *The Meaning of Soul: Black Music and Resilience since the 1960s* (Durham, NC: Duke University Press, 2020).

22. David Marriott, "Corpsing; or, The Matter of Black Life," *Cultural Critique* 94 (Fall 2016), 32–64, 33.

23. Cf. Achille Mbembe, *Necropolitics*, trans. Steven Corcoran (Durham, NC: Duke University Press, 2019).

24. Brooks, "Nina Simone's Triple Play," 179.

25. Scribner, "1968, take two," 67.

26. Kernoodle, "I Wish I Knew."

27. Frank B. Wilderson III, *Afropessimism* (Toronto: Penguin Random House, 2020), 251.

28. Cf. Rebecca Schneider, *Performing Remains: Art and War in Times of Theatrical Reenactment* (London: Routledge, 2011); David Román, *Performance in America: Contemporary U.S. Culture and the Performing Arts* (Durham, NC: Duke University Press, 2005), 137–78.

29. Ariella Azoulay, *Civil Imagination: A Political Ontology of Photography* (London: Verso Books, 2012).

30. Deborah Levitt, *The Animatic Apparatus: Animation, Vitality, and the Futures of the Image* (Alresford, UK: Zero Books, 2018).

31. Simone Browne, *Dark Matters: On the Surveillance of Blackness* (Durham, NC: Duke University Press, 2015), 80, 164.

32. Heard, "DON'T LET ME BE MISUNDERSTOOD."

33. "I cannot go to a film without seeing myself. I wait for me. In the interval, just before the film starts, I wait for me." Frantz Fanon, *Black Skin, White Masks*, trans. Charles Lam Markmann (New York: Grove Press, 1967), 107.

34. David Lloyd, *Under Representation: The Racial Regime of Aesthetics* (New York: Fordham University Press, 2019). See also Sylvia Wynter, "Rethinking 'Aesthetics': Notes Towards a Deciphering Practice," in Mbye B. Cham, ed., *Ex-Iles: Essays on Caribbean Cinema* (Trenton, NJ: Africa World Press, 1992), 237–79.

35. *Online Etymology Dictionary*, s.v. "ante-," accessed 6 June 2020, https://www.etymonline.com/word/ante-.

36. For a reading of black dereliction which overturns this aesthetic grammar, in and through its hermeneutics of the vertiginous, see Marriott, *Whither Fanon?*

37. Spillers, "'All the Things You Could Be by Now, If Sigmund Freud's Wife Was Your Mother': Psychoanalysis and Race," in *Black, White, and in Color*, 397. I would suggest that the black critique of ontology is in fact as old as the cataclysm of transatlantic slavery, regardless of whether that critique has assumed forms that would be epistemologically legible to Western philosophy.

38. Marriott, *Whither Fanon?*, 5.

39. Fred Moten, *The Universal Machine* (Durham: Duke University Press, 2018), 186; cf. Nahum Dimitri Chandler, *Beyond This Narrow Now: Or, Delimitations, of W. E. B. Du Bois* (Durham, NC: Duke University Press, 2022), 185. See also Nahum Dimitri Chandler, *X—The Problem of the Negro as a Problem for Thought* (New York: Fordham University Press, 2014).

40. R. A. Judy, *Sentient Flesh: Thinking in Disorder, Poiēsis in Black* (Durham, NC: Duke University Press, 2020), xiiv, xviii.

41. Axelle Karera, "Paraontology: Interruption, Inheritance, or a Debt One Often Regrets," *Critical Philosophy of Race* 10, no. 2 (2022), 158–97, 183.

42. Christina Sharpe, *In the Wake: On Blackness and Being* (Durham, NC: Duke University Press, 2016), 18. Emphases in original.

43. Saidiya Hartman, "Venus in Two Acts," *Small Axe* 12, no. 2 (June 2008), 1–14, 11, 12. See also her creative extensions of this project in *Lose Your Mother: A Journey along the Atlantic Slave Route* (New York: Farrar, Straus, and Giroux, 2008); and *Wayward Lives, Beautiful Experiments: Intimate Histories of Social Upheaval* (New York: W. W. Norton, 2019).

44. Spillers, *Black, White, and in Color*, 297.

45. Calvin Warren, *Ontological Terror: Blackness, Nihilism, and Emancipation* (Durham, NC: Duke University Press, 2018), 13.

46. Warren, *Ontological Terror*, 7.

47. Warren, 37, 13, 171.

48. Immanuel Kant, *Critique of Pure Reason* [1781], quoted in Judy, *Sentient Flesh*, 339; Martin Heidegger, *The Metaphysical Foundations of Logic* (Bloomington: Indiana University Press, 1984), 195. On the "interdependence of Dasein and World," see Hubert Dreyfus,

Being-in-the-World: A Commentary on Heidegger's Being and Time, Division I (Cambridge, MA: MIT Press, 1991), 96–99.

49. Frank B. Wilderson III, *Red, White, and Black: Cinema and the Structure of U.S. Antagonisms* (Durham: Duke University Press, 2010), 11.

50. Gayatri Chakravorty Spivak, "Three Women's Texts and a Critique of Imperialism," *Critical Inquiry* 12, no. 1 (Autumn 1985), 235–61, 260n1.

51. Kathleen Stewart, "Worlding Refrains," in Melissa Gregg and Greg Seigworth (eds.), *The Affect Theory Reader* (Durham, NC: Duke University Press, 2010), 339–53, 39.

52. Saidiya Hartman, "The Belly of the World: A Note on Black Women's Labors," *Souls* 18, no. 1 (January–March 2016), 166–173.

53. Sianne Ngai, *Our Aesthetic Categories: Zany, Cute, Interesting* (Cambridge, MA: Harvard University Press, 2012), 240.

54. Simon Gikandi, "Aesthetic Reflection and the Colonial Event: The Work of Art in the Age of Slavery," *Journal of the International Institute* 4, no. 3 (Summer 1997), http://hdl.handle.net/2027/spo.4750978.0004.306.

55. Lloyd, *Under Representation*, 38.

56. Terry Eagleton, *The Ideology of the Aesthetic* (Malden, MA: Blackwell Publishers, 1990), 37.

57. Eagleton, *Ideology of the Aesthetic*, 3.

58. Wynter, "Rethinking 'Aesthetics.'"

59. "Who knows but that, on the lower frequencies, I speak for you?" Ralph Ellison, *Invisible Man* (New York: Vintage Books, 1995 [1952]), 581.

60. See Rizvana Bradley, "Picturing Catastrophe: The Visual Politics of Racial Reckoning," *The Yale Review* 109, no. 2 (Summer 2021), 155–77.

61. Lloyd, *Under Representation*, 7,

62. Immanuel Kant, *Critique of Judgment* (Oxford: Clarendon Press, 1952 [1790]).

63. Lloyd, *Under Representation*, 7.

64. Alexander G. Weheliye, *Habeas Viscus: Racializing Assemblages, Biopolitics, and Black Feminist Theories of the Human* (Durham, NC: Duke University Press, 2014), 45; Sylvia Wynter, "Unsettling the Coloniality of Being/Power/Truth/Freedom: Towards the Human, After Man, Its Overrepresentation—An Argument," *cr: The New Centennial Review* 3, no. 3 (Fall 2003), 257–337.

65. Georg Wilhelm Friedrich Hegel, *The Philosophy of History* (Mineola, NY: Dover Publications, 1956), 93.

66. Hegel, *Philosophy of History*, 99.

67. Denise Ferreira da Silva, "The Scene of Nature," in Justin Desautels-Stein and Christopher Tomlins (eds.), *Searching for Contemporary Legal Thought* (Cambridge: Cambridge University Press, 2017), 275–89, 277.

68. Lindon Barrett, *Racial Blackness and the Discontinuity of Western Modernity* (Urbana: University of Illinois Press, 2014), 76.

69. Lloyd, *Under Representation*, 14.

70. Rizvana Bradley and Denise Ferreira da Silva, "Four Theses on Aesthetics," *e-flux*, no. 120 (September 2021), https://www.e-flux.com/journal/120/416146/four-theses-on-aesthetics/.

71. Jared Sexton quoted in "On Black Negativity, Or the Affirmation of Nothing: Jared Sexton, Interviewed by Daniel Barber," *Society and Space*, 18 September 2017.

72. Hal Foster, *The Anti-Aesthetic: Essays on Postmodern Culture* (Seattle: Bay Press, 1983), xv.

73. Foster, *The Anti-Aesthetic*, xv.

74. Foster, xv.

75. Foster, xv.

76. Foster, xvii.

77. According to Hans-Ernst Schiller and Lars Fischer, "[Max] Horkheimer and [Theodor] Adorno first publicly introduced the term 'administered world' during a radio discussion with Eugen Kogon in 1950." Schiller and Fischer, "The Administered World," in Beverley Best, Werner Bonefeld, and Chris O'Kane (eds.), *The SAGE Handbook of Frankfurt School Critical Theory* (Los Angeles: SAGE Publications, 2018).

78. It is precisely because of this generality that "theoretical formulations by white European thinkers are granted a conceptual carte blanche, while those uttered from the purview of minority discourse that speak to the same questions are almost exclusively relegated to the jurisdiction of ethnographic locality," as rightly observed by Weheliye, *Habeas Viscus*, 6.

79. Foster, *The Anti-Aesthetic*, xv.

80. See Hortense Spillers, "Who Cuts the Border?: Some Readings on America" in Spillers, *Black, White, and in Color*, 319–36.

81. Marriott, *Whither Fanon?*, 3. Emphasis in original.

82. Sianne Ngai, *Ugly Feelings* (Cambridge: Harvard University Press, 2005), 1.

83. In turning to the language of the black femme, I am guided by Kara Keeling's assertion that "the black femme is a figure that exists on the edge line, that is, the shoreline between the visible and the invisible, the thought and the unthought in the critical theories that currently animate film and media studies." See Kara Keeling, *The Witch's Flight: The Cinematic, the Black Femme, and the Image of Common Sense* (Durham, NC: Duke University Press, 2007), 4. Though I do not mean to conflate the nuance and specificity of Keeling's intervention with the theoretical inflections of my own argument regarding the singular aesthetic problematics that obtain to black femininity, I do take the black femme as a figure that may be powerfully invoked across a wide range of artistic mediums and aesthetic genres.

84. For more on the "exorbitant feeling" demanded of the black femme, see Bradley, "Too Thick Love." See also Tyrone S. Palmer, "'What Feels More Than Feeling?' Theorizing the Unthinkability of Black Affect," *Critical Ethnic Studies* 3, no. 2 (Fall 2017), 31–56.

85. Ngai, *Ugly Feelings*, 130.

86. Lauren Berlant, *Cruel Optimism* (Durham, NC: Duke University Press, 2011), 4.

87. Berlant, 4.

88. Berlant, 11.

89. Fanon, *Black Skin, White Masks*, 95, 133; cf. Louis Althusser, "Contradiction and Overdetermination: Notes for an Investigation," in *For Marx*, trans. Ben Brewster (London: Verso, 2005), 3–22.

90. Marriott, *Whither Fanon?*, 15. Emphasis in original.

91. Yuk Hui, *Recursivity and Contingency* (London: Rowman & Littlefield, 2019), 27.

92. For another compelling reading of black recursivity, see Kodwo Eshun, "Recursion,

Interrupted," *e-flux*, no. 109 (May 2020), https://www.e-flux.com/journal/109/331340/recursion-interrupted/.

93. This episode is recounted in Nadine Cohodas, *Princess Noire: The Tumultuous Reign of Nina Simone* (Chapel Hill: University of North Carolina Press, 2010), 295–96.

94. My usage of the term *appositional* follows Fred Moten, for whom the term denotes not so much standing beside a set of binary positions as a radical (di)vergence that calls position itself into question. See Moten, *In the Break: The Aesthetics of the Black Radical Tradition* (Minneapolis: University of Minnesota Press, 2003), 21, passim.

95. Saidiya Hartman, *Lose Your Mother: A Journey Along the Atlantic Slave Route* (New York: Farrar, Straus and Giroux, 2008), 5.

96. Wendy Haslem, *From Méliès to New Media: Spectral Projections* (Chicago: University of Chicago Press, 2019), 7.

97. Warren, *Ontological Terror*, 28–29.

98. Warren, 15.

99. Warren, 15.

100. See Rizvana Bradley, "Reinventing Capacity: Black Femininity's Lyrical Surplus and the Cinematic Limits of *12 Years a Slave*," in *Black Camera* 7, no. 1 (Fall 2015), 162–78. "Lyrical surplus" echoes and revises Moten's usage in *In the Break*, 38.

101. Hartman, *Scenes of Subjection*, 19.

102. Lisa Lowe, *The Intimacies of Four Continents* (Durham, NC: Duke University Press, 2015), 46, 64.

103. Lowe, *Intimacies of Four Continents*, 70, 1.

104. My terminology here implicitly references the polyvalent resonances of the hold in recent black critical theory, particularly interlocutions with Frank Wilderson's politico-philosophical commitment to "to stay[ing] in the hold of the [slave] ship, despite [his] fantasies of flight." See Wilderson, *Red, White, and Black*, xi. See also Fred Moten and Stefano Harney, "Fantasy in the Hold," in *The Undercommons: Fugitive Planning and Black Study* (New York: Autonomedia, 2013), 84–99; Sharpe, *In the Wake*, 68–101.

105. Sora Han, "Slavery as Contract: Betty's Case and the Question of Freedom," *Law & Literature* 27, no. 3 (2015), 395–416; Fred Moten, *Stolen Life* (Durham, NC: Duke University Press, 2018), especially 241–67.

106. Han, "Slavery as Contract," 408.

107. Han, 408.

108. Moten, *Stolen Life*, 258–59.

109. Moten, 258.

110. Moten, 264.

111. Moten, 251.

112. Here I am thinking specifically of Mackey's beautiful and incisive reflections on "Black centrifugal writing" in Nathaniel Mackey, *Paracritical Hinge: Essays, Talks, Notes* (Iowa City: University of Iowa Press, 2018), 239.

113. Wilderson, *Afropessimism*, 14, passim.

114. Here I am referencing Ruthie Wilson Gilmore's modification of David Harvey's phrase in her lecture "Organized Abandonment and Organized Violence: Devolution and the Police," The Humanities Institute, UC Santa Cruz (11 September 2015), https://vimeo.

com/146450686. For Harvey's use, see David Harvey, *The Limits to Capital* (Chicago: University of Chicago Press, 1989), 303.

115. Wilderson, *Red, White, and Black.*

116. Jacques Rancière, *Aisthesis: Scenes from the Aesthetic Regime of Art,* trans. Zakir Paul (London: Verso, 2013), xi.

117. Rancière, *Aisthesis,* xi.

118. Rancière, xi.

119. David Marriott, "The Thought of Poetry," in *Of Effacement: Blackness and Non-Being* (Stanford, CA: Stanford University Press, forthcoming). My use of the term *exorbitance* here and throughout *Anteaesthetics* is informed by, though not necessarily reducible to Nahum Chandler's deconstructivist reflections in Chandler, "Of Exorbitance: The Problem of the Negro as a Problem for Thought," in Chandler, *X—The Problem of the Negro,* 11–67. Chandler's deployment of the term pertains to the ways in which "the problem of the Negro" manifests as "an exorbitance for [modern] thought: an instance outside of all forms of being that truly matter. That is to say, something called the Negro is understood as approachable or nameable from within the architectonic of reason . . . [yet] announces an exorbitance that cannot be reduced therein." Chandler, "Of Exorbitance," 23.

120. Judy, *Sentient Flesh,* 446. For a more pointed discussion of Aristotle's use of the term, see D. W. Hamlyn, "Aristotle's Account of Aesthesis in the De Anima," *Classical Quarterly* 9, no. 1 (May 1959), 6–16.

121. See also Rizvana Bradley, "Living in the Absence of a Body: The (Sus)Stain of Black Female (W)holeness," *Rhizomes: Cultural Studies in Emerging Knowledge,* no. 29 (2016).

122. Zakiyyah Iman Jackson, "Black Light: On the Origin and Materiality of the Image," in David Breslin and Adrienne Edwards (eds.), *Whitney Biennial 2022: Quiet as It's Kept* (New Haven, CT: Yale University Press, 2022), 148–53, 148.

123. Moten, *Universal Machine,* ix.

124. I've adapted Hurston's original text, this portion of which is written in vernacular: "de mule uh de world." Zora Neale Hurston, *Their Eyes Were Watching God* (New York: Perennial Classics, 1998), 14.

125. See Joshua Bennett's reading of Hurston's allegorical invocation of the mule as "a creature invented *for the sake of labor and labor alone,* as well as a useful metonym for describing the experiences of black women living under patriarchy's unremitting pressures." Bennett, *Being Property Once Myself: Blackness and the End of Man* (Cambridge, MA: Harvard University Press, 2020), 116. Emphasis in original. On indebtedness, see Hartman, *Scenes of Subjection,* 125–63; and Denise Ferreira da Silva, *Unpayable Debt* (London: Sternberg Press, 2022).

126. Jay Wright's line "the art of dissimulation" occurs in his book-length poem *The Presentable Art of Reading Absence* (Dallas: Dalkey Archive Press, 2008), 9.

127. Dionne Brand, *A Map to the Door of No Return: Notes to Belonging* (Toronto: Vintage Canada, 2001), 14.

128. Krista Thompson, *Shine: The Visual Economy of Light in African Diasporic Aesthetic Practice* (Durham, NC: Duke University Press, 2015), 260.

129. Kobena Mercer, *Travel & See: Black Diasporic Art Practices since the 1980s* (Durham, NC: Duke University Press, 2016), 2.

130. Denise Ferreira da Silva, quoted in "An End to 'This' World: Denise Ferreira da Silva Interviewed by Susanne Leeb and Kerstin Stakemeier," *Texte zur Kunst*, April 12, 2019, https://www.textezurkunst.de/articles/interview-ferreira-da-silva/.

131. Giorgio Agamben, *Means without End: Notes on Politics* (Minneapolis: University of Minnesota Press, 2000).

132. Copeland, *Bound to Appear*, 31.

133. Mercer, *Travel & See*, 81.

134. Huey Copeland and Krista Thompson, "Afrotropes: A Conversation with Huey Copeland and Krista Thompson," *October*, no. 162 (2017), 3–18.

135. Huey Copeland and Sampada Aranke, "Afro-Pessimist Aesthetics: An Open Question," *ASAP/Journal* 5, no. 2 (2020): 241–80.

136. See, inter alia, Nicholas Manning and Lauren Berlant, "'Intensity Is a Signal, Not a Truth': An Interview with Lauren Berlant," *Revue française d'études américaines* 1, no. 154 (2018), 113–20.

137. Da Silva, "An End to 'This' World."

138. Denise Ferreira da Silva, "In the Raw," *e-flux*, no. 93 (September 2018), https://www.e-flux.com/journal/93/215795/in-the-raw/.

139. Da Silva, "In the Raw."

140. Da Silva.

141. Da Silva.

142. Sharpe, *In the Wake*, 12.

143. Da Silva, "In the Raw."

144. Manthia Diawara, "Édouard Glissant's Worldmentality: An Introduction to *One World in Relation*," *South as a State of Mind*, no. 6 [documenta 14 #1] (2015), https://www.documenta14.de/en/south/34_edouard_glissant_s_worldmentality_an_introduction_to_one_world_in_relation.

145. Édouard Glissant, *Poetics of Relation*, trans. Betsy Wing (Ann Arbor: University of Michigan Press, 1997). See also Rizvana Bradley and Damien-Adia Marassa, "Awakening to the World: Relation, Totality, and Writing from Below," *Discourse: Journal for Theoretical Studies in Media and Culture* 36, no. 1 (2014), 112–31.

146. Max Hentel, "Errant Notes toward a Caribbean Rhizome," *Rhizomes: Cultural Studies in Emerging Knowledge*, no. 24 (2012), http://www.rhizomes.net/issue24/hantel.html; Glissant, *Poetics of Relation*, 15. Hentel's emphasis.

147. Judy, *Sentient Flesh*, xiii.

148. Brent Hayes Edwards, *Epistrophies: Jazz and the Literary Imagination* (Cambridge, MA: Harvard University Press, 2017), 19.

149. Edwards, *Epistrophies*, 273n54. Emphasis in original. Here Edwards is quoting from Raymond Williams, *Marxism and Literature* (Oxford: Oxford University Press, 1977), 159.

150. Jussi Parikka, *What Is Media Archaeology?* (Cambridge, UK: Polity Press, 2012), 3. For an insightful survey and assessment of different approaches to media archaeology, see Thomas Elsaesser, *Film History as Media Archaeology: Tracking Digital Cinema* (Amsterdam: Amsterdam University Press, 2016), 17–70.

151. Elsaesser, *Film History as Media Archaeology*, 66, 68.

152. Glissant, *Poetics of Relation*, 18.

153. Erica Hunt, "Prologue," in Erica Hunt and Dawn Lundy Martin (eds.), *Letters to the Future: Black Women/Radical Writing* (Tucson: Kore Press, 2018), 15.

154. Clement Greenberg, *Art and Culture: Critical Essays* (Boston: Beacon Press, 1961), 18; Copeland, *Bound to Appear*, 10–11.

155. Copeland, 10–11.

156. Darby English, *How to See a Work of Art in Total Darkness* (Cambridge: MIT Press, 2007), 5.

157. Spillers, *Black, White, and in Color*, 85.

158. Spillers, 207.

159. Karl Marx and Frederick Engels, *The Communist Manifesto: A Modern Edition* (London: Verso, 1998 [1848]), 38.

160. Fredric Jameson, *The Modernist Papers* (London: Verso, 2007), xix.

161. Caroline Levine, *Forms: Whole, Rhythm, Hierarchy, Network* (Princeton, NJ: Princeton University Press, 2015), 3. Emphasis in original.

162. Levine, *Forms*, 9.

163. Anna Kornbluh, *The Order of Forms: Realism, Formalism, and Social Space* (Chicago: University of Chicago Press, 2019), 2, 3.

164. Peter Osborne, "Notes on Form," in Peter Osborne (ed.), *Thinking Art: Materialisms, Labours, Forms* (Kingston, UK: CRMEP Books, 2020), 159–82, 160

165. Kornbluh, *Order of Forms*, 168n13, 14.

166. Theodor W. Adorno, *Aesthetic Theory*, trans. Robert Hullot-Kentor (London: Continuum Books, 1997 [1970]), 6.

167. Calvin Warren, "The Catastrophe: Black Feminist Poethics, (Anti)form, and Mathematical Nihilism," *qui parle* 28, no. 2 (December 2019), 353–71.

168. Warren, "The Catastrophe," 357. Warren is here referring to David Marriott's thinking and phraseology in "The Perfect Beauty of Black Death," *Los Angeles Review of Books*, Philosophical Salon, June 2017, https://thephilosophicalsalon.com/the-perfect-beauty-of-black-death/.

169. Denise Ferreira da Silva, "1 (life) ÷ 0 (blackness) = ∞ – ∞ or ∞ / ∞: On Matter Beyond the Equation of Value," *e-flux*, no. 79 (February 2017), https://www.e-flux.com/journal/79/94686/1-life-0-blackness-or-on-matter-beyond-the-equation-of-value/.

170. Da Silva, "1 (life)."

171. Warren, "The Catastrophe," 368.

172. Warren, 368.

173. Georges Bataille, "Formless," in Allan Stoekl (ed.), *Visions of Excess: Selected Writings, 1927–1939*, trans. Allan Stoekl, with Carl R. Lovitt and Donald M. Leslie Jr. (Minneapolis: University of Minnesota Press, 1985), 31.

174. Yve-Alain Bois, "Introduction: The Use Value of the 'Formless,'" in Yve-Alain Bois and Rosalind E. Krauss, *Formless: A User's Guide* (New York: Zone Books, 1997), 18.

175. Cf. Denise Ferreira da Silva, "Toward a Black Feminist Poethics: The Quest(ion) of Blackness Toward the End of the World," *Black Scholar* 44, no. 2 (2014), 81–97.

176. Fred Moten, *Black and Blur* (Durham, NC: Duke University Press, 2017), ix.

177. Seb Franklin, *The Digitally Disposed: Racial Capitalism and the Informatics of Value* (Minneapolis: University of Minnesota Press, 2021), 5.

178. Barrett, *Racial Blackness*, 88.

179. Andrew Benjamin deploys the term *anoriginal* as a means of working with and through Jacques Derrida's insistence on the origineity of *différance* and hence the displacement of "the myth of a present origin." Jacques Derrida, *Writing and Difference* (Chicago: University of Chicago Press, 1978), 203; Andrew Benjamin, *Translation and the Nature of Philosophy: A New Theory of Words* (New York: Routledge, 1989). Fred Moten's reiteration and revision of Benjamin's term throughout his work draws inspiration from Nathaniel Mackey's *Bedouin Hornbook*—in which N. posits "a sexual 'cut'" as "an insistent previousness evading each and every natal occasion"—and could be said to disclose the blackness of Derrida's formulation, which is anticipated by the passages of black existence. See especially Moten, *In the Break*; and Nathaniel Mackey, *Bedouin Hornbook* (Lexington: University Press of Kentucky, 1986), 34.

180. Spillers, "Mama's Baby, Papa's Maybe," 203.

181. Spillers, 203.

Chapter 1

1. Spillers, "Mama's Baby, Papa's Maybe," 19.

2. Fred Moten, "Black Op," *PMLA* 123, no. 5, Special Topic: Comparative Racialization (October 2008), 1743–47.

3. Alessandra Raengo, "*Dreams Are Colder Than Death* and the Gathering of Black Sociality," *Black Camera* 8, no. 2, new series (Spring 2017), 120–40, 122.

4. Michael Boyce Gillespie, *Film Blackness: American Cinema and the Idea of Black Film* (Durham, NC: Duke University Press, 2016), 2.

5. Gillespie, *Film Blackness*, 12.

6. Gillespie.

7. Vivian Sobchack, *The Address of the Eye: A Phenomenology of Film Experience* (Princeton, NJ: Princeton University Press, 1992), 290.

8. Sobchack, *Address of the Eye*, 290.

9. Spillers, "Mama's Baby, Papa's Maybe," 206.

10. Cf. Sarah Jane Cervenak, *Wandering: Philosophical Performances of Racial and Sexual Freedom* (Durham, NC: Duke University Press, 2014).

11. Arthur Jafa, quoted in "Philosophy with Cinematographer Arthur Jafa," ed. Kodwo Eshun, *Black Film Bulletin* 1, no. 3/4 (Autumn/Winter 1993–94), 22–23.

12. Jafa, quoted in "Philosophy with Cinematographer Arthur Jafa."

13. Maurice Merleau-Ponty, *Sense and Non-Sense*, trans. Hubert L Dreyfus (Evanston, IL: Northwestern University Press, 1964), 54.

14. Tina Campt and Arthur Jafa, "Love Is the Message, The Plan Is Death," *e-flux*, April 2017, https://www.e-flux.com/journal/81/126451/love-is-the-message-the-plan-is-death/.

15. Merleau-Ponty, *Sense and Non-Sense*, 54.

16. Shane Denson, *Discorrelated Images* (Durham, NC: Duke University Press, 2020), 8–9.

17. See Sharpe, *In the Wake*, 75–76.

18. Raengo, "*Dreams Are Colder Than Death*," 129.

19. Gillespie, *Film Blackness*, 16.

20. Hilary Radner and Alistair Fox, *Raymond Bellour: Cinema and the Moving Image* (Edinburgh: Edinburgh University Press, 2018), 56–57.

21. Bellour quoted in Radner and Fox, *Raymond Bellour*, 52.

22. Gillespie, *Film Blackness*, 31–32.

23. Bellour quoted in Radner and Fox, *Raymond Bellour*, 52.

24. Frantz Fanon quoted in Marriott, *Whither Fanon?*, 296.

25. See Stanley Cavell, *The World Viewed: Reflections on the Ontology of Film* (Cambridge, MA: Harvard University Press, 1971).

26. I am invoking Gilles Deleuze's reference of Michel Foucault's use of the term *subjectivation* as a relation to oneself or the continuous renewal of a process of self-articulation in relation to both knowledge and power. See Gilles Deleuze, *Foucault*, trans. Séan Hand (Minneapolis: University of Minnesota Press, 1988), 104–6.

27. Mary Ann Doane, *Femmes Fatales: Feminism, Film Theory, Psychoanalysis* (New York : Routledge, 1991), 196.

28. Keeling, *The Witch's Flight*, 36.

29. Constance Penley, "The Avant-Garde and Its Imaginary," in Bill Nichols (ed.), *Movies and Methods II: An Anthology* (Berkeley: University of California Press, 1985), 596.

30. Keeling, *The Witch's Flight*, 36

31. Doane, *Femmes Fatales*, 196.

32. Keeling, *The Witch's Flight*, 36.

33. Denise Ferreira da Silva, *Toward a Global Idea of Race* (Minneapolis: University of Minnesota Press, 2007).

34. David Marriott, *Haunted Life: Visual Culture and Black Modernity* (New Brunswick, NJ: Rutgers University Press, 2007), xv.

35. For a thoughtful problematization of the "post" as it pertains to post-cinematic media, see Denson, *Discorrelated Images*, 237–38n2.

36. Azoulay Aïsha Azoulay, *Potential History: Unlearning Imperialism* (London: Verso, 2019).

37. Merleau-Ponty, *Sense and Non-Sense*, 54.

38. For a theoretical introduction to post-cinema, see Shane Denson and Julia Leyda (eds.), *Post-Cinema: Theorizing 21st-Century Film* (Falmer, UK: REFRAME Books, 2016).

39. Spillers, "Mama's Baby, Papa's Maybe," 219.

40. Pooja Rangan, *Immediations: The Humanitarian Impulse in Documentary* (Durham, NC: Duke University Press, 2017), 15, 4. Emphasis added.

41. Cf. Rangan, *Immediations*.

42. Hartman, "The Belly of the World," 166. Emphasis in original.

43. Some important works that engage these entanglements but that I do not have space to take up here include, among others, Stephanie E. Smallwood, *Saltwater Slavery: A Middle Passage from Africa to American Diaspora* (Cambridge, MA: Harvard University Press, 2009); Sowande M. Mustakeem, *Slavery at Sea: Terror, Sex, and Sickness in the Middle Passage* (Chicago: University of Illinois Press, 2016); Lisa Ze Winters, *The Mulatta Concubine: Terror, Intimacy, Freedom, and Desire in the Black Transatlantic* (Athens: University of Georgia Press, 2016); Deborah Gray White, *Ar'n't I a Woman?: Female Slaves in the Plantation South* (New York: W.W. Norton, 1985); Stephanie M. Camp, *Closer to Freedom: Enslaved Women and Everyday Resistance*

in the Plantation South (Chapel Hill: University of North Carolina Press, 2004); Rashauna Johnson, *Slavery's Metropolis: Unfree Labor in New Orleans during the Age of Revolutions* (Cambridge: Cambridge University Press, 2016); Tera W. Hunter, *Bound in Wedlock: Slave and Free Black Marriage in the Nineteenth Century* (Cambridge. MA: Harvard University Press, 2017); Marisa J. Fuentes, *Dispossessed Lives: Enslaved Women, Violence, and the Archive* (Philadelphia: University of Pennsylvania Press, 2016); Daina Ramey Berry, *The Price for Their Pound of Flesh: The Value of the Enslaved, from Womb to Grave, in the Building of a Nation* (Boston: Beacon Press, 2017); Stephanie E. Rogers-Jones, *They Were Her Property: White Women as Slave Owners in the American South* (New Haven, CT: Yale University Press, 2019); Daina Ramey Berry and Leslie M. Harris (eds.), *Sexuality and Slavery: Reclaiming Intimate Histories in the Americas* (Athens: University of Georgia Press, 2018); Sasha Turner, *Contested Bodies: Pregnancy, Childrearing, and Slavery in Jamaica* (Philadelphia: University of Pennsylvania Press, 2017).

44. For a substantive etymology, see Alys Eve Weinbaum, *Wayward Reproductions: Genealogies of Race and Nation in Transatlantic Modern Thought* (Durham, NC: Duke University Press, 2004), 1.

45. For example, Paul Cammack, "Marx on Social Reproduction," *Historical Materialism* 28, no. 2 (May 2020), 76–106.

46. Notably in their association with the International Wages for Housework Campaign. For a historical overview, see Louise Toupin, *Wages for Housework: A History of an International Feminist Movement, 1972–1977* (London: Pluto Press, 2018). Texts prominently associated with this movement include Selma James and Mariarosa Dalla Costa, *The Power of Women and the Subversion of the Community* (Bristol, UK: Falling Wall, 1973); Silvia Federici and Nicole Cox, *Counter-Planning from the Kitchen: Wages for Housework, A Perspective on Capital and the Left* (New York: Falling Wall Press, 1975).

47. Kathi Weeks, *The Problem with Work: Feminism, Marxism, Antiwork Politics, and Postwork Imaginaries* (Durham, NC: Duke University Press, 2011), 121.

48. In this regard, it is worth mentioning that Wages for Housework ultimately witnessed the formation of "autonomous factions" along racial cleavages, such as "the US/UK-based Black Women for Wages for Housework." For one study, see Beth Capper and Arlen Austin, "Wages for Housework Means Wages Against Heterosexuality": On the Archives of Black Women for Wages for Housework and Wages Due Lesbians," *GLQ: A Journal of Lesbian and Gay Studies* 24, no. 4 (October 2018), 445–66.

49. Angela Davis, "Reflections on Black Women's Role in the Community of Slaves," *Black Scholar* 13, no. 4 (1971), 2–15; Angela Y. Davis, *Women, Race, and Class* (New York: Random House, 1981). On the latter point, see Stephanie E. Jones-Rogers, *They Were Her Property: White Women as Slave Owners in the American South* (New Haven, CT: Yale University Press, 2020).

50. Davis, "Reflections on Black Women's Role," 7.

51. Davis, 13.

52. Hartman, "The Belly of the World," 172n1; Jennifer L. Morgan, *Laboring Women: Reproduction and Gender in New World Slavery* (Philadelphia: University of Pennsylvania Press, 2004).

53. Jennifer L. Morgan, "Partus Sequitur Ventrem: Law, Race, and Reproduction in Colonial Slavery," *Small Axe* 22, no. 1 (March 2018), 1–17, 1.

54. Christopher Tomlins, *Freedom Bound: Law, Labor, and Civic Identity in Colonizing English America, 1580–1865* (Cambridge: Cambridge University Press, 2010), 469.

55. Morgan, "Partus Sequitur Ventrem," 4.

56. Weinbaum, *Wayward Reproductions*, 5.

57. Morgan, "Partus Sequitur Ventrem," 10.

58. Cf. Weinbaum, *Wayward Reproductions*.

59. Dorothy Roberts, *Killing the Black Body: Race, Reproduction, and the Meaning of Liberty* (New York: Vintage Books, 1997), 9. Emphasis in original. The myriad reverberations and reiterations of the forms of violently imposed, racially gendered (re)production on the plantation following the "nonevent of emancipation" are explored in a wide range of studies, too numerous to review here. See, for example, among many others, Sarah Haley, *No Mercy Here: Gender, Punishment, and the Making of Jim Crow Modernity* (Chapel Hill: University of North Carolina Press, 2016); Christina Sharpe, *Monstrous Intimacies: Making Post-Slavery Subjects* (Durham, NC: Duke University Press, 2010); Sharpe, *In the Wake*; and Hartman, *Wayward Lives, Beautiful Experiments*.

60. Françoise Vergès, *The Wombs of Women: Race, Capital, Feminism* (Durham, NC: Duke University Press, 2020), 51.

61. Hartman, *Scenes of Subjection*, 99.

62. Hartman, 100.

63. Spillers, "Mama's Baby, Papa's Maybe," 207.

64. Cf. Bedour Alagraa, *Interminable Catastrophe: Fatal Liberalisms, Plantation Logics, and Black Political Life in the Wake of Disaster* (forthcoming).

65. Spillers, "Mama's Baby, Papa's Maybe," 214.

66. Spillers, 204, 214, 214–15, 215, 206. Emphasis in original.

67. I take up the paradoxical valences of (un)gendering in and through various black artistic practices in earlier articles, such as Rizvana Bradley, "Transferred Flesh: Reflections on Senga Nengudi's R.S.V.P.," *TDR: The Drama Review* 59, no. 1 (2015), 161–66; Rizvana Bradley, "Black Cinematic Gesture and the Aesthetics of Contagion." *TDR: The Drama Review* 62, no. 1 (2018), 14–30; Rizvana Bradley, "Aesthetic Inhumanisms: Toward an Erotics of Otherworlding," in Johanna Burton and Natalie Bell (eds.), *Trigger: Gender as a Tool and a Weapon* (New York: The New Museum, 2018), 195–203.

68. Zakiyyah Iman Jackson, *Becoming Human: Matter and Meaning in an Antiblack World* (New York: NYU Press, 2020), 10.

69. Jackson, *Becoming Human*.

70. Jackson, 18.

71. Spillers, "Mama's Baby, Papa's Maybe," 223.

72. As shown, for example, by Silvia Federici's *Caliban and the Witch: Women, the Body, and Primitive Accumulation* (Brooklyn, NY: Autonomedia, 2004), a crucial study of the role of witch hunts in the violent construction of a new gendered division of labor in early modern Europe.

73. Morgan, "Partus Sequitur Ventrem," 13. On this point, see also Hartman, *Scenes of Subjection*.

74. Glissant, *Poetics of Relation*, 6.

75. Morgan, "Partus Sequitur Ventrem," 7, 15.

76. Spillers, "Mama's Baby, Papa's Maybe," 228.

77. Joy James, "The Womb of Western Theory: Trauma, Time Theft and the Captive Maternal," *Carceral Notebooks* 12, 2016, 253–96.

78. James, "Womb of Western Theory," 256.

79. James, 264.

80. James, 261.

81. Davis, "Reflections on Black Women's Role," 8.

82. Davis, 8.

83. Morgan, "Partus Sequitur Ventrem," 7. Tiffany Lethabo King has been at the forefront of developing a radical critique of *terra nullius* that thinks through the entanglements of Black Studies and Native Studies, suggesting that "the Black female form in the New World appears as a metaphor for terra nullius, the plantation (or the planting of settlements), unfettered access to property, and the unending reproduction of bodies and land." Tiffany Jeannette King, "In the Clearing: Black Female Bodies, Space and Settler Colonial Landscapes" (Ph.D. diss., University of Maryland, College Park, 2013), 23. See also Tiffany Lethabo King, *The Black Shoals: Offshore Formations of Black and Native Studies* (Durham, NC: Duke University Press, 2019).

84. Morgan, "Partus Sequitur Ventrem," 13.

85. Denise Ferreira Da Silva, *Toward a Global Idea of Race* (Minneapolis: University of Minnesota Press, 2007).

86. M. NourbeSe Philip, "Dis Place—The Space Between," *A Genealogy of Resistance and Other Essays* (Toronto: Mercury Press 1997), 74.

87. Katherine McKittrick, *Demonic Grounds: Black Women and the Cartographies of Struggle* (Durham, NC: Duke University Press, 2006), 46–52, passim; Katherine McKittrick, "'Who Do You Talk To, When a Body's in Trouble?': M. Nourbese Philip's (Un)silencing of Black Bodies in the Diaspora," *Social & Cultural Geography* 1, no. 2 (2000), 223–36.

88. Harriet A. Jacobs [Linda Brent], *Incidents in the Life of a Slave Girl: Written by Herself*, ed. L. Maria Child (Cambridge, MA: Harvard University Press, 1987 [1861]).

89. McKittrick, *Demonic Grounds*, 43, 61, 61–62; Spillers, "Mama's Baby, Papa's Maybe," 223. See also, Rizvana Bradley, "The Difficulty of Black Women (A Response), *Artforum*, 20 December 2022, https://www.artforum.com/slant/the-difficulty-of-black-women-a-response-89859.

90. Hartman, "The Belly of the World," 168.

91. Jessica Marie Johnson, *Wicked Flesh: Black Women, Intimacy, and Freedom in the Atlantic World* (Philadelphia: University of Pennsylvania Press, 2020), 134.

92. Fred Moten, "Of Human Flesh: An Interview with R. A. Judy" (part 2), *boundary 2 online*, 6 May 2020, https://www.boundary2.org/2020/05/of-human-flesh-an-interview-with-r-a-judy-by-fred-moten/.

93. Jean-Luc Nancy, *Corpus*, trans. Richard A Rand (New York : Fordham University Press, 2008), 7

94. Nancy, *Corpus*, 5. Emphasis in original.

95. Nancy, 5.

96. Ed Cohen, *A Body Worth Defending: Immunity, Biopolitics, and the Apotheosis of the Modern Body* (Durham, NC: Duke University Press, 2009), 7.

97. David Harvey, *Spaces of Hope* (Berkeley: University of California Press, 2000), 97–116.

98. Michel Foucault, *Discipline and Punish: The Birth of the Prison* (New York: Vintage Books, 1991), 135–69, 138.

99. Sigmund Freud, *The Ego and the Id* (New York: W.W. Norton, 1960 [1923]), 20.

100. Patricia Ticineto Clough (ed.), *The Affective Turn: Theorizing the Social* (Durham, NC: Duke University Press, 2007), 10. Benjamin Fong suggests that the drive to mastery remains undertheorized and ought to be thought through its constitutive relation with the death drive: "The *death drive* becomes its own counterdrive, a *drive to mastery*." Benjamin Fong, *Death and Mastery: Psychoanalytic Drive Theory and the Subject of Late Capitalism* (New York: Columbia University Press, 2016), 18. Emphasis in original.

101. John Locke, *The Two Treatises of Government* (Cambridge: Cambridge University Press, 1960 [1689]). Brenna Bhandar argues that it is, more specifically, the "power of appropriation," including the exercise of that power over one's "very capacity for self-constitution," that is the true "point of origin for the Lockean subject." Bhandar, *Colonial Lives of Property: Law, Land, and Racial Regimes of Ownership* (Durham, NC: Duke University Press, 2018).

102. A historicist account of the myriad social developments that have produced this heightened disruption of the authority of bodily certitude lies beyond the scope of this book. However, some of the most remarked-upon examples might include the advent of biogenetics, the movement of long-standing revolts against heteropatriarchy's binary system of sex and gender into a new sphere of visibility, a growing if nascent recognition of complex (micro)biological entanglements, the magnification and proliferation of surveillance technologies, and, of course, the increasingly unavoidable confrontation with the geological epoch misleadingly referred to as the Anthropocene. Although popular and academic accounts of these developments generally treat race as ancillary, if it is commented upon at all, the writings of black feminist, queer, and/or trans scholars make it abundantly clear that it is impossible to understand a single one of them (whether or not one begins from questions of corporeality) without grappling with their constitutive relations to raciality.

103. Judith Butler, *Bodies That Matter: On the Discursive Limits of "Sex"* (New York: Routledge, 1993).

104. Diana Coole and Samantha Frost (eds.), *New Materialisms: Ontology, Agency, Politics* (Durham, NC: Duke University Press, 2010), 4; Clough, *Affective Turn*; Timothy Campbell and Adam Sitze (eds.), *Biopolitics: A Reader* (Durham, NC: Duke University Press, 2013).

105. Roderick A. Ferguson, *The Reorder of Things: The University and Its Pedagogies of Minority Difference* (Minneapolis: University Of Minnesota Press, 2012).

106. Butler, *Bodies That Matter*, 30.

107. Judith Farquhar and Margaret Lock, *Beyond the Body Proper: Reading the Anthropology of Material Life* (Durham, NC: Duke University Press, 2007), 1.

108. Stacy Alaimo and Susan Hekman (eds.), *Material Feminisms* (Bloomington: Indiana University Press, 2008); Donna Haraway, *Staying with the Trouble: Making Kin in the Chthulucene* (Durham, NC: Duke University Press, 2016); Elizabeth Grosz, *Time Travels: Feminism, Nature, Power* (Durham, NC: Duke University Press, 2005); Karen Barad, *Meeting the Universe Halfway: Quantum Physics and the Entanglement of Matter and Meaning* (Durham, NC: Duke University Press, 2007).

109. Stacy Alaimo and Susan Hekman, "Introduction: Emerging Models of Materiality in Feminist Theory," in Alaimo and Hekman, *Material Feminisms*. On the "material-discursive," see Barad, *Meeting the Universe Halfway*. On the "material-ideal," see Elizabeth Grosz, *The Incorporeal: Ontology, Ethics, and the Limits of Materialism,* (New York: Columbia University Press, 2017).

110. Nancy, *Corpus*, 5, 83, 95, 97, 99, 140, 154.

111. Nancy, 15. Emphasis in original.

112. Nancy, 101, 121.

113. Nancy, 9. Emphasis in original.

114. Nancy, 73. Emphasis in original.

115. Nancy, 7.

116. Nancy, 7.

117. Nancy, 7.

118. Spillers, "Mama's Baby, Papa's Maybe," 206.

119. Da Silva, *Toward a Global Idea of Race*, xiii.

120. Da Silva, 117.

121. Cf. da Silva.

122. René Descartes, *Meditations on First Philosophy,* trans. George Heffernan (Notre Dame, IN: University of Notre Dame Press, 1990 [1641]).

123. Da Silva, *Toward a Global Idea of Race*, 42. Emphasis in original.

124. Da Silva, *Toward a Global Idea of Race*.

125. Da Silva, 44.

126. Calvin Warren, "Improper Bodies: A Nihilistic Meditation on Sexuality, the Black Belly, and Sexual Difference," *Palimpsest: A Journal on Women, Gender, and the Black International* 8, no. 2 (2019), 35–51.

127. On "the principle of separability" within "The Ordered World," see Denise Ferreira da Silva, "Difference without Separability," text for the catalogue of the 32nd Bienal de São Paulo, "Incerteza viva" (São Paulo: Fundaçao Bienal de São Paulo, 2016), 57–65.

128. Warren, "Improper Bodies," 47.

129. This formulation is notably associated with Gilles Deleuze's work on Baruch de Spinoza. Deleuze, *Expressionism in Philosophy: Spinoza* (New York: Zone Books, 1990), 226.

130. Grosz, *The Incorporeal*, 67.

131. Fanon, *Black Skin, White Masks*.

132. Even a cursory search on Google Scholar (access date 29 December 2020), without differentiating between the social and natural sciences, reveals that the phrase *black bodies* appears at least two and a half times more frequently than the phrase *white bodies*.

133. Tiffany Lethabo King, "Off Littorality (Shoal #1): Black Study Off the Shores of 'the Black Body,'" *Propter Nos* 3 (2019), 40–50, 43; Katherine McKittrick, *Demonic Grounds: Black Women and the Cartographies of Struggle* (Minneapolis, MN: University of Minnesota Press, 2006).

134. King, "Off Littorality," 43.

135. McKittrick, *Demonic Grounds*, 79.

136. Farquhar and Lock, *Beyond the Body Proper*.

137. See Bradley, "Living in the Absence of a Body."

138. See, inter alia, Sitze and Campbell, *Biopolitics: A Reader*.

139. Michel Foucault, "Confessions of the Flesh," in *Power/Knowledge: Selected Interviews and Other Writings, 1972–1977*, ed. Colin Gordon (New York: Pantheon Books, 1980), 194.

140. Foucault, "Confessions of the Flesh," 194, 195.

141. Foucault, 195.

142. Foucault, 196.

143. Giorgio Agamben, *What Is an Apparatus? And Other Essays*, trans. David Kishik and Stefan Pedatella (Stanford, CA: Stanford University Press, 2009), 13.

144. Agamben, *What Is an Apparatus?*, 14.

145. Barad, *Meeting the Universe Halfway*.

146. Barad, 142.

147. Barad, 206, 142.

148. Spillers, "Mama's Baby, Papa's Maybe," 206. Emphasis in original.

149. Jackson, *Becoming Human*, 93.

150. Weheliye, *Habeas Viscus*, 39. For a contrasting interpretation, see Judy, *Sentient Flesh*.

151. Weheliye, *Habeas Viscus*, 39.

152. "Ed Atkins in Conversation with Tom McCarthy," Architectural Association School of Architecture, 8 December 2017, https://www.youtube.com/watch?v=Lt4TfzN-f2s.

153. Mayra Rivera, *Poetics of the Flesh* (Durham, NC: Duke University Press, 2015), 7.

154. Maurice Merleau-Ponty, *The Phenomenology of Perception*, trans. Donald A. Landers (Abingdon, UK: Routledge, 2012), 73.

155. Merleau-Ponty, *Phenomenology of Perception*; Maurice Merleau-Ponty, *The Visible and the Invisible*, trans. Alphonso Lingis (Evanston, IL: Northwestern University Press, 1968).

156. Leonard Lawlor and Ted Toadvine (eds.), *The Merleau-Ponty Reader* (Evanston, IL: Northwestern University Press, 2007), xiii.

157. Representative examples of work in which Merleau-Ponty figures heavily across these respective fields include Vivian Sobchack, *Carnal Thoughts: Embodiment and Moving Image Culture* (Berkeley: University of California Press, 2004); Paul Crowther, *What Drawing and Painting Really Mean: The Phenomenology of Image and Gesture* (New York: Routledge, 2017); Dorothea Olkowski and Gail Weiss (eds.), *Feminist Interpretations of Merleau-Ponty* (University Park: University of Pennsylvania Press, 2006); and Sara Ahmed, *Queer Phenomenology* (Durham, NC: Duke University Press, 2006).

158. Merleau-Ponty, *Phenomenology of Perception*.

159. Merleau-Ponty, 525, 84.

160. Thomas Baldwin (ed.), *Maurice Merleau-Ponty: Basic Writings* (New York: Routledge, 2004), 36.

161. Merleau-Ponty, *Phenomenology of Perception*, trans. Landers, 146.

162. Maurice Merleau-Ponty, *The Phenomenology of Perception*, trans. Colin Smith (London: Routledge Classics, 2002), 140. Emphasis added.

163. Merleau-Ponty, *Phenomenology of Perception*, trans. Smith, 140, 242.

164. Merleau-Ponty, *Phenomenology of Perception*, trans. Landers, 480.

165. Aimé Césaire, *Discourse on Colonialism* (New York: Monthly Review Press, 2000 [1955]), 42.

166. Fanon, *Black Skin, White Masks*, 82.

167. Spillers, "Mama's Baby, Papa's Maybe," 206. Emphasis in original.

168. Fanon, *Black Skin, White Masks*, 84.

169. Merleau-Ponty, *Phenomenology of Perception*, trans. Smith, 346.

170. Merleau-Ponty, 112.

171. Lillian Yvonne Bertram, "—The Dream World Is a Place She Can Reach Through Her Own Body," in Hunt and Martin (eds.), *Letters to the Future*, 58.

172. Moten, *In the Break*, 1.

173. Barrett, *Racial Blackness*, 139.

174. Barrett, 138. Emphasis in original.

175. Spillers, *Black, White, and in Color*, xiv.

176. Ashley Woodward, "Nihilism and the Sublime in Lyotard," *Angelaki: Journal of the Theoretical Humanities* 16, no. 2, (2011), 57–71; Jean-François Lyotard, *Libidinal Economy*, trans. Iain Hamilton Grant (Bloomington: Indiana University Press, 1993 [1974]).

177. Jacques Derrida, *Languages of the Unsayable: The Play of Negativity in Literature and Literary Theory* (New York: Columbia University Press, 1989), 25.

178. Warren, *Ontological Terror*, 148.

179. Bois and Krauss, *Formless: A User's Guide*, 40.

180. Fanon, *Black Skin, White Masks*, 86.

181. Marriott, *Whither Fanon?*, 230.

182. Denise Ferreira da Silva, "No-Bodies: Law, Raciality and Violence," *Griffith Law Review* 18, no. 2 (2009), 212–36.

183. Elizabeth Grosz, *Volatile Bodies: Toward a Corporeal Feminism* (Bloomington: Indiana University Press, 1994), 103, 96.

184. Grosz, *Volatile Bodies*, 107.

185. Merleau-Ponty, *The Visible and the Invisible*, 152.

186. For varying theorizations of what R. A. Judy describes as "feeding on the flesh" or what Calvin Warren refers to as "the insatiable appetite of antiblackness," see Judy, *Sentient Flesh*, 8, passim; Warren, *Ontological Terror*, 25, passim; Vincent Woodward, *The Delectable Negro: Human Consumption and Homoeroticism within US Slave Culture* (New York: NYU Press, 2014); and Kyla Wazana Tompkins, *Racial Indigestion: Eating Bodies in the 19th Century* (New York: NYU Press, 2012).

187. Moten, *Black and Blur*, ix.

188. Moten, *Universal Machine*, ix.

189. Frank B. Wilderson III, "The Vengeance of Vertigo: Aphasia and Abjection in the Political Trials of Black Insurgents," *InTensions Journal*, no. 5 (Fall/Winter 2011), http://www.yorku.ca/intent/issue5/articles/frankbwildersoniii.php.

190. Wilderson, "The Vengeance of Vertigo."

191. Elaine Scarry, *The Body in Pain: The Making and Unmaking of the World*, (New York: Oxford University Press, 1985), 27–59.

192. Scarry, *Body in Pain*, 30.

193. Weheliye, *Habeas Viscus*, 125–26. The quote Weheliye echoes in this passage, "It's after the end of the world. . . . Don't you know that yet," is from June Tyson's serial recitation at the beginning of the Sun Ra Arkestra's 1974 film *Space Is the Place*, which he reads elsewhere in the book. Weheliye, 132.

194. Scarry, *Body in Pain*, 29, 30.

195. Spillers, "Mama's Baby, Papa's Maybe," 206. Emphasis in original.

196. Hortense Spillers, "To the Bone: Some Speculations on Touch," keynote address, There's a Tear in the World: Touch After Finitude, Stedelijk Museum of Art and Studium Generale Rietveld Academy, 23 March 2018.

197. Spillers, *Black, White, and in Color*, 454.

198. Laura U. Marks, *The Skin of the Film: Intercultural Cinema, Embodiment, and the Senses* (Durham, NC: Duke University Press, 2000).

199. Hortense Spillers, "To the Bone."

200. Bernadette Wegenstein, "Body," in W. J. T. Mitchell and Mark B. N. Hansen (eds.), *Critical Terms for Media Studies* (Chicago: University of Chicago Press, 2010), 21.

201. Wegenstein, "Body," 19.

202. Wegenstein, 21.

203. Merleau-Ponty, *The Visible and the Invisible*, 266. Emphasis in original.

204. Cf. Karl Marx, *The Economic and Philosophic Manuscripts of 1844*, ed. Dirk J. Struik (New York: International Publishers, 1964).

205. W. J. T. Mitchell and Mark B. N. Hansen, "Introduction," in Mitchell and Hansen, *Critical Terms for Media Studies*, ix.

206. Da Silva, *Toward a Global Idea of Race*, 20. Also da Silva, "The Scene of Nature."

207. Geoffrey Winthrop-Young, "Hardware/ Software/ Wetware," in Mitchell and Hansen, *Critical Terms for Media Studies*, 197.

208. Da Silva, *Toward a Global Idea of Race*, 20.

209. Warren, *Ontological Terror*, 4.

210. Mitchell and Hansen, "Introduction," *Critical Terms for Media Studies*, x.

211. Mitchell and Hansen, xiii.

212. Bernard Stiegler, *Technics and Time, 1: The Fault of Epimetheus*, trans. Richard Beardsworth and George Collins (Stanford, CA: Stanford University Press, 1998), 6–7.

213. Stiegler, *Technics and Time, 1*, 6.

214. Mitchell and Hansen, "Introduction," *Critical Terms for Media Studies*, ix.

215. Mitchell and Hansen, ix. Emphasis in original.

216. Hartman, *Scenes of Subjection*, 21.

217. Jackson, *Becoming Human*, 3.

218. Ted Nannicelli and Malcolm Turvey, "Against Post-Cinema," *Cinéma et Cie: International Film Studies Journal*, nos. 26–27 (2016), 33–44, cited in Denson, *Discorrelated Images*.

219. Denson, 63. Emphasis in original. Denson cites his primary interlocutionary texts as Niklas Luhmann, *Die Gesellschaft der Gesellschaft* (Frankfurt: Suhrkamp, 1997), 190–412; Niklas Luhmann, *Die Kunst der Gesellschaft* (Frankfurt: Suhrkamp, 1995), ch. 3, 165–214, translated as Niklas Luhmann, *Art as a Social System*, trans. Eva M. Knodt (Stanford, CA: Stanford University Press, 2000); and a shorter article, Niklas Luhmann, "The Medium of Art," *Thesis Eleven*, nos. 18–19 (1987): 101–13. Denson also notes that because "there are terminological pitfalls involved in Luhmann's approach"—namely, that "*medium* is sometimes used for the substrate/form constellation and sometimes just for the substrate"—he uses "the term *mediality* rather than *medium* to refer to the substrate/form constellation" to avoid confusion. Denson, 250n49.

220. Denson, 63–64.

221. Denson, 64.

222. Warren, *Ontological Terror*.

223. Richard Grusin, "Radical Mediation," *Critical Inquiry* 42, no. 1 (Autumn 2015), 124–48, 128.

224. Denson, *Discorrelated Images*, 64.

225. Denson, *Discorrelated Images*, 65.

Chapter 2

1. W. E. B. Du Bois, *The Souls of Black Folk* (Chicago: A. C. McClurgh, 1903), 213.

2. David Bindman and Henry Louis Gates Jr. (eds.), *The Image of the Black in Western Art*, vol. 4: *From the American Revolution to World War I, Part 1: Slaves and Liberators* (Cambridge, MA: Harvard University Press, 1989), 119.

3. Alexandre Corréard and Jean-Baptiste-Henri Savigny, *Narrative of a Voyage to Senegal in 1816* (Middlesex, UK: Echo Library, 2007 [1817]). See Jonathan Miles, *The Wreck of the Medusa: The Most Famous Sea Disaster of the Nineteenth Century* (New York: Grove Press, 2007), for a recent historical overview.

4. Darcy Grimaldo Grigsby, *Extremities: Painting Empire in Post-Revolutionary France* (New Haven, CT: Yale University Press, 2002), 168.

5. Albert Alhadeff, *Théodore Géricault, Painting Black Bodies: Confrontations and Contradictions* (London: Routledge, 2020), 30–31.

6. Hugh Honour, "Philanthropic Conquest," in Bindman and Gates, *Image of the Black in Western Art*.

7. Thomas Crow, *Restoration: The Fall of Napoleon in the Course of European Art, 1812–1820* (Princeton, NJ: Princeton University Press, 2018), 187.

8. Crow, *Restoration*, 181.

9. Crow, 187.

10. Charmaine Nelson, *The Color of Stone: Sculpting the Black Female Subject in Nineteenth-Century America* (Minneapolis: University of Minnesota Press, 2007), 127.

11. Nelson, 68, passim.

12. Carol Ockman, *Ingres's Eroticized Bodies: Retracing the Serpentine Line* (New Haven, CT: Yale University Press, 1995), 4.

13. Frantz Fanon, *The Wretched of the Earth*, trans. Constance Farrington (London: Penguin Books, 1963).

14. David Marriott, "The Racialized Body," in David Hillman and Ulrika Maude (eds.), *The Cambridge Companion to the Body in Literature* (Cambridge: Cambridge University Press, 2015), 163–76, 167.

15. Marriott, "The Racialized Body," 167.

16. Linda Nochlin, *The Body in Pieces: The Fragment as a Metaphor for Modernity* (New York: Thames and Hudson, 1994), 53.

17. Crow, *Restoration*, 187.

18. Rancière, *Aisthesis*, 1–21; Johann Joachim Winckelmann, *The History of Ancient Art*, trans. G. Henry Lodge (Boston: James R. Osgood and Company, 1880).

19. Christopher S. Wood, *A History of Art History* (Princeton: Princeton University Press, 2019), 155.

20. Rancière, *Aisthesis*, xiii.

21. Winckelmann, *History of Ancient Art*, 264, quoted in Rancière, 1.

22. Jacques Rancière, *The Politics of Aesthetics: The Distribution of the Sensible* (London: Bloomsbury Academic, 2004), 49.

23. Rancière, *Aisthesis*, 3.

24. Rancière, 4.

25. Rancière, 11.

26. Rancière, 20.

27. As David Marriott writes, "The *nègre* is *n'est pas*, yet this *n'est pas* is not a metaphor." Marriott, *Whither Fanon?*, 223.

28. Rancière, *Aisthesis*, 9, 20.

29. Rancière, 67.

30. Crow, *Restoration*, 3.

31. Crow, 187.

32. Alhadeff, *Théodore Géricault*, 167. As Alhadeff notes, although "*Joseph*'s links with the Raft are now an integral part of the Géricaultian literature . . . what may only be hearsay has hardened into a fact. Clément was the first to link Joseph, a favored dark-skinned model in Parisian circles in the 1840s, with the Raft . . . [but this declaration is] long unsubstantiated" (166); see 165–73 for elaboration.

33. Eric Hobsbawm, "The Making of a 'Bourgeois Revolution,'" in Ferenc Fehér (ed.), *The French Revolution and the Birth of Modernity* (Berkeley: University of California Press, 1990), 30–46, 40. Emphasis in original.

34. C.L.R. James, *The Black Jacobins: Toussaint L'Ouverture and the San Domingo Revolution*, 2nd ed. (New York: Random House, 1963); Robin Blackburn, *The Overthrow of Colonial Slavery, 1776–1848* (London: Verso, 1988), 163.

35. Michel-Rolph Trouillot, *Silencing the Past: Power and the Production of History* (Boston: Beacon Press, 1995).

36. David Brion Davis, "The Impact of the French and Haitian Revolutions," in David P. Geggus (ed.), *The Impact of the Haitian Revolution in the Atlantic World* (Columbia: University of South Carolina Press, 2001), 3–7, 5.

37. Trouillot, *Silencing the Past*, 96.

38. For a more detailed analysis, see Alhadeff, *Théodore Géricault*, 98–101.

39. Grigsby, *Extremities*.

40. Grigsby, 169.

41. Le Clerc, "Campagne du Limbé, et détail de quelques évenements qui ont eu lieu dans ce quartier (ou commune) jusqu'au 20 Juin 1793, époque de l'incendie du Cap, ville capitale de la Province du Nord, distante de 7 à 8 lieues du Limbé," n.d., Centre des Archives d'Outre-Mer (Aix), carton CC 9 A 8, quoted in Jeremy D. Popkin, *Facing Racial Revolution: Eyewitness Accounts of the Haitian Revolution* (Chicago: University of Chicago Press, 2007), 30.

42. In other words, my interest is not so much in forms of ruination as "protracted imperial processes" as in the ruination of (the order of) forms. Cf. Ann Laura Stoler (ed.), *Imperial Debris: On Ruins and Ruination* (Durham, NC: Duke University Press, 2013), 5.

43. David Marriott, *On Black Men* (New York: Columbia University Press, 2000), xiv.

44. The examples offered by Grigsby in *Extremities*, 168, are Bindman and Gates, *Image*

of the Black in Western Art, 119–26; and Albert Boime, *The Art of Exclusion: Representing Blacks in the Nineteenth Century* (Washington, DC: Smithsonian Institution Press, 1990), 51–61.

45. Grigsby, 168.

46. Verity Platt, "Re-membering the Belvedere Torso: Ekphrastic Restoration and the Teeth of Time," *Critical Inquiry* 47, no. 1 (Autumn 2020), 49–75.

47. Jacques Rancière, *Dissensus: On Politics and Aesthetics*, trans. Steven Corocan (London: Bloomsbury Academic, 2015).

48. Grigsby, *Extremities*, 178.

49. Jacques Derrida, *Memoirs of the Blind: The Self-Portraits and Other Ruins*, trans. Pascale-Anne Brault and Michael Naas (Chicago: University of Chicago Press, 1993), 18. For elaborations, see Michael Newman, "Derrida and the Scene of Drawing," *Research in Phenomenology* 24 (1994), 218–34; Jane Tormey, Andrew Selby, Phil Sawdon, Russell Marshall, and Simon Downs (eds.), *Drawing Now: Between the Lines of Contemporary Art* (London: I. B. Tauris, 2007), ix–xxii.

50. Alhadeff, *Théodore Géricault*, 33.

51. Alhadeff, 33.

52. Alhadeff, 31.

53. Here I follow Darieck Scott's translation. As Scott notes, the Richard Philcox translation is "the mirage sustained by his unmediated physical strength." Frantz Fanon, *The Wretched of the Earth*, trans. Richard Philcox (New York: Grove Press, 2004 [1961]), 88. For an extended treatment of these questions, see Darieck Scott, *Extravagant Abjection: Blackness, Power, and Sexuality in the African American Literary Imagination* (New York: NYU Press, 2010), especially 32–95.

54. Marriott, *Whither Fanon?*, 20.

55. Alhadeff, *Théodore Géricault, Painting Black Bodies*, 30–31.

56. Jaś Elsner, "Art History as Ekphrasis," *Art History* 33, no. 1 (2010), 11.

57. Frank B. Wilderson III, Samira Spatzek, and Paula von Gleich, "'The Inside-Outside of Civil Society': An Interview with Frank B. Wilderson, III," *Black Studies Papers* 2, no. 1 (2016), 4–22, 12.

58. Quoted in Nina Athanassoglou-Kallmyer, "Géricault's Severed Heads and Limbs: The Politics and Aesthetics of the Scaffold," *Art Bulletin* 74, no. 4 (1992), 599–618, 618.

59. Quoted in Athanassoglou-Kallmyer, "Géricault's Severed Heads and Limbs," 616–17.

60. Athanassoglou-Kallmyer, 599; Anthea Callen, *Looking at Men: Anatomy, Masculinity, and the Modern Male Body* (New Haven, CT: Yale University Press, 2018), 195.

61. Athanassoglou-Kallmyer, "Géricault's Severed Heads and Limbs," 610.

62. Athanassoglou-Kallmyer, 617.

63. Marriott, *Haunted Life*, 211.

64. Alhadeff, *Théodore Géricault*, 45.

65. Grigsby, *Extremities*.

66. Grigsby, 168.

67. Grigsby, 167.

68. Eric Santner, *The Royal Remains* (Chicago: University of Chicago Press, 2011), 4.

69. Richard Sherwin, "What Authorizes the Image? The Visual Economy of Post-Secular

Jurisprudence," in Desmond Manderson (ed.), *Law and the Visual: Representation, Technologies, and Critique* (Toronto: University of Toronto Press, 2018), 330–53, 336.

70. Marriott, *Haunted Life*, 211.

71. Crow, *Restoration*, 184.

72. Derrida, *Memoirs of the Blind*, 65. Emphasis in original.

73. Crow, *Restoration*, 184.

74. Spillers, "To the Bone."

75. Spillers.

76. Marriott, *On Black Men*, 27.

77. Ian Haywood, *Romanticism and Caricature* (Cambridge: Cambridge University Press, 2013), 6.

78. Hartman, *Scenes of Subjection*; on Romanticism and abolitionism, see Debbie Lee, *Slavery and the Romantic Imagination* (Philadelphia: University of Pennsylvania Press, 2002); on liberal abolitionism's implicatedness in "settlement, slavery, coerced labor, and imperial trades," see Lowe, *The Intimacies of Four Continents*, 16.

79. Haywood, *Romanticism and Caricature*, 9.

80. Natasha Gordon-Chipembere, "Introduction: Claiming Sarah Baartman, a Legacy to Grasp," in Natasha Gordon-Chipembere (ed.), *Representation and Black Womanhood: The Legacy of Sarah Baartman* (New York: Palgrave Macmillan, 2011), 1–14, 6. Emphasis added.

81. Marcus Wood, "The Deep South and English Print Satire 1750–1865," in Joseph P. Ward (ed.), *Britain and the American South: From Colonialism to Rock and Roll* (Jackson: University of Mississippi Press), 107–40; Marcus Wood, *Blind Memory: Visual Representations of Slavery in England and America, 1780–1865* (Manchester, UK: Manchester University Press, 2000); Marcus Wood, *Radical Satire and Print Culture, 1790–1822* (Oxford: Clarendon Press, 1994). Note that although Britain had nominally abolished the transatlantic slave trade in 1807, it continued to be deeply implicated in it until and after the 1833 Act for the Abolition of Slavery, which itself ultimately propelled "a terrible convergence between U.S. slavery and British imperial expansion" over the following three decades. Zach Sell, *Trouble of the World: Slavery and Empire in the Age of Capital* (Chapel Hill: University of North Carolina Press, 2021), 1.

82. Scholars refer to Saartjie Baartman with various orthographic iterations of the forename Sara(h) and the surname Ba(a)rtman(n). For an elaboration of the problematic of nomination and black femininity as it pertains to Baartman in particular, see my discussion in the following chapter.

83. T. Denean Sharpley-Whiting, *Black Venus: Sexualized Savages, Primal Fears, and Primitive Narratives in French* (Durham, NC: Duke University Press, 1999), 21.

84. Spillers, *Black, White, and in Color*, 155.

85. Peter Abélard, *Les Lettres complètes*, fifth letter (Paris: Garnier frères, 1870 [c. 1119–1142]), 89–90, quoted in Sharpley-Whiting, *Black Venus*, 1; Sharpley-Whiting's translation.

86. Constance Classen, "Introduction: The Transformation of Perception," in Constance Classen (ed.), *A Cultural History of the Senses in the Age of Empire* (London: Bloomsbury Academic, 2014), 3.

87. Jacques Derrida, *On Touching—Jean-Luc Nancy*, trans. Christine Irizarry (Stanford, CA: Stanford University Press, 2000), 139.

88. Nancy, *Corpus*, 43–45.

89. Jean-Luc Nancy, *The Sense of the World*, trans. Jeffrey S. Librett (Minneapolis: University of Minnesota Press, 1997 [1993]), 63, emphasis in original; Nancy, *Corpus*, 37.

90. Nancy, *Corpus*, 87, 19.

91. Da Silva, "Difference without Separability."

92. Constance Classen, *The Deepest Sense: A Cultural History of Touch* (Urbana: University of Illinois Press, 2012), xii.

93. However, Baartman's "given name," as I explain in the following chapter, is no less implicated in the racially gendered violence of colonial nomination.

94. Cf. Spillers, "Mama's Baby, Papa's Maybe." I address the problem of naming as it pertains to Baartman in further detail in the next chapter.

95. Alan Barbard, *Hunters and Herders of Southern Africa: A Comparative Ethnography of Khoisan Peoples* (Cambridge: Cambridge University Press, 1992), 7.

96. David Johnson notes that "the distinction between the Khoikhoi [the so-called Hottentots] and the San [the so-called Bushmen] has always been vague, but in the seventeenth and eighteenth centuries the Khoikhoi were pastoralists, whereas the San were hunter-gatherers." Johnson, "Representing the Cape "Hottentots," from the French Enlightenment to Post-Apartheid South Africa," *Eighteenth-Century Studies* 40, no. 4 (Summer 2007), 525–52, 546n3. Shane Moran's *Representing Bushmen: South Africa and the Origin of Language* (Rochester, NY: University of Rochester Press, 2009) provides a rich philosophical critique of the instrumentalization of such racial-ethnographic-philological schemas toward various discursive teloi, under both colonial and nominally postcolonial regimes.

97. Leonhard Schultze [Leonhard Schultze-Jena], *Aus Namaland und Kalahari* (Jena, DE: Gustav Fischer, 1907), 211; Isaac Schapera, "A Preliminary Consideration of the Relationship between the Hottentots and the Bushmen," *South African Journal of Science*, no. 23 (1926), 833–66, both cited in Barbard, *Hunters and Herders of Southern Africa*, 7.

98. Adrian Koopman, "The Use of the Ethnonym 'Hottentot' in the Birdnames 'Hottentot Teal' and 'Hottentot Buttonquail,'" *Ostrich* 92, no. 1 (2021), 151–55, 152. See 151–52 for a survey of the racist characterizations made by early Dutch settlers, which the quote in the chapter text paraphrases.

99. Barrett, *Racial Blackness*, 216.

100. Sharpley-Whiting, *Black Venus*, 7.

101. Lynda Nead, *The Female Nude: Art, Obscenity, and Sexuality* (London: Routledge, 1992), 19.

102. Spillers, "Mama's Baby, Papa's Maybe," 206.

103. Weheliye, *Habeas Viscus*, 90.

104. Weheliye, 108.

105. Judith Butler, *Senses of the Subject* (New York: Fordham University Press, 2015), 51.

106. Anna Arabindan-Kesson, *Black Bodies, White Gold: Art, Cotton, and Commerce in the Atlantic World* (Durham, NC: Duke University Press, 2021), 23.

Chapter 3

1. Mark Fisher, *The Weird and the Eerie* (London: Repeater Books, 2016), 10, 12.

2. Alessandra Raengo, review of *Mickalene Thomas: Mentors, Muses, and Celebrities*, Spel-

man College Museum of Fine Art, *CAA Reviews*, March 2018, http://www.caareviews.org/reviews/3247#.YNei6W4pDOQ.

3. Hal Foster, "Round Table: The Projected Image in Contemporary Art" (Malcolm Turvey, Hal Foster, Chrissie Iles, George Baker, Matthew Buckingham, Anthony McCall), *October* 104 (Spring 2003), 71–96, 79–80.

4. See, inter alia, Hartman, *Scenes of Subjection*; Browne, *Dark Matters*; and Ruha Benjamin (ed.), *Captivating Technology: Race, Carceral Technoscience, and Liberatory Imagination in Everyday Life* (Durham, NC: Duke University Press, 2019).

5. Eartha Kitt interviewed on the Terry Wogan show, 11 September 1989, https://www.youtube.com/watch?v=MwU34galKbo.

6. Chrissie Iles, "Round Table: The Projected Image in Contemporary Art," 80.

7. Raengo, review of *Mickalene Thomas*. Another example is Denise Murrell's celebration of Thomas's "artistic commitment to achieving a centrality for the black female figure within the canons of art . . . [fashioning a] radically new black muse [which] transcends an antecedent history of subordination and obliteration and assumes the power of her central subject position." Murrell, *Posing Modernity: The Black Model from Manet and Matisse to Today* (New Haven, CT: Yale University Press, 2018), 168, 171. Without taking away from Murrell's important scholarly contributions, I would question the theoretical presumptions that enable the "black muse" to be figured as "assum[ing] . . . the power of her central subject position."

8. "Carrie Mae Weems in Conversation with Mickalene Thomas," in *Muse: Mickalene Thomas Photographs* (New York: Aperture, 2015), 108.

9. Karl Marx, *Capital*, vol. 1, afterword to second German ed. (London: Lawrence & Wishart, 1974 [24 January 1873]), 29.

10. Mercer, *Travel and See*, 60.

11. Kris Paulsen, *Here/There: Telepresence, Touch, and Art at the Interface* (Cambridge, MA: MIT Press, 2017).

12. Paulsen, *Here/There*, 8.

13. Paulsen, 5.

14. Paulsen, 186.

15. Paulsen, 10, 43; Rosalind Krauss, "Video: The Aesthetics of Narcissism," *October* 1 (Spring 1976), 50–64.

16. Paulsen, 40.

17. Cf. Paulsen, 15.

18. Karl Marx, *The Eighteenth Brumaire of Louis Bonaparte* (Moscow: Progress Publishers, 1934 [1852]), 10.

19. Ockman, *Ingres's Eroticized Bodies*; Roger Benjamin, "Ingres chez les fauves," in Susan Siegfried and Adrian Rifkin (eds.), *Fingering Ingres* (Oxford: Blackwell Publishers, 2001), 93–121, 104–5.

20. Anne Anlin Cheng, *Ornamentalism* (New York: Oxford University Press, 2019).

21. Cheng, *Ornamentalism*, x. This institutionalization, as Cheng no doubt recognizes, has become particularly acute within the academy, as the neoliberal university has increasingly moved to strategically recuperate "intersectionality" within what Jennifer C. Nash calls the "diversity and inclusion complex." See Nash, *Black Feminism Reimagined: After Intersectionality* (Durham, NC: Duke University Press, 2019).

22. Cheng, 17.

23. Cheng, 16.

24. The most obvious problem, which I will not belabor here, is Cheng's presumption that racial-aesthetic formations—such as flesh or the ornamental—are simply interchangeable across various "identities" (even as, it would seem, "bare flesh" remains the general paradigm for the black woman, while the "complex fabrication[s]" and "assiduous assembl[ages]" of the ornamental constitute the general paradigm for the yellow woman). Such a presumption conveniently sidesteps an expansive black intellectual tradition which arguably stretches back at least as far as W. E. B. Du Bois that has posited blackness and anti-blackness as metaphysical problematics, the ontological codifications of which become evident in the constitutive interdictions of the black from the pretenses of personhood, subjectivity, humanity, and their various iterations in and as bodily sovereignty. Cheng's passing conflation of the enslavement endured by the black woman with that endured by the yellow woman ("she, too, has been enslaved") not only reduces slavery to an axiomatic, historico-empirical category and thereby elides black theories of the means by "which Blackness and Slaveness are imbricated *ab initio*" within modernity but, moreover, fails to acknowledge the singular racial gendering of black femininity within the reproduction nexus of transatlantic slavery and its afterlives. See Wilderson, *Red, White, and Black*, 340; and Morgan, "Partus Sequitur Ventrem," respectively.

25. Cheng, *Ornamentalism*, x, 2, 3.

26. Cheng, 4.

27. Cheng, 17–18.

28. Cheng, 4, 5, 6. Emphasis in original.

29. Cheng, 6. Emphasis in original.

30. Cheng, 6–7; Anne Anlin Cheng, *Second Skin: Josephine Baker and the Modern Surface* (New York: Oxford University Press, 2011).

31. Cheng, *Ornamentalism*, 7.

32. Cheng, *Second Skin*, 150–52.

33. Cheng, *Ornamentalism*, 6.

34. Hortense Spillers, "Notes on an Alternative Model—Neither/Nor," in *Black, White, and in Color: Essays on American Literature and Culture* (Chicago: University of Chicago, 2003), 301–18, 316.

35. Cheng, *Ornamentalism*, 17. First emphasis in original; second emphasis added.

36. Cheng, *Second Skin*, 12, 7.

37. Cheng, 7.

38. Cheng, 12.

39. Marriott, *Whither Fanon?*, 67–68. First emphasis mine; second emphasis in original.

40. Marriott, 121, passim.

41. Fanon, *Black Skin, White Masks*, 110.

42. Cheng, *Ornamentalism*, 7, 161n11.

43. Cheng, 172n4, passim.

44. Cheng, 23.

45. Cheng, 19.

46. Cheng, 172n4.

47. Cheng, 6, 161n13.

48. Given these erroneous attributions, one cannot help but wonder whether a text must actually be read in order to become "dominant," particularly when its author is a black woman.

49. Cheng, *Ornamentalism*, 65.

50. Cheng, 160fn4.

51. Here I am guided by David Marriott's compelling efforts to think toward a "black materialism." See Marriott, *Of Effacement*.

52. Warren, *Ontological Terror*, 148.

53. Spillers, *Black, White, and in Color*, 21.

54. Spillers, 203. Emphasis in original.

55. Spillers, 20.

56. Spillers, 203.

57. Cheng, *Ornamentalism*, 4.

58. Spillers, "Mama's Baby, Papa's Maybe," 203.

59. Spillers, 203.

60. Marriott, *Whither Fanon?*, 237.

61. Fred Moten and Stefano Harney make this formulation in Zach Ngin, Sara Van Horn, and Alex Westfall, "When We Are Apart We Are Not Alone: A Conversation with Fred Moten and Stefano Harney," *College Hill Independent*, 1 May 2020, https://www.theindy.org/2017.

62. Cheng, *Ornamentalism*, 152.

63. Cheng, 153; cf. Toni Morrison, *Beloved* (New York: Alfred A. Knopf, 1987).

64. Cheng, 153.

65. Cheng, 153.

66. Spillers, "Mama's Baby, Papa's Maybe," 207.

67. Spillers, 207.

68. Spillers, 207.

69. For an overview of the relevant literature, see Emiko Ohnuki-Tierney, "The Power of Absence: Zero Signifiers and Their Transgressions," *L'Homme*, 34ᵉ année, no. 130 (April–June 1994), 59–76. On "anagrammatical blackness," see Sharpe, *In the Wake*.

70. Cf. Cheng, *Ornamentalism*, 6, 156.

71. Abigail Solomon-Godeau, "Male Trouble: A Crisis in Representation," *Art History* 16, no. 2 (June 1993), 286–312, 286.

72. One notable exception is the work of Katherine Brion, which I take up later in this chapter. Brion, "Courbet's *The Bathers* and the 'Hottentot Venus': Destabilizing Whiteness in the Mid-Nineteenth-Century Nude," *Word & Image: A Journal of Verbal/Visual Enquiry* 35, no. 1 (2019), 12–32.

73. Cf. Patrice Douglass and Frank Wilderson, "The Violence of Presence: Metaphysics in a Blackened World," *Black Scholar* 43, no. 4 (2013), 117–23.

74. Da Silva, *Toward a Global Idea of Race*.

75. Samantha Pinto, *Infamous Bodies: Early Black Women's Celebrity and the Afterlives of Rights* (Durham, NC: Duke University Press, 2020), 106

76. Hartman, "Venus in Two Acts," 2.

77. For an exploration of the problem of the archive specifically as it pertains to Baartman, see Siphiwe Gloria Ndlovu, "'Body' of Evidence: Saartjie Baartman and the Archive," in Gordon-Chipembere, *Representation and Black Womanhood*, 17–30.

78. Scholars propose dates ranging from the mid-1770s to 1789. The years 1788 or 1789 are more commonly asserted, although Clifton Crais and Pamela Scully argue that Baartman was born at least a decade earlier. See Clifton Crais and Pamela Scully, *Sara Baartman and the Hottentot Venus: A Ghost Story and a Biography* (Princeton, NJ: Princeton University Press, 2009), 184n1.

79. See, e.g., Sharpley-Whiting, *Black Venus*, 17.

80. On the case for settler/state genocide under Dutch colonial rule, see Mohamed Adhikari, "A Total Extinction Confidently Hoped For: The Destruction of Cape San Society under Dutch Colonial Rule, 1700–1795," *Journal of Genocide Research* 12, no. 1–2, (March–June 2010), 19–44.

81. Crais and Scully, *Sara Baartman and the Hottentot Venus*, 9.

82. Spillers, "Mama's Baby, Papa's Maybe," 214.

83. Cf. Spillers.

84. In 1795 or 1796, not long after her mother died, Baartman was sold as chattel to Pieter Cesars, the employee of a wealthy merchant, and was brought to Cape Town, where she would spend the next decade in various forms of domestic slavery. During this period she would lose three children, each of whom died in infancy, and endure countless reiterations of the nexus of racial-sexual violence. It was supposedly Hendrick Cesars, a "Free Black," who first initiated the exhibitionary history for which Baartman would become synonymous. Crais and Scully, *Sara Baartman and the Hottentot Venus*, 1–58; Sharpley-Whiting, *Black Venus*, 17–18. Although, apropos Calvin Warren in *Ontological Terror*, the term "Free Black" itself exhibits a syntactical figuration of a metaphysical war rather than the existence of a historical figure, and thus the axiomatics of individuated agency must here be held in abeyance. Be that as it may, in what Hartman, *Scenes of Subjection*, might call his "indebted servitude" to one of the most powerful settlers in the colony, Jacobus Johannes Vos, Cesars began exhibiting Baartman to sailors in a military hospital for a few shillings each, overtly foreshadowing the modalities of fleshly violation and forms of bodily dissimulation that were to be her fate in Europe.

85. Sadiah Qureshi, "Displaying Sara Baartman, the 'Hottentot Venus,'" *History of Science* 42, no. 2 (2004), 233–57; Sadiah Qureshi, *Peoples on Parade: Exhibitions, Empire, and Anthropology in Nineteenth-Century Britain* (Chicago: University of Chicago Press, 2011).

86. Z. S. Strother, "Display of the Body Hottentot," in Bernth Lindfors (ed.), *Africans on Stage: Studies in Ethnological Show Business* (Bloomington: Indiana University Press, 1999), 1–61, 24.

87. Qureshi, "Displaying Sara Baartman," 236.

88. Strother, "Display of the Body Hottentot"; Qureshi, "Displaying Sara Baartman"; Qureshi, *Peoples on Parade*. In fact, Baartman's display, "the first celebrity exhibit of the nineteenth century," might be said to have inaugurated a new genre, "the ethnopornographic freak show," even as such innovation is only a historical variation on the transhistorical refrain of pornotroping within the modern world. Qureshi, *Peoples on Parade*, 3; Crais and Scully, *Sara Baartman and the Hottentot Venus*, 73.

89. On the British urban geography of formal and informal state and parastatal regulation and enclosure of sex work, see Phil Hubbard, "Red-Light Districts and Toleration Zones: Geographies of Female Street Prostitution in England and Wales," *Area* 29, no. 2 (1997), 129–40.

90. Crais and Scully, *Sara Baartman and the Hottentot Venus*, 78.

91. Moten, *Black and Blur*, 75.

92. From the "Transcripts of the Sworn Affidavits Filed During the Trial of 1810," cited in Strother, "Display of the Body Hottentot," 43.

93. Robert Chambers (ed.), *The Book of Days: A Miscellany of Popular Antiquities, in Connection with the Calendar* (2 vols., London and Edinburgh, 1863), ii, 621, quoted in Qureshi, "Displaying Sara Baartman," 236.

94. Steatopygia, which the *OED* defines as a "protuberance of the buttocks, due to an abnormal accumulation of fat in and behind the hips and thighs, found (more markedly in women than in men) as a characteristic of certain peoples, esp. the Khoekhoe and San of South Africa," is, of course, a racially gendered anatomization which is as much aesthetic as it is scientific.

95. Rizvana Bradley, "The Vicissitudes of Touch: Annotations on the Haptic," *b2o review* (21 November 2020). https://www.boundary2.org/2020/11/rizvana-bradley-the-vicissitudes-of-touch-annotations-on-the-haptic/.

96. Testimony of William Bullock from the trial of 1810, cited in Crais and Scully, *Sara Baartman and the Hottentot Venus*, 80.

97. This is the explanation given by Qureshi, "Displaying Sara Baartman," 246.

98. Sharpley-Whiting, *Black Venus*, 31.

99. As Christina Sharpe astutely contends, the concurrent debates over Baartman's remains amongst activists, scholars, and artists became "laden with the promise and weight of national healing," too often overdetermined by the hope or demand for redemption, which, "as a political strategy . . . replaces a real reckoning with history (state brutality, colonialism, slavery, apartheid, ethnocentrism, truth and reconciliation) and its consequences with a symbolic sacrifice; it demands that some atrocities remain unspoken and unspeakable." Sharpe, *Monstrous Intimacies*, 74, 73. For a survey of the various debates concerning Baartman's remains, see Ciraj Rassool, "Human Remains, the Disciplines of the Dead, and the South African Memorial Complex," in Derek R. Peterson, Kodzo Gavua, and Ciraj Rassool (eds.), *The Politics of Heritage in Africa: Economies, Histories, and Infrastructures* (Cambridge: Cambridge University Press, 2015), 133–56.

100. Hartman, *Scenes of Subjection*, 103.

101. Cf. Jacques Derrida, *Before the Law: The Complete Text of Préjugés*, trans. Sandra van Reenen and Jacques de Ville (Minneapolis: University of Minnesota Press, 2018).

102. Sharpe, *Monstrous Intimacies*, 81.

103. Kate Flint, "The Social Life of the Senses: The Assaults and Seductions of Modernity," in Classen, *A Cultural History of the Senses in the Age of Empire*, 25–46, 32.

104. Bhandar, *Colonial Lives of Property*.

105. Antonio Barrera-Osorio, *Experiencing Nature: The Spanish American Empire and the Early Scientific Revolution* (Austin: University of Texas Press, 2006); James Delbourgo, *Collecting the World: Hans Sloane and the Origins of the British Museum* (Cambridge: Belknap

Press, 2017); Immanuel Wallerstein, *The Modern World-System II: Mercantilism and the Consolidation of the European World-Economy, 1600–1750* (Berkeley: University of California Press, 2011 [1980]).

106. On this latter point, see James Poskett, *Materials of the Mind: Phrenology, Race, and the Global History of Science, 1815–1920* (Chicago: University of Chicago Press, 2019).

107. Spillers, "Mama's Baby, Papa's Maybe," 208.

108. Warren, *Ontological Terror*, 118. Emphasis in original.

109. For a historical overview, see Andrew S. Curran, *The Anatomy of Blackness: Science and Slavery in an Age of Enlightenment* (Baltimore: Johns Hopkins University Press, 2011). Britt Rusert has made a case for black and indigenous "re-visionings" of race science during the 1830s and 1840s, suggesting a "dialectic of calculated visibility and strategic invisibility . . . [that shaped] black ethnology's theorization of the visual in and against race science." Rusert, *Fugitive Science: Empiricism and Freedom in Early African American Culture* (New York: NYU Press, 2017), 26, 65–112.

110. Quoted in Curran, 81.

111. The significance of the gradual displacement of racial theories of monogenesis by racial theories of polygenesis should not, however, be overstated. As Zakiyyah Iman Jackson has suggested, "These positions . . . were more of a threshold effect than opposing positions: what they lacked in logical clarity they more than made up for in complementary social and political agendas." Jackson, *Becoming Human*, 171.

112. Michel Foucault, *The Order of Things: An Archeology of the Human Sciences* (London: Routledge, 2002 [1966]), 294.

113. Anne McCauley, "Beauty or Beast? Manet's Olympia in the Age of Comparative Anatomy," *Art History* 43, no. 4 (September 2020), 742–73.

114. McCauley, 752.

115. Mel Y. Chen, *Animacies: Biopolitics, Racial Mattering, and Queer Affect* (Durham: Duke University Press, 2012). Relevant texts include Jackson, *Becoming Human*; Bennett, *Being Property Once Myself*; Achille Mbembe, *On the Postcolony* (Berkeley: University of California Press, 2001); among others. See also, inter alia, Bénédicte Boisseron, *Afro-Dog: Blackness and the Animal Question* (New York: Columbia University Press, 2018); Claire Jean Kim, *Dangerous Crossings: Race, Species, and Nature in a Multicultural Age* (Cambridge: Cambridge University Press, 2015); Lindgren Johnson, *Race Matters, Animal Matters: Fugitive Humanism in African America, 1840–1930* (New York: Routledge, 2018); Jack Halberstam, *Wild Things: The Disorder of Desire* (Durham, NC: Duke University Press, 2020); and Julietta Singh, *Dehumanism and Decolonial Entanglements* (Durham, NC: Duke University Press, 2017).

116. Spillers, *Black, White, and in Color*, 155.

117. Henri de Blainville, "Sur une femme de la race Hottentote," *Bulletin du Société philomatique de Paris* 183–90, 183, quoted in Anne Fausto-Sterling, "Gender, Race, and Nation: The Comparative Anatomy of 'Hottentot' Women in Europe, 1815–1817," in Londa Schiebinger (ed.), *Feminism and the Body* (Oxford: Oxford University Press, 2000), 203–33, 218.

118. Jackson, *Becoming Human*, 48.

119. Martin Heidegger, *Introduction to Metaphysics*, rev. and expanded 2nd ed., trans. Gregory Fried and Richard Polt (New Haven, CT: Yale University Press, 2014 [1935/1953]), 17. For black theoretical engagements with Heidegger's invocation of the "Hottentot," see

Warren, *Ontological Terror*, 13, 174–75n12, 180n7; Jackson, *Becoming Human*, 8, 34, 98–99, 233n29, 234n33. See also Nelson Maldonado-Torres, "On the Coloniality of Being: Contributions to the Development of a Concept," *Cultural Studies* 21, no. 2–3 (2007), 240–70.

120. Warren, *Ontological Terror*, 175n12. Emphasis in original.

121. Fausto-Sterling, "Gender, Race, and Nation," 209.

122. Londa Schiebinger, "Introduction," in Schiebinger, *Feminism and the Body*, 10. To these latter fixations, he dedicated many pages in his documentation of Baartman's dissection, while devoting only one paragraph to her brain. Schiebinger, 10.

123. Quoted in Crais and Scully, *Sara Baartman and the Hottentot Venus*, 135.

124. Karl Marx, *Grundrisse: Foundations of the Critique of Political Economy*, trans. Martin Nicolaus (London: Penguin Books, 1973 [1858]), 408.

125. Crais and Scully, *Sara Baartman and the Hottentot Venus*, 138.

126. Marriott, "Perfect Beauty of Black Death."

127. Honoré de Balzac, *The Wild Ass's Skin* (London: J. M. Dent & Sons, 1906 [1831]), 21.

128. Michel Foucault, "Cuvier's Situation in the History of Biology," trans. Lynne Huffer, *Foucault Studies*, no. 22 (January 2017 [1969]), 208–37; Foucault, *The Order of Things*, 304.

129. Foucault, trans. Huffer, "Cuvier's Situation," 208. The epistemological transformation Cuvier effected, Foucault suggests, unfolded against the grain of Cuvier's own commitment to the principles of "fixism and finality," the presuppositions through which Cuvier was able to fabricate a rapprochement between his comparative anatomy and paleontology. Foucault, 214.

130. Foucault, *Order of Things*, 294. To be clear, I am by no means suggesting that Baartman was exceptional in these respects. Countless black people have been literally and figuratively exhibited, studied, dismembered, and put to scientific and aesthetic use. However, as one of the quintessential figures of black femininity during the nineteenth century (and still today) who was quite explicitly fashioned and fetishized as a limit or threshold case for the entwined scientific and aesthetic codifications of the corporeal division of the world, it would be difficult to understate her material-discursive significance.

131. Lynne Huffer, *Are the Lips a Grave? A Queer Feminist on the Ethics of Sex* (New York: Columbia University Press, 2013), 142–60.

132. Georges Cuvier, *Discours sur les révolutions de la surface du globe: et sur les changements qu'elles ont produits dans le règne animal* (Paris, 1825).

133. Cf. da Silva, "No-Bodies."

134. Kyla Schuller, *The Biopolitics of Feeling: Race, Sex, and Science in the Nineteenth Century* (Durham, NC: Duke University Press, 2018).

135. Schuller, *Biopolitics of Feeling*, 5, 6.

136. Schuller, 54.

137. Erica Fretwell, *Sensory Experiments: Psychophysics, Race, and the Aesthetics of Feeling* (Durham, NC: Duke University Press, 2020).

138. Fretwell, *Sensory Experiments*, 17.

139. Schuller, *Biopolitics of Feeling*, 84.

140. Schuller, 144.

141. Cuvier, *Discours sur les révolutions de la surface du globe*, 214. Quoted in Sharpley-Whiting, *Black Venus*, 24.

142. Sharpley-Whiting, 24.

143. Georges Bataille, "The Big Toe," in *Visions of Excess*, 20–23.

144. Bataille, "The Big Toe," 22. Emphasis added.

145. Bataille, 23.

146. Bataille, 23.

147. Marriott, *Whither Fanon?*, 327.

148. Chandler, *X—The Problem of the Negro*, 20.

149. Cuvier, *Discours sur les révolutions du globe*, 214–15, quoted in Sharpley-Whiting, *Black Venus*, 25.

150. Sharpley-Whiting, 25.

151. Moten, *In the Break*, 1.

152. Cuvier, *Discours sur les révolutions du globe*, 216–218, quoted in Sharpley-Whiting, *Black Venus*, 28.

153. Sharpley-Whiting, 28.

154. Marriott, "Perfect Beauty of Black Death."

155. Bataille, "The Big Toe," 22.

156. Karl Marx, *Capital*, vol. 3 (London: Penguin, 1981), 949.

157. C. L. R. James, *Beyond a Boundary* (Durham, NC: Duke University Press, 1993 [1963]).

158. T. J. Clark, *The Painting of Modern Life: Paris in the Art of Manet and His Followers*, rev. ed. (Princeton, NJ: Princeton University Press, 1984), 79–146, 146.

159. Clark, *The Painting of Modern Life*, xxviii.

160. Moten, *Universal Machine*, 199.

161. Nead, *Female Nude*, 43; Neil Maclaren, *Velazquez: The Rokeby Venus in the National Gallery, London* (London: Percy Lund Humphries, 1943).

162. Maclaren, *Velazquez*, 1.

163. Nead, *Female Nude*, 43.

164. Nead, 43–44.

165. Nead, esp. 12–22; Kenneth Clark, *The Nude: A Study in Ideal Form* (Princeton, NJ: Princeton University Press, 1984 [1972]).

166. Nead, *Female Nude*, 18.

167. Mary Ann Doane, *Bigger Than Life: The Close-Up and Scale in the Cinema* (Durham, NC: Duke University Press, 2021), 72. Doane emphasizes this point in relation to the ambitions of architecture, a matter to which we turn in chapter 5.

168. Nead, *Female Nude*.

169. Nead, 17.

170. Nead, 17.

171. Nead, 17.

172. Nead, 44.

173. Nelson, *Color of Stone*, 75.

174. Nelson, 75.

175. Clark, *The Nude*, 20.

176. Charmaine Nelson, *Representing the Black Female Subject in Western Art* (Hoboken: Taylor & Francis, 2010), 147. This same passage is quoted in Katherine Brion's study of Courbet ("Courbet's *The Bathers* and the 'Hottentot Venus'"). However, I want to note the

differential emphasis in my study, which concerns the displacement of flesh in nineteenth-century painting and black femininity's bearing of the burden of that displacement.

177. Elsewhere, drawing on Christina Sharpe's concept of "the weather," I have theorized this process as *the weathering of form*. See Rizvana Bradley, "The Weathering of Form: Jennifer Packer's Abstract Figures," in Melissa Blanchflower and Natalia Grabowska (eds.), *Jennifer Packer: The Eye Is Not Satisfied With Seeing* (London: Serpentine Galleries, 2020). Cf. Sharpe, *In the Wake*.

178. Clark, *The Nude*, 150–51.

179. Susan L. Siegfried, *Ingres: Painting Reimagined* (New Haven, CT: Yale University Press, 2009).

180. Susan Siegfried, "Ingres' Reading—The Undoing of Narrative," in Siegfried and Rifkin (2001), 4–30, 5.

181. Quoted in Benjamin, "Ingres chez les fauves," 105.

182. Andrew Carrington Shelton, *Ingres and His Critics* (Cambridge: Cambridge University Press, 2005), 169.

183. The *ingristes*, as Ingres scholar Sarah Betzer explains, were said to be disciples and pupils of Ingres who generally defended the master painter's aesthetic against his critics. See Betzer, *Ingres and the Studio: Women, Painting, History* (University Park: Pennsylvania State University Press, 2012), 86.

184. Shelton, *Ingres and His Critics*, 169.

185. Shelton, 169.

186. Shelton, 169.

187. Siegfried, "Ingres' Reading," 5.

188. Siegfried, 5.

189. Siegfried, 5.

190. Siegfried, *Ingres: Painting Reimagined*, 6.

191. Shelton, *Ingres and His Critics*, 177–78.

192. Charles Baudelaire, "Salon of 1846," in *Charles Baudelaire: Selected Writings on Art and Literature*, trans. P. E. Charvet (Cambridge: Cambridge University Press, 1972 [1846]), 51.

193. Ockman, *Ingres's Eroticized Bodies*, 4, 4–5.

194. Ockman, 4.

195. Ockman.

196. Benjamin, "Ingres chez les fauves," 104–5.

197. Benjamin, 105.

198. Benjamin, 166.

199. Ockman, *Ingres's Eroticized Bodies*, 7.

200. Ockman, 1.

201. Ockman, 1.

202. Ockman, 2

203. William Hogarth, quoted in Ockman, 2.

204. Ockman, 2.

205. Ockman, 4.

206. Kirsten Hoving Powell, "*Le Violon d'Ingres*: Man Ray's Variations on Ingres, Deformation, Desire and de Sade," in Siegfried and Rifkin, *Fingering Ingres*, 122–49, 142.

207. Siegfried, *Ingres: Painting Reimagined*.

208. Ockman, *Ingres's Eroticized Bodies*, 5.

209. Siegfried, *Ingres: Painting Reimagined*, 107.

210. Siegfried, 107.

211. Siegfried, 107.

212. Sharpley-Whiting, *Black Venus*, 28.

213. Emmelyn Butterfield-Rosen, *Modern Art and the Remaking of Human Disposition* (Chicago: University of Chicago Press, 2021), 27; see 1–30 for a review of the relevant literature.

214. Nead, *Female Nude*, 63.

215. Siegfried, "Ingres' Reading," 9–10, 12.

216. Siegfried, *Ingres: Painting Reimagined*, 108.

217. Her centrality to the aesthetic and artistic imagination of Paris at this time may be noted in various examples of artists engaging her directly as their subject. For instance, "Vaudeville dramatists crafted a new opera *La Venus Hottentote*." Crais and Scully, *Sara Baartman and the Hottentot Venus*, 116.

218. Crais and Scully, 120.

219. Crais and Scully, 120.

220. Crais and Scully, 117.

221. Crais and Scully, 124.

222. See, inter alia, Giovanni Arrighi, *The Long Twentieth Century: Money, Power, and the Origins of Our Times* (London: Verso Books, 1994).

223. Brion, "Courbet's *The Bathers* and the 'Hottentot Venus.'"

224. Brion, 25, 13.

225. Brion, 27.

226. Brion, 16.

227. Betzer, *Ingres and the Studio*, 90.

228. Trouillot, *Silencing the Past*, 73.

229. Hartman, *Scenes of Subjection*, 11.

230. Cf. Wilderson, *Red, White, and Black*, passim.

231. Clark, *The Nude*, 3.

232. Nead, *Female Nude*, 12.

233. "Civil Actions—The Hottentot Venus," *Times of London*, 29 November 1810, 3.

234. Fanon, *Black Skin, White Masks*, 34.

235. Wilderson, *Red, White, and Black*, 324–25.

236. Craig Dworkin, *No Medium* (Cambridge, MA: MIT Press, 2013), 10.

237. Jacques Derrida quoted in Dworkin, *No Medium*, 10.

238. Cheng, *Ornamentalism*, 5.

239. Cheng, 179–80n34.

240. Tamar Garb, *The Painted Face: Portraits of Women in France: 1814–1914* (New Haven, CT: Yale University Press, 2007), 4, 9.

241. Moten, *In the Break*, 180.

242. Brion, "Courbet's *The Bathers* and the 'Hottentot Venus,'" 13.

243. Marriott, *Haunted Life*, 5.

244. Cf. Paulsen, *Here/There*, 8.

245. Cf. Merleau-Ponty *The Phenomenology of Perception*, trans. Smith, 140.

246. Laura U. Marks, Dominique Chateau and José Moure, "The Skin and the Screen—A Dialogue," in Dominique Chateau and José Moure (eds.), *Screens: From Materiality to Spectatorship—A Historical and Theoretical Reassessment* (Amsterdam: Amsterdam University Press, 2016), 258–63, 259.

Chapter 4

1. On untimeliness, see Marriott, *Whither Fanon?*

2. Glenn Ligon, *Yourself in the World: Selected Writings and Interviews*, Scott Rothkopf, ed. (New Haven, CT: Yale University Press, 2011), 77.

3. Ligon, 77.

4. Ligon, x.

5. Zora Neale Hurston, "How It Feels to Be Colored Me," in *I Love Myself When I Am Laughing: A Zora Neale Hurston Reader* (New York: Feminist Press, 1979), 152–55.

6. Christine Poggi, "Following Acconci/Targeting Vision," in Amelia Jones and Andrew Stephenson (eds.), *Performing the Body/Performing the Text* (London: Routledge, 1999), 255–72, 255.

7. For example, Andrew Maerkle, "Glenn Ligon: Pt I: ECRITURE/ERASURE/ECSTASIS," ART iT, 12 December 2013, https://www.art-it.asia/en/u/admin_ed_itv_e/bveaxyvutf2zjdpmko5w.

8. Krista Thompson, "'Negro Sunshine': Figuring Blackness in the Neon Art of Glenn Ligon," in Hamza Walker (ed.), *Black Is, Black Ain't* (Chicago: Renaissance Society at the University of Chicago Press, 2013), 16–25, 18–19.

9. Donika Kelly, *Bestiary: Poems* (Minneapolis: Graywolf Press, 2016), 16.

10. See Mercer, *Travel & See*, 164.

11. I am referring, of course, to the "iron bit," or "gag," which was one of many of the instruments of torture and repression during the formal epoch of transatlantic slavery.

12. Marriott, *Whither Fanon?*, 64. Emphasis in original.

13. Michael Fried, *Absorption and Theatricality: Painting and Beholder in the Age of Diderot* (Chicago: University of Chicago Press, 1980).

14. Michael Fried, *Art and Objecthood: Essays and Reviews* (Chicago: University of Chicago Press, 1998), 155. Original emphasis; Fried, *Absorption and Theatricality*, 103.

15. Du Bois, *Souls of Black Folk*, 2.

16. Du Bois, 2.

17. Niklas Luhmann, *Art as a Social System*, trans. Eva M. Knodt (Stanford, CA: Stanford University Press, 2000).

18. Lauri Firstenberg, "Neo-Archival and Textual Modes of Production: An Interview with Glenn Ligon," *Art Journal* 60, no. 1 (2001), 42–47, 46.

19. *Online Etymological Dictionary*, s.v. "translate (v.)," accessed 22 December 2021, https://www.etymonline.com/word/translate.

20. This phrasing comes from the organizing theme of the 2nd International Conference on Intersemiotic Translation, "Transmedial Turn? Potentials, Problems, and Points to Consider," e-conference, 8–11 December 2020. For an example of a reading of Ligon's work as an

instantiation of a more general "transmedial conceptualism," see Garrett Stewart, *Transmedium: Conceptualism 2.0 and the New Object Art* (Chicago: University of Chicago Press, 2017).

21. Benedict Anderson, *Imagined Communities: Reflections on the Origin and Spread of Nationalism* (London: Verso Books, 1983), 46, passim.

22. Harold A. Innis, *The Bias of Communication* (Toronto: University of Toronto Press, 1951); Harold A. Innis, *Empire and Communications* (Victoria: Press Porcépic, 1986); Marshall McLuhan, *The Gutenberg Galaxy: The Making of Typographic Man* (Toronto: University of Toronto Press, 1962); Friedrich A. Kittler, *Discourse Networks, 1800/1900* (Stanford, CA: Stanford University Press, 1990 [1985]); Walter J. Ong, *Orality and Literacy: The Technologizing of the Word* (London: Methuen, 1982).

23. Kittler, *Discourse Networks*; Innis, *Bias of Communication*.

24. McLuhan, *Gutenberg Galaxy*, 18. For a thoughtful, critical engagement of McLuhan on this point, see Armond R. Towns, "The (Racial) Biases of Communication: Rethinking Media and Blackness," *Social Identities: Journal for the Study of Race, Nation and Culture* 21, no. 5 (2015), 474–88.

25. Henry Louis Gates Jr., "Literary Theory and the Black Tradition," in James L. Machor and Philip Goldstein (eds.), *Reception Study: From Literary Theory to Cultural Studies* (New York: Routledge, 2001), 105–17, 113.

26. Lindon Barrett, "African-American Slave Narratives: Literacy, the Body, Authority," in Lindon Barrett, *Conditions of the Present: Selected Essays*, ed. Janet Neary (Durham, NC: Duke University Press, 2018), 92–118, 100.

27. Barrett, "African-American Slave Narratives," 114. Emphasis in original.

28. On logocentrism, see Jacques Derrida, *Of Grammatology* (Baltimore: Johns Hopkins University Press, 1976). See also Donald M. Lowe, *History of Bourgeois Perception* (Chicago: University of Chicago Press, 1982); John McCumber, "Derrida and the Closure of Vision," in David Michael Levin (ed.), *Modernity and the Hegemony of Vision* (Berkeley: University of California Press, 1993), 234–51.

29. Lindon Barrett, *Blackness and Value: Seeing Double* (Cambridge: Cambridge University Press, 1999), 216.

30. Cf. Moten, *In the Break*.

31. See, inter alia, W. J. T. Mitchell, *Iconology: Image, Text, Ideology* (Chicago: University of Chicago Press, 1986); W. J. T. Mitchell, *Picture Theory: Essays on Verbal and Visual Representation* (Chicago: University of Chicago Press, 1994).

32. W. J. T. Mitchell, "Word and Image," in Robert S. Nelson and Richard Shiff (eds.), *Critical Terms for Art History*, 2nd ed. (Chicago: University of Chicago Press, 2003), 58–59. Emphasis in original.

33. W. J. T. Mitchell, *Seeing Through Race* (Cambridge: Harvard University Press, 2012).

34. Mitchell, "Word and Image," 59–60.

35. Barrett, *Blackness and Value*, 75.

36. Sarah Whitcomb Laiola, "From Float to Flicker: Information Processing, Racial Semiotics, and Anti-Racist Protest, from 'I Am a Man' to 'Black Lives Matter,'" *Criticism* 60, no. 2 (Spring 2018), 247–68; N. Katherine Hayles, *How We Became Posthuman: Virtual Bodies in Cybernetics, Literature, and Informatics* (Chicago: University of Chicago Press, 1999).

37. Hayles, *How We Became Posthuman*, 30. In contrast to oral articulations or the written mark, Hayles suggests, the flickering signifiers that appear on computer screens are merely the visible surface of deeper computational operations, "which MANIFEST themselves as marks to a user, but are properly understood as processes when seen in the context of the digital machine." From Hayles's email correspondence with Lisa Gitelman, quoted in Lisa Gitelman, *Always Already New: Media, History, and the Data of Culture* (Cambridge: MIT Press, 2006), 160n36.

38. Laiola, "From Float to Flicker."

39. Kari Rittenbach, "Glenn Ligon, *Condition Report*, 2000," summary, Tate, https://www.tate.org.uk/art/artworks/ligon-condition-report-l02822.

40. Laiola, "From Float to Flicker," 252, 250.

41. Laiola, 260.

42. Laiola, 262.

43. Cf. Laura U. Marks, *Enfoldment and Infinity: An Islamic Genealogy of New Media Art* (Cambridge, MA: MIT Press, 2010).

44. Zora Neale Hurston, "Characteristics of Negro Expression," in Nancy Cunard (ed.), *The Negro: An Anthology* (London: Wishart & Co., 1934), 24–31, 39.

45. Laiola, "From Float to Flicker," 261.

46. Laiola, 261.

47. Scott Rothkopf, "Glenn Ligon: America," in *Glenn Ligon: America* (New Haven, CT: Yale University Press, 2011), 15–49, 26–27.

48. English, *How to See a Work of Art*, 211.

49. Clement Greenberg, "Modernist Painting," in Francis Frascina and Charles Harrison (eds.), *Modern Art and Modernism: A Critical Anthology* (Toronto: Westview Press, 1983), 5–10, 6; Hayles, *How We Became Posthuman*, 26. Here Hayles is reading Kittler, *Discourse Networks*.

50. Ligon, *Yourself in the World*, 79.

51. Nicole R. Fleetwood, *Troubling Vision: Performance, Visuality, Blackness* (Chicago: University of Chicago Press, 2011), 20.

52. For a series of thoughtful reflections on "contemporary art," see "Questionnaire on 'The Contemporary,'" *October* 130 (2009), 3–124.

53. For overviews of this variegated tradition, see Luis Camnitzer, Jane Farver, and Rachel Weiss (eds.), *Global Conceptualism: Points of Origin, 1950s–1980s* (New York: Queens Museum of Art, 1999); and Peter Osborne (ed.), *Conceptual Art: Themes and Movements* (London: Phaidon, 2002).

54. Rosalind Krauss, *A Voyage on the North Sea: Art in the Age of the Post-Medium Condition* (London: Thames & Hudson, 1999), 9.

55. Greenberg, *Art and Culture*, 6.

56. Albert Stabler, "The Contractual Aesthetics of Sharecropping in Black Conceptualism," *Critical Arts: South-North Cultural and Media Studies*, October 2020, 1–15, 1; Mark Sheerin, "Artists Come from Such Strange Places: Glenn Ligon Talks Abstraction, Discrimination and Nottingham Contemporary," *Culture24*, 17 May 2015.

57. In Henry Flynt's well-known formulation, "'concept art' is first of all an art of which the material is concepts, like the material of music is sound. Since concepts are closely

bound up with language, concept art is the kind of art of which the material is language." Flynt, "Concept Art," 1961, in La Monte Young (ed.), *An Anthology of Chance Operations, Concept Art, Anti Art, Indeterminacy, Plans of Action, Diagrams, Music, Dance Constructions, Improvisation, Meaningless Work, Natural Disasters, Compositions, Mathematics, Essays, Poetry* (New York: George Maciunas and Jackson MacLow, 1963).

58. Benjamin H. D. Buchloh, "Conceptual Art 1962–1969: From the Aesthetic of Administration to the Critique of Institutions," *October* 55 (Winter 1990), 105–43, 113.

59. Buchloh, "Conceptual Art 1962–1969."

60. English, *How to See a Work of Art*, 208.

61. English, 9.

62. Both Moten and Hartman are engaged in readings of Frederick Douglass's harrowing narrativization of "the blood-stained gate, the entrance to the hell of slavery" as a primal scene. Douglass, *Narrative of the Life of Frederick Douglass, An American Slave, Written by Himself* (New York: New American Library, 1968 [1845]), 25–26; Hartman, *Scenes of Subjection*, 3–4; Moten, *In the Break*, 1–24.

63. Sarah Kirk Hanley, "Ink | Working Proof: Glenn Ligon's Editions," *art21 magazine*, 4 May 2012, https://magazine.art21.org/2012/05/04/ink-working-proof-glenn-ligons-editions/ #.YcvEeSyIbOS.

64. Ellison, *Invisible Man*, 581.

65. Ellison, 3.

66. Quoted in John F. Callahan (ed.), *Ralph Ellison's Invisible Man: A Casebook* (Oxford: Oxford University Press, 2004), 24. Emphasis added.

67. William Lyne, "The Signifying Modernist: Ralph Ellison and the Limits of the Double Consciousness," *PMLA* 107, no. 2 (March 1992), 318–30, 329. For another effort to complicate Ellison's relationship to modernism, see Matthew Wilkens, *Revolution: The Event in Postwar Fiction* (Baltimore: Johns Hopkins University Press, 2016), 97–114.

68. Moten, *In the Break*, 68.

69. Moten, 68.

70. Ellison, *Invisible Man*, xi.

71. Ellison, xi.

72. Zach Blas, "Opacities: An Introduction," *Camera Obscura* 31, no. 2 (2016), 149–53, 149.

73. Thinking with and toward the terrible beauty of blackness is one of the principal commitments of Fred Moten's oeuvre.

74. Moten, *Universal Machine*, 140–246.

75. Edwards, *Epistrophies*, 69.

76. Frank B. Wilderson III, "The Vengeance of Vertigo: Aphasia and Abjection in the Political Trials of Black Insurgents," *InTensions Journal*, no. 5 (Fall/Winter 2011), 3, https:// intensions.journals.yorku.ca/index.php/intensions/article/view/37360. Emphasis added.

77. For a reflection on the appearance of the "negro girl meagre" in the archive of transatlantic slavery, see Marlene NourbeSe Philip and Patricia Saunders, "Defending the Dead, Confronting the Archive: A Conversation with M. NourbeSe Philip," *Small Axe* 12, no. 2 (June 2008), 63–79.

78. Moten, *Stolen Life*, 81.

79. Ligon, *Yourself in the World*, 113.

80. Ligon, 113, 114.

81. Marriott, "Perfect Beauty of Black Death."

82. Marriott. Emphasis in original.

83. Fred Botting and Scott Wilson, "Introduction: From Experience to Economy," in Fred Botting and Scott Wilson (eds.), *The Bataille Reader* (Malden, MA: Blackwell Publishers, 1997), 1–34, 2; Georges Bataille, "The Notion of Expenditure" in Stoekl, *Visions of Excess*, 116–29.

84. As evidenced, for instance, in the title and lyrics of Richard Whiting's popular 1916 song "Mammy's Little Coal Black Rose."

85. Kathryn Yusoff, "Queer Coal: Genealogies in/of the Blood," *philoSOPHIA* 5, no. 2 (Summer 2015), 203–29, 205.

86. Audre Lorde, "Coal," in *Coal* (New York: W. W. Norton, 1976), 6.

87. Mignon Nixon, "On the Couch," *October* 113 (Summer 2005), 39–76, 70.

88. I say this, fully realizing that Ligon has himself at times embraced the language of appropriation, albeit while emphasizing its quotidian meaning within a black vernacular context. In this respect, we might be better served by reading Ligon's language through Zora Neale Hurston's ethnographic theories of black expression than the oeuvres of Joseph Kosuth or Barbara Kruger. See, for example, Nikita Gale, "Q&A: Glenn Ligon Explores Sources, Influences, Racial Politics of His Text-Based Abstractions," *ArtsATL*, 7 (January 2013), https://www.artsatl.org/qa/; Hurston, "Characteristics of Negro Expression." On appropriation, see David Evans (ed.), *Appropriation* (London and Cambridge: Whitechapel Gallery and MIT Press, 2009).

89. Scott Rothkopf also uses the language of transposition in his preface to Ligon, *Yourself in the World*, x, although he does not pursue it as a theoretical intervention in and of itself.

90. Edwards, *Epistrophies*, 19.

91. Daniel Albright, *Panaesthetics: On the Unity and Diversity of the Arts* (New Haven: Yale University Press, 2012), 209.

92. Edwards, *Epistrophies*, 17, passim.

93. Barrett, *Racial Blackness*, 49.

94. Bradley and Marassa, "Awakening to the World, 118.

95. Ligon, *Yourself in the World*, 76.

96. Ligon, 76.

97. Thelma Golden quoted in Cathy Byrd, "Is There a 'Post-Black' Art? Investigating the Legacy of the Freestyle Show," *Art Papers*, November–December 2002, 35–39, 35. See also Thelma Golden, "Introduction," in *Freestyle* (Studio Museum in Harlem: New York, 2001); as well as James Small, "Post-Blackness and New Developments in African American Art and Art History," in Eddie Chambers (ed.), *The Routledge Companion to African American Art History* (New York: Routledge, 2020), 450–59.

98. See, for example, Margo Natalie Crawford, *Black Post-Blackness: The Black Arts Movement and Twenty-First Century Aesthetics* (Urbana: University of Illinois Press, 2017).

99. Samantha Pinto, *Difficult Diasporas: The Transnational Feminist Aesthetic of the Black Atlantic* (Durham, NC: Duke University Press, 2013), 120.

100. Barbara Johnson, "Thresholds of Difference: Structures of Address in Zora Neale Hurston," *Critical Inquiry* 12, no. 1 (Autumn 1985), 278–89, 279.

101. Barbara Johnson, *A World of Difference* (Baltimore: The Johns Hopkins University Press, 1987), 163.

102. Johnson, *A World of Difference*.

103. Hurston, "How It Feels to Be Colored Me," 153; Johnson, "Characteristics of Negro Expression," 281.

104. Marriott, *Whither Fanon?*, 64. Emphasis in original.

105. Rosalind Krauss, "Grids," *October* 9 (Summer 1979), 50–64, 50.

106. More specifically, in Krauss's view, "a fourfold field, a square" structured by the divisions of figure/ground and not-figure/not-ground. See Rosalind E. Krauss, *The Optical Unconscious* (Cambridge, MA: MIT Press, 1994), 13, 13–14, 19–20.

107. Hurston, "How It Feels to Be Colored Me," 152, 153, 154.

108. Here I borrow Brent Hayes Edwards's formulation in his reading of James Weldon Johnson to develop a theory of "black vernacular music" and "black vernacular time." Edwards, *Epistrophies*, 70, 59–85.

109. Rosalind E. Krauss, *The Originality of the Avant-Garde and Other Modernist Myths* (Cambridge, MA: MIT Press, 1985), 38.

110. Phillip Brian Harper, *Abstractionist Aesthetics: Artistic Form and Social Critique in African American Culture* (New York: NYU Press, 2015), 45–46. Emphasis in original.

111. Cf. Harper, *Abstractionist Aesthetics*, 73.

112. On this point, see also, Rizvana Bradley, "The Weathering of Form: Jennifer Packer's Abstract Figures," in Melissa Blanchflower and Natalia Grabowska (eds.), *Jennifer Packer: The Eye Is Not Satisfied with Seeing* (London: Serpentine Galleries, 2020).

113. Ligon, *Yourself in the World*, x.

114. Eve Meltzer, *Systems We Have Loved: Conceptual Art, Affect, and the Antihumanist Turn* (Chicago: University of Chicago Press, 2013), 88. The phrase "murky amalgam" is Adorno's. See Adorno, *Aesthetic Theory*, 275.

115. Du Bois, *Souls of Black Folk*, 1.

116. Chandler, *X—The Problem of the Negro*.

117. Moten, *In the Break*, 18.

118. Hurston, "How It Feels to Be Colored Me," 252.

119. This formulation marks a kind of gendered friction one might find between two strains of critical reflection on blackness and Heideggerian thrownness by Fred Moten, which could be discerned in the nonlinear declension from "they" to "she" or "her," between "they [who] remain outside of the world into which they have been brought, . . . they [who] are outside of the world into which they have been thrown," and "the little girl [who] poses a problem, posing as a problem, as a kind of thrownness; thrown into a problem and a pose and that pose's history." Moten, *Universal Machine*, 31; Moten, *Black and Blur*, 71. On the constitutive relation between (human) Being and thrownness in Heidegger, see Warren, *Ontological Terror*.

120. Ellison, *Invisible Man*, 7.

121. Harriet Beecher Stowe, *The Annotated Uncle Tom's Cabin*, ed. Henry Louis Gates Jr. and Hollis Robbins (New York: W. W. Norton, 2007), 486.

122. Cf. Andrew V. Uroskie, *Between the Black Box and the White Cube: Expanded Cinema and Postwar Art* (Chicago: University of Chicago, 2014). For an influential analysis of phan-

tasmagoria as a specific operation that has "pervaded the worlds of art and cinema, theater and spectacle," see Noam M. Elcott, "The Phantasmagoric Dispositif: An Assembly of Bodies and Images in Real Time and Space," *Grey Room*, no. 62 (Winter 2016), 42–71, 47.

123. See Fisher, *The Weird and the Eerie*, 61.

124. For detailed accounts, see John W. Frick, *Uncle Tom's Cabin on the American Stage and Screen* (New York: Palgrave Macmillan, 2012); Ben Brewster and Lea Jacobs, *Theatre to Cinema: Stage Pictorialism and the Early Feature Film* (Oxford: Oxford University Press, 1997).

125. Quoted in Brewster and Jacobs, *Theatre to Cinema*, 54.

126. Eric Lott, *Love and Theft: Blackface Minstrelsy and the American Working Class* (Oxford: Oxford University Press, 1993), 34. Emphasis in original.

127. Hartman, *Scenes of Subjection*, 28.

128. In Ligon's exhibition, the viewer is greeted by a wall text with a synopsis of this scene before encountering the film itself: "The scene shows an old woodshed. Uncle Tom is lying on the floor, and Cassy is seen to steal in, raise Uncle Tom's head, give him a drink of water, and steal away again. George Shelby enters. Going over to Uncle Tom, he raises his head from the floor and asks him if he did not remember him, also saying that he had come to take Tom back home. Tom tells him that it is too late; he is dying, and pointing to the sky, says that he can see his Heavenly home; a vision of Eva in Heaven appears on the wall of the shed, and as it disappears, Tom drops back dead. Shelby kneels by his side, and in rapid succession of visions of John Brown being led to execution, a battle scene from the Civil War, and a cross with a vision of emancipation, showing Abraham Lincoln with the negro slave kneeling at his feet with broken manacles, appear." "Uncle Tom's Cabin: Edison Film," in Thomas A. Edison, *Film Catalogue* (1903), http://utc.iath.virginia.edu/onstage/films/ficattaeat.html.

129. Louis Chude-Sokei, *The Last Darky: Bert Williams, Black-on-Black Minstrelsy, and the African Diaspora* (Durham, NC: Duke University Press, 2006).

130. Glenn Ligon quoted in Jason Moran, "Glenn Ligon," *Interview Magazine*, 22 May 2009, https://www.interviewmagazine.com/art/glenn-ligon.

131. Ligon quoted in Moran, "Glenn Ligon."

132. Ligon quoted in Moran.

133. Berlant, *Cruel Optimism*, 198.

134. Cf. Legacy Russell, *Glitch Feminism: A Manifesto* (London: Verso Books, 2020).

135. Moran, "Glenn Ligon"; Rick Altman, "The Silence of the Silents," *Musical Quarterly* 80, no. 4 (1996), 648–718.

136. Moran; Chude-Sokei, *The Last Darky*, 35.

137. Jane P. Tompkins, "Sentimental Power: Uncle Tom's Cabin and the Politics of Literary History," in Elaine Showalter, *The New Feminist Criticism: Essays on Women, Literature, and Theory* (New York: Pantheon Books, 1985), 81–104, 82.

138. Michelle Wallace, "Uncle Tom's Cabin: Before and after the Jim Crow Era," *TDR* 44, no. 1 (Spring 2000), 136–56, 141; Amanda Claybaugh, "Introduction," in Stowe, *Annotated Uncle Tom's Cabin*, xliii.

139. Quoted in Wallace, "Uncle Tom's Cabin," 142.

140. Wallace, 142; Manisha Sinha, *The Slave's Cause: A History of Abolition* (New Haven, CT: Yale University Press, 2016), 440. Indeed, as Sinha notes, the black abolitionist Martin

Delany decried Stowe for effectively stealing from the autobiographies of former slaves. Sinha, *The Slave's Cause*, 444.

141. Lauren Berlant, "Poor Eliza," *American Literature* 70, no. 3 (September 1998), 635–68, 638.

142. Hartman, *Scenes of Subjection*, 28.

143. Hartman, passim.

144. Daphne A. Brooks, *Bodies in Dissent: Spectacular Performances of Race and Freedom, 1850–1910* (Durham, NC: Duke University Press, 2006), 30.

145. Robin Bernstein, *Racial Innocence: Performing Childhood from Slavery to Civil Rights* (New York: New York University Press, 2011), 4, passim.

146. Hartman, *Scenes of Subjection*, 89.

147. Spillers, *Black, White, and in Color*, 188. Emphasis in original.

148. Marriott, "Perfect Beauty of Black Death." Emphasis in original.

149. For another inquiry that stresses the significance of repetition, see Yasmin Ibrahim, "The Dying Black Body in Repeat Mode: The Black 'Horrific' on a Loop," *Identities* 29, no. 6 (2022), 711–29.

150. Frick, *Uncle Tom's Cabin on the American Stage and Screen*, 133. See also Marc Robinson, *The American Play, 1787–2000* (New Haven, CT: Yale University Press, 2009).

151. Cf. Hartman, *Scenes of Subjection*.

152. Lott, *Love and Theft*.

153. Eric J. Sundquist (ed.), *New Essays on Uncle Tom's Cabin* (Cambridge: Cambridge University Press, 1987), 4.

154. Frick, *Uncle Tom's Cabin on the American Stage and Screen*, 17.

155. Hartman, *Scenes of Subjection*, 30.

156. As Bernstein notes, "It was this vision of Tom's death that motivated . . . [Stowe] to write her novel . . . [and] she wrote the first forty chapters to build toward that climax." Bernstein, *Racial Innocence*, 135–36.

157. In this regard, it is telling that Stowe sometimes slipped between narrating Tom's death and Tom's whipping as the visionary impetus for the novel. See Thomas F. Gossett, *Uncle Tom's Cabin and American Culture* (Dallas: Southern Methodist University Press, 1985), 92–93, on this discrepancy.

158. While discussion of these subsequent adaptations is not immediately pertinent to the present argument, it is worth noting that there have been numerous filmic and televisual adaptations of *Uncle Tom's Cabin*, in both the United States and internationally, over the course of the twentieth century. Indeed, Stephen Railton notes that were nine filmic adaptations during the 1903-1927 era of silent film alone. See Stephen Railton, "Readapting Uncle Tom's Cabin," in R. Barton Palmer (ed.), *Nineteenth-Century American Fiction on Screen* (Cambridge: Cambridge University Press, 2009), 62–76.

159. Charles Musser, *Before the Nickelodeon: Edwin S. Porter and the Edison Manufacturing Company* (Berkeley: University of California Press, 1991), 1, 4. See also Charles Musser, *The Emergence of Cinema: The American Screen to 1907* (Berkeley: University of California Press, 1994).

160. Mary Ann Doane, *The Emergence of Cinematic Time: Modernity, Contingency, and the Archive* (Cambridge, MA: Harvard University Press, 2002), 11. I should stress that, for

Doane, contingency is hardly axiomatic but rather a rich and complicated concept that assumes a "double function" due to "the tensions internal to its own definition"—expressing, on the one hand, "a resistance to systematicity" that nevertheless "partakes of systematicity, locked within the terms of its antagonist," and, on the other hand, a "reflexive concept" which compels reflection on "the history of its own impossible fate within modernity." Doane, *Emergence of Cinematic Time*, 231–32.

161. Doane, 22, 22–23.

162. Doane, 24.

163. Tom Gunning, "The Cinema of Attractions: Early Film, Its Spectator and the Avant-Garde," in Thomas Elsaesser (ed.), *Early Cinema: Space Frame Narrative*, (London: British Film Institute, 1990), 56–62; Tom Gunning, "cinema of attractions" in Richard Abel (ed.), *Encyclopedia of Early Cinema* (London/New York: Routledge, 2007), 124–27, 124; André Gaudreault and Tom Gunning, "Le cinéma des premiers temps: Un défi à l'histoire du cinéma?," in Jacques Aumont, André Gaudreault and Michel Marie (eds.), *Histoire du cinéma: Nouvelles approches* (Paris: Sorbonne, 1989) 49–63. See also Tom Gunning, "An Aesthetic of Astonishment: Early Film and the (In)Credulous Spectator," *Art and Text*, no. 34 (Spring 1989), 31–45.

164. Charles Musser, introduction to "The Early Cinema of Edwin S. Porter," *Cinema Journal* 19, no. 1 (Fall 1979), 1–38, reprinted in Cynthia Lucia, Roy Grundmann, and Art Simon (eds.), *The Wiley-Blackwell History of American Film* (Oxford, UK, and Malden, MA: Wiley-Blackwell, 2011); Tom Gunning, *D. W. Griffith and the Origins of American Narrative Film: The Early Years at Biograph* (Urbana and Chicago: University of Illinois Press, 1991).

165. Musser, *Emergence of Cinema*, 349.

166. Stephen Johnson, "Time and Uncle Tom: Familiarity and Shorthand in the Performance Traditions of Uncle Tom's Cabin," in Michelle MacArthur, Lydia Wilkinson, and Keren Zaiontz (eds.), *Performing Adaptations* (Cambridge: Cambridge Scholars Press, Fall 2009), 87, cited in Frick, *Uncle Tom's Cabin on the American Stage and Screen*, 193.

167. Noël Burch, "Porter, or Ambivalence," *Screen* 19, no. 4 (Winter 1978), 91–105.

168. Burch, "Porter, or Ambivalence," 97, 98.

169. Doane, *Emergence of Cinematic Time*, 163, 164.

170. Wilderson, *Red, White, and Black*.

171. David Marriott, *Lacan Noir: Lacan and Afro-pessimism* (Cham, CH: Palgrave Macmillan, 2021), 160. Emphasis in original.

172. Doane, *Emergence of Cinematic Time*, 230.

173. See, e.g., Steen Christiansen, "Metamorphosis and Modulation: Darren Aronofsky's *Black Swan*," in Denson and Leyda (2016), *Post-Cinema*, 514–37, 516; and, Ruth Mayer, "Early/Post-Cinema: The Short Form, 1900/2000," in Denson and Leyda (2016), *Post-Cinema*, 616–646.

174. Tom Gunning, "A Little Light on a Dark Subject," *Critical Quarterly* 45, no. 4 (2003), 50–69, 50–51.

175. Sobchack *Carnal Thoughts*, 160–61.

176. Sobchack, 161, 153.

177. Avery F. Gordon, *Ghostly Matters: Haunting and the Sociological Imagination* (Minneapolis: University of Minnesota Press, 1997), xvi.

178. Marriott, *Haunted Life*, 2.

179. Marriott, "Corpsing," 33, 35.

180. Derrida, *Of Grammatology*, 61.

181. Moten, *In the Break*.

182. Alexander R. Galloway, Eugene Thacker, and McKenzie Wark, *Excommunication: Three Inquiries in Media and Mediation* (Chicago: University of Chicago Press, 2014), 13.

183. Galloway, Thacker, and Wark, *Excommunication*, 10.

184. Eugene Thacker, "Dark Media," in Galloway, Thacker, and Wark, 77–150, 85.

185. For more extended reflections on the racial entanglements of lightness and darkness, transparency and opacity, color and its absence, see Moten, *Universal Machine*, 140–246; Jared Sexton, "All Black Everything," *e-flux*, no. 79 (February 2017), https://www.e-flux.com/journal/79/94158/all-black-everything/.

186. Thacker, "Dark Media," 80.

187. Vivian Sobchack, "The Scene of the Screen: Envisioning Photographic, Cinematic, and Electronic 'Presence,'" in Denson and Leyda, *Post-Cinema*, 120.

188. Saidiya Hartman quoted in Judith Butler, "Is Kinship Always Already Heterosexual?" *differences: A Journal of Feminist Cultural Studies* 13, no. 1 (Spring 2002), 14–44, 15; Marriott, *Haunted Life*, 32.

189. Here I am invoking and modifying Laura Mulvey's classic theorization of the apparatic in "Visual Pleasure and Narrative Cinema," *Screen* 16, no. 3 (Autumn 1975), 6–18.

190. On Topsy as the paradigmatic figure of the pickaninny, see Bernstein, *Racial Innocence*; Patricia A. Turner, *Ceramic Uncles and Celluloid Mammies: Black Images and Their Influence on Culture* (Charlottesville: University of Virginia Press, 2002); Jayna Brown, *Babylon Girls: Black Women Performers and the Shaping of the Modern* (Durham, NC: Duke University Press, 2008); Tavia Nyong'o, "Racial Kitsch and Black Performance," *Yale Journal of Criticism* 15, no. 2 (2002), 371–91.

191. Stowe, *The Annotated Uncle Tom's Cabin*, 249, 260; Bernstein, *Racial Innocence*, 45.

192. Stowe, 260. Emphasis in original.

193. Stowe, 249–50.

194. Sharpe, *Monstrous Intimacies*, 214n2.

195. Hartman, *Scenes of Subjection*, 20.

196. Hartman, 26.

197. Stowe, *The Annotated Uncle Tom's Cabin*, 258.

198. Ngai, *Ugly Feelings*, 95.

199. Ngai, 95.

200. Ngai, 97.

201. That being said, I believe that Hortense Spillers's suggestion that the figure of Uncle Tom serves as a cipher for the simultaneous expression and displacement of a nineteenth-century white feminine desire for the "dyadic taboo— . . . the 'black man' and the 'white woman'" (*Black, White, and in Color*, 191–94)—notwithstanding the fact that, as Robin Bernstein notes, "Eva's physical engagement with Tom is chaste in comparison to the unbridled sensuality between Eva and Mammy." Bernstein, *Racial Innocence*, 93. For not only is the subsequent aesthetic life of *Uncle Tom's Cabin* across a myriad of mediums and forms at

least as significant as, if not more significant than the letter of the novel itself, but as I have argued throughout *Anteaesthetics*, Spillers's analysis of the racially disjunctive economies of touch which are constitutive of the modern world also goes far beyond the reduction of touch to an axiomatic conception of literal, tactile contact.

202. Stowe, *The Annotated Uncle Tom's Cabin*, 259.

203. Bernstein, *Racial Innocence*, 30–68.

204. Moten, *Black and Blur*, 66–85.

205. Moten, 71.

206. Doane, *Emergence of Cinematic Time*, 1; James Brander Matthews, "The Kinetoscope of Time," *Scribner's Magazine* 18 (July–December 1895), 733–44.

207. Cf. Fisher, *The Weird and the Eerie*, 18.

208. Matthews, "Kinetoscope of Time," 734.

209. Matthews, 741, 742.

210. Matthews, 744.

211. Doane, *Emergence of Cinematic Time*, 2.

212. Stephen Railton, "Readapting Uncle Tom's Cabin," in E. Barton Palmer (ed.), *Nineteenth-Century America Fiction on Screen* (Cambridge: Cambridge University Press, 2007), 62–76, 67.

213. Doane, *Emergence of Cinematic Time*, 3.

214. Srinivas Aravamudan, *Tropicopolitans: Colonialism and Agency, 1688–1804* (Durham, NC: Duke University Press, 1999), 161.

215. Doane, *Emergence of Cinematic Time*, 3.

216. See, inter alia, Adam Barrows, "Time Without Partitions: Midnight's Children and Temporal Orientalism," *ariel: A Review of International English Literature* 42, no. 3–4 (2012), 89–101.

217. See, inter alia, Gayatri Chakravorty Spivak, *Death of a Discipline* (New York: Columbia University Press, 2003), 79–81. For a Native Studies critique of the postcolonial interpretation of colonialist historicity, see Jodi A. Byrd, *The Transit of Empire: Indigenous Critiques of Colonialism* (Minneapolis: University of Minnesota Press, 2011).

218. Warren, *Ontological Terror*, 97. Emphasis in original.

219. See Michel Foucault, "Of Other Spaces: Utopias and Heterotopias," trans. Jay Miskowiec, *Architecture /Mouvement/ Continuité* (October 1984 [1967]).

220. On the dancing commodity, see Karl Marx, *Capital*, vol. 1 (London: Penguin, 1990 [1867]), 163–64.

221. Moten, *In the Break*.

222. Sobchack, *Carnal Thoughts*, 147. Emphasis added.

223. Kathleen Stewart, "Atmospheric Attunements," *Environment and Planning D: Society and Space* 29, no. 3 (2011), 445–53.

224. See Philip and Saunders, "Defending the Dead, Confronting the Archive."

225. On the relation between the minor and the major, see Erin Manning, *The Minor Gesture* (Durham, NC: Duke University Press, 2016).

226. Chude-Sokei, *The Last Darky*, 35.

227. Da Silva, "Toward a Black Feminist Poethics."

228. Stowe, *The Annotated Uncle Tom's Cabin*, 253–54, 254.

229. For an extended reflection on this "originary displacement," see Chandler, *X—The Problem of the Negro*, 129–70.

230. Hartman, "The Belly of the World," 16; Chandler, *X—The Problem of the Negro*, 129–70.

231. See, inter alia, Moten *In the Break*; Moten, *Stolen Life*; Moten, *Universal Machine*; Mackey, *Paracritical Hinge*.

232. James Weldon Johnson (ed.), *The Book of American Negro Poetry* (Auckland: Floating Press, 2008 [1922]), 10, 11.

233. For my previous reading of black femininity's lyrical surplus, see Bradley, "Reinventing Capacity"; see also Moten, *In the Break*, 38.

Chapter 5

1. Dawn Lundy Martin, *Good Stock Strange Blood* (Minneapolis: Coffee House Press, 2017), 45.

2. Francis Fukuyama, *The End of History and the Last Man* (New York: Free Press, 1992).

3. Aihwa Ong, "Worlding Cities, or the Art of Being Global," in Ananya Roy and Aihwa Ong, *Worlding Cities: Asian Experiments and the Art of Being Global* (Malden, MA: Blackwell Publishing, 2011), 12, 13.

4. Ashon Crawley, *Black Pentecostal Breath: The Aesthetics of Possibility* (Durham, NC: Duke University Press, 2016), 27.

5. For example, Bradley, "Aesthetic Inhumanisms."

6. Martin Heidegger, *Poetry, Language, Thought* (New York: Harper & Row Publishes, 1971); Judy, *Sentient Flesh*, 343. Emphasis in original.

7. Warren, *Ontological Terror*, 179–180n3. Emphasis added.

8. Martin, *Good Stock Strange Blood*, 103. Emphasis in original.

9. With respect to the Kantian sublime, not only must Kant "presuppose the world of appearance in order to conceive of the sublime as the limit of representation," as George Hartley observes, but, moreover, the failure elicited by the sublime ultimately functions to reinscribe the law of reason, as Meg Armstrong contends. See George Hartley, *The Abyss of Representation: Marxism and the Postmodern Sublime* (Durham, NC: Duke University Press, 2003), 169; Meg Armstrong, "'The Effects of Blackness': Gender, Race and the Sublime in Aesthetic Theories of Kant and Burke," *Journal of Aesthetics and Art Criticism* 54, no. 3 (Summer 1996), 213–36. For an account of the racial constitution of the sublime in Kant and Burke, see Lloyd, *Under Representation*, 44–68.

10. Albert Boime, "Turner's Slave Ship: The Victims of Empire," *Turner Studies: His Art & Epoch, 1775–1851* 10, no. 1 (1990), 34–43, 34.

11. Text from A.J. Finberg, *The Life of J. M. W. Turner* (Oxford: Clarendon Press, 1961), 505.

12. Paul Gilroy, *The Black Atlantic: Modernity and Double Consciousness* (London: Verso Books, 1993), 13; Paul Gilroy, "Black Art and the Problem of Belonging to England," *Third Text* 4, no. 10 (1990), 42–52, 50.

13. Gilroy, "Black Art and the Problem of Belonging to England," 51; John Ruskin, *Modern Painters*, vol. 1 (Frankfurt am Main, Germany: Outlook Verlag Gmbh, Deutschland, 2018 [London 1848]), 360.

14. John Ruskin quoted in Gilroy, "Black Art and the Problem of Belonging to England," 51.

15. Ruskin quoted in Gilroy .

16. In *J. M. W. Turner and the Subject of History* (New York: Ashgate Publishing, 2012), Leo Costello states that the connection between Turner's *Slave Ship* and the *Zong* massacre was first established by T. S. R. Boase, "Shipwrecks in English Romantic Painting," *Journal of the Warburg and Courtauld Institutes* 22, no. 3-4 (1959), 334-46. For a dissenting view, see John McCoubrey, "Turner's *Slave Ship*: Abolition, Ruskin, and Reception," *Word & Image* 14, no. 4 (October–December 1998), 319-53.

17. Elicia Brown Lathon, "I Cried Out and None but Jesus Heard" (Ph.D. diss., Louisiana State University and Agricultural Mechanical College, 2005), quoted in M. NourbeSe Philip, *Zong!* (Middletown, CT: Wesleyan University Press, 2008), 201.

18. James Walvin, *The Zong: A Massacre, the Law, and the End of Slavery* (New Haven, CT: Yale University Press, 2011), 21.

19. See Bradley, "Too Thick Love."

20. Ian Baucom, *Specters of the Atlantic: Finance, Capital, Slavery, and the Philosophy of History* (Durham, NC: Duke University Press, 2005), 33.

21. Baucom, *Specters of the Atlantic*, 72.

22. Cf. Marx, *Capital*, vol. 1.

23. Spillers, "Mama's Baby, Papa's Maybe," 215. Emphasis in original.

24. My reading of Heidegger here is guided by Warren, *Ontological Terror*, especially ch. 3.

25. Alain Badiou, *Being and Event*, trans. Oliver Feltman (London: Continuum, 2007).

26. Warren, *Ontological Terror*, 117.

27. Katherine McKittrick, "Mathematics Black Life," *The Black Scholar* 44, no. 2 (2014), 16-28, 17.

28. Warren, *Ontological Terror*, 10, 116.

29. Jackson, *Becoming Human*, 1.

30. Brian Rotman, *Signifying Nothing: The Semiotics of Zero* (London: Macmillan Press, 1987).

31. Da Silva, "The Scene of Nature."

32. Bhandar, *Colonial Lives of Property*, 77-114.

33. Franklin, *The Digitally Disposed*, 12, 120-25.

34. Franklin, 120-22.

35. Spivak, "Three Women's Texts and a Critique of Imperialism," 260n1.

36. Pheng Cheah, *What Is a World? On Postcolonial Literature as World Literature* (Durham, NC: Duke University Press, 2016), 8.

37. Cheah, *What Is a World?*, 8.

38. Cheah, 8.

39. Cheah, 9.

40. Cheah, 17.

41. Cheah, 9-10, 9.

42. Martin Heidegger, *The Fundamental Concepts of Metaphysics: World, Finitude, Solitude*, trans. William McNeill and Nicholas Walker (Bloomington: Indiana University Press, 1995 [1929-30]), 177.

43. Jackson, *Becoming Human*, 99. Emphasis in original. Chen, *Animacies*.

44. See, inter alia, J. R. Ackermann (ed.). *The Imperial Map: Cartography and the Mastery of Empire* (Chicago: University of Chicago Press, 2009).

45. Marx, *Capital*, vol. 1.

46. Marshall Berman, *All That Is Solid Melts Into Air: The Experience of Modernity* (London: Verso Books, 1982), 36.

47. For an analysis of the ship as the materialization of "the matrix of the crisis of modernity," see Cesare Casarino, *Modernity at Sea: Melville, Marx, and Conrad in Crisis* (Minneapolis: University of Minnesota Press, 2002).

48. Foucault, "Of Other Spaces," 9.

49. G. W. F. Hegel, *Lectures on the Philosophy of History*, trans. J. Sibree (London: George Bell & Sons, 1894), 94. Emphasis in original.

50. Spillers, *Black, White, and in Color*, 302, 215.

51. Brand, *Map to the Door of No Return*, 85.

52. David Lambert, Luciana Martins, and Miles Ogbor, "Currents, Visions and Voyages: Historical Geographies of the Sea," *Journal of Historical Geography* 32 (2006) 479–93; Monica Mulrennan, "Mare Nullius: Indigenous Rights in Saltwater Environments," *Development and Change* 31, no. 3 (December 2002), 681–708; Liam Campling and Alejandro Colás *Capitalism and the Sea: The Maritime Factor in the Making of the Modern World* (London: Verso Books, 2021).

53. Glissant, *Poetics of Relation*, 6. For a more nuanced exposition, see Bradley and Marassa, "Awakening to the World, 121–26.

54. Tamar Clarke-Brown, "Adrift in the Chroma Key Blues: A Chat with Sondra Perry on Black Radicality + Things That Are Yet to Happen in *Typhoon coming on*," AQNB (1 May 2018), https://www.aqnb.com/2018/05/01/adrift-in-the-chroma-key-blues-a-chat-with-sondra-perry-on-black-radicality-things-that-are-yet-to-happen-in-typhoon-coming-on/.

55. Elizabeth DeLoughrey and Tatiana Flores, "Submerged Bodies: The Tidalectics of Representability and the Sea in Caribbean Art," *Environmental Humanities* 12, no. 1 (2020), 132–66.

56. *Online Etymology Dictionary*, s.v. "ship," accessed 25 October 2022, https://www.etymonline.com/word/ship.

57. Lauren Berlant and Kathleen Stewart, *The Hundreds* (Durham, NC: Duke University Press, 2019), 22.

58. Fred Moten, "sol aire," Flexner Lectures, 28 October 2020, Bryn Mawr College. For a previous reading of the open boat, with which I could now be said to part ways, see my "Poethics of the Open Boat (In Response to Denise Ferreira da Silva, 'Fractal Thinking')," *AcceSSions: Center for Curatorial Studies*, Bard College, no. 2 (2016), https://static1.squarespace.com/static/59bd603cb1ffb64dbd8f40f3/t/59c164ccbce1767e99989a456/1505846478691/Bradley+Accessions+.pdf.

59. Sharpe, *In the Wake*, 41.

60. Jackson, *Becoming Human*, 117.

61. See Lauren Berlant, *On the Inconvenience of Other People* (Durham, NC: Duke University Press, 2022), 117–49, passim. There seems to be an emergent critical discourse on unworlding, which perhaps speaks to a growing sense of the failures of discourses centered on

worlding and otherworlding to sufficiently grapple with the violent conditions of possibility for every world(ing). Jack Halberstam has notably argued for the importance of a project of unworlding, proclaiming that, "before we start thinking in utopian terms about what should come next, we have to do the hard work of unmaking this particular arrangement of power, bodies, and being." Jack Halberstam, "Un/Worlding: An Aesthetics of Collapse," lecture at Sheldon Museum of Art, 21 October 2021, Lincoln, NE, https://m.youtube.com/watch?v= Wf6Xw6bHAfs.

62. Simone White, *Or, on being the other woman* (Durham, NC: Duke University Press, 2022), 67.

63. Wilderson, "The Vengeance of Vertigo."

64. Hito Steyerl, "In Free Fall: A Thought Experiment on Vertical Perspective," *e-flux*, no. 24 (April 2011), https://www.e-flux.com/journal/24/67860/in-free-fall-a-thought-experi ment-on-vertical-perspective/

65. Franklin, *The Digitally Disposed*, 123.

66. Franklin, 123.

67. Franklin, 123. Emphasis in original.

68. Franklin.

69. Claire Bishop, *Installation Art: A Critical History* (London: Tate Publishing, 2005).

70. Spillers, "Mama's Baby, Papa's Maybe," 215. Emphasis in original.

71. "Sondra Perry Interviewed by Hans Ulrich Obrist at the Serpentine Galleries, London," n.d., https://www.youtube.com/watch?v=Qunkb4piXGw.

72. "Sondra Perry Interviewed by Hans Ulrich Obrist."

73. Daniela Agostinho, "Chroma Key Dreams: Algorithmic Visibility, Fleshy Images and Scenes of Recognition," *Philosophy of Photography* 9 no. 2 (2018), 131–55, 139.

74. Agostinho, "Chroma Key Dreams," 145.

75. Amiri Baraka and Theodore A. Harris, "Our Flesh of Flames," *Callaloo* 26, no. 1 (Winter 2003), 129–45.

76. Bradley, "Picturing Catastrophe."

77. Jacques Derrida and Geoffrey Bennington, "A Silkworm of One's Own (Points of View Stitched on the Other Veil)," *Oxford Literary Review* 18, no. 1/2 (1996), 3–65, 13.

78. For more on my understanding of seriality, see Bradley and da Silva, "Four Theses on Aesthetics."

79. D. S. Marriott, *Hoodoo Voodoo* (Exeter, UK: Shearsman Books, 2008), 96.

80. Karl Marx, *Capital*, vol 1., trans. Samuel Moore and Edward Aveling (London: Kimble & Bradford, 1938 [1867]), 775.

81. Mike Davis and Daniel Bertrand Monk, *Evil Paradises: Dreamworlds of Neoliberalism* (New York: The New Press, 2007).

82. Miwon Kwon, *One Place after Another: Site-Specific Art and Locational Identity* (Cambridge, MA: MIT Press, 2002), 2, 11.

83. Kwon, *One Place after Another*, 12.

84. Benjamin Chesluk, *Money Jungle: Imagining the New Times Square* (New Brunswick, NJ: Rutgers University Press, 2007), 1. Other prominent ethnographic and historical studies of Times Square include Marshall Berman, *On the Town: One Hundred Years of Spectacle in Times Square* (New York: Random House, 2006); William R. Taylor, *Inventing Times Square:*

Commerce and Culture at the Crossroads of the World (New York: Russell Sage Foundation, 1991); Daniel Makagon, *Where the Ball Drops: Days and Nights in Times Square* (Minneapolis: University of Minnesota Press, 2004).

85. Taylor, *Inventing Times Square*, xii.

86. Manfred B. Steger, *Globalization: A Very Short Introduction* (Oxford: Oxford University Press, 2009), 15.

87. Cf. Berlant, *Cruel Optimism*, especially 233–64.

88. John Helmer and Neil A. Eddington (eds.), *Urbanman: The Psychology of Urban Survival* (New York: Free Press, 1973), quoted in Chesluk, *Money Jungle*, 199n13.

89. Elena Gorfinkel, "Tales of Times Square: Sexploitation's Secret History of Place," in Elena Gorfinkel and John David Rhodes (eds.), *Taking Place: Location and the Moving Image* (Minneapolis: University of Minnesota Press, 2011), 55–76, 62.

90. Annie Dell'Aria, *The Moving Image as Public Art: Sidewalk Spectators and Modes of Enchantment* (Cham, CH: Palgrave Macmillan, 2021), 94.

91. Kwon, *One Place after Another*, 30, 8.

92. Cf. Robert Freestone and Edgar Liu (eds.), *Place and Placelessness Revisited* (New York: Routledge, 2016); Neil Smith, *The New Urban Frontier: Gentrification and the Revanchist City* (New York: Routledge, 1996).

93. Dave Colangelo, *The Building as Screen: A History, Theory, and Practice of Massive Media* (Amsterdam: University of Amsterdam Press, 2019).

94. Notable texts include but are not limited to Darrell Wayne Fields, *Architecture in Black: Theory, Space, and Appearance*, 2nd ed. (London: Bloomsbury Publishing, 2015); Irene Cheng, Charles L. Davis, and Mabel O. Wilson (eds.), *Race and Modern Architecture: A Critical History from the Enlightenment to the Present* (Pittsburgh: University of Pittsburgh Press, 2020); Charles L. Davis, *Building Character: The Racial Politics of Modern Architectural Style* (Pittsburgh: University of Pittsburgh Press, 2019); Cheng, *Second Skin*; Sean Anderson and Mabel O. Wilson (eds.), *Reconstructions: Architecture and Blackness in America* (New York: Museum of Modern Art, 2021); Adrienne R. Brown, *The Black Skyscraper: Architecture and the Perception of Race* (Baltimore: Johns Hopkins University Press, 2017); Mabel O. Wilson, *Negro Building: Black Americans in the World of Fairs and Museums* (Berkeley: University of California Press, 2012); Mabel O. Wilson, *Begin with the Past: Building the National Museum of African American History and Culture* (Washington DC: Smithsonian Books, 2016).

95. Cheng, Davis, and Wilson, *Race and Modern Architecture*, 4.

96. Brian Irwin, "Architecture as Participation in the World: Merleau-Ponty, Wölfflin, and the Bodily Experience of the Built Environment," *Architecture Philosophy* 4, no. 1 (2019), 89–102, 100.

97. Irene Cheng, "Structural Racialism in Modern Architectural Theory," in Cheng, Davis, and Wilson, *Race and Modern Architecture*, 134–52, 134.

98. Davis, *Building Character*, 13.

99. Doane, *Bigger Than Life*, 74.

100. Davis, *Building Character*, 15.

101. This is not to suggest that the dissimulated image of blackness functioned only as an artifact within modern architectural style. Far from it. Anne Anlin Cheng, for example, has undertaken a study of "Modernism's dream of a second skin," and in particular, the

manner in which the figure of Josephine Baker becomes differentially positioned in the fantasies of architects like Adolf Loos and Le Corbusier as the threshold for the morphing of racialized skin into modern surface. Cheng, *Second Skin*, 1. As I have already elaborated a critique of Cheng's reading of black feminine embodiment, I will not reiterate it here.

102. Quoted in Francesco Vitale, *The Last Fortress of Metaphysics: Jacques Derrida and the Deconstruction of Architecture*, trans. Mauro Senatore (New York: SUNY Press, 2018), xvi. In this respect, I am in complete agreement with Hashim Sarkis, Roi Salgueiro Barrio, and Gabriel Kozlowski that the world is an architectural project, although I am considerably less sanguine about the implications of this pronouncement. Sarkis, Barrio, and Kozlowski, *The World as an Architectural Project* (Cambridge, MA: MIT Press, 2020).

103. Martin Heidegger, "Letter on 'Humanism,'" trans. Frank A. Capuzzi, in William McNeill (ed.), *Pathmarks*, (Cambridge: Cambridge University Press, 1998 [1946]), 239.

104. Here I draw upon Darrell Wayne Fields's important observation that "the independent and systemic nature of . . . [Kant's] architectonic is measured in specific relation to a 'black' body," while adding my own distinctive theoretical emphasis. Fields, *Architecture in Black*, 386.

105. Irwin, "Architecture as Participation," 97.

106. Here I am riffing on Soyoung Yoon's evocative conceptualization of Perry's "skin-become-flesh-become-sea-become-skin" (83). See Soyoung Yoon, "Figure versus Ground, White versus Black (Blue), or: Sondra Perry's Blue Room and Technologies of Race," in Amira Gad (ed.), *Sondra Perry: Typhoon Coming On* (London: Serpentine Galleries, 2018), 75–85.

107. Mark Wigley, *The Architecture of Deconstruction* (Cambridge, MA: MIT Press, 1993), 42, 44, 35–58.

108. Cf. Wigley, *Architecture of Deconstruction*.

109. "*Flesh Wall*: February 1, 2021–February 28, 2021, Sondra Perry" Times Square Arts, http://arts.timessquarenyc.org/times-square-arts/projects/midnight-moment/flesh-wall/index.aspx.

110. Mark Wigley, "The Architectural Cult of Synchronization," *October* 94 (Autumn 2000), 31–61, 39.

111. Gorfinkel, "Tales of Times Square," 59–60.

112. Wigley, "The Architectural Cult of Synchronization," 33.

113. Merleau-Ponty, *The Phenomenology of Perception*, trans. Landers, 84, passim.

114. Cf. Wigley, "The Architectural Cult of Synchronization," 43.

115. Walter Benjamin, *Illuminations: Essays and Reflections*, trans. Harry Zohn (New York: Schocken Books, 1968), 255.

116. William D. Blattner, *Heidegger's Temporal Idealism* (Cambridge: Cambridge University Press, 1999), 127.

117. Merleau-Ponty, *The Visible and the Invisible*, 140, 147, 139; Grosz, *Volatile Bodies*, 95.

118. Grosz, 96.

119. Cf. Beata Stawarska, "From the Body Proper to Flesh: Merleau-Ponty on Intersubjectivity," in Olkowski and Weiss, *Feminist Interpretations of Merleau-Ponty*, 91–106.

120. Cf. Spillers, "Mama's Baby, Papa's Maybe," 207; and Moten, *Stolen Life*, 161–82.

121. Grosz, *Volatile Bodies*, 101.

122. Thacker, "Dark Media," 95.

123. Ed Roberson, *To See the Earth before the End of the World* (Middletown, CT: Wesleyan University Press, 2010), 3.

124. As this figuration is engaged by works too numerous to mention here, see, for example, T. J. Demos, *Beyond the World's End: Arts of Living at the Crossing* (Durham, NC: Duke University Press, 2020); Anna Lowenhaupt Tsing, *The Mushroom at the End of the World: On the Possibility of Life in Capitalist Ruins* (Princeton, NJ: Princeton University Press, 2015); Timothy Morton, *Hyperobjects: Philosophy and Ecology after the End of the World* (Minneapolis: University of Minnesota Press, 2013); Natalie Loveless, *How to Make Art at the End of the World: A Manifesto for Research-Creation* (Durham, NC: Duke University Press, 2019).

125. Thacker, "Dark Media," 80.

126. For critical perspectives on the inhuman challenge of the so-called Anthropocene, see, inter alia, Dana Luciano, "The Inhuman Anthropocene," *Los Angeles Review of Books*, 22 March 2015, https://avidly.lareviewofbooks.org/2015/03/22/the-inhuman-anthropocene/; Kathryn Yusoff, *A Billion Black Anthropocenes or None* (Minneapolis: University of Minnesota Press, 2018); Kathryn Yusoff, "The Inhumanities," *Annals of the American Association of Geographers* 111 (2021), 663–76; Nigel Clark, *Inhuman Nature: Sociable Life on a Dynamic Planet* (Thousand Oaks, CA: SAGE Publications, 2011).

127. Thacker, "Dark Media," 80. Emphasis in original.

128. Glissant, *Poetics of Relation*, 191. Emphasis in original.

129. See Thomas Nail, *Theory of the Earth* (Stanford, CA: Stanford University Press, 2021); Barad, *Meeting the Universe Halfway*; da Silva, "Difference without Separability"; Fred Moten and Stefano Harney, *All Incomplete* (Colchester: Minor Compositions, 2021), 113–18.

130. Roberson, *To See the Earth*, 3.

131. For an appositional meditation on this question, see Bradley, "Too Thick Love."

132. Unworlding is deployed in this latter sense, for example, by Donna Haraway, *Staying with the Trouble*.

133. Brand, *A Map to the Door of No Return*, 14.

Index

Inventions Black Philosophy, Politics, Aesthetics
Edited by David Marriott

Le véritable saut consiste à introduire l'invention dans l'existence—the real leap consists in introducing invention into existence. Among this and other demands for a thought, a blackness of thought that is itself an act of liberation, for Frantz Fanon, the critical task of any aspirational black philosophy is its ability to tell apart blackness from its mirages and impossibilities in science, art, and European history and philosophy. Is it still possible to pursue this goal today, within the ongoing reaches of anti-blackness? And what could this "leap" be, given the undecidability of blackness as a concept, feeling, or figure? The premise of the series is that blackness cannot be subsumed under the prevailing forms of philosophy, politics, or aesthetics without putting into question what this leap could be, or mistaking invention for their presuppositions, and so losing sight of what this invention could be *in its very difference*. To that end, *Inventions* seeks to publish works that set the agenda for what this leap would look like or be.

Anteaesthetics Black Aesthesis and the Critique of Form
Rizvana Bradley

Of Effacement Blackness and Non-Being
David Marriott

Printed in the USA
CPSIA information can be obtained
at www.ICGtesting.com
JSHW010058111123
51694JS00001B/1